Arab American Public History

In the series *History and the Public*, edited by Steven Conn

ALSO IN THIS SERIES:

Brad Austin and Donna Seger, *Salem's Centuries: New Perspectives on the History of an Old American City*

Robin F. Bachin and Amy L. Howard, eds., *Engaging Place, Engaging Practices: Urban History and Campus-Community Partnerships*

David W. Young, *The Battles of Germantown: Effective Public History in America*

Edited by Edward E. Curtis IV

Arab American Public History

TEMPLE UNIVERSITY PRESS
Philadelphia • *Rome* • *Tokyo*

TEMPLE UNIVERSITY PRESS
Philadelphia, Pennsylvania 19122
tupress.temple.edu

Copyright © 2026 by Temple University—Of The Commonwealth System
 of Higher Education
All rights reserved
Published 2026

Cataloging information is available from the Library of Congress.

Names: Curtis, Edward E., IV, 1970- editor
Title: Arab American public history / edited by Edward E. Curtis IV.
Other titles: History and the public (Philadelphia, Pa.)
Description: Philadelphia : Temple University Press, 2026. | Series:
 History and the public | Includes bibliographical references and index.
 | Summary: "Examines the presentation and reception of Arab American
 public history"— Provided by publisher.
Identifiers: LCCN 2025046001 (print) | LCCN 2025046002 (ebook) | ISBN
 9781439927212 cloth | ISBN 9781439927229 paperback | ISBN 9781439927236 pdf
Subjects: LCSH: Arab Americans—History | Arab Americans—Historiography |
 Arab Americans—Social conditions | Arab Americans—Ethnic identity |
 Public history—United States
Classification: LCC E184.A65 A667 2026 (print) | LCC E184.A65 (ebook) |
 DDC 305.892/7073—dc23/eng/20251114
LC record available at https://lccn.loc.gov/2025046001
LC ebook record available at https://lccn.loc.gov/2025046002

The manufacturer's authorized representative in the EU for product safety is
Temple University Rome, Via di San Sebastianello, 16, 00187 Rome RM, Italy
(https://rome.temple.edu/).
tempress@temple.edu

∞ The paper used in this publication meets the requirements of the
American National Standard for Information Sciences—Permanence
of Paper for Printed Library Materials, ANSI Z39.48-1992

Printed in the United States of America

9 8 7 6 5 4 3 2 1

Contents

1. Introduction 1
 Edward E. Curtis IV
2. An Ethnic Home? Countering Geopolitical and Bureaucratic Definitions of Arab American Identity 22
 Randa A. Kayyali
3. Syrian Boston from Ottoman Emigration to Urban Renewal: Neighborhood History on Foot, on Display, and Online 45
 Chloe Bordewich and *Lydia Harrington*
4. Houston, We Have a Hafli! Public History and Cultural Production among Arab American Communities in Texas and the Gulf Coast 72
 Maria F. Curtis
5. Midwest Mahjar: Cityscapes, Soundscapes, and Centering Arab American Biographies in Public History 105
 Richard M. Breaux
6. The Arab Indianapolis Community History Project 128
 Edward E. Curtis IV
7. Arab American Genealogy Research as a Form of Public History 151
 Reem Awad-Rashmawi

8. Yalla Eat! Walking an Arab American Food Landscape 174
 Matthew Jaber Stiffler
9. Conclusion: Shared Authority and Reflective Practice in Public History 195
 Rebecca K. Shrum

Acknowledgments 205
About the Contributors 207
About the Editor 209
Index 211

Arab American Public History

1

Introduction

Edward E. Curtis IV

For much of the twentieth century and all of the twenty-first, public scholarship on Arab American history, like all of Arab American life, has been pursued in the shadow of prejudice.[1] This edited volume, the first formal study of Arab American public history, aims to show how public history projects have sought to counter anti-Arab bias and discrimination. It also showcases the Arab American community's role in creating their own narratives, sometimes explicitly in response to bias but not always. Though the book is the first to examine Arab American history produced *with* and *for* the public, the scholar-practitioners featured in these pages build on a deep well of both Arab American studies scholarship and Arab American community history. Public history, as the National Council of Public History points out, is "history beyond the walls of the traditional classroom."[2] As this book defines it, it includes the history that Arab Americans write, film, map, archive, perform, and engage among themselves and in cooperation with others in museums, historical sites, theaters, genealogy groups, and restaurants; on city streets, social media, and the internet; and in other public spaces.

The question of audience is key to this volume, as it examines the purposes for which practitioners of Arab American public history write, blog, curate, collaborate, and broadcast. In chapters penned by a diverse group of both Arab and non-Arab American authors, the book provides an excellent overview of the kinds of public history projects that Arab American com-

munities and engaged scholars of the Arab American past have produced. In addition to describing and thus preserving significant work in Arab American public history, the volume's contributors reflect on how the larger social and political contexts affect their work, offer self-reflection, and attempt to chart a variety of paths forward for expanded scholarly and popular attention to the Arab American past.

The methodology of the book's production also attempts to "practice what it preaches" in its inclusion of community voices. Several of the contributors are themselves members of the Arab American community or have a history of community collaboration with Arab Americans. But whether Arab or not, all contributors submitted drafts of their chapters for comment not only by qualified peer reviewers but also by community members and public historians who gathered at an Indianapolis conference for this purpose.[3] As Rebecca K. Shrum's conclusion to this volume shows, these interactions led contributors to think through how foundational public history concepts of *shared authority* and *reflective practice* have informed their work. The formal interactions and informal conversations of community members, public historians, and Arab American studies scholars within this framework prompted essential reflection on the ethics of scholarship that felt especially urgent in light of anti-Arab animus and other forms of prejudice, discrimination, and violence faced in the past and present by Arab Americans. Do scholars believe that they possess the authority to decide what is worth studying, that they hold power to share authority, as they wish, with people outside the academy? Or do scholars proceed with the assumption that community members also possess authority to determine what is worth studying, how to study it, and how to share such knowledge? Do scholars look mainly to other scholars to reflect on the design and outcomes of their projects, or are they also reflecting on the work with community members?

Our hope is that by grappling with such questions, this volume makes an important contribution inside and outside higher education. For public historians, museum studies professionals, applied anthropologists, and other publicly allied and community-engaged scholars, the book is an invitation to engage more deeply with Arab American communities and an orientation to such work. For Arab American studies scholars, it is a love letter to all those who work beyond the walls of the academy and one of the few book-length studies to consider the significance of community-engaged research in the field.[4] We also hope it is a resource for Arab American community members who are interested in learning about and contributing to narrating their own history. Finally, the book is intended to help all those readers who care about diversity, equity, and inclusion apply the lessons of the American past in their daily lives.

Who Is Arab?

Because the subjects of Arab American public history are not well known in the field of public history—or among the general American public, for that matter—the chapter immediately following this introduction is a discussion of the contested meanings of Arab American identity. People who have called themselves Arabs have contested the meaning of their group identity since late antiquity, and their debates about the relative significance of shared communal history, language, blood, geography, religion, and political allegiance have always been part of Arab American identity making, too.[5] One of the reasons why grappling with the definition of Arab identity is an urgent task is because the erroneous conflation of Arab and Muslim identities became more pronounced in the aftermath of 9/11.[6] For example, reading lists for Arab American heritage month every April inevitably include books about Afghan, African American, Bangladeshi, Bosnian, Indian, Iranian, Pakistani, Turkish, and other non-Arab Muslims.[7] This is problematic not only for Arabs but also for the Muslims who wish to be identified by their non-Arab cultural and ethnic backgrounds. No one really knows, but perhaps one-fifth to one-quarter of the U.S. Muslim community is Arab; Muslim Americans also identify as African American, South Asian, West African, East African, European, Latino/a, Iranian, Afghan, Turkish, Southeast Asian, and so on.[8] Moreover, the conflation of Arab and Muslim identities obscures the reality that perhaps more than half of Arab Americans likely identify as Christian.[9]

Arab histories in the Americas date to the sixteenth century, when Arabic-speaking nominal converts to Christianity from Iberia and North Africa migrated to New Spain, including what would become the U.S. Southwest.[10] But the first Arabic speakers in any large number were the tens of thousands of African Muslims who arrived as enslaved people on North American shores beginning in the 1600s and continuing through the end of the international slave trade and of U.S. slavery in 1865. Many more Arabophone Muslims were present in South America and the Caribbean. Arabic was a religious, literary, and scientific language for these African Muslims, and they did not generally identify their peoplehood as "Arab," with only a few exceptions.[11] The first major period of free immigration took place between the late nineteenth century and the passage of the National Origins Act of 1924, which virtually cut off immigration from most countries save those in Northwestern Europe. Perhaps a half-million people from the Levant, or Eastern Mediterranean, migrated to the Americas in this period, with about one hundred thousand coming to the United States.[12] Most of these immigrants were from what today is Lebanon but was then part of the Ottoman-governed Eastern Mediterranean.[13] To this day, Lebanese are the largest single "national origin"

group of Arab Americans. According to the 2020 U.S. Census, 685,672, or 20 percent of all people who identified as having Middle Eastern and North African descent, were Lebanese.[14] Even as Lebanese continued to migrate to the United States, especially throughout the long Lebanese Civil War of 1975, the Arab American population started to grow far more diverse in the post–World War II period. The beginnings of immigration reform that would culminate in the passage of the new Immigration and Naturalization Act of 1965 saw larger migrations from across North Africa and the Middle East.[15] Not all of these persons identified as Arab, but most of them did.

Around 3.5 million people in the United States "reported Middle Eastern or North African descent in the 2020 Census." Among those respondents who *do not* generally self-identify as Arabs included in the count are Iranians (about 413,000 of the total) and smaller groups of Kurdish, Israeli, Assyrian, Syriac, and Yazidi people. Among the largest groups who do generally identify as Arab (but not always) are, after the Lebanese, Egyptians (314,000) and people who simply say they are Arab or Arabic (170,000).[16] The term *Arab* or *Arabic* in the Census has a host of possible meanings, including the idea of identifying culturally, linguistically, ethnically, or politically as Arab over and instead of identifying with one single nation-state.

For those of us who grew up Arab or have studied the issue, it all makes perfect sense, even though we never stop arguing about what makes us Arab.[17] But for most Americans, it is no wonder Arab identity is difficult to figure out. That confusion is reflected quite broadly in U.S. society. In order to parse the problem of what being Arab means, Randa A. Kayyali's chapter, "An Ethnic Home?," takes a deep dive into how *Arab American* is defined by analyzing the new federal "Middle East and North Africa" racial-ethnic category, Google searches, Wikipedia entries, ChatGPT, and media from the Arab American National Museum. Kayyali suggests that, above all, the Arab American label should be understood as a transnational, affective category rather than a geographic one. She rightly points out that Arab identities do not have to refer to a country of origin, despite the tendency to conflate "national origins" with Arab identities (from Moroccan to Iraqi). For Kayyali, the idea of an ethnic home "describes an emotional-affective bond with a corresponding territory that cannot be seen or drawn but is felt." The Arab's map need not correspond to a particular nation-state, although it is hard to imagine it excluding some sort of identification with peoples and places in the North Africa and the Middle East, whether material, mythical, or aesthetic.

Arab American Public Historiography

Arab Americans' conceptions of our own history have been central to the making of our identities, political alliances, and social locations.[18] Since the

arrival of my own Arabic-speaking ancestors in the late nineteenth century, the Arab American community has engaged in local, regional, and national efforts to record our history in this country and the Arabic-speaking diaspora across the Americas, Europe, and West Africa in addition to celebrating our roots in what today is called the Middle East and North Africa (or Southwest Asia and North Africa, SWANA). Stories of ethnic and civilizational pride, so much a part of the U.S. immigrant experience overall, have been passed along in homes and recorded in the community's Arabic- and English-language newspapers from the late 1800s until today.[19] Like children in other ethnic and racial groups, Arab American children have been told about the "firsts," a civilizational discourse that claims our contributions to science, industry, the arts, and the humanities. As a child growing up in Southern Illinois during the 1970s, I was told—incorrectly—that Ernest Hamawi, who invented the ice cream cone at the St. Louis World's Fair in 1904, was my great-great-grandfather.[20] (He was the brother of my great-great-grandfather, I believe.) In fact, I heard about even greater feats—Harun ar-Rashid's court in Baghdad, the land of *alf layla wa layla* (*The Thousand and One Nights*), may have been mentioned. Kahlil Gibran, referred to as the greatest English poet ever, was definitely part of kitchen conversations. My Arab grandmother's stories were echoed in many homes. Such home-based histories performed a variety of functions and were resources for some of us in the battle against the racial, ethnic, or religious discrimination that we faced. So much of our Arab American grassroots public history has been made in the context of antidiscrimination work, whether it was for internal or external consumption.

The first generation of free Arabic-speaking settlers and their children also launched more public forms of history making, which became part of their efforts to explain to themselves and other Americans in both Arabic and English how they were deserving of citizenship and respect. Because they hailed from Asia, it was unclear whether they were legally entitled to become naturalized citizens. The Asian Exclusion Acts of the 1880s had clearly prohibited the naturalized citizenship of Chinese and other races who were considered by the courts to be "mongoloid," and Syrians and Lebanese were called "Oriental" by U.S. newspapers. But for some legal purposes, my ancestors qualified as white. For example, in the Plains states, they were able to file homesteads—which was only possible if they were eligible to become naturalized citizens.[21] When, in the early twentieth century, the federal government instructed local courts that Syrians and Lebanese were actually Asian and thus should not be granted naturalized citizenship, these immigrants organized nationwide civil rights campaigns that eventually led to a federal court case, *Dow v. United States*, which, on appeal, declared them to be white.[22] Their historical origins in the land from which Jesus came and narratives

about their civilizational achievements such as the ancient Phoenicians' invention of letters were evoked to prove their worthiness.[23]

Regardless of these efforts, however, federal immigration restrictions enshrined in the Johnson-Reed Act of 1924 in addition to popular anti-immigrant, racist violence meant that many Arab Americans did not have full social or legal citizenship. Like other immigrants who were not white Anglo-Saxon Protestants, they were always vulnerable to racism, xenophobia, sexism, and religious bigotry, a fact detailed in Richard M. Breaux's chapter, "Midwest Mahjar [Diaspora]." Arabic-speaking Americans and their children responded to such problems by creating their own communal institutions, including Syrian and Lebanese ethnic clubs, newspapers, philanthropic organizations, and other public ventures. History making was one tool in sustaining their humanity and defending their peoplehood but so was merrymaking, humor, music, dance, poetry, and more.[24] This is the world so well described by Breaux regarding the Syrian and Lebanese communities of La Crosse, Wisconsin, and by Chloe Bordewich and Lydia Harrington about Little Syria in Boston. As ethnic clubs and other Arab American institutions proliferated during the interwar period, they became affiliated with regional associations such as the Midwest Federation of Syrian American Clubs, the Syrian and Lebanese American Federation of the Eastern States, and the Southern Federation of Syrian American Lebanese Clubs, described in Chapter 4, "Houston, We Have a Hafli [Party]!," by Maria F. Curtis.

What this book and other scholarship on Arab American history make abundantly clear is that it was often women, sometimes born in the "old country" but more often in the United States, who launched the first formal Arab American public history initiatives in the United States. Arab American women had taken up writing and publishing almost as soon as they arrived in the 1800s, but by the 1960s, their daughters and granddaughters were the ones who sought to record, archive, and analyze the histories of the communities in which they were raised. Alixa Naff, whose collection in the Smithsonian did as much as anyone to launch the academic study of Arab Americans, began interviewing Arab Americans about the experiences of immigration in 1962, leading to her designation as the "grande dame" of Arab American studies, as Maria F. Curtis points out in this book.[25] Curtis's entire chapter is about her work with another of the great Arab American leaders, Ruth Ann Skaff, whose archive is so enormous that it is not yet clear where all of it will find a home. As Bordewich and Harrington note in Chapter 3, "Syrian Boston from Ottoman Emigration to Urban Renewal," Adele Younis completed her dissertation at Boston University in 1961. Entitled "The Coming of the Arabic-Speaking People to the United States," it included many sources from her local community. Bordewich and Harrington also point to the leadership

of Evelyn Shakir, Evelyn Abdalah Menconi, and Elaine Hagopian in various public history endeavors.[26]

Public history was also used to support political causes in the Arab world. Starting in the 1930s, speakers associated with these groups and eventually with the Arab National League (1936–1941) and the Institute for Arab American Affairs (1945–1950) paid special attention to the history of Palestine.[27] They published newspaper articles, pamphlets, and books and sponsored local talks about Palestinian history as a counterclaim to Zionist historical narratives, a key part of the creation of an Israeli national home in the Eastern Mediterranean. Other topics included the historic nature of Antiochian and Coptic Orthodox churches, the civilizational achievements of Islam, folkloric dance, ethnic food, and so on.[28]

Later, in the wake of Israel's 1967 military defeat of Egypt, Jordan, Lebanon, and Syria and a second major exodus of Palestinian refugees, Arab American intellectuals, mainly secular and leftist in orientation, began to write and publish public histories not to celebrate the assimilation of Arab Americans in the United States but to resist the dispossession of Palestinians by showing their long history in Palestine and their connections to other global anti-colonial, anti-racist struggles.[29] Activists such as Boston's Elaine Hagopian cofounded the Association of Arab American University Graduates, as Bordewich and Harrington describe. In the 1980s, the anti-colonial, anti-racist mantle of Arab American activism was claimed by Arab American Senator James Abourezk, who established the American-Arab Anti-Discrimination Committee (ADC) in the nation's capital.[30] In addition to focusing on contemporary affairs and legacy advocacy, the ADC formed an educational division that published curricula for schools and pamphlets for the general public about both Arab and Arab American history.[31]

During the last three decades of the twentieth century, Arab Americans sought to document their own history and control the means by which such information was distributed, consumed, and interpreted, carrying on the legacy of the first Arabic- and English-language newspapers. Now, however, stories about our roots and our heritage began to appear in multiple genres, including on the silver screen. During the era of Black consciousness and ethnic revival of the 1970s, ethnic history was a popular form of entertainment and consumer culture.[32] Arab Americans wanted their heritage to be recognized along with that of other groups as worthy of respect. Arab American film producer Moustapha Akkad, whose *Halloween* (1978) inaugurated one of the most successful horror series in film history, produced a major motion picture about the Prophet Muhammad titled *The Message* (also known as *Mohammad, Messenger of God*) in 1976 and went on in 1980 to direct *Lion of the Desert*, a film starring Anthony Quinn about Umar al-Mukhtar, the

leader of the resistance against the Italian occupation of Libya. Both of these films valorized the history of Arab peoples. In addition to such well-funded Hollywood films, grassroots television programs showed up on local public-access stations, and videotapes about Arab American culture were distributed among community members.[33]

Arab Americans continued to print their own books and periodicals, too. Most notable during this era was perhaps the work of Joseph R. Haiek, who established News Circle Publishing House in 1972. Two years later, he published the first of six editions of the *Arab American Almanac*, a reference book that would eventually total 608 pages. Billed as the "most comprehensive reference source on Arab Americans," the almanac contained a wealth of information on "Arab contributions to world civilization," "the Arabic literary renaissance" among writers such as Ameen Rihani, "Arab American organizations," "Arab American press," "religious institutions," "Who's Who among Arab Americans," the "Arab world," the "U.S.A.," a "Century of Arab American Achievements and Contributions," and a bibliography. Haiek also founded the Arab American Historical Foundation, which produced videos, lectures, exhibits, and brochures about Arab American history.[34]

In sum, through outlets ranging from local newspaper articles and ethnic club lectures to museum exhibits and film, Arab Americans in the twentieth century celebrated their achievements and defended their political, cultural, and economic interests against anti-Arab racism and xenophobia. They often identified transnational and diasporic connections to other Arabs in the Americas and Afro-Eurasia as resources in that struggle. More often than not, Arab Americans harnessed history, like other ethnic and racial groups, to claim their belonging to the United States. The examples mentioned here are merely illustrative, and a comprehensive history of how Arab Americans have imagined the past in the twentieth century as a source of identity and power is yet to be written. But suffice to say that when Arab Americans faced the terrible consequences of 9/11, they did not do so without this legacy of grassroots community history. There was already a rich archive of the historical imagination that had sought to sustain Arab humanity and memory and to nurture a sense of Arab community for more than a century.

Contemporary Arab American Public History and the Shadow of Racism

It is not an exaggeration to claim that for many Arab Americans in the wake of 9/11, our very lives and liberty became existential questions. When al-Qaeda attacked the United States, they also struck terror in the hearts of Arab Americans, Muslim Americans, and others who feared that the people about

whom they cared, both at home and abroad, would become the victims of revenge, a feeling perfectly captured by Palestinian American poet Suheir Hammad's poem "first writing since."[35] Hate crimes spiked immediately afterward, declined, and then would rise again in response to political events over which Arab Americans had little control, including, for example, the 2016 U.S. presidential campaign of Donald Trump.[36] Though acts of individual hatred and popular ignorance have fueled anti-Arab discrimination and violence, the nature of anti-Arab racism is also structural and institutional.[37] Local and state law enforcement, the federal government, media, lobby groups, politicians, and think tanks have all contributed to anti-Arab prejudice and discrimination by conflating Arab and Muslim identities. President Trump's "Muslim Ban" is only one dramatic example of a variety of discriminatory practices, including employment discrimination, no-fly lists, proxy denaturalization, counterintelligence operations, immigrant visa discrimination, and harassment at U.S. borders, as well as the torture of Arabs and Muslims at secret "black sites," Abu Ghraib prison in Iraq, and Guantanamo Bay in Cuba.[38]

All of the projects described in this book have been launched, at the very least, in the shadow of this era's terrorizing of the Arab American community. Breaux, trained as a scholar of African American studies, explains, for example, that he began his work on Arab American history in 2016 in the midst of attempts to prevent Syrian refugees from resettling in the Midwest. One of the important themes of Breaux's chapter is the desire to include Arab Americans in local histories that have erased them. In the case of Eau Claire, Wisconsin, dominant historical narratives have ignored or never bothered to explore the presence of pre–World War I Arabic-speaking immigrants who once lived in thriving neighborhoods. This erasure, as Breaux points out, perpetuates stereotypes of Arab peoples and cultures as new to the United States. In addition to researching, designing, and conducting a walking tour and an active Facebook book group in which the descendants of the Syrian and Lebanese immigrants participate, Breaux also focused on researching the music that they listened to and, in some cases, produced. His popular blog, *Midwest Mahjar*, reveals the incredibly rich world of Arab American musicians, music consumers, and music store owners, showing for the first time the role of 78 rpm records in the making of the Arab American sonosphere.

Like Breaux's project on Eau Claire, my own chapter, "The Arab Indianapolis Community History Project," is an effort to integrate Arab Americans into the larger history of another Midwestern city. What began as a blog morphed into a book of stories and photographs, a virtual heritage tour on TheClio.com, an Indiana Historical Bureau marker at Lucas Oil Stadium, PBS LearningMedia for educators, an educators' workshop, twenty Indiana Humanities community dialogues around the state, and a thrice Emmy award–winning documentary made for the local PBS affiliate. *Arab Indianapolis: A*

Hidden History (2022) begins with the attempt of Governor Mike Pence to ban Syrian refugees from the state and goes on to explore the anti-Arab racism behind such a policy by revealing the long history and participation of Arab Hoosiers in the life of the community.

In demonstrating how anti-Arab prejudice, discrimination, and violence are always in the background of such public history initiatives, this book also explains that Arab Americans both accept and challenge the limiting effects of anti-Arab animus on their imaginations. Matthew Jaber Stiffler, in Chapter 8, "Yalla [Let's Go and] Eat!," suggests that Arab American public history projects, like those that engage the histories of other racial and ethnic minorities, may sometimes depoliticize Arab American culture, disconnecting it from the community's experiences of oppression and their attempts to fight back. This is particularly true when it comes to Arab American culture as a form of consumerism. "As bell hooks warns," note Anny Gaul, Graham Auman Pitts, and Vicki Valosik, "the commodification and uncritical enjoyment of 'Otherness' can lead to a self-satisfied, reductive form of consumption devoid of context or politics. Embracing intercultural exchanges does not erase the structures of domination that frame them."[39] Stiffler describes himself as "grappling" with the issue, as I do in my own chapter about the Arab Indianapolis project. His analysis is an important reminder that all our public history projects, whether explicitly political or not, have political implications and that ignoring the roots of Arab American oppression may do some harm as well as some good.

In its focus on *public* history, this book includes modes of historical query sometimes marginalized in the academic field of history, as discussed by Reem Awad-Rashmawi in Chapter 7, "Arab American Genealogy Research as a Form of Public History." As in other chapters, the analysis includes the politics of responding to anti-Arab discrimination. In one case, for example, an Arab American seeks out their Palestinian roots as a form of resistance against the Israeli dispossession of Palestinians. But the creation of genealogical memory and narrative is about much more than that, too. We learn about Arab Americans who study how to sew *tatreez*, needlework patterns associated with their ancestors' Palestinian village. As Awad-Rashmawi reports, the sewing becomes more than a form of politics or even a skill; it is also an aesthetic ritual that has spiritual meaning, meeting the need to address "something missing" in this person's life. In another case, a subject who enlisted the assistance of genealogical researchers went on to apply for Lebanese citizenship and move to Lebanon, an act reminiscent of journalist Anthony Shadid's memoir about rebuilding his ancestral home there.[40] Another person changed their last name to match that of their ancestors—a conversion of identity. Awad-Rashmawi shows how in dismissing genealogical research, some academic historians can ignore many of the important reasons why,

according to other public historians, genealogy has emerged as a major activity of nonacademic history. If public historians wish to take seriously the history making of the community members with and for whom we work, genealogical research must be included as one possible mode of our work.

As the research involved in Arab American genealogy suggests, public history is not the watering down of academic history. Neither is it the mere translation of academic history into more intelligible language, no matter how important that task is. Public history is also, as Bordewich and Harrington declare, an opportunity for scholars and community members to adopt different intellectual frameworks—different theories and methods—than those pursued in academic literature. Had they wanted to write an academic journal article on Little Syria in Boston, for instance, their training suggested that they should respond to scholarly questions about "the transformation of the built environment, 'urban renewal,' and large-scale departure to the suburbs." By working with and for Arab Bostonians, however, they decided instead to create a "multimodal public history project" focusing on historical reclamation, one that included digital mapmaking, an historical exhibit, and, most importantly, a series of historical walking tours in what used to be Little Syria. Digital historians and humanities scholars will be particularly interested in Bordewich and Harrington's discussion of their decision to create a digital map of Little Syria and the challenges of doing so.

A theme that runs across all of the chapters in the book is the importance of institutional support for Arab American public history. Awad-Rashmawi's genealogy work is largely self-funded, while Breaux's Eau Claire and Bordewich and Harrington's Boston projects have received modest institutional funding. My Indianapolis and Maria Curtis's Houston projects have won major grants in addition to support from governmental, semigovernmental, university, foundation, and individual sources.

Stiffler's work is different. As research and content manager at the Arab American National Museum and now director of the Center for Arab Narratives, Stiffler is an employee of the Arab Community Center for Economic and Social Services (ACCESS), "a multi-site, multi-service organization with an annual budget of $35 million with over one hundred different programs." The Yalla Eat! culinary tour of Dearborn, Michigan, that is described and analyzed by Stiffler is but one of those programs. More specifically, Yalla Eat! is the brainchild of the Arab American National Museum, a "38,500-square-foot facility" in Dearborn, Michigan, with an approximately $2 million annual budget and about twenty-two employees.[41] The Arab American National Museum partners intentionally and thoughtfully with the residents of Dearborn and the Detroit metropolitan area, working with schoolchildren, musicians, artists, researchers, and others to make its exhibits, building, collections, and other resources relevant to its local circumstances.

But as the chapters in this book show, the museum's reach is national, as it inspires or supports public scholars and community members across the United States. The museum sponsors the annual Arab American National Book awards, the only national awards that recognize books by and about Arab Americans. It has welcomed submissions from anyone for its annual Arab film festival. It also produces its own publication on occasion, as Kayyali's examination of her work on *Arab Americans: History, Culture, and Contributions* demonstrates.[42] Maria F. Curtis notes how the museum has offered advice about the Skaff Family Archive and how its website hosts its "introductory archival informational sessions" about family and community archiving in Arab America. Bordewich and Harrington, who have used the digital collections at the museum, mention that in the near future, the museum will organize programs and curate an exhibit about Boston's Little Syria in "Beantown" itself, to which the authors will contribute their content knowledge. Awad-Rashmawi states that the collections of the museum are of critical importance to genealogical research. These examples demonstrate the museum's central role in the institutional support of Arab American public history outside Detroit.

Perhaps the most robust academic center supporting Arab American public history is the Khayrallah Center for Lebanese Diaspora Studies at North Carolina State University. Funded by an $8.1 million endowment, a gift of Lebanese Americans Moise A. and Vera Khayrallah, the program first started by historian Akram Khater became a full-fledged research center in 2014 and has been led by him since then.[43] Though focused on Lebanese stories, the bulk of the center's public history efforts concentrate on the late 1800s and first half of the twentieth century, thus including Syrians, Palestinians, and others who were part of the mass migration from the Eastern Mediterranean. The center supports traditional research by sponsoring academic conferences, visiting scholars, digital archives, and *Mashriq & Mahjar*, an academic journal about the Middle East (or Southwest Asia) and its diasporas. In addition, it offers the most comprehensive, searchable collection available of "Arab American books and newspapers published in North and South America from the late 1880s to the mid-1900s." As of this writing, the database included sixty-three collections, 30,174 documents, and 296,318 pages.[44]

From the outset, the center was also designed to be a public history institution, reflecting North Carolina State University's commitments to community engagement. A leader in the digital humanities, it designs and maintains projects such as interactive digital maps of Lebanese American businesses from the early period of immigration as well as maps of Arab American archives in the United States and information on the return of Lebanese migrants from the Americas to Lebanon, the domiciles of Lebanese Americans, and the impacts of migration on the health of early immigrants.[45] The center hosts *Turath*, a virtual exhibit about early Arab American culture to which Chap-

ter 5 author Breaux loaned some music.⁴⁶ Other digital projects include online family archives, podcasts, the multimodal "Texas Bound" website described by Maria Curtis in this book, and a project on Arab American labor. In addition to its digital projects, the center sponsors prizes for various public-facing projects and produces its own historical documentaries, including an exploration of the Lebanese American physician Herbert Nassour's fight to expand health-care access and the killing of Arab Americans Hasna and N'oula Romey in Florida in 1929.⁴⁷

Its impact on Arab American public history is also evidenced by the center's engagement with the projects analyzed in this volume. For example, the Khayrallah Center has worked with Maria Curtis and the Southern Federation of Syrian Lebanese American Clubs to encourage the preservation and archiving of family documents and help members of the group trace their roots in the United States and the Levant. As Awad-Rashmawi notes, it has been an important participant in Arab American genealogical circles, providing not only sources but also practical advice on surmounting the challenges of such work. Moreover, it made accessible copies of *Fatat Boston*, the Syrian Lebanese newspaper, for Bordewich and Harrington's Little Syria in Boston project.

By including discussion of major public history producers such as the Khayrallah Center and the Arab American National Museum, this volume provides an excellent overview of the world of Arab American public history and charts an agenda for its expansion. But the book is not a comprehensive examination of the subject, and it is important that we name topics essential to explore in the future study of Arab American public history. One of them is perhaps the best publicized of all Arab American public history projects, the Washington Street Historical Society (WSHS), which has been covered by the BBC, the *Wall Street Journal*, the *New York Times*, and CBS.⁴⁸ Established in 2013, the WSHS is a large-scale public history project that "fosters education and awareness about the first Arabic-speaking community in the United States, which was located on the Lower West Side of Manhattan in New York City between 1880 and 1940." Like Richard Breaux's work in Eau Claire and my own in Indianapolis, the WSHS resists the erasure of Arab American history. "In 1946, eviction notices were distributed to the residents of Washington Street for Robert Moses's plans to construct the Brooklyn Battery Tunnel," according to the WSHS. Then, "the later construction of the World Trade Center demolished much that remained and put the nail in the coffin for Washington Street as an ethnic enclave." Afterward, the old neighborhood would be left with few "physical reminders except for a handful of buildings that activists have been trying to preserve for over a decade."⁴⁹

Led by Linda Jacobs, whose grandmother lived in the neighborhood, the project has offered walking tours and lectures and maintains a blog.⁵⁰ In addition to relying on Jacobs's exhaustive study of the quarter's history,

WSHS incorporates the oral histories of descendants.[51] Its elegantly illustrated and content-rich English and Arabic "Virtual Tour" website features interactive pages on "Arriving," "Living," "Work," "Religion," "Health," and "Arts and Culture." Users can read texts, watch mini-documentaries, look at historic photographs, and, most impressively, explore interactive digital maps that reveal the location of Arab American businesses, religious congregations, streetscapes, and residential buildings on an 1897 city map and also superimpose these sites on a contemporary map of lower Manhattan.[52]

The group's latest project is a public art installation called *Al Qalam [The Pen]: Poets in the Park*, which celebrates the English and Arabic literary contributions of early Arab American male and female writers and poets such as Kahlil Gibran and Afifa Karam. According to the organization, "Moroccan French artist Sara Ouhaddou has designed five mosaic panels displaying excerpts from their work" that will be installed at the Elizabeth H. Berger Plaza, located in the area that used to be the Syrian Quarter. While funds for the installation have been obtained and the Public Design Commission of New York City unanimously approved the design, as of this writing, the WSHS is raising the $200,000 required by the city for a "conservation endowment, which will ensure that the artwork is regularly cleaned, mosaic tiles replaced, and any damage repaired."[53]

In addition to further study of efforts commemorating Manhattan's Little Syria, there is work yet to be done on non–Levantine American communities in the United States. A number of the book's chapters, including those about Boston, Eau Claire, and Houston, focus on public history projects that center Syrian Lebanese communities in the United States, while others, including the exploration of genealogy, devote significant attention to Palestinian Americans. This Levantine bias is partly a result of the scholars and activists who responded to the call for proposals, but it also reflects the fact that these communities were the first to settle in large numbers in the United States, so their critical mass led to the production of archives, collections, exhibits, publications, and other media required for the making of public history. The volume does include discussion of other, non-Levantine communities—for example, the Yalla Eat! food tour in Detroit pays attention to Yemeni and Iraqi places of business—but future studies of Arab American public history must highlight more recent efforts by community members and scholars to document other experiences, including, for example, Yemeni American history.

Though formal academic studies of Yemeni American history were launched in the 1970s and 1980s, public history projects about Yemeni American history are more recent.[54] Advocacy groups such as the Yemeni American Merchants Association in Brooklyn, New York, have helped to bring more attention to the long presence of Yemenis in the United States.[55] To name another example, the settling of Yemeni Americans in small towns such as

Coldwater, Michigan, 125 miles southwest of Detroit, has inspired local arts and other groups to document and celebrate the community's history. In Coldwater (population 14,314), the Tibbits Opera House worked with Yemeni community members, the Arab American Society of Coldwater, and the Arab American National Museum to stage events for hundreds of visitors and 1,500 schoolchildren. Then, the Tibbits curated an "exhibit that told the story of Yemeni immigration to Coldwater and explored cultural life in the community through objects, images, and oral histories." It is "located in the entryway and common spaces of Tibbits Opera House," where it "greets the roughly 5,000 people who attend the venue's forty annual events."[56]

Perhaps the best-known and most commemorated moment of Yemeni American history is the martyrdom of twenty-four-year-old farm worker Nagi Daifallah. Daifallah was an organizer of the United Farm Workers (UFW) grape strikes in 1973. That year, he was killed by a Kern County sheriff's deputy, and his funeral, attended by UFW members and leaders such as Cesar Chavez, helped to galvanize the movement for fair wages and better working conditions.[57] Even as the death of Daifallah is remembered as part of the UFW's history, its meaning and significance has also been contested by members of the Yemeni community itself. Neama Alamri argues, for example, that while the UFW was happy to incorporate Yemenis into its domestic struggles, it did not in turn support Yemeni activism on behalf of Palestinian self-determination and instead issued a statement supporting Israel in the 1973 Yom Kippur war.[58]

Another fruitful area for future exploration is the emerging public and academic scholarship on the role of Americans who identify as Afro-Arab and Black Arab. Some Black Arab Americans trace their roots to African countries such as Eritrea, Mauritania, Morocco, and Sudan, while others are the descendants of Black Palestinians, Saudis, Iraqis, and Yemenis.[59] Still others identify as biracial, having one African American parent and one Arab American parent. Because my ancestors and those of other Levantine Americans fought so hard to be on the "white side" of the U.S. color line, many of the publicly focused community histories outlined here erased what, in a U.S. context, would be called our community's racial diversity. The idea that all of us are "Semitic," made popular by nineteenth-century Euro-American racial science, is similarly hegemonic and incorrect. In reality, North Africa and the Middle East have always been a crossroads of what modern Americans would label as "racial" diversity. In addition to Imazighen (Berbers) and ancient Near Eastern peoples, there have been West Africans, Turks, Northwest Europeans, Armenians, East Africans, Greeks, Indians, Circassians, and others who have been forced or have chosen to migrate to the Arabic-speaking world.

Among the several recent public projects that recognize the impact of Black Arab people on the United States are news articles, blogs, and a docu-

mentary film about the influence of figures such as Ahmed Osman and Malik Badri on Malcolm X.[60] Another example is the Black SWANA takeover issue of *Mizna*, a literary and art journal based in Minnesota's Twin Cities: Guest editor Safia Elhillo led an all-Black team of artists, poets, scholars, and writers who identify with a SWANA or Arab identity. Among the many historically minded pieces included is Ladin Awad's meditation on "subjecthood, personhood, and gaze in the archive" by way of "eighteenth- and nineteenth-century daguerreotypes of Sudanese women as well as self-portraits."[61]

Finally, Arab American public history must become hemispherically *American*. The majority of the half-million Arabic-speaking immigrants who arrived in the Americas before World War I landed in Latin America.[62] The Khayrallah Center and some recent scholarship in the field have emphasized how these populations remained connected to one another as well as to the Middle East.[63] These migrants shared many of the same dreams, wanting to participate or integrate in their new countries while also advocating for the independence of their countries of origin, especially Palestine.[64] Even as Latin American Arabs faced discrimination, the community as a whole experienced economic success, and at least eleven heads of state in Latin America have been Arab Americans.[65] They also made lasting cultural contributions. For example, their dance styles, especially *raqs sharqi*, sometimes called belly dancing, have been adopted and adapted by many amateur and professional dancers. One important example of a public history project that studies and participates in this phenomenon is the "Hunna Collective: Historians Who Dance." Naiara Müssnich Rotta Gomes de Assunção, Ana Terra de Leon, Francismara Lelis, Jéssica Melo Prestes, and Nina Ingrid Caputo Paschoal are professional historians who also perform Arab dances. By teaching independent classes and developing a large online and social media presence, the Hunna Collective attempts to educate dance communities in Brazil about the harmful aspects of Brazilian Orientalism while nurturing the creative space to appreciate these Arab cultural traditions.[66] Their project speaks to the possibility of a public history—in this case, an aesthetic and kinesthetic public history—that cultivates political solidarity among peoples of the Global South.

Overall, our volume's purpose is to bring attention to such efforts and to offer an itinerary for their expansion. Without any claims to comprehensiveness, the book is an important step forward in acknowledging this work as a critical component of the Arab American experience, one worthy of our collective labor. Arab American history is not something *only* to be analyzed in a campus classroom or an academic journal. Encouraging scholars to invest in community building, this volume calls on the nurturing of history created *with* the community. A willingness to enter the messy space of Arab American public history leads us to resist the isolation of the academy and to engage a

diverse range of groups and institutions in the beautiful life of democratic knowledge making.

NOTES

1. Among the many excellent studies that analyze anti-Arab and related forms of prejudice, see Sarah M. A. Gualtieri, *Between Arab and White: Race and Ethnicity in the Early Syrian Diaspora* (Berkeley: University of California Press, 2009); Jack G. Shaheen, *Reel Bad Arabs: How Hollywood Vilifies a People* (Northampton, MA: Olive Branch, 2009); Amaney Jamal and Nadine Naber, eds., *Race and Arab Americans Before and After 9/11: From Invisible Citizens to Visible Subjects* (Syracuse, NY: Syracuse University Press, 2008); and Louise Cainkar, *Homeland Insecurity: The Arab American and Muslim American Experience after 9/11* (New York: Russell Sage Foundation, 2009). For an accessible narrative about post-9/11 experiences, see Moustafa Bayoumi, *How Does It Feel to Be a Problem? Being Young and Arab in America* (New York: Penguin, 2008).

2. "About the Field," National Council on Public History, accessed May 31, 2025, https://ncph.org/what-is-public-history/about-the-field/.

3. On February 16, the authors met for a daylong conference with Arab American community respondents Hiba Alalami, Josh Chitwood, Maria Nimri, and Ruba Marshood as well as public historians Jill Weiss-Simins, Nicole Poletika, and Nicole Martinez-LeGrand, all of whom read drafts of the chapters ahead of time.

4. For an introduction to community-based research in Arab American communities, see "Community-Empowered Research," Center for Arab Narratives, accessed May 31, 2025, https://www.arabnarratives.org/.

5. For an anthropology of primary sources featuring the contested meanings of Arabness in the modern era, see Sylvia G. Haim, ed., *Arab Nationalism: An Introduction* (Berkeley: University of California Press, 1962).

6. Nadine Naber, "Introduction: Arab Americans and Racial Formations," in Jamal and Naber, *Race and Arab Americans*, 1–45. Arabs were not always the public face of Islam in U.S. politics. In the 1960s and 1970s, Black Muslims such as Malcolm X and Muhammad Ali were more prominent. See Edward E. Curtis IV, *Muslim American Politics and the Future of U.S. Democracy* (New York: New York University Press, 2019).

7. For example, the Boston Public Library's Arab American Heritage Month selections have included Ayad Akhtar, *American Dervish* (New York: Little, Brown, 2012), about a Pakistani American family; see "Arab American Heritage Month," Boston Public Library, accessed November 1, 2024, https://bpl.bibliocommons.com/v2/list/display/2080350369/2736352217. Similarly, the University of Maine Folger Library's "Arab American Heritage Month Resources" feature Pakistani Canadian Rukhsana Khan's *Big Red Lollipop* (New York: Viking, 2010), which depicts characters wearing a *shalwar khamees* and South Asian–style hijab, and African American Muslim author Jamilah Thompkins-Bigelow's *Mommy's Khimar* (New York: Salaam Reads, 2018), which "centers Black Muslim protagonists." See University of Maine, accessed May 31, 2025, https://libguides.library.umaine.edu/arabamerican.

8. "U.S. Muslims Concerned About Their Place in Society, but Continue to Believe in the American Dream," Pew Research Center, July 26, 2017, https://www.pewresearch.org/religion/wp-content/uploads/sites/7/2017/07/U.S.-MUSLIMS-FULL-REPORT-with-population-update-v2.pdf.

9. The Arab American Institute in 2005 claimed that Christians were a supermajority. "Arab Americans: Demographics," Arab American Institute, accessed May 31, 2025,

https://web.archive.org/web/20060601221810/http://www.aaiusa.org/arab-americans/22/demographics.

10. Karoline P. Cook, *Forbidden Passages: Muslims and Moriscos in Colonial Spanish America* (Philadelphia: University of Pennsylvania Press, 2016).

11. Sylviane Diouf, *Servants of Allah: African Muslims Enslaved in the Americas* (New York: New York University Press, 2013); Allan D. Austin, *African Muslims in Antebellum America: Transatlantic Stories and Spiritual Struggles* (New York: Routledge, 2011); and Michael A. Gomez, *Black Crescent: The Experience and Legacy of African Muslims in the Americas* (New York: Cambridge University Press, 2005).

12. Table IIa and Table X, *International Migration Statistics*, National Bureau of Economic Research Inc. [1925], 418–443, as quoted in Gregory Orfalea, *The Arab Americans: A History* (Northampton, MA: Olive Branch, 2006), 436–437.

13. The scholarly literature on this period and these immigrants is well developed. See Eric J. Hooglund, ed., *Crossing the Waters: Arabic-Speaking Immigrants in the United States Before 1940* (Washington, DC: Smithsonian Institute, 1987); Alixa Naff, *Becoming American: The Early Arab Immigrant Experience* (Carbondale: Southern Illinois University Press, 1985); Akram Fouad Khater, *Inventing Home: Emigration, Gender, and the Middle Class in Lebanon, 1870–1920* (Berkeley: University of California Press, 2001); Gualtieri, *Between Arab and White*; and Charlotte Karem Albrecht, *Possible Histories: Arab Americans and the Queer Ecology of Peddling* (Berkeley: University of California Press, 2023).

14. Rachel Marks, Paul Jacobs, and Alli Coritz, "3.5 Million Reported Middle Eastern and North African Descent in 2020," U.S. Census Bureau, September 21, 2023, https://www.census.gov/library/stories/2023/09/2020-census-dhc-a-mena-population.html.

15. Orfalea, *The Arab Americans*, 189–212.

16. Marks, Jacobs, and Coritz, "3.5 Million."

17. For a reader on the state of the field of Arab American studies, including a discussion of Arab versus Southwest Asian and North African, or SWANA, see Louise Cainkar, Pauline Homsi Vinson, and Amira Jarmakani, eds., *Sajjilu Arab American: A Reader in SWANA Studies* (Syracuse: Syracuse University Press, 2022).

18. See, for example, the "Phoenician theory" of Lebanese migration in Gualtieri, *Between Arab and White*, 21–24.

19. For instance, *Kawkab Amrika* [The American Star], established by Orthodox Christian brothers Ibrahim and Najeeb Arbeely in 1892, regularly extolled Arab and Muslim civilizations. See Deanna Ferree Womack, "Syrian Christians and Arab-Islamic Identity: Expressions of Belonging in the Ottoman Empire and America," *Studies in World Christianity* 25, no. 1 (2019): 29–49.

20. "St. Louis Businessman Returns to Native Syria," *St. Louis Globe-Democrat*, June 3, 1928, 6.

21. William C. Sherman, Paul L. Whitney, and John Guerrero, *Prairie Peddlers: The Syrian-Lebanese in North Dakota* (Bismark, ND: University of Mary Press, 2004), 123–131.

22. Naber, "Introduction," 20–24; Gualtieri, *Between Arab and White*, 52–80.

23. Curtis, *Muslims of the Heartland*, 62.

24. Edward E. Curtis IV, "Indianapolis' *Syrian Ark*: Crossing and Dwelling in the Arab American Midwest, 1936–1954," *Indiana Magazine of History* 120, no. 1 (March 2024): 1–31.

25. Compare "Remembering Alixa Naff," *Arab Studies Quarterly* 37, no. 1 (Winter 2015): 96–123.

26. See Elaine C. Hagopian and Ann Paden, *The Arab Americans: Studies in Assimilation* (Wilmette, IL: Medina University Press International, 1969); Adele L. Younis with

Philip M. Kayal, *The Coming of the Arabic-Speaking People to the United States* (Ann Arbor, MI: Center for Migration Studies, 1995); and Evelyn Shakir, *Bint Arab: Arab and Arab American Women in the United States* (Westview, CT: Praeger, 1997).

27. Hani J. Bawardi, *The Making of Arab Americans: From Syrian Nationalism to U.S. Citizenship* (Austin: University of Texas Press, 2014).

28. Curtis, "Indianapolis' Syrian Ark."

29. Pamela E. Pennock, *The Rise of the Arab American Left: Activists, Allies, and Their Fight against Imperialism and Racism, 1960s–1980s* (Chapel Hill: University of North Carolina Press, 2017), 1–120.

30. Pennock, *The Rise of the Arab American Left*, 201–229.

31. "ADCRI Education," accessed July 9, 2025, Arab American Anti-Discrimination Committee, https://adcri.org/education/.

32. See, for example, William L. Van DeBurg, *New Day in Babylon: The Black Power Movement and American Culture, 1965–1975* (Chicago: University of Chicago Press, 1992), especially Chapter 5, and note Nathan I. Huggins's analysis of the television phenomenon *Roots* in the new introduction to his *Black Odyssey: The African American Ordeal in Slavery* (New York: Vintage, 1990), xlvii.

33. Matthew Jaber Stiffler to Edward E. Curtis IV, personal correspondence, January 19, 2024.

34. "Arab American Civic Council Mourns the Passing of Joseph Haiek," Arab American Civic Council, January 25, 2018, https://aaciviccouncil.org/2018/01/26/arab-american-civic-council-mourns-the-passing-of-joseph-haiek/; Joseph R. Haiek, *Arab American Almanac*, 6th ed. (Glendale, CA: News Circle, 2010); "About the Arab American Historical Foundation," Arab American Historical Foundation, accessed July 9, 2025, https://www.arabamericanhistory.org/about/.

35. Suheir Hammad, "first writing since," Def Poetry Jam, YouTube, 5 min., 48 sec., July 22, 2011, https://www.youtube.com/watch?v=FDyLNgLHprI; see also Suheir Hammad, "First Writing Since," *Meridians: Feminism, Race, Transnationalism* 2, no. 2 (2002): 254–258, https://muse.jhu.edu/article/407935.

36. Katayoun Kishi, "Assaults Against Muslims Surpass 2001 Levels," Pew Research Center, November 15, 2017, accessed July 9, 2025, https://www.pewresearch.org/short-reads/2017/11/15/assaults-against-muslims-in-u-s-surpass-2001-level/.

37. Analysis of the institutional and structural roots of anti-Muslim racism and xenophobia, often the framework in which Arab Americans are implicated, can be found in Edward W. Said, *Covering Islam: How the Media and the Experts Determine How We See the Rest of the World* (New York: Vintage, 1997); Junaid Rana, *Terrifying Muslims: Race and Labor in the South Asian Diaspora* (Durham, NC: Duke University Press, 2011); Deepa Kumar, *Islamophobia and the Politics of Empire* (Chicago: Haymarket, 2012); Carl W. Ernst, ed., *Islamophobia in America: The Anatomy of Intolerance* (New York: Palgrave Macmillian, 2013); Christopher Bail, *Terrified: How Anti-Muslim Fringe Organizations Became Mainstream* (Princeton, NJ: Princeton University Press, 2015); Todd H. Green, *The Fear of Islam: An Introduction to Islamophobia in the West* (Minneapolis: Fortress, 2015); Nathan Lean, *The Islamophobia Industry: How the Right Manufactures Hatred of Muslims*, 2nd ed. (London: Pluto, 2017); and Peter Gottschalk and Gabriel Greenberg, *Islamophobia and Anti-Muslim Sentiment: Picturing the Enemy*, 2nd ed. (Lanham, MD: Rowman & Littlefield, 2018).

38. In addition to Bayoumi, *How Does It Feel to Be a Problem?*; Cainkar, *Homeland Insecurity*; and Jamal and Naber, *Race and Arab Americans Before and After 9/11*, see Council of American-Islamic Relations, *Targeted: 2018 Civil Rights Report* (Washington, DC:

CAIR, 2018), accessed July 9, 2025, https://islamophobia.org/civil-rights-reports/2018-civil-rights-report-targeted/; "Anti-Muslim Discrimination," accessed July 9, 2025, American Civil Liberties Union, https://www.aclu.org/anti-muslim-discrimination; Jesse J. Norris and Hanna Grol-Prorkopczyk, "Temporal Trends in U.S. Counterterrorism Sting Operations, 1989–2014," *Critical Studies on Terrorism* 11, no. 2 (2018); Trevor Aaronsen, *The Terror Factory: Inside the FBI's Manufactured War on Terrorism* (New York: Ig, 2013); Human Rights Watch, *Illusion of Justice: Human Rights Abuses in U.S. Terrorism Prosecutions* (New York: Human Rights Watch and Columbia University, Human Rights Institute, 2014); and Daviel DeFraia, "Scenes from a Black Site," ProPublica, May 7, 2018, accessed July 9, 2025, https://www.propublica.org/article/haspel-nashiri-cia-black-site-interrogation-documents.

39. Anny Gaul, Graham Auman Pitts, and Vicki Valosik, eds., *Making Levantine Cuisine: Modern Foodways of the Eastern Mediterranean* (Austin: University of Texas Press, 2021), xii; and see bell hooks, "Eating the Other: Desire and Resistance," in *Black Looks: Race and Representation* (Boston: South End, 1992), 21–39.

40. Anthony Shadid, *House of Stone: A Memoir of Home, Family, and a Lost Middle East* (Boston: Houghton Mifflin Harcourt, 2012).

41. "Annual Reports," Arab American National Museum, accessed May 31, 2025, https://arabamericanmuseum.org/annual-reports/; "Our Staff," Arab American National Museum, accessed May 31, 2025, https://arabamericanmuseum.org/our-staff/.

42. Arab American National Museum with Randa A. Kayyali, Ph.D., *Arab Americans: History, Culture, and Contributions* (Dearborn, MI: Arab American National Museum, 2019), https://arabamericanmuseum.org/wp-content/uploads/2020/03/Arab-Americans.pdf.

43. Mick Kulikowski, "Khayrallahs Give $8.1 Million for New Lebanese Diaspora Studies Center," NC State News, October 14, 2014, https://news.ncsu.edu/2014/10/khayrallahs-give-8-1-million-for-new-lebanese-diaspora-studies-center/.

44. "Explore Arab American History," Khayrallah Center for Lebanese Diaspora Studies, accessed May 31, 2025, https://arabicsearch.org/home.

45. "Projects," Khayrallah Center for Lebanese Diaspora Studies, accessed May 31, 2025, https://lebanesestudies.ncsu.edu/explore/projects/.

46. *Turath* [Heritage], Khayrallah Center for Lebanese Diaspora Studies, accessed May 31, 2025, https://www.turath2020.org/.

47. "Fighting Injustice: The Story of Herbert Nassour," Khayrallah Center for Lebanese Diaspora Studies, accessed May 31, 2025, https://lebanesestudies.ncsu.edu/news/2019/03/25/fighting-injustice-the-story-of-herbert-nassour; and "The Romey Lynchings," Khayrallah Center for Lebanese Diaspora Studies, accessed May 31, 2025, https://lebanesestudies.ncsu.edu/explore/projects/romey-lynchings/.

48. "WSHS News," Washington Street Historical Society, accessed May 31, 2025, https://washingtonstreethistoricalsociety.org/press/.

49. "History," Washington Street Historical Society, accessed May 31, 2025, https://washingtonstreethistoricalsociety.org/history/.

50. "Blog," Washington Street Historical Society, accessed May 31, 2025, https://washingtonstreethistoricalsociety.org/blog/.

51. Linda K. Jacobs, *Strangers in the West: The Syrian Colony of New York City, 1880–1900* (New York: Kalimah, 2015).

52. "WSHS," Washington Street Historical Society, accessed May 31, 2025, https://alqalamjourney.org/en.

53. Newsletter, Washington Street Historical Society, December 2023, https://mailchi.mp/8b9cf183143d/washington-street-historical-society-end-of-year-update?e=acccbf9ed0.

54. See, for example, Mary Bisharat, "Yemeni Migrant Workers in California," in *Arabs in America: Myths and Realities*, ed. Baha Abu-Laban and Faith T. Zedley (Wilmette, IL: Medina University Press International, 1975), 202–209; and Jonathan Friedlander, ed., *Sojourners and Settlers: The Yemeni Immigrant Experience* (Salt Lake City: University of Utah Press, 1988).

55. "The Untold History of Yemeni Americans," Yemeni American Merchants Association, accessed May 31, 2025, https://www.yamausa.org/yemen-history/.

56. Tammy Barnes and Joseph Cialdella, "Sharing Yemeni History in Coldwater, Michigan," *History@Work*, National Council of Public History blog, April 20, 2017, https://ncph.org/history-at-work/sharing-yemeni-history-in-coldwater-michigan-photo-credit-tammy-barnes/.

57. Jocelyn Sherman, "50 Years Since UFW Strikers Nagi Daifallah & Juan De La Cruz Gave Their Lives to Build the UFW," United Farm Workers, August 17, 2023, https://ufw.org/50-years-since-ufw-strikers-nagi-daifallah-juan-de-la-cruz-gave-their-lives-to-build-the-ufw/.

58. Neama Alamri, "Yemeni Farm Workers and the Politics of Arab Nationalism in the UFW," *Boom California*, 2020, accessed June 21, 2025, https://boomcalifornia.org/2020/02/18/yemeni-farm-workers-and-the-politics-of-arab-nationalism-in-the-ufw/amp/.

59. Edward E. Curtis IV, "The Heirs of Bilal in North Africa and the Middle East," in *The Call of Bilal: Islam in the African Diaspora* (Chapel Hill: University of North Carolina Press, 2014), 21–51.

60. Adamu Munu, "Diaspora Deliverance: Black Arab Pioneers You Should Know and Celebrate," *The New Arab*, February 22, 2022, https://www.newarab.com/features/black-arab-pioneers-you-should-know-and-celebrate; Hisham Aidi, "Interview: Malcolm X and the Sudanese," *Sapelo Square*, March 5, 2020, https://sapelosquare.com/2020/03/05/interview-malcolm-x-and-the-sudanese/; *Malcolm X and the Sudanese*, VisuaLive Productions, Vimeo, 26 min., 16 sec., February 28, 2020, https://vimeo.com/394471323.

61. *Mizna: Black Takeover Issue* 23, no. 2 (February 2023), https://mizna.org/literary/black-swana-takeover/.

62. For a hemispheric approach to this migration, see Stacy D. Fahrenthold, *Between the Ottomans and the Entente: The First World War in the Syrian and Lebanese Diaspora, 1908–1925* (New York: Oxford University Press, 2019).

63. See *Mashriq & Mahjar* 1–11 (2011–2024), https://lebanesestudies.ojs.chass.ncsu.edu/index.php/mashriq.

64. Nadim Bawalsa, "Palestine West of the Andes," *NACLA Report on the Americas* 50, no. 1 (March 2018): 34–39.

65. Jose Pelayo, "¡Viva los Arabes!: Underreported Stories of the Arabs of the Americas," Atlantic Council, April 28, 2021, https://www.atlanticcouncil.org/blogs/menasource/viva-los-arabes-underreported-stories-of-the-arabs-of-the-americas/.

66. Hunna Collective, accessed May 31, 2025, https://www.hunnacoletivo.com/.

2

An Ethnic Home?

Countering Geopolitical and Bureaucratic Definitions of Arab American Identity

Randa A. Kayyali

What should we call ourselves? How do others refer to us? And why does the label matter? The label *Arab American* merges two identities into a hybrid ethnicity. *Arab American* refers to individuals of Arab descent who are living in the United States. *American* often assumes a United States–based identity, though the term technically describes origins or belonging in North, Central, and/or South America. Leaving out non-U.S.-based American locations seems like hubris yet is done over and over in American and Arab American studies, including in public histories. *Arab* also carries a homogenizing assumption of origins in the Middle East or North Africa, often corresponding with Muslim religious identity, which in turn carries anti-American and/or anti-Israeli political undertones to those unwilling to understand or examine the diversity of religious, political, and even racial affiliations in this ethnic group.

U.S. government classifications make these assumptions, though obliquely. In March 2024, the U.S. Office of Management and Budget (OMB) announced a new racial and ethnic category, Middle Eastern or North African (MENA), in the *Federal Register*. It was a proposal to revise the OMB's 1997 "Statistical Policy Directive No. 15: Standards for Maintaining, Collecting, and Presenting Federal Data on Race and Ethnicity" and modify race and ethnicity data collection. Under this proposal, the OMB's definition of the White racial category would be edited to remove people who self-identify as having MENA roots.[1] MENA would become one of seven combined racial and ethnic categorizations and a stand-alone option for the first time. The categories form the

minimum-reporting requirements for all race and ethnicity data, including the federal surveys, public benefit forms, crime reports, and the U.S. Census, which the U.S. Constitution mandates every decade.

The addition of a MENA checkbox resulted from four decades of work and numerous campaigns by the Arab American Institute (AAI) and the American Arab Anti-Discrimination Committee (ADC). In the mid-1990s, these organizations held divergent opinions on whether *Middle Eastern* or *Arab* was the desirable label. This discord was partially responsible for the omission of either in the recommendations for OMB minimum data standards on race and ethnicity in 1997.[2] In the 1990s, AAI expanded its ask to *Middle Eastern and North African* as their preferred ethnic category option due to annual increases in the number of North African immigrants, particularly from Morocco. The MENA category is similar to the *Asian American* category in that they both encompass people of diverse heritages and ethnicities from a region. Thus, the MENA category explicitly includes Iranians, Israelis, Turks, and, since the definition remains unclear, perhaps people from adjacent countries.

The new proposed combined race-ethnicity question in the 2030 U.S. Census will ask people to identify themselves in various federal forms with the following question: "What is your race and/or ethnicity? Select all that apply." Although there will be a period of testing, the form in the *Federal Register* now defines MENA as *"Middle Eastern or North African. Individuals with origins in any of the original peoples of the Middle East or North Africa, including, for example, Lebanese, Iranian, Egyptian, Syrian, Iraqi, and Israeli."*[3] Other MENA group examples are "Moroccan, Yemeni, Kurdish, etc." for the write-in responses.[4] The omission of *Arab* in the category title, as a subgroup or as a write-in example under the MENA categorization, is glaring.[5]

Both ADC and AAI released press statements that welcomed the revision outlined in the Federal Register but expressed that it fell short of their expectations, noting that the narrow definition of MENA that would impact response rates and data accuracy. AAI objected to the lack of a Black Arab example in the 2015 National Content Test (NCT) run by the Census Bureau and noted that they had recommended further testing on a MENA category, including detailed subgroups.[6] The standards announcement in the *Federal Register* preempted this criticism in footnote 29, which stated that in the NCT, the majority of Armenian respondents chose the White category, while the overwhelming majority of Somalis and Sudanese chose the Black or African category, despite the presence of a MENA checkbox.[7]

In 2015, the Census Bureau's Population Division was aware that the vast majority of selected experts and community activists thought that the MENA category should include Armenian, Sudanese, and Mauritanian national origins. In addition, "between 60 and 70 percent of participants thought that Western Saharan, Somali, and Djiboutian should be included, with one ex-

pert stating, 'I am in great support of including Somalis (as well as Sudanese and Djiboutian) within the MENA category.' The expert described their own research, which found that Somalis in the United States find the Black category very alien and that they prefer to identify in other ways, such as Somali or Arab."[8] Regardless, there are many Arabs who self-identify as Black and/or African. As it stands in the proposed 2030 Census, respondents can check more than one box, allowing for multiple identifications, but the lack of an example of a Black MENA identity by the Census Bureau exposes an institutional racial landscape that places MENA/Arab and Black identities as mutually exclusive.

Even if the MENA checkbox examples are limited, the use of national labeling relieves the pressure to directly name ethnic identifications and, by so doing, includes non-Arab and non-Muslim identified groups. Many Christians identifying as Assyrian, Chaldean, Copt, Maronite, and Syriac do not consider themselves Arab by way of not being Muslim. A MENA checkbox will facilitate more accurate data collection and analysis on MENA communities, which will enable policymakers and advocacy groups to better understand the socioeconomic, health, and educational disparities affecting different nationalities and identity groupings. This, in turn, can inform targeted interventions and policy initiatives to address the needs and challenges specific to these communities.

The desire to define the racial and ethnic identities of Americans by referring to geographic origins is a powerful one in U.S. immigration history. As a scholar of Arab American history who identifies as Arab American, I experience it as a form of erasure. *Middle East* and *North Africa* are geographic terms applied by colonial powers to regions that they sought to occupy and control. Though all identity terms may have oppressive histories, many Arab Americans use the label *Arab* as one of pride and self-definition. I know very few people who say "I am proud to be a Middle Easterner." MENA feels like an externally constructed race box that does not resonate with me. Ultimately, MENA refers not to a homeland but to a region whose importance lies in its proximity to the European subcontinent. Though many Arab Americans may feel that their Arab identity is the most salient ethnic and racial category, the OMB's MENA checkbox makes it take a back seat because it omits mention of *Arab* as an example in the subcategory or write-in examples.

While the introduction of the MENA category represents a significant stride toward recognition and visibility within the American demographic framework, there is an erasure of *Arab/Arabic* as a valid ethnic category in the broader sociopolitical context. Arab Americans have historically grappled with issues of marginalization, stereotyping, and invisibility in mainstream discourse. The recognition of their distinct racial and ethnic category could have opened avenues for increased representation and participation in var-

ious sectors, including government, media, academia, and civil society. In contrast, the institutionalization of a regional MENA in race-ethnic categorizations will likely solidify its dominance as a naming device, eclipsing *Arab American* as the external racial/ethnic identifier, even if Arab Americans themselves continue to self-identify with the Arabic ethnic home.

This chapter intervenes in these current debates about MENA and Arab identities by scrutinizing the power of geographic definitions of identity beyond the recent decisions of the federal government. My itinerary includes (1) sketching the history of changing ethnic labels among Arab Americans; (2) examining the influence of online and digital sources such as Google, Wikipedia, and ChatGPT on definitions of Arab American identity; and (3) narrating my own engagement with the Arab American National Museum regarding the question of geography. My goal is to highlight the powerful role of geography and other external definitions in shaping public understandings of Arab American identity so that historians and other scholars are aware of the fundamental choices to be made in narrating the Arab American past. My clear preference, articulated at the end of the chapter, is for scholars to prioritize thematic connections grounded in shared languages/dialects, cultural customs, and historical events when we conceptualize Arab American identity as an inclusive ethnic home that can transcend borders, both geographic and imaginary. Such an approach, I argue, better captures and embraces the linguistic, artistic, and cultural manifestations of Arab identity in the United States.

Contested Definitions of Arab and Arab American Identity

Centuries-old contestations over defining Arab identity indicate a complex and multifaceted process that has, in effect, no simple or static answer. Historians in the nineteenth and twentieth centuries struggled to define Arab identity. Scholars offered various perspectives—racial, religious, linguistic, and geographic—to defend their definitions, reflecting the broader issue of understanding and categorizing the people of the Arab world. While these scholars were influenced by their time's political, social, and ideological forces, their publications are reprinted, repeatedly offered as textbooks in college classes, and reinforced by contemporary scholars through repetitive references. Hence, twentieth-century historians' perspectives and terminologies remain relevant to public understandings of Arab identity.

The racialist definition, influenced by European scientific racism, categorized Arabs as a distinct race within the broader Semitic family. Ernest Renan, a nineteenth-century French philosopher, argued that the Semitic languages

(including Arabic, Hebrew, and Aramaic) fundamentally differed from Indo-European languages. He linked these linguistic differences to the Semitic peoples' inherent racial and intellectual traits.[9] The racialist perspective emphasized biological essentialism that often intersected with European colonial and Orientalist views, which categorized and ranked different races.

The religious definition closely associates Arab identity with being Muslim, particularly with Sunni Muslims. Historians like Bernard Lewis emphasized the central role of Islam in Arab culture and identity, arguing that the spread of Islam was intertwined with the development of Arab society at its core.[10] Some scholars criticize Lewis heavily for his Orientalist perspectives, his oversimplification of the relationship between Arab and Islamic identities, and his marginalization of non-Muslim Arabs and non-Sunni Muslims.

The linguistic definition centered around the Arabic language as the primary marker of Arab identity. According to this view, anyone who spoke Arabic as their mother tongue or identified culturally with the Arabic language and its literature could be considered Arab. Thus, this definition of Arabs was inclusive of diverse people across different regions, religions, and backgrounds who spoke and read formal Arabic. Albert Hourani, a prominent historian of the Middle East, emphasized the importance of the Arabic language and a shared cultural and intellectual tradition in defining Arab identity. Like Hourani, Peter Mansfield, a historian and journalist specializing in the Middle East, also saw the Arabic language and a shared cultural heritage as central to defining what it means to be Arab.[11]

The geographic definition tied Arab identity to specific regions and could range from narrow to broad, either restricting it to only those originating from the Arabian Peninsula or expanding it to include people from the Middle East and North Africa region. Some historians viewed geography as crucial in shaping the linguistic, cultural, and historical characteristics of the Arab peoples, with Arab identity closely tied to the specific lands and regions where Arabic-speaking peoples have historically lived. Three of them—Ira Lapidus, Hourani, and Philip Hitti[12]—emphasize the importance of the Arabian Peninsula as the birthplace of Arab culture and Islam and stress how the geographic spread of Arabs and Islam across the Middle East and North Africa influenced the identity of populations, helping to define what it means to be Arab and developing Arab culture, language, and identity.

Arab remains a complex identity, combining elements of race, religion, language, and geography. From the outset, a public historian today must acknowledge the diversity within the populations from the Arab world and allow multiple factors to define what it means to be Arab, accepting that there will be heated debates and disagreements over Arab identity.

Similarly, throughout Arab American history, there have been (and continue to be) many alternative, even competing, labels for Arab and related communities. The authors in this volume have grappled with community names

in their public history projects. Before 1967, when Arab American identity was more widely embraced, the communities identified by nationality, such as *Syrian* or *Lebanese*, with origins in specific villages, cities, and localized regions such as Mount Lebanon. In narrating the first period of Arab American history from the 1870s to 1924, authors use the terms *Arabic-speaking*, *Ottoman subjects*, *Syrian*, or *Syrian/Lebanese* to reference the community histories of Arabic-speaking immigrants who arrived from the Greater Syrian province (present-day Syria, Lebanon, Jordan, Palestine, and Israel) of the Ottoman Empire before its dissolution in 1922. They resist the label of *Ottoman*, which is associated with Turks and native Turkish speakers, based on their Arabic-speaking culture but also due to family narratives of Ottoman oppression and persecution. Yet as Edward E. Curtis IV cautions in the introduction, *Arabic-speaking peoples* must also refer to the tens of thousands of African Muslims who came to the Americas as enslaved people—a very different experience than that of the "free Arabic-speaking settlers and their children" who immigrated from Greater Syria. Thus, *Arabic-speaking* and *Ottoman subjects* are problematic community labels, and among the authors in this volume, *Syrian* stands as a popular choice for community histories when Syria was a province within the Ottoman Empire. For those not from Greater Syria, continental labels such as *African* or *North African* or more specific country-based labels such as *Egyptian* and *Moroccan* were used from the nineteenth century to the present day.

In Chapter 3 of this volume, historians Chloe Bordewich and Lydia Harrington report that their Boston Little Syria Project was initially imagined as focusing on a broader "Ottoman Boston" history that includes Arabs, Greeks, Turks, Jews, and Armenians from the Ottoman Empire. However, at their first exhibition, *Ottoman Boston: Little Syria*, some Syrian/Lebanese community members expressed skepticism about or unease with the name. They resisted the framing of *Ottoman* and preferred *Syrian* as a stand-alone identity label. Richard M. Breaux's chapter on the community in Eau Claire, Wisconsin, uses a slash to indicate the hybrid identities of *Syrian/Lebanese* for his Facebook group page and historic walking tour. He named his blog *Midwest Mahjar*, using the Arabic *Mahjar* to reference the "Arabic-speaking populations who had been emigrating from Greater Syria and settling across the country since the 1870s and their descendants." In Chapter 6 on Arab Indianapolis, Edward Curtis refers to "the descendants of Syrian and Lebanese immigrants who arrived in Indiana in the 1800s" as well as to Arab Americans from Arabic-speaking countries today. Curtis recognizes self-identification shifts from Syrian or Syrian/Lebanese to an ethnic Arab identity, partially due to new arrivals into the Arabic-speaking communities.

Since historical work relies on the intelligibility of contemporary naming, three authors used *Arab American* to describe archives, culinary tours, and nonprofit organizations. Yet the authors framed these public history

projects differently. Reem Awad-Rashmawi embraces *Arab American* as a stand-alone identity in genealogy, naming and founding the National Society for Arab and Arab American Genealogy.[13] In Chapter 4, Maria F. Curtis describes Syrian and Lebanese identities as "nested" within an Arab identity so that the Skaff Family Arab American Archive can simultaneously include Arab, Syrian, and Lebanese histories. Matthew Jaber Stiffler's chapter on food tours in Dearborn and Detroit uses the Arabic command of *Yalla!*, or Hurry Up!, in the title to urge the reader to try and enjoy the city's Arab American food landscape (Chapter 8). He mobilizes the terms *Arab* and *Arab American* to label people and communities, but also points out that the cuisine is more precisely "Levantine fare," which "has come to stand in for all Middle Eastern or Arab food." In this case, *Middle Eastern* is used as an adjective for cuisine rather than people. These authors considered *Arab American* a popular self-descriptor, whether as a stand-alone or pan-ethnic identity.

To be clear, however, the first major group of free Arabic-speaking immigrants did not generally refer to themselves as Arab. They deliberately affixed *Syrian* to "the Holy Land" to evoke perceptions of their biblical origins in early Christian history. During the period of racial prerequisite court cases spanning from 1909 to 1915, they defended their right to obtain U.S. citizenship and self-identified as Syrians, arguing against being categorized as Asiatic or Mongolian to exempt themselves from anti-Asian citizenship laws. Publicly asserting their Caucasian and Semitic heritage, akin to that of Europeans, they contended that they were "white" and eligible for naturalization as U.S. citizens. A pivotal ruling in 1915 overturned the lower court's denial of most Syrian naturalization cases. The presiding judge concluded that Syrians, Armenians, and Parsees, despite diverse racial backgrounds, were closely akin to their European Mediterranean neighbors and thus classified as white. While the final 1915 ruling did not mention the defendant's religion, earlier racial prerequisite cases underscored the Christian identity of Syrian defendants.[14]

The Online Arab American

Today's Arab Americans have to contend with similarly powerful externalities in negotiating their identities, especially in terms of how official, institutional, and online forces define them as racial and racialized subjects. Online information sources increasingly shape how identities and histories are understood. Google is the dominant search engine, ChatGPT is the dominant artificial intelligence (AI) generator, and Wikipedia is the dominant online encyclopedia, especially for U.S. history. Combined, they impact the classification and organization of information across a broad range of research topics. The heavy use of digital technology and computers in today's research

environment has made many of us believe that these web-based tools are objective and "reliable" sources of information that provide access to credible, accurate, depoliticized, and neutral information.[15]

This section delves into how online research technologies discipline and institutionalize characterizations of people from the Arab World and those who are categorized as MENA and South West Asian and North African (SWANA) in similar digital sense-making processes. When these regions remain ambiguous in visuals and on maps, their people are concurrently positioned as distinct and different from people in other world regions and as indecipherable and unintelligible groups. While all world regions and people are stereotyped, the terms *Middle Eastern* and *Arab* invoke derogatory connotations. Enduring, deep-rooted Orientalist discourses prevail in everyday real life and are mirrored online in social media. These misrepresentations include stereotyping Arab/Middle Eastern women as oppressed by men and victims of their culture, while Arab/Middle Eastern men are cast as concurrently violent, barbaric, and submissive.[16] Digital decisions made by Wikipedians (Wikipedia's core of editors), weighted Google searches, and AI chatbots often "reinforce oppressive social relationships and enact new modes of racial profiling."[17]

Google

As the largest and most popular internet search engine, Google carries weight in digital sense making. Google searches present results ranked according to a specialized algorithm from the user's location, past searches, maps, phone calls, AI, and machine learning to organize information and curate results. Google also pulls information from openly licensed sources, including Wikipedia, the Encyclopedia of Life, and the Data Commons Project.[18] The user picks can attribute the source of information in their research, giving Google searches more academic applications and transparency than AI-generated text. However, Google search results are neither relative nor random. They are a product of the majority culture that rarely questions the historical and social conditions behind ethnic groups that may be considered minorities. In her book *Algorithms of Oppression*, Safiya Umoja Noble reminds us that human beings who "hold all values, many of which openly promote racism, sexism and false notions of meritocracy,"[19] make the mathematical formulations that drive automated decisions behind Google searches.

So, what are the hegemonic digital frameworks for Arab Americans? An "Arab American Identity" Google search found 68,800,000 results in 0.36 seconds, with no sponsored links.[20] The first entry was a U.S. government article by two Arab American service officers for the State Department's series,

DipNote, as part of Arab American Heritage Month. The article's purpose appeared in its concluding paragraph: the recruitment of Arab Americans and advocacy for more Arab American representation in foreign affairs agencies, meaning at the State Department, United States Agency for International Development (USAID), or elsewhere.[21] The fact that Google placed a state.gov site at the top of its search results shows an algorithmic bias for official governmental sites, particularly those fulfilling foreign policy objectives. Mainstream American media frames Arabs and Muslims as terrorists and threats, manufacturing a need to prove one's U.S. patriotism, especially after 9/11.[22] An effective way for Arab Americans to "prove" their patriotism is to join the State Department, USAID, Central Intelligence Agency, Federal Bureau of Investigation, or Department of Homeland Security. The prominent placement of this article and the accompanying photo of the author in a Middle East location in the first Google Images results point to the search engine directing how a "good" Arab American is defined.[23]

Google's question suggestions, which followed the link to *DipNote*, indicated algorithmic predictions funneling the user into specific lines of inquiry. On a search for "Arab American Identity," Google prompted me with these question suggestions:

What is the identity of the Arabs?
What constitutes an Arab American?
What is the ethnicity of the Arab people?
What religion do Arab Americans practice?

The first and third questions divert the user to ask about a homeland-defined distinctiveness, indicating that naming ethnic origins is central to definitions. Such questions surround most "ethnic immigrant" groups in the United States, implying that identity is derivative from geographic origins. This line of questioning presumes a singular, stable, preexisting identity, as if formed holistically abroad and imported into an American context. Rather than acknowledging the hybrid, evolving, lived experiences and new cultural expressions, these questions assume that *Arab American* references a static geographic Arab homeland identity.

The last question assumes that Arab Americans practice a single religion. This reminded me of the Orientalist supposition that *Arab* equals *Muslim*. To state that not all Arabs are Muslim and not all Muslims are Arab is to state the obvious. Therefore, a Google search question that does not acknowledge religions in the plural is misleading, especially since Christians form a significant portion of, or even a majority of, Arab Americans. This question pulled the researcher toward a simplified representation of Arab Americans as Muslims.

The second link in this Google Search was to an academic article in the *Middle East Research and Information Project (MERIP)* journal.[24] The pull quote that appeared on the search page was from the last paragraph of the article: "Arab American is a pan-ethnic, racialized identity that embraces non-whiteness while conferring a coherent position in a racially organized society. Being Arab . . ." The full sentence reads, "Being Arab American reconciles all sorts of contradictions that being Palestinian American cannot in the US."[25] The well-researched article by Louise Cainkar was about a Palestinian youth who lived in Chicago and had moved back to Palestine.[26] This article conveys a complex understanding of the relationship between national (i.e., Palestinian) identity in tandem with a pan-ethnic Arab American identity that is racialized as non-white.

The third search result was linked to a U.K. blog post reprinted as an article in the University of Edinburgh's journal, *RACE.ED*, titled, "White, But Not Quite: Identity Development in Arab American Adolescents."[27] The Google search quoted the first sentence: "Arab Americans have been categorized as White on official government forms for several decades, which grossly misrepresents this population." The article's main point was a critique of U.S. government policies and the mainstream media, which have impacted Arab American youth's experiences of stereotypes and discrimination in schools, resulting in them feeling ostracized by their peers, teachers, and school staff. The lack of references to the study's location, design, and authors limits the article's use and reliability as an information source. The front cover of the *RACE.ED* journal appears "above the fold" (the area visible without scrolling) in the same "Arab American Identity" Google Images search results. The cover has an eyeball reflecting a cartoon drawing of a man in a turban at its center, surrounded by various people of color. The message is clear: Arabs are not white. Arabs are racialized as "brown."

If an initial 2024 Google search netted poor results with limited working definitions of Arab Americans, no reference to Arab American history, and no maps, then a second Google foray into the debate of Middle Eastern versus Arab highlighted the importance of maps in visualizing geographical origins.

A Google search asking "What is the difference between Middle Eastern and Arab?" brought up numerous historical references to the terms.[28] The first of 1,470,000,000 results was a snippet from Community Commons that was informative, correct, and worth quoting at length: "The term 'Middle East' itself is rooted in Eurocentricism, as it references the region's location relative to Europe rather than its actual geographical location. The term 'Arab' is used to refer to people with ancestries traced to the Arab world, a group of nations all connected by the use of the Arabic language."[29]

Although the term *Middle East* is Eurocentrist, it is more precisely a British colonial term that emerged in the early twentieth century. It was insti-

tutionalized by Winston Churchill in 1921 with the establishment of the Middle East Department within the British Colonial Office, formalizing the term as part of imperial administrative discourse. The United Nations defined the Middle East in 1948 as "stretching across three continents to include Afghanistan, Iran, Iraq, Syria, Lebanon, Turkey, Saudi Arabia, Yemen, Egypt, Ethiopia, and Greece."[30] The UN's definition added Afghanistan, Ethiopia, and Greece to the OMB's delineation of the Middle East, highlighting the lack of consensus on the geographical reach of the region.

The Google Images results from the exact same search produced a bonanza of maps to illustrate the differences between Middle Eastern and Arab. Six of the ten results above the fold were maps from Quora, a crowdsourcing question-and-answer platform on various topics. For example, one curious user asked,

> Is the Middle East the same region as "Arabic World"? Can I use these names in the same context? I need this for my thesis, but I'm not sure since, depending on the source, the Middle East has a slightly different range (for example, Egypt can be included or not).

Most public replies were unequivocal—no, absolutely not—and included maps to illustrate how the two are not the same. Ian Hunt, whose byline reads that he has posted 638 answers with 1.6 million views on Quora, uploaded a map from the Arab League to define the Arabic World—a definitive visual statement in contrast to the Middle East, which he considered to be "a very poorly defined region." He included four conflicting cartographical definitions of the Middle East and two maps on Central Asia with his statement for good measure.[31]

Although the initial Google search on Arab American identity did not offer precise or useful definitions, the Images section of a comparison question comparing Arab and Middle Eastern identity provided crowdsourced clarity between Islamic, Arab, and Middle Eastern identities.

Wikipedia

Wikipedia, an online encyclopedia freely accessible to all, is a primary source for AI-generated searches and knowledge dissemination. Its English-language edition, the largest among multiple language editions, boasted over 6.8 million articles as of March 2024. Notably, Americans accounted for about 40 percent of its active editors in 2022, according to Amy Bruckman's book, "Should You Believe Wikipedia? Online Communities and the Construction of Knowledge."[32] Bruckman's work explores the dynamics of online communities, focusing on Wikipedia's reliability and credibility. Bruck-

man delves into the collaborative nature of platforms like Wikipedia and analyzes various factors influencing trust in online information, such as community norms, governance structures, and individual contributors' roles. She challenges readers to critically evaluate the information they encounter online and offers insights into the complexities of online knowledge production.

While Wikipedia praises itself for enabling the democratization of knowledge and offering extensive coverage, it acknowledges systemic biases, including gender bias against women and geographical bias against the Global South (Eurocentrism).[33] Critics like Bruckman have highlighted the typical demographic of the average Wikipedia editor, noting a predominance of white males. Controversially, a large-scale quantitative study found that the "most stridently opinionated Western white male editors" continued to dominate the English-language Wikipedia platform.[34]

Wikipedia's Arab American and Arab immigration pages do not fully reflect recent demographic shifts and developments due to outdated data and limited contributions. The exclusion of current information could be perceived as a form of bias or oversight rather than deliberate Islamophobia. However, it is essential for Wikipedia contributors to continually update and revise articles to ensure accuracy and inclusivity, especially regarding sensitive topics such as demographics and cultural identity.

Wikipedia's "Arab immigration to the United States" entry is outdated and cites the latest period of immigration as vague: 1960s to 2010s.[35] Since the last date of information cited is 2005, the information is twenty years old; this means the information skews away from immigration trends in the last two decades. Included on the page is a pie chart from 2002 of the religious breakdowns that cites Muslims as only 24 percent of the Arab American population. Since 2002, the Muslim population growth from immigration has meant that the percentage of Muslims in the overall Arab American population has increased.[36] By excluding immigration statistics and Census data after 2005, Wikipedia ignores a rise in the Arab Muslim population and the growing national diversity among Arab Americans. Wikipedia's policies are to follow conventional wisdom, offer no attributions beyond contributors, and avoid bias. But my examination of the Arab American pages has prompted me to ask if the omission of current information constitutes bias. Is acknowledging Muslim Arab American demographics too political or controversial for Wikipedia?[37] Is Wikipedia Islamophobic, ignorant, or avoiding controversy?

ChatGPT

AI's rising relevance in research signifies a paradigm shift in how knowledge is generated and applied across diverse fields. As AI advances, its integration

into research processes will likely deepen, so we must understand how AI analyzes vast amounts of data, identifies patterns, and makes predictions. We know that AI searches use open sources such as Wikipedia, but they are not online encyclopedias themselves. We know that AI-generated definitions can be repetitive in multiple searches because they source the same information, called a context window. AI models answer questions and engage in conversation by generating humanlike sentences and do not include attributions or footnoted references.

ChatGPT (Generative Pre-Trained Transformer) is the most widely used chatbot. OpenAI developed ChatGPT, a conversational AI language model built on the GPT architecture. OpenAI released its machine learning model, GPT-4, in March 2023. OpenAI's GPT-4 technical report recorded that this version, like previous iterations, "is not fully reliable (e.g., can suffer from 'hallucinations'), has a limited context window, and does not learn from experience."[38] The term *hallucinations* refers to the chatbot's random response when it does not know the answer to something. One tech critic warned users about the extent of these hallucinations: "Its lies get detailed, too, like making up the names of people who founded a company or lying about how many wins a certain sports team has."[39] Therefore, a researcher must verify all facts and claims of an AI-generated text. Often, secondary checks are done online, perhaps on Wikipedia or through a Google search.

I was unaware of two additional issues before this research: ChatGPT does not search the web and is limited to a cordoned-off dataset containing nothing after September 2021.[40] In addition, the chatbot's answers to questions related to history or politics, for example, are what the developers viewed as a "standard" version of events, usually from a pre–September 2021 Wikipedia entry, *Encyclopedia Brittanica* information, or some other "neutral" source. Narratives outside of a perceived mainstream are excluded, which is primarily a concern for cutting-edge and controversial topics.[41]

With trepidation, I researched AI's generative content by prompting it for "Arab American Identity." The humanlike response was a bland mainstream characterization of Arab origins from one of twenty-two member countries in the Arab League. When I searched for "the meaning of Arab Americans in public history," ChatGPT gave a vague response that called the history of Arab Americans "multifaceted" but without dates for the "waves of immigration."[42] ChatGPT's public history of Arab Americans remained focused on promoting "understanding, inclusivity, and respect for the contributions of Arab Americans to the cultural mosaic of the United States." This keeps Arab Americans as a cookie-cutter neoliberal multicultural iteration of an ethnic immigrant community. References to the "cultural mosaic" are trite and bland, avoiding controversy and acknowledg-

ment of the significant economic and political challenges of race, ethnicity, discrimination, and marginalization that Arab immigrants and their descendants face.

In terms of the recent recategorization of MENA people out of the "White" race box in March 2024, ChatGPT referenced historical U.S. Census categorizations of individuals from the MENA region as "white" while stating that "this classification has been a subject of debate and contention" on April 30, 2024, after the OMB announcement of the revisions of the race and ethnic data minimum-reporting standards. ChatGPT did not mention that the term *MENA* had colonialist origins or what North Africa was north of (the Saharan desert) and sidestepped the controversies of whether Mauritania, Somalia, and Djibouti are included as part of North Africa. However, it did say that individuals from the MENA region may identify as "White, Black, Asian, or others, depending on their cultural, historical, and personal experiences."[43]

ChatGPT considered MENA and SWANA synonyms,[44] offering an alphabetical list of countries commonly associated with both. The Middle East consisted of Bahrain, Cyprus, Iran, Iraq, Israel, Jordan, Kuwait, Lebanon, Oman, Palestine, Qatar, Saudi Arabia, Syria, Turkey, United Arab Emirates, and Yemen. North Africa included Algeria, Egypt, Libya, Mauritania, Morocco, Sudan, and Tunisia. SWANA is an identity category and a student organizing ontology that began in the University of California system in the early 2010s to replace Middle Eastern (due to its colonialist origins). The students advocated an admissions SWANA checkbox that "united Afghan, Armenian, Iranian, Kurdish, Turkish, Druze, Arab, Chaldean, Yazidi, Azerbaijani, Somali, Amagizh, Sudanese, Circassian, Djiboutian, Assyrian and many more students" behind it.[45] Though there is no official definition of SWANA, this list indicates that SWANA includes identities beyond the geopolitical states of MENA. Thus, we can conclude that ChatGPT hallucinated a definition of SWANA based on its MENA definition.

Arab American National Museum Definitions

In their important work, "The Presence of the Past: Popular Uses of History in American Life," Roy Rosenzweig and David Thelen illuminate how individuals utilize the past to construct and shape their identities, forge enduring connections, and perpetuate memories across generations.[46] Notably, participants in their study regarded museums as the most credible venues for engaging with history, viewing them as impartial conduits to the past so visitors can independently explore artifacts and sites to draw their own conclusions. However, this perception of public trust overlooks the reality that

museums and historical sites, like their counterparts in academia, possess inherent perspectives, make selective choices, and present arguments in their exhibitions.

Nestled within the vibrant East Dearborn, Michigan, community, the Arab American National Museum (AANM) stands as a beacon of cultural connection and understanding between the American public and Arab Americans. With a steadfast commitment to community engagement, facilitating dialogue, and preserving diverse narratives, the AANM has emerged as a trusted repository for Arab American histories, as Edward Curtis points out in his introduction. At its core, the museum acknowledges the multifaceted and nuanced experiences of Arab Americans, embracing inclusivity by affording individuals the agency to self-identify. This inclusive ethos stems from extensive consultation with various groups, reflecting a profound reverence for the myriad voices within the community.

In 2018, AANM secured a grant from the Institute of Museum and Library Services, an independent U.S. government agency, for a public outreach publication. This booklet would be for sale in the museum bookstore, downloadable for free through their website, and distributed in educator workshops. The AANM would be the primary author and publisher, and there would be no public review process.

Shortly after they secured the grant, I accepted the position of freelance writer of the primer. In the original version, I emphasized the commonalities of history, language, and cultural heritage for Arab American identity, writing, "Arab Americans refers to citizens, residents, and long-term visa holders from the Arab world living in the United States. They share similar histories, languages, and cultural heritage from countries stretching from northern Africa to western Asia." The AANM staff added an introductory paragraph on the book's purpose and edited my draft, changing the definition of *Arab Americans*: "The term 'Arab American' refers to anyone living in the United States with ancestry in any of the twenty-two Arab countries, which stretch from northern Africa to western Asia."[47]

The revised definition matched the map in the museum's vestibule. From its inception, AANM's interior architecture featured a prominent and large map delineating "the Arab world," symbolizing the ancestral origins of Arab Americans from the twenty-two member states of the Arab League.[48] This cartographical reference offers the public a clear visual definition of Arab heritage as they enter and ascend into the permanent exhibitions that contain complex, nuanced cultural understandings of Arab American histories and cultures. I mention it not so much to critique the decision as to note the incredible framing power of political geography. My advice to public historians is to consider what is lost and what is gained in starting from a national origin definition of Arab American identity.

Finding an Arab Ethnic Home

I would like to suggest an alternative approach to Arab American identity that does not do away with political geography altogether but insists on problematizing it from the beginning. Geographer Karen Culcasi and I share an understanding that Arab identity is deeply rooted in linguistic, historical, and cultural ties while also acknowledging the significance of territory in conceptualizing the "Arab homeland." Culcasi's research delves into the complexities surrounding the term *Arab homeland*, examining its historical and geopolitical dimensions. Through analysis of Arabic maps from the mid-1950s, she found that the concept of an Arab homeland is closely tied to the pan-Arab political movement, shaped by twentieth-century conflicts with European imperialists and Israelis.[49]

Culcasi's study reveals that defining the Arab world based on cartographic boundaries often aligns with state membership in the League of Arab States. However, she notes discrepancies in the inclusion of certain territories, such as Western Sahara, Mauritania, Somalia, and Djibouti, despite their affiliation with the Arab League. The geopolitical dynamics of the region, including the labeling of Palestine and the naming of the Arabian Gulf, influence these mappings, reflecting political stances and biases.

This research highlights a fundamental challenge in defining Arab Americans, as geopolitical constructs often blur ethnic and religious identities within national affiliations. Significant non-Arab populations within Arab countries, such as the Amazigh, Kurds, Chaldeans, and Nubians, risk being subsumed under the broader Arab identity when state-based membership is used as a model for defining Arab Americans. Significant Christian populations including Assyrians, Chaldeans, Copts, and Maronites trace their existence to before the Islamic Empires and reject the term *Arab* based on their pre-Islamic histories and lineages.[50] Historically, these groups with ancient Christian lineages emigrated in greater numbers from the region and chose to immigrate to North America, partially due to a perceived shared Christian identity.

Regional alternatives, such as *Near Eastern* or *Middle Eastern*, deliberately exclude—and perhaps deny—pan-Arab ethnicity. Culcasi strongly advocates for completely abandoning the term *Middle East* from the discipline of geography.[51] This stance is primarily grounded in its lack of a clear continental reference combined with the persistent ambiguity regarding the geographical extent of the region. Additionally, Culcasi underscores the historical connotations of the term, which are laden with imperialist and racist undertones. Instead, Culcasi explores alternatives like *West Asian and North African (WANA)* and *Southwest Asian and North African (SWANA)* and calls for adopting *SWANA* in academic circles. But for me, *MENA* and *SWANA* still adhere

to Western constructs of regional divisions, resulting in a generalized and somewhat dehumanizing portrayal of the diverse populations.

Public historians committed to working in Arab American communities must be willing to explore the use of other labels beyond those generated by governmental, bureaucratic, online, and institutional sources. There are different ways to conceptualize Arab American identity that reduce hard-line definitions of geographic origins into a more qualitative and descriptive zone. An alternative perspective would be to focus on the idea of the ethnic home, which embraces Arab identity without naming countries of origin, remaining unattached to the *al-watan*, or the "Arab homeland." The ethnic home describes an emotional-affective bond that cannot be seen or drawn but is felt. Finding an ethnic home involves complex negotiations of identity and cultural belonging in a transcultural context.

This concept is inspired by the anthropologist James Clifford's writing on travel and diaspora, which emphasizes the fluidity of identity in a globalized world, where people constantly negotiate their sense of self and belonging across different cultural landscapes.[52] Forming and maintaining an ethnic home continually evolves as individuals and communities find rootedness without attachment to a defined physical location.

An excerpt from an interview with a male-female married couple in northern Virginia in 2010 highlights how racial ascriptions in the ethnic home were negotiated:

RANDA KAYYALI: Census 2010 classified Arab Americans as "white." Do you agree with that racial designation?
HER: No, do you? [Turning to her husband]
HIM: Well, it depends. If it's my nephew who's pretty white, then it would make sense, but Arab is not a racial designation, it's an ethnic designation, so I, I would—we talked about this last night—so I would check the box that says "Olive."
HER: Olive? Mafie shi olive! [There's no such thing as olive!]
HIM: Well, that's what I am. I'm Olive.
HER: I would always compare my kids—a sheet of white paper—to their skin. I'm like, are you white? That's white [pointing to a sheet of white paper]. Are you? [Laughter] . . . I don't know.
HIM: [Then] Even Newt's not white. [Referring to Newt Gingrich and the white paper]
HER: There's Arabs who are clearly dark-skinned.
HIM: That's why I said it's an ethnic, not a racial, designation. A Sudani is "soud" [A Sudanese man is black].
HER: But if he's Arab, he has to [check the "White" box]; he's considered white?[53]

This couple shared an Arab identity, and they were perplexed by the U.S. Census classifications and racial structures in 2010 that defined people from the MENA region, including Arabs, as white. The man identified as "olive," yet he considered his nephew "fairly white," implying that he could pass as white. Yet, both he and his nephew were Arab—an ethnic designation that does not exist on forms. The woman found skin color a more appropriate way to ascertain race. She lamented a binary racial system that omits olive-skinned people and places Arab Americans into a white race box. They agreed that a Black race designation did not fit them, referencing a contrasting Sudanese blackness. What this conversation highlights is that for this couple and many others I interviewed before 2024, Arab Americans do not fit into a racial binary structure.

Intersection of Black and Arab Identities

Although this Lebanese-Palestinian couple did not identify as white or Black, there are Middle Eastern and North African Americans who identify as Black by race and Arab by ethnicity. The intersection of these identities can be both empowering and challenging to U.S. racial structures. This dual identification reflects diverse histories and experiences within the Arab world and the African diaspora that, after migration, can become a complex negotiation of identities intertwining culture, race, ethnicity, and national origins. For example, a Sudanese American woman in the United States might identify as Black due to her physical appearance and African heritage yet also embrace her Arab identity, celebrating Sudanese traditions, speaking Arabic, and practicing Islam. She may choose to participate in African American and Arab American communities, sometimes explaining her dual identity to those unfamiliar with Sudan's cultural complexity.

Black Arab Americans may move between different cultural worlds, sometimes having to assert their Blackness in Arab contexts or their Arab heritage in African American spaces. Their stories reflect a broader struggle for recognition and respect within Arab and African diasporas. Migration patterns spurred on by mercantile trade, slavery, or fleeing war have caused people to move from sub-Saharan Africa to North African countries like Sudan, Mauritania, Morocco, Algeria, Libya, and Egypt as well as to West Asia, including Yemen, Oman, and Palestine. In Morocco and Algeria, there are communities of Haratin and Gnawa, who are descendants of enslaved sub-Saharan Africans. These groups often identify as both Black and Arab/Berber, the latter being more appropriately known as Amazigh. The Haratin, for example, live in southern Morocco and are known for their distinct cultural practices that blend Amazigh and sub-Saharan African traditions. A Haratin man might emphasize his Black identity when confronting discrimination or racism

within Moroccan circles while also embracing his Amazigh and Arab heritage. He may participate in Gnawa music, a spiritual and cultural practice rooted in West African traditions, to honor his Black ancestry while remaining connected to the broader Moroccan identity. A Somali American woman might find herself in spaces where she has to assert her Black identity, especially when encountering anti-Blackness within Arab communities. At the same time, she may feel a strong connection to her Somali heritage, speaking the language and participating in Islamic cultural and religious practices while embracing the broader African American identity. She may find solidarity with Arab and African Americans due to shared experiences of racism while also promoting awareness of the diverse racial identities.

Developing the Arab American Ethnic Home

Arab Americans already self-identify in fluid, multilayered ways that include pan-Arab ethnicity and religious and national identities. Through public history, we can redirect discussions on Arab American identity away from stiff MENA Census categories and U.S.-only definitions and move back to cultural and linguistic commonalities and the ethnic home that connects Arab Americans to the Arab world in a loose, transnational manner that is inclusive of continental America.

The Arab American ethnic home has a linguistic fluidity, using American English, Modern Standard Arabic, colloquial dialects, non-Arabic languages spoken in the MENA region, as well as Spanish and Portuguese. For Arab Americans whose families emigrated not directly from the Arab world but via South or Central America—including Brazil, Argentina, Honduras, Chile, and other nations—Spanish or Portuguese may be the dominant heritage language rather than Arabic. This layered migration history adds another dimension to the linguistic repertoire of Arab American households and circles.

Although Modern Standard Arabic may unite Arabic speakers in discussions and understandings of transcultural Arab belonging, colloquial dialects are more often used in everyday conversation or informally in domestic spaces. We sometimes call them "kitchen Arabic." These dialects vary significantly and are often broadly associated with national identity (e.g., "Egyptian Arabic"), or regional identity (e.g., "Gulfi Arabic"), but in reality the dialects differ in intonation, accent, and vocabulary not only between countries or subregions, but within them, such as Sai'di (Upper Egyptian) and Cairene Arabic—or even across urban, rural, and ethnic lines, as seen in the distinctiveness of Bedouin dialects, for example. Languages such as Chaldean, Amazigh, Syriac, and Kurdish frequently denote non-Arab identities and are essential to the cultural fabric of these communities. Among diasporic North Africans, the Haratin and Gnawa communities from Morocco

and Algeria also bring unique dialects and expressions rooted in sub-Saharan African, Amazigh, and Arab cultures.

Arab cuisine also celebrates cultural belonging that can be shared with the American public through foods such as hummus, falafel, pita bread, and tabbouleh, which are commonplace in many U.S. grocery stores and in restaurants across borders. Meals, spices, and recipes can act as cultural objects passed down from generation to generation, bringing Arab American families into an ethnic home. During one Arab American Heritage Month, a local news network in California broadcast a segment on a restaurant called Beit Rima, named after the chef's mother, Rima. The chef explained, "Beit means home, house, or town, so I wanted to give the public an excellent introduction to Arabic food and Arabic hospitality."[54] The chef-owner, Samir, explained the origins of a rustic Palestinian dish, *musakhan*, exposing the viewing audience to Arabic food, yes, but also to the language, history, and culture. His cultural identification as Arab and Palestinian was embodied in the media presentation of the intersections of his food, home, and historical narratives.

This chapter advocates the identification, examination, and subsequent reevaluation of the significance of present or historical geography in shaping a praxis of Arab American public histories. I propose prioritizing an Arab ethnic home concept over maps and the MENA ethno-racial classification. Portraying Arab Americans solely through the lens of geographic origins or as a monolithic identity constrains the comprehensive understanding of the multifaceted histories, cultures, and communities of Arabs in the United States and beyond in North, Central, and South America. Rather than basing conceptualizations of identity on borders alone, we must see the linguistic, artistic, and cultural manifestations of Arab American identities, in the plural, in historical and contemporary narratives.

NOTES

1. "Initial Proposals For Updating OMB's Race and Ethnicity Statistical Standards," *Federal Register*, January 27, 2023, https://www.federalregister.gov/documents/2023/01/27/2023-01635/initial-proposals-for-updating-ombs-race-and-ethnicity-statistical-standards.

2. "Initial Proposals for Updating OMB's Race and Ethnicity Statistical Standards," 1306–1307.

3. "Revision to OMB's Statistical Policy Directive No. 15: Standard for Maintaining, Collecting and Presenting Federal Data on Race and Ethnicity," *Federal Register*, March 9, 2024, https://www.federalregister.gov/documents/2024/03/29/2024-06469/revisions-to-ombs-statistical-policy-directive-no-15-standards-for-maintaining-collecting-and-, 22191.

4. "Revision to OMB's Statistical Policy Directive No. 15," 22193.

5. Only ADC mentioned this in their press release, stating, "Moving forward ADC will be committed to advocating for additional changes, including inclusion of *Arab* in the category title, based on the fact that an overwhelming majority of those who are from

the region are Arab." See "ADC Statement on Directive 15 Revisions (MENA Box)," ADC, March 29, 2024, https://adc.org/adc-statement-on-directive-15-revisions-mena-box/.

6. "Arab American Institute Welcomes New 'Middle Eastern or North African' (MENA) Category & Revision of Race and Ethnicity Standards," Arab American Institute, March 28, 2024, https://www.aaiusa.org/library/arab-american-institute-welcomes-new-middle-eastern-or-north-african-mena-category-amp-revision-of-race-and-ethnicity-standards?rq=directive%2015. According to the AAI, "While we do not believe the MENA examples for the 2015 National Content Test (NCT) were sufficient to capture the full racial diversity of Arab Americans because of their omission of a Black Arab example, they still remain constructive testing the Census Bureau could have built on after the release of the new Standards and in preparation for the 2030 decennial."

7. "Revision to OMB's Statistical Policy Directive No. 15."

8. As quoted in Angela Buchanan, Rachel Marks, and Magdaliz Álvarez Figueroa, *2015 Forum on Ethnic Groups from the Middle East and North Africa: Meeting Summary and Main Findings* (Washington, DC: U.S. Census Bureau Population Division, 2016), 31, https://www.census.gov/library/working-papers/2015/demo/2015-MENA-Experts.html.

9. Ernest Renan, *Histoire générale et système comparé des langues sémitiques*, 2nd ed. (Paris: Imprimerie Impériale, 1858).

10. Bernard Lewis, *The Arabs in History*, 6th ed. (Oxford: Oxford University Press, 2002 [1950]); and Lewis, *The Middle East: A Brief History of the Last 2,000 Years* (New York: Scribner, 1997).

11. Albert Hourani, *A History of the Arab Peoples*, 2nd ed. (Cambridge, MA: Harvard University Press, 2010); and Peter Mansfield, *A History of the Middle East*, 5th ed. (London: Penguin, 2013).

12. Ira Lapidus, *A History of Islamic Societies*, 3rd ed. (New York: Cambridge University Press, 2014); Hourani, *History of the Arab Peoples*; and Philip K. Hitti, *History of the Arabs*, 10th ed. (Hampshire: Palgrave MacMillan, 2002 [1937]).

13. Of the three DNA testing companies cited, only 23andMe includes Arabs by name in the Western Asian and North African section. AncestryDNA divides the Middle Eastern region into more specific areas: the Arabian Peninsula, Levant, and Egypt. In Chapter 7, Reem Awad-Rashmawi notes that FamilyTreeDNA divides their Middle East and North Africa section into Middle East, North Africa, Caucasus, Arabia, and Middle East Jewish, denoting religion as a significant DNA tracker in the region.

14. Sarah Gualtieri, *Between Arab and White: Race and Ethnicity in the Early Syrian American Diaspora* (Berkeley: University of California Press, 2009).

15. Alex Halavais, *Search Engine Society* (Cambridge, MA: Polity, 2009).

16. Edward Said, *Orientalism* (New York: Vintage, 1978); Jack Shaheen, *Guilty: Hollywood's Verdict on Arabs after 9/11* (Northampton, MA: Olive Branch, 2008); Lila Abu-Lughod, *Do Muslim Women Need Saving?* (Cambridge, MA: Harvard University Press, 2013).

17. Safiya Umoja Noble, *Algorithms of Oppression: How Search Engines Reinforce Racism* (New York: New York University Press, 2018), 1. Noble argues that digital platforms reproduce social inequalities by privileging dominant cultural frameworks in algorithmic systems, often rendering marginalized communities less visible or misrepresented in search results.

18. Nick Fox, "Organizing the World's Information: Where Does It All Come From?," *How Search Works*, December 3, 2020, https://blog.google/products/search/information-sources-google-search/.

19. Noble, *Algorithms of Oppression*, 1–2.
20. Google Search, "Arab American Identity," February 24, 2024.
21. Leyth Swidan and Rahaf Safi, "National Arab American Heritage Month: Embracing Identities While Enriching Diplomacy," *DipNote*, April 20, 2023, https://2021-2025.state.gov/dipnote-u-s-department-of-state-official-blog/national-arab-american-heritage-month-embracing-identities-while-enriching-diplomacy/.
22. Evelyn Alsultany, *Arabs and Muslims in the Media: Race and Representation after 9/11* (New York: New York University Press, 2012), 18–38; and Matthew Pratt Guterl, *Seeing Race in Modern America* (Chapel Hill: University of North Carolina Press, 2013).
23. See Mahmood Mamdani, *Good Muslim, Bad Muslim: America, the Cold War and the Roots of Terror* (New York: Pantheon, 2004). I have written about this binary "good" and "bad" Arab American framing. See Randa Kayyali, "Jihad Jane as 'Good' American Patriot and 'Bad' Arab Girl: The Case of Nada Prouty after 9/11," in *Bad Girls of the Arab World*, ed. Nadia Yaqub and Rula Quawas (Austin: University of Texas Press, 2017), 63–77.
24. Louise Cainkar, "Becoming Arab American," *MERIP* 278 (Spring 2016), https://merip.org/2016/04/becoming-arab-american/.
25. Cainkar, "Becoming Arab American."
26. Cainkar, "Becoming Arab American."
27. Rhonda Tabbah, "White, But Not Quite: Identity Development in Arab American Adolescents," *RACE.ED*, University of Edinburgh, December 10, 2021, https://www.race.ed.ac.uk/blog/2021/white-not-quite-identity-development-arab-american-adolescents.
28. Google Search, "What is the difference between Middle Eastern and Arab?," April 30, 2024. Note that in 2024, Google searches did not pull up AI overviews.
29. Community Commons, "Middle Eastern and Arab Americans," https://www.communitycommons.org/entities/6b7bade6-5425-4080-a18b-09d9c8ef0526.
30. Karen Culcasi, "Constructing and Naturalizing the Middle East," *Geographical Review* 100, no. 4 (October 2010): 583–597.
31. Ian Hunt, post on Quora, circa 2021, accessed March 22, 2024, https://www.quora.com/Is-Middle-East-the-same-region-as-Arabic-World-Can-I-use-these-names-in-the-same-context-I-need-this-for-my-thesis-but-Im-not-sure-since-depending-on-the-source-Middle-East-has-a-bit-different-range-for-example.
32. "English Wikipedia," Wikipedia, accessed April 30, 2024, https://en.wikipedia.org/wiki/English_Wikipedia.
33. "Wikipedia," Wikipedia, accessed April 30, 2024, https://en.wikipedia.org/wiki/Wikipedia.
34. Danielle Morris-O'Connor, Andreas Strotmann, and Dangzhi Zhao, "The Colonization of Wikipedia: Evidence from Characteristic Editing Behaviors of Warring Camps," *Journal of Documentation* 79, no. 3 (October 24, 2022): 784–810.
35. "Arab Immigration to the United States," Wikipedia, accessed April 30, 2024, https://en.wikipedia.org/wiki/Arab_immigration_to_the_United_States.
36. Besheer Mohamed, "Muslims Are a Growing Presence in US but Still Face Negative Views from the Public," Pew Research Center, September 1, 2021, https://www.pewresearch.org/short-reads/2021/09/01/muslims-are-a-growing-presence-in-u-s-but-still-face-negative-views-from-the-public/.
37. For example, *Demographic Portrait of Muslim Americans*, Pew Research Center, July 26, 2017, https://www.pewresearch.org/religion/2017/07/26/demographic-portrait-of-muslim-americans/.
38. Quoted in Megan Skalbeck, "Four Things to Know About GPT-4," July 31, 2023, https://www.verblio.com/blog/gpt-4-release.

39. Fergus O'Sullivan, "ChatGPT vs Search Engines," *Addictive Tips*, November 27, 2023, https://www.addictivetips.com/ai/chatgpt-vs-search-engines/.

40. O'Sullivan, "ChatGPT." Here is what ChatGPT replied to me on April 30, 2024, upon prompting: "That's correct. As an AI language model, I don't have the ability to access the internet or any external sources of information. My responses are generated based on the data I was trained on, which includes a diverse range of text from various sources up until September 2021. If you have any questions or need information, feel free to ask, and I'll do my best to help based on the knowledge I have!"

41. Fergus O'Sullivan, "What Is ChatGPT & How Does It Work?," *Addictive Tips*, November 27, 2023, https://www.addictivetips.com/ai/what-is-chatgpt/.

42. "The meaning of 'Arab American' in public history," Open AI/ChatGPT, accessed December 14, 2023.

43. "What does Middle Eastern and North African mean?," Open AI/ChatGPT, February 24, 2024; "Are MENA people white?," Open AI/ChatGPT, April 30, 2024.

44. "What does Southwest Asian and North African mean?" and "Which countries are in SWANA?" Open AI/ChatGPT, accessed February 24, 2024.

45. Sophia Armen, "Rooted in the (Youth) Movement, Onward to Liberation," *Journal of Asian American Studies* 26, no. 2 (June 2023): 200.

46. Roy Rosenzweig and David Thelen, *The Presence of the Past: Popular Uses of History in American Life* (New York: Columbia University Press, 2000).

47. Arab American National Museum with Randa A. Kayyali, *Arab Americans: History, Culture and Contributions* (Dearborn, MI: Arab American National Museum, 2019), 5.

48. The map is seen at 0:18 in the "AANM Virtual Tour: Coming to America" video, Arab American National Museum, accessed April 30, 2024, https://arabamericanmuseum.org/coming-to-america/. I am told that this map was replaced by a digital version in 2023.

49. Karen Culcasi, "Cartographies of Supranationalism: Creating and Silencing Territories in the 'Arab Homeland,'" *Political Geography* 30 (2011): 417–428.

50. Randa A. Kayyali, "US Census Classifications and Arab Americans: Contestations and Definitions of Identity Markers," *Journal of Ethnic and Migration Studies* 39, no. 8 (2013): 1299–1318, 1311.

51. Karen Culcasi, "Decolonizing 'the Middle East,'" *Arab World Geographer* 26, no. 2 (2023): 108–118.

52. James Clifford, *Routes: Travel and Translation in the Late Twentieth Century* (Cambridge, MA: Harvard University Press, 2007).

53. Randa A. Kayyali, "Race, Religion, and Identity: Arab Christians in the United States," *Culture and Religion* 19, no. 1 (2018): 1–19, quoted on 11–12, italics removed.

54. "Celebrating National Arab American Heritage Month with Musakhan," NBC California Live, YouTube, 5 min., 57 sec., May 1, 2023, https://www.youtube.com/watch?v=sKLvNPFk8us.

3

Syrian Boston from Ottoman Emigration to Urban Renewal

Neighborhood History on Foot, on Display, and Online

Chloe Bordewich and Lydia Harrington

Bostonians and tourists strolling through the city's South End often remark on the bold red, yellow, and white sign affixed to the boarded-up brick building at 296 Shawmut Avenue. Its mid-century lettering reads "Sahara Syrian Restaurant." Today, real estate in this part of town is precious: in March 2024, the median list price for a condo in the neighborhood was over one million dollars.[1] Renovated nineteenth-century townhouses and gourmet markets on Shawmut Avenue suggest that these blocks belong to a squarely patrician tradition. Yet there is another history to this neighborhood. The former Sahara Restaurant, which closed more than fifty years ago, is one of the last visible traces of the Syrian community that first began settling in Boston in the late 1880s.

The Boston Little Syria Project is a public history initiative we launched in May 2022 to document the city's first Arabic-speaking community, which flourished from the 1890s through the 1950s. By 1920, Boston's Syrian population of approximately 3,150 was the third largest in the United States, after New York's and Detroit's.[2] The population continued to grow during and after World War I, and in 1937, the *Boston Globe* estimated that the city was home to as many as 15,000 Syrians—though this may be an overestimate.[3] Little Syria (also known as Syriantown, the Syrian Colony, and Little Lebanon) was originally centered in a part of downtown Boston known as the South Cove—now part of Chinatown.[4] It extended over time into the South End and was home mostly to Christian families with origins in the villages of Mount Lebanon, including Zahleh and Bsharreh, as well in cities, including

Damascus. Our project has employed various media to move through urban space physically and virtually, including walking tours, exhibitions, live events, a podcast, a bilingual article, and a digital map. These have engaged several different audiences: descendants of the Syrians who once inhabited the neighborhood, Bostonians unaware of its existence, Arab Americans beyond Boston, and the Syrian and Lebanese diaspora around the world.[5]

Boston is thick with historical commemoration. Founded by the Puritans in September 1630, it was one of the earliest towns in the territory that was chartered in 1691 as the Massachusetts Bay Colony. Boston's settler founders built the city's foundations on the Shawmut Peninsula, named by the Massachusett (Algonquian) people whose presence there preceded and was virtually erased by the Puritan settlement. Today, postcolonial immigration to Boston is most closely associated with the Irish and Italians. Several public history projects have documented the histories of these and other immigrants to Boston, including the West End Museum, the Chinatown Community Land Trust's (CCLT) Immigrant History Trail, the Armenian Museum of America in Watertown, and Global Boston.[6] These initiatives laid the groundwork for our own by noting the long-standing Arabophone presence in the city, preserving the history of places where Syrians lived alongside others, and documenting various ethnic groups' emigration from the Ottoman Empire and its successor states. Still, a comprehensive accounting of the foundations of Arab Boston specifically remained elusive until the launch of the Boston Little Syria Project.

As the founders of the Boston Little Syria Project, we reflect in this chapter on the choices and challenges involved in doing public history across several modes—an ephemeral walking tour, a physical exhibition of material culture, and a digital map—particularly as they bear on Arab American communities. We trace how we identified interlocutors through our networks and built trust with new ones. And we consider how the project has connected the stories of the first Syrian immigrants in Boston to those of their descendants and to the post-2011 Syrian diaspora.

The History of Arab Public History in Boston

The Boston Little Syria Project began in February 2020, when we stopped at the Syrian Grocery at 270 Shawmut Avenue to speak with co-owner Joe Mansour. At the time, we were doctoral students in Ottoman and post-Ottoman Arab history at Boston-area universities and had both returned recently from conducting research abroad. As scholars immerse themselves in places far from home, they can become estranged from those in which they live and work; we embarked on the Boston Little Syria Project in an endeavor to bridge this gap. Soon after our visit to the Syrian Grocery, the COVID-19 pandemic

broke out, and we had to pause our plans to share the work we had begun with a wider audience. Yet we continued to discover ways our own city's history was enmeshed with that of the places on which our scholarly work focused.

Records of Boston's early Arab past were plentiful, we found, but scattered. One useful point of departure was a short three-part video series made by *AJ+* in which producer Omar Duwaji situates his family's migration from Damascus in 1981 between two other significant periods of Syrian immigration to Massachusetts: the late nineteenth century and the ongoing exodus since the 2011 revolution.[7] Like Duwaji, we set out to elucidate connections and similarities over nearly a century and a half of Syrian migration. At the same time, we sought to acknowledge and explore the political and social reasons for disconnection and dissimilarity between its different periods.

One of the ways we position Boston's Syrian community in context is by linking it to early Syrian settlements across New England. Syrians also lived in Quincy, Lawrence, Worcester, and Pittsfield, Massachusetts; Waterville, Maine; the Merrimack Valley; northern Rhode Island; and Winsted, Connecticut. While dispersed across the region, Syrians were connected to their compatriots in other towns, subregions, and places outside of New England through family, social and religious organizations, and businesses. We also conceive of Boston's Little Syria within the umbrella of "Ottoman Boston," a category that captures the multiplicity of ethnolinguistic groups whose members left the Ottoman Empire and its successor states for the Shawmut Peninsula between the 1880s and the 1920s: Arab, Greek, Turkish, Jewish, Armenian, and others.[8] Our third frame is the urban history of Boston, in which city dwellers of all origins have played a part. This includes the transformation of the built environment, urban renewal, and large-scale departure to the suburbs in the mid-twentieth century.

When we began our research, we took stock of how the fact that we were two academics who did not grow up in or have family ties to the neighborhood we were documenting might influence both the questions we were posing and where we went to answer them. We had lived in the Boston area for several years and were aware of how divorced the academic community could be from the city at large. Thus, we trod cautiously. What previous efforts to preserve and convey the history of the community might we overlook or overwrite as scholars accustomed to looking for sources in a certain set of places? In addition to surveying the scholarly literature, we sought to track down private, community-based, and ephemeral documentation initiatives from the past that had not been archived or cataloged in academic databases.[9] The community had physically dispersed, taking its archives with it. Our task was to stitch frayed threads back together in fresh ways.

Earlier works by three Arab American women scholars with firsthand knowledge of Boston's Syrian community served as a bridge between academ-

ic and community knowledge production. Adele Younis (1907–1990), Evelyn Shakir (1938–2010), and Elaine Hagopian (1933–) all received Ph.D.s from Boston University. Younis went on to teach at Salem State University, Shakir at Bentley University, and Hagopian at Simmons College, all in the Boston area. Younis's dissertation, "The Coming of the Arabic-Speaking People to the United States" (1961), places Boston within the larger scope of early Syrian immigration.[10] Shakir was the daughter of Wadie Shakir (1886–1961), founder of the Arabic newspaper *Fatat Boston*, and of Hannah Sabbagh Shakir (1895–1990), founder of the Lebanese Syrian Ladies' Aid Society (LSLAS) and the key figure in *Bint Arab: Arab and Arab American Women in the United States* (1997), a memoir centering the stories of women in the Boston Syrian community and beyond.[11] Hagopian, a sociologist and long-time political activist, is the author of "The Institutional Development of the Arab-American Community of Boston: A Sketch" (1969), among many other works.[12] Unfortunately, neither Younis nor Shakir was still alive by the time we began our project. Others of Shakir and Hagopian's generation—perhaps the last to remember firsthand a time when there were still many Syrians in the South Cove and South End—are now in their eighties and nineties. This fact underscored the temporal urgency of the Boston Little Syria Project.

At the same time, we discovered that many members of the next generation had moved out of the city but retained rich family archives. We began collaborating with Richard Shibley (1959–), one of the few from this later generation to have remained continuously in the South End. Shibley gave what we believe to be the first walking tour of the Syrian South End in 2011, sponsored by United South End Settlements. This sort of ephemeral public history practice must not be overlooked. It coincided with another source typically absent from academic databases: a neighborhood historical association's quarterly e-newsletter, which featured a profile of Shibley's father, Fred (1905–1970), a former vaudeville acrobat, alleged bank robber, and newspaper publisher. Shibley's unusual biography, which his son recounted to us, warned us away from flattening the stories of Little Syria into familiar tropes.[13] While Shibley had chosen not to pursue a formal project on his own, he has brought his knowledge and networks to bear on ours. His recollections, as a lifelong resident of the South End, helped us overcome the narrative rupture brought about by the community's mid-century departure to the suburbs.

Churches proved to be another crucial link between past and present. Shibley's cousin, Father John Teebagy of St. John of Damascus in Dedham, introduced us to Father Timothy Ferguson, the former priest at St. George Orthodox Church of Boston in West Roxbury; both churches trace their roots to the early twentieth century in the South Cove.[14] Father Timothy, who served as pastor of St. George's from 2004 to 2021, wrote a deeply researched series of nearly twenty essays for the parish newsletter, *The Messenger*, which painted

a rich portrait of everyday life based on period newspaper reports and parishioners' family papers and photographs. The contents included descriptions of disputes over black market arak sales, marriage and veterans' ceremonies, favorite local hangouts, and episodes like the Orthodox-Maronite "South End Riots" of 1905, for example.[15] "Calling to Remembrance" circulated only among St. George's parishioners, which meant readers belonged to the families whose stories were being told. Centering this kind of audience is critical to public history work. Yet the series' limited circulation also reflects a common dilemma of grassroots projects: uncatalogued in any larger repository, the essays were liable to be overlooked by other researchers, especially after Father Timothy's retirement from St. George's.

Several years before Father Timothy's tenure began, a prominent St. George's parishioner had spearheaded a separate effort to collect the community's history. Evelyn Abdalah Menconi (1919–2003) was a longtime educator in the Boston Public Schools, where she was known for teaching about both the Arab world and Arab Americans in Boston.[16] Then, in the 1980s, she established the William G. Abdalah Memorial Library at St. George's in West Roxbury in her brother's memory. First and foremost a resource center supplying material on national Arab American affairs, the Abdalah Memorial Library also collaborated with Boston's *Arabic Hour* public access television program to run storytelling and oral history workshops.[17] "Coffeehouse Wayn Ma Kan," as these were called, led to at least one publication of collected memories of Syrian Boston.[18] Menconi moved the Abdalah Memorial Library collection to the Boston Public Library in 2001, shortly before her death. Even materials that end up among the holdings of major institutions have often not been linked to other relevant materials, making them hard to locate. For example, we tracked down *The Coffeehouse Wayn Ma Kan Collection: Memories of the Syrian-Lebanese Community of Boston* (1996) at the University of Massachusetts Boston Joseph P. Healey Library University Archives and Special Collections, where it is not part of a larger Arab or Syrian collection.

On the other hand, the oral history interviews historian Alixa Naff (1919–2013) conducted with Syrian and Lebanese Americans across the country in the 1960s and 1980s are archived on cassette at the National Museum of American History in Washington, D.C., and digitized by the Arab American National Museum. Five interviews were recorded in the Boston area, all in August 1962.[19] Cross-listing these interviews across the two institutions makes it possible to situate them both in an Arab American context and in the broader scope of U.S. history. The Naff Collection, along with the work of Younis, Shakir, Menconi, and Hagopian, is also symbolic of women's prominent role in documenting the Boston Syrian community. Notably, the most cohesive relevant archival collections open to the public are at the Schlesing-

er Library at Harvard's Radcliffe Institute—an archive dedicated to women's history—and belong to women's organizations: LSLAS and Denison House.[20] Women have also played a pivotal role in more "informal" history making in and about the community. For example, several have written self-published or small-press memoirs.[21]

As we have worked to integrate these intimate narratives with communal, institutional, and political ones, we have been conscious of the fact that our profile as academic researchers has given us a platform that community-driven efforts have not always had. Trust building relies on the processes of research and dissemination being mutually reinforcing and enriching. As Edward E. Curtis IV notes in his chapter on Arab Indianapolis, researchers like us must deliver a project already in progress, not just an idea, to the community. This gives them the opportunity to decide whether their involvement in the project is worth their time and effort. Learning about our work in progress at different stages has encouraged more community members to come forward and share photographs, documents, objects, and memories. For example, features on WBUR—one of Boston's public radio stations—and in the *Boston Globe* reached people with connections to Little Syria who were not active in Arab cultural networks and/or did not grow up speaking the language.[22] Because each stage of sharing has produced new leads and enabled us to forge relationships we are eager to nourish, we have abandoned the notion of working in a linear fashion toward a "completed" project.

Building trust also takes time, especially given our position as relative outsiders to the community. We cannot gather material from our interlocutors, write about it, and disappear. As Rebecca K. Shrum, reflecting on Michael Frisch's landmark work, *A Shared Authority: Essays on the Craft and Meaning of Oral and Public History* (1990), writes in the conclusion to this volume, "Shared authority should always be the recognition of the multiple places in a community where authority exists, not the doling out of authority in a hierarchical system that privileges trained historians." We have thus sought to approach the project as connectors of people and of fragments rather than solely as disseminators of knowledge. For example, a blog post by fellow contributor Richard M. Breaux inspired us to contact the family of an oud virtuoso and Arabic music producer named Anton "Tony" Abdelahad (1915–1995) through the website his grandson, Anthony Abdelahad, had set up in his memory.[23] The site allowed us to listen for the first time to songs performed for Boston's Syrian community. The Abdelahad family then accompanied us on one of our Little Syria walking tours, as several other families have now done, and identified specific locations related to Tony Abdelahad, the music scene, and their own memories. (Tony's son, Arthur Abdelahad, even identified the Sahara Restaurant on Shawmut Avenue as the site of his bachelor party.)[24] We realized we had heard the Abdelahad name before: Ramza,

Tony Abdelahad's mother, had been interviewed by Naff in 1962. Her descendants said they were previously unaware of the recorded interview's existence. Those who had known her before her death in 1975 had not heard her voice in decades—and the younger generations not at all—so the family gathered to listen to the digital copy from the Arab American National Museum.[25] Drawing personal links of this sort is as important a part of the Boston Little Syria Project as publications, tours, and exhibitions.

The outbreak of COVID-19 soon after our visit to the Syrian Grocery on Shawmut Avenue—as we were completing our doctoral dissertations—had delayed the public start of the project by nearly two years. Those two years saw us walking along old routes and new ones, uncovering unexpected layers of places we thought we knew. Connections surfaced between our research in the former Arab provinces of the Ottoman Empire and the city we called home. This walking practice, slow and attentive, became the cornerstone of the Boston Little Syria Project when it launched in 2022.

The Walking Tour

The walking tour, a particularly ephemeral medium, is well matched to what we hope to convey: what it looks and feels like when a community that was once present in a place nearly disappears from it. As Matthew Jaber Stiffler's and Breaux's contributions to this volume also demonstrate, the walking tour is at once a vehicle for gathering information (from residents, business owners, and community participants) and a vehicle for sharing it. We started offering our tour in May 2022 and led a dozen of them in the two years that followed. While group size has varied, no more than twenty-five can comfortably navigate the narrow streets of Chinatown at one time. In all, over 250 people participated in Boston Little Syria walking tours between May 2022 and November 2024.

Participants include former Syrian residents, their descendants, current non-Arab residents, Americans of Arab descent without ties to this specific community, general enthusiasts of Boston history, scholars of the Middle East, and high school and university student groups. This range reflects the ways we have publicized the tour. While we first promoted it within our existing academic networks, we soon built an extensive email list thanks to word of mouth, newspaper coverage, and visits to our website (http://www.bostonlittlesyria.org). Several tours have been sponsored by Boston-area cultural and educational organizations. Thus, participants join the tour for different reasons, which we invite them to share at the tour's outset. Many note family ties to the neighborhood. For those who have personal memories of it, the tour provides a platform for sharing them with others, often prompted by a glimpse of a specific building or plot of land to which those memories are tied. Some par-

ticipants join, they say, out of curiosity about what they *had not* known about their city. Others—more recent Syrian and Lebanese immigrants—express surprise at the existence of a longer Arab presence than they realized.

Frequently, participants of various backgrounds initially convey interest in Muslim American history. When we explain that residents of Boston's Little Syria were almost entirely Christian, a discussion ensues about why the category of *Syrian* was once understood to mean Christian, the mechanisms by which Muslim Arabs were excluded from immigration and naturalization, the foundation of the earliest Muslim community in Massachusetts (in Quincy), and the mid-twentieth-century changes to the U.S. immigration regime that made it possible for a more diverse spectrum of immigrants from the Arab world to settle in this country. It was not an accident, we make clear, that so few Muslims were part of the early Syrian community: while Christian Syrians managed to litigate their right to naturalization in several federal court cases—arguing, ultimately successfully, to be considered white—this did not apply to Muslims from the same places.[26] As an illustration of strategies of exclusion as they were applied in Boston, we share an example of deportation proceedings of a group of five Muslim men barred as suspected believers in polygamy.

Tours were initially free and have largely remained so for individual participants. Organizational sponsors have occasionally asked participants to pay a small fee (usually $10) and compensated us in turn. In other cases, local universities and museums have paid us an honorarium of $200–$500 as part of member programming or course curricula. At times, a student intern paid by a local university assists us during the tour. Interest in tours exceeds the capacity of our small team; meeting demand would require substantial external funding as well as more volunteers or paid staff.

Tours start at the Chinatown Gate, which was given to the city by Taiwan in 1982 and sits on a site occupied long ago by the boardinghouse and restaurant of a Syrian named Khalil Nassar. As in other Chinatowns across the world, the gate functions as a landmark for giving directions, a symbol of the neighborhood, and a literal door by which one enters the district. It allows us to draw a striking contrast between the neighborhood of the late nineteenth century and that of today. Once water and marshland, the area was reclaimed and made habitable by the South Cove Corporation between 1833 and 1839. It was also a center of transit in Boston: the first rail terminus was built here in the 1830s, and by 1867, the Boston and Albany Railroad had both passenger and freight depots nearby.[27]

The tour then covers approximately one mile, though its exact route has shifted over time to reflect new research. As of November 2024, it included ten separate stops and the following sixteen sites:

1. Early Syrian family's tenement and Al-Wataniyya Hotel and Restaurant—6 Hudson Street
2. Property of Moses Khalil Shibley—12 Hudson Street
3. Syrian American Club—35 Hudson Street
4. Garment District—between Washington, Essex, Kingston, and Kneeland Streets
5. Arax Grocery—30 Kneeland Street
6. *Fatat Boston* Newspaper—40 Tyler Street
7. Our Lady of the Cedars of Mt. Lebanon Church—78 Tyler Street
8. Quincy Grammar School—90 Tyler Street
9. Denison House—93 Tyler Street
10. Lebanese Syrian Ladies' Aid Society (LSLAS) Headquarters—101 Tyler Street
11. John S. Lufty Square—99 Tyler Street
12. Harrison Avenue over Interstate I-90
13. Peters Park and Sadie Peters Plaque—42 Bradford Street
14. The Syrian Grocery Importing Co.—270 Shawmut Avenue
15. Deeb Corner—275 Shawmut Avenue
16. Sahara Syrian Restaurant—296 Shawmut Avenue

In this discussion, we focus on several sites that illustrate how the walking tour allows participants to visualize the past presence of a community in its present absence and fosters opportunities for interaction. We set the scene by pointing out addresses where Syrians established themselves in Boston, renting apartments and sometimes later purchasing tenement buildings to lease out or operate shops. Many of the earliest arrivals gravitated toward boardinghouses north of Beach Street, on Oliver Place and Oxford Street. But the street most associated with the early Syrian community was Hudson Street, and this is where we turn next. At 6 Hudson Street, beside Mary Soo Hoo Park, an empty lot recently excavated by the City of Boston Archaeology Program was once home to a rotating assortment of Syrian families and to Al-Wataniyya Hotel and Restaurant, operated by Hanna Nikola (or John Nichols, as he was known in English). Tour participants who can read Arabic are delighted by a newspaper advertisement we pass around that boasts of the inn being among the first in Boston to serve Middle Eastern food and Turkish coffee. We pass 12 Hudson Street, one of several properties in the area once owned by Shibley's grandfather, Moses Khalil Shibley. Census records show that Syrians with surnames like Hadge, Haddad, Abdallah, and Homsy lived on both sides of the narrow street alongside those with names like Wah and Wong. At the corner of Hudson and Kneeland, we point out one former location of the Syrian American Club (founded

in 1913), where Syrian men raised funds and debated the politics of Boston and Syria at a moment of intense uncertainty about the future of their homeland.

Next we stop on Kneeland Street in the Garment District—once located between Washington, Essex, Kingston, and Kneeland—to discuss economic and professional life. We ask participants if they know how Syrians supported themselves upon arriving in Boston. Some suggest peddling, a popular trade among Syrian men and women in the nineteenth and early twentieth centuries and one that provided immigrants with a relatively easy way to make money even if they knew little English. Peddling was also a stereotype of Syrians, however. We take care to mention other professions of Syrians in Boston: factory workers, mechanics, carpenters, priests, lawyers, doctors, newspaper publishers, writers, teachers, politicians, and musicians. Women, in particular, were active in lacemaking (which many had learned in Syria), textile weaving, and piecework in factories.

The Garment District, where laborers made ready-to-wear clothes and leather shoes in tall brick loft factories, was formed in the mid-nineteenth century and employed Jewish, Italian, Hungarian, Egyptian, Greek, Armenian, and Chinese workers along with Syrians. The district was booming by the 1920s. In the 1950s, however, the development of the John F. Fitzgerald Expressway (Central Artery) threatened to (and eventually did) raze parts of Chinatown. Garment industry employees and South Cove residents opposed the destruction of the district with some success, but it eventually lost its prominence due to foreign competition and the movement of second- and third-generation immigrant workers into suburban white-collar jobs.[28] The Immigration and Nationality Act of 1965 generated an influx of Chinese women textile workers, but by the 1980s, Tufts University was buying up many of the district's loft buildings for its medical school.

We pause here to discuss how Syrians were perceived in Boston. Participants with Syrian forebears share both positive and negative recollections, and we offer a few primary sources that illustrate the range of ideas that once circulated among non-Syrians about the community. Many played up stereotypes, like sociologist William Cole's "Immigrant Races in Massachusetts: The Syrians" (1921), written for the Massachusetts Department of Education. He describes Syrian immigrants as "born traders," alluding to their occupations as peddlers and dry-goods sellers. "Allowing for their oriental cunning . . . they are thoroughly honest," he writes, at once praising and insulting them. He continues, "[A] high degree of native intelligence, an individualism which retards co-operative effort and often passes into factionalism, shrewdness and cleverness in business . . . self-respect and self-reliance." He adds that Syrians loved to talk about "the glory of ancient Syria," yet the "Syrian . . . is first and last and always an American in spirit and action. He has no other country which claims the slightest part of his

allegiance."[29] As we discuss later on the tour, Cole's idea that Syrians were admirable so long as they remained patriotic was typical of its time.

After passing the site of Armenian Syrian Michael Ajemian's Arax Grocery, which once imported record albums of famous Egyptian singers, we gather in a parking lot on Tyler Street where the silhouettes of two demolished brick row houses are visible against the side of an art deco office building. Part of the parking lot is slated to become the permanent home of the Chinatown branch of the Boston Public Library, after decades without an adequate library in the neighborhood. Here, several layers of the neighborhood's history are exposed at once. Before the Hudson Building was erected in 1928, a smaller building at the former 40 Tyler Street housed the office of the Arabic-language newspaper *Fatat Boston*. Launched in 1914 under the editorial leadership of Wadie Shakir, it was printed two to three times a week and appears to have ended its run within a few years of World War I.[30] The paper aspired to circulate well beyond Boston, advertising subscriptions in Cuba and Mexico. This was indicative of the connectedness of the Syrian diaspora in the Americas more broadly. Throughout World War I, *Fatat Boston* published devastating news from the Syrian front as violence, famine, and plague sent another major wave of emigrants to the Americas. We show here, with a copy of the newspaper to pass around, that *Fatat Boston* covered the disaster in Syria while encouraging readers to buy U.S. government war bonds. This illustrates how Syrians were socially and politically engaged with life both in Boston and back in Syria and lays the foundation for a later discussion of how this civicism was cheered by some non-Syrians—such as Cole—who gave it as evidence that Syrians could be categorized as "white" and therefore assimilated as citizens.[31]

Next, we visit the Josiah Quincy Grammar School (90 Tyler Street), which was important to Bostonians of many ethnic backgrounds and in the history of U.S. educational reform. The school was designed in 1848 by Boston architect Gridley J. F. Bryant, known for foundational buildings at Tufts College and Harvard University, in the Greek Revival style that sought to emulate the democratic ideals its advocates associated with the American Revolution. Quincy pioneered the "single-headed" system we still use today, in which students are divided into grades and taught by different teachers in separate classrooms. Syrian, Chinese, and many other students—including the poet Gibran Khalil Gibran (also written as Kahlil Gibran)—learned English and civics. They even taught each other; as one former pupil remarked, "we learned to swear in ten different languages!"[32] The school also hosted evening classes for adults.[33] It closed in 1976, and in 1983, the building was bought by the Chinese Consolidated Benevolent Association of New England, which added a large statue of Confucius and continues to operate today. The building is listed in the National Register of Historic Places and

is marked with a plaque, though it does not currently reference the Syrian community.

We expand on the themes of civicism, assimilation, education, and social organizations as the tour continues. Nearly all inhabitants of Boston's Little Syria belonged to Orthodox, Maronite, or Melkite churches. Next door to Quincy School at 78 Tyler Street is the original location of Our Lady of the Cedars of Mount Lebanon Church, dedicated by Father Joseph Yazbek in 1899.[34] One of four churches formerly located within a few blocks of each other, this Maronite church was prominent enough by 1902 for its Easter Bazaar to be opened by Boston's mayor. In 1904, Our Lady was given a piece of what was allegedly the True Cross, and in 1931, it held a memorial service for Khalil Gibran. When the congregation grew too large, the church moved to another building on Shawmut Avenue and eventually to its current home in Jamaica Plain in 1969. Like Quincy School, the church building passed to the Chinese community when it was dedicated as a Chinese Christian mission in 1946. This, too, is commemorated with a plaque, yet like the school's, it makes no mention of the building's Arab past. Just next door, however, at 76 Tyler, CCLT's Immigrant History Trail is erecting a marker on an unassuming brick building where Gibran's sister Marianna once lived and which is still owned by a Syrian Lebanese family today.[35]

Across the street at 93 Tyler Street was Denison House, founded in 1892. Like they did at other settlement houses—such as Hull House in Chicago and Downtown Community House in Manhattan—white middle-class women offered classes and assistance obtaining food, housing, and work to newly arrived immigrants. While living in Boston, the famed pilot Amelia Earhart helped found a Syrian Mother's Club at Denison House.[36] Another local celebrity, Gibran, again appears on our tour, having taken art classes here as a child. Denison's workers perceived the settlement house as more than a charity: it was an engine of upward mobility. Though they resisted the ugly wave of nativism that plagued early twentieth-century America, settlement staff advanced an assimilationist vision characterized by the National Trust for Historic Preservation as "prioritizing their own approaches to child-rearing, hygiene, and education," sometimes "denigrat[ing] the traditions or overlook[ing] the priorities of the communities they hoped to serve."[37] Nevertheless, our community interlocutors often cite Denison House as an anchor of social life for Syrian families.

Denison House moved in the 1940s and merged with other local social service providers; today, the Asian American Civic Association, which similarly serves new arrivals and lower-income second-generation families, is one of several organizations occupying Denison's former site. Nearby was once the headquarters of LSLAS. This group was established in 1917 by Lebanese and Syrian American women to send food and supplies to communi-

ties in Syria that had been devastated by war and famine. It continued aiding families in need closer to home after the war, following those it served first to the South End and then to West Roxbury. It is still active today.[38]

Our last stop before we cross the highway that divides the former Little Syria in two is John S. Lufty Square at the end of Tyler Street. This memorial sign is one of over 1,200 in Boston—and several on our route—that commemorate city residents who were killed in action as service members. We ask participants if they notice anything peculiar about the surname, and usually someone suggests that *Lutfy* sounds "more Arab." Two letters were swapped, perhaps to make the name easier for the Anglophone tongue—a common complication for researchers tracing family histories.[39] A child of Syrian immigrants who enlisted in the army at sixteen, Lufty died tragically in France on October 30, 1918, just days before the armistice. The marker was dedicated in his honor in 1921, when a parade of three thousand people—mostly Syrians—gathered to commemorate the sacrifices of local soldiers.[40] Syrians were naturally concerned with the war ravaging their homeland, which drove them to enlist and fundraise. This display of self-sacrifice reinforced the view of certain non-Syrians that this predominantly Christian community could assimilate with American society—a point that was often made in disparaging contrast with, for example, the largely non-Christian Chinese and that echoes the early twentieth-century claims of Cole that patriotism made Syrian immigrants worthy of admiration.

Now we reach a crucial part of the tour—a long walk full of traffic noise, sirens, and wind across Harrison Avenue over the Massachusetts Turnpike (I-90). The shift from narrow streets filled with older Chinese men playing cards, boba tea shops, and children coming and going from school is stark as we stare down at the highway below. This experience helps participants see how deeply the Turnpike extension project of the 1960s cut into the fabric of the Syrian and Chinese communities, as many residents were forced to move to other parts of Boston and its suburbs.[41] After ten minutes of walking, we arrive in a lush and busy park that features tennis and basketball courts, a dog park, and a playground. There we find a stone memorial plaque dedicated to George and Sadie Peters in 1976. Peters Park is named for Sadie Peters and her husband, George, a shoemaker, who came to Boston in 1908 from the village of Kafr-Hilda in Mount Lebanon and adopted the English version of their Arabic surname, Boutros. Tour participants are always surprised to learn that the park's namesake was Arab, assuming Peters to have been Anglo-Saxon.

In 1957, the City of Boston established the Boston Redevelopment Authority (BRA) to carry out urban renewal in neighborhoods it deemed "blighted," among them the South Cove/Chinatown and the South End. The BRA took possession of what is now Peters Park in 1966. This came alongside the

Central Artery cutting off access to the waterfront and the Pike cutting a wide gash through the center of the neighborhood. Some residents found eviction notices on their doors and were offered paltry sums for homes razed for the project.

Many Syrian and Lebanese residents, including Sadie and George Peters, campaigned against the BRA. Urban renewal came at a time when the national civil rights struggle was at its peak. "Inspired by [the movement's] victories," notes historian Seth Bruggeman, "Bostonians increasingly applied direct action" across the city.[42] As the adjacent neighborhood of New York Streets was demolished and perceptions of the municipality's vision worsened, coordination between different ethnic groups was especially important. "Coalition politics in the South End held the BRA at bay for well over a decade," Bruggeman argues—but it could not stave off a major wave of gentrification.[43] One Syrian resident, the boardinghouse owner Nabeeha Hajjar, explained in an oral history how she had at first agreed to serve as a community representative to the BRA. Before long, however, she began to doubt its claim that the authority was improving people's lives: none of the projects seemed to come to fruition or serve the community.[44] Sadie Peters did stay in her home at 42 Bradford Street, which today looks out over the park and its unassuming stone marker. But urban renewal and highway construction were significant factors in the exodus of the Syrian community to the suburbs between the 1950s and the 1970s. West Roxbury, Dedham, and Norwood were major destinations, though Syrians also went farther afield. These building projects, the resistance they encountered, and their impact on suburban migration closely resemble patterns in other American cities. In New York, for example, the construction of the Battery Tunnel pushed most of the area's Syrian community out of Manhattan into Brooklyn.

After about an hour and a half of walking, our group is tiring and starting to feel pangs of hunger. What better way to end the tour than with two food-related sites, a figurative appetizer for a post-tour dinner? We stop at the Syrian Grocery Importing Co. at 270 Shawmut Avenue, whose owner we spoke with in February 2020. Since then, the store has been closed each time we have passed by. If it does not reopen, no more businesses of Little Syria will be left, although some that moved out decades ago, such as Kfoury Keefe Funeral Home, now operate in the suburbs. Import stores have long been essential to U.S. cities; like their counterparts in Chinatowns and Little Saigons, they draw community members, outsiders, and tourists, supporting the social and economic life of the neighborhood. The closure of spaces like them exacerbates the risk of the neighborhood's disappearance from living memory as members of the Syrian community who once lived there age and pass on.

Our final stop, 296 Shawmut Avenue, is the sturdy brick building with the colorful sign advertising the long-closed Sahara Syrian Restaurant we introduced earlier. Originally a German Lutheran church established in 1847, the building changed hands many times and was owned for a period by Armenians. The Sahara opened in 1965 and sought to attract a wide variety of tastes by offering both Syrian and "American" food: its newspaper advertisements mention dishes like "shishkebab, kibbi, [and] also steak and chops all fit for a sultan!"[45] Tour participants are bemused by the name *Sahara* ("But the Sahara isn't in Syria," they say), and we explain that the name, like advertisements featuring the Pyramids of Giza, are typical of a time when Arab-run businesses appealed to the broader public by harnessing vague, popular clichés of the Middle East. (Another Syrian-owned restaurant in Boston was The Nile, and the beloved dancer Laurice Rizk Teebagy went by the stage name Morocco.)[46] By 1972, the Sahara had closed, and the building was sold to the Mansour family, owners of the nearby Syrian Grocery. It is unclear what will happen to the building, located as it is amid upscale restaurants and expensive condominiums in what is now an important center of the Boston LGBTQ+ community.[47] Some residents consider the Sahara an eyesore and want the property to be developed; others consider its dazzling sign a reminder of the South End's past.

We end our tour by soliciting questions and recollections, inviting anyone interested to share a meal at a nearby Middle Eastern restaurant. Many do. No matter the background of the participant, everyone has brought something unique to share and has learned something new about Little Syria, Chinatown, and the South End. We have met collaborators for our project on the tour, and other participants have made new friends. The unexpected encounters these tours foster have continued to improve the project, leading us to revise its contents and changing our relationship to the historiography of both the Syrian diaspora and Boston.

From Ephemeral to Material: Little Syria on Display

Our first exhibition, titled *Ottoman Boston: Little Syria*, was held at Rotch Library in Massachusetts Institute of Technology's (MIT) School of Architecture and Planning from December 2022 to April 2023. By curating a series of pop-up exhibitions, we were able to share the material evidence of lives lived there in a manner that was impossible while walking. Catering to architecture students, we highlighted the architects and styles of the Quincy School, Denison House, and Sahara Restaurant. Members of the local Syrian community visited as well. Some community members expressed skepticism

or unease at the title, recalling family stories of Ottoman oppression. We clarified that we used this title to connect Syrians to other groups of people who had migrated from the Ottoman Empire to New England (e.g., Armenians and Greeks), yet we ultimately changed the title of the next version of the exhibition to *Wandering Boston's Little Syria* in recognition of the community's concerns, to accurately reflect the objects on display, and to draw attention to the experience of recreating the neighborhood on foot. We displayed the collection at the Massachusetts Historical Society (MHS) during Arab American Heritage Month in April 2023, in tandem with a hybrid event we hosted with a three-person panel of community members. All were men, and we committed to seeking out more women contributors for future programming. With nearly one hundred in-person and two hundred virtual attendees, the MHS event had the highest attendance of any held there since the COVID-19 pandemic started. The event also brought a new topic to MHS, whose collections lean toward the American Revolution and the antislavery struggle.

The exhibition, now titled *Boston's Little Syria*, was next on display from January to May 2024 at the Grossmann Gallery at University of Massachusetts Boston's Joseph P. Healey Library. The venue made the exhibition—our largest to date—more accessible to students from working-class, immigrant, and first-generation backgrounds, many of whom commute from outside of the city. In April 2024, we hosted a reception and curator tour of the exhibition, which drew around seventy-five people. This initiated a partnership with the Healey Library that culminated in a community digitization day in April 2025, based on the Mass Memories Road Show model that the Library's Special Collections has implemented across the state.[48]

The community's desire for an opportunity to preserve and catalog family archives according to professional standards was demonstrated by the fact that several attendees brought photographs to the April 2024 event. One person even brought objects to donate—a brass mortar and pestle from Syria and handmade lace. These complemented the array of objects we displayed in the first three exhibitions, including fire insurance maps, Father George Maloof's talismanic scroll from St. George Church, photographs of Denison House and Quincy School, community members' autobiographies and family photographs, a large banner from a Syrian American Auxiliary, a matchbook and restaurant advertisements, a church cookbook, newspaper pages, record albums, and musician Anton Abdelahad's oud—objects either donated or on loan from community members, shown as copies, or purchased by us. Yet the lack of an adequate storage facility for items community members hope to donate underscores the need for sustained funding and institutional partnership.

A highlight of the event at the Healey Library was the introduction of Shibley, whose father published the *Mid-Town Journal* (included in the exhibition), to Bobby Gamel, who delivered it as a boy living on Shawmut Avenue. Gamel left the event with several original copies of the newspaper, which he had not seen in decades, under his arm. Thus, the reception functioned as a site of gathering and recollection for the Syrian and Lebanese community, an opportunity to meet individuals with material to contribute, and a demonstration that the project merits further support to meet community members' desire to share their stories.

Digital Little Syria: Mapping the Neighborhood Online

The Boston Little Syria Project was not initially meant to be digital. On the contrary, we saw moving through the physical space of the former neighborhood as essential to reasserting its presence. Yet introducing a digital component to the project offered the possibility of documenting more sites while ameliorating some of the walking tour's limitations. Still, we viewed the digital as a complement, rather than a replacement, to the walking tours and prioritized the preservation of the sense of place that walking affords. The construction of the Boston Little Syria digital map was supported by a Small Grants Fund for Early Career Digital Publications at Boston Public Library's Leventhal Map and Education Center.

Participants on our early walking tours and visitors to our exhibitions at MIT and MHS often asked: What's next? Where will the stories here go when you stop giving tours or when the objects on display are returned to their owners? Publications were only a partial answer. In addition to the pieces published about the Boston Little Syria Project in the *Boston Globe* and other outlets, we had written our own article in English and in Arabic for the online Syrian magazine *al-Jumhuriya* in November 2022.[49] These offered an overview—how the neighborhood had come into being, what life was like for its inhabitants, and how it nearly disappeared—and included selected anecdotes. But much of what former residents and their descendants shared with us were places: a grandfather's shop, an aunt's house, and even a parking lot where a storied female taxi driver, possibly the first of her kind in Boston, learned her way around a car.[50] Such rootedness in the physical space of the neighborhood undergirded our decision to dedicate resources to building a digital map.[51]

By the time we began developing the map, we had compiled a list of far more sites than could be included in a two-hour walking tour without impos-

ing unreasonable standards of endurance on participants. We would not have to choose whose family business would stand in for the history of neighborhood commerce because we could include many of them. Another appeal of the digital map was reaching audiences who were physically unable to attend a walking tour or exhibition. We were keenly aware of the restrictive immigration laws limiting the mobility of many in the Arab diaspora, and the response to our bilingual article for *al-Jumhuriya*, whose readership is concentrated in the post-2011 Syrian diaspora, had demonstrated the existence of an interested audience among Syrians far from Boston. Designing a more accessible way to engage individuals with certain physical disabilities was also important, especially given the advanced age of the last generation of Syrians to have lived in the South End in sizable numbers.

As we reflected on the question the tour participants and exhibition visitors had asked us—where will this all go?—a digital map emerged as an answer, if not a permanent one. We were well aware that many digital projects before ours had struggled to secure a permanent status. As digital humanists at King's College London have written, "A generation of [digital] legacy projects that need maintenance but are out of funding have reached critical stages of their life cycles, an increasingly hostile security context has made Digital Humanities projects potential attack vectors into institutional networks, heterogeneous and often delicate technologies have complicated the task of maintenance, and an increasing number of emerging formats have made archiving and preservation yet more difficult."[52] The result is, unfortunately, a "digital wasteland" of excellent ideas.[53] This applies even to projects much larger than our own, with funding and an institutional setting that ensures some degree of support and continuity. We embarked on the digital component of the Boston Little Syria Project with a grant of $1,200 and no guaranteed institutional home, which made sustainability an even greater concern. We came to view the map as a way station between ephemeral walking tours and a more secure future, a form that would allow us to continue engaging with the community along the way. At the same time, we committed to continuing walking tours, exhibitions, and events to ensure the collective knowledge of the project would not be bound up solely in a digital format that was at risk of becoming defunct.

New questions emerged. Should the sites on the map be accompanied by narrative? Should images, videos, and recordings be included? What was the right balance between incorporating as much supplementary material as possible, in the interest of a more textured story, and the maintenance it would entail? Above all, it was essential that the map convey change over time. Most of the places that once constituted the Syrian community in the South Cove and South End are no longer there, and their disappearance corresponds with mid-century upheavals in the urban landscape along with a generational shift into the suburban middle class. However, accurately capturing phases

of change over more than a century would prove to be among the most difficult challenges of the project.

Partway through the planning process, we were introduced to the Washington Street Historical Society's (WSHS) Touring App, an elegantly designed interactive map documenting significant sites in New York City's former Little Syria.[54] Accessible to both desktop and mobile users, the WSHS application wove its featured sites into rich thematic narratives. We especially admired the bilingualism (English/Arabic) of the map and the forum it provided for the submission of stories or places from people connected with the community. Yet we were working with a fraction of the WSHS's budget and timeline and thus had to jettison more sophisticated features we would have otherwise prioritized.

We constructed an initial dataset of sixty sites stretching from just north of where the Chinatown Gate now stands to the Sahara Restaurant on Shawmut Avenue, drawing primarily on the sources we had consulted for our tours and exhibitions. These sources included, among others, the LSLAS records; the Boston City Archives; Arabic newspapers, including *Fatat Boston* and *al-Wafa*; Naff's 1962 oral history recordings; Census records; historical property records from the Massachusetts Historical Commission's Cultural Resource Information System; and interviews with residents and their descendants. We also combed through digitized Boston city directories to document Arab-owned businesses.

Next we turned to the Leventhal Center's Atlascope tool (https://www.atlascope.org/), which allows users to toggle between the present-day street map and dozens of urban atlases of Boston and surrounding towns that date from the 1860s through the 1930s. The historical atlases have been georeferenced, making it possible to search a contemporary address and view cartographic representations of the same location in the past. These were produced for the fire insurance and real estate industries as risk assessment tools and typically include property owners' names.[55] Thus, we could chart which buildings in the neighborhood were Syrian-owned (though not necessarily which ones were Syrian-inhabited) and how ownership increased over time.

Our grant included periodic technical consultations and support over more than a year. Instead of hiring an external developer to write the map's code, we worked alongside the Leventhal Center's Ian Spangler to design the map and build its technical features. This ensured that we, as the project leaders, would not be left with something whose workings we did not understand or that we would be unable to maintain. Our involvement in the technical aspects of the map's creation also showed us the benefits of relying on existing tools and templates instead of creating each element from scratch.

Having already used Atlascope's georeferenced fire insurance atlases in our research, we made them the base layers onto which our dataset was

mapped. The Boston Little Syria map primarily uses G. W. Bromley's *Atlas of the City of Boston* (1895, 1912, 1922, and 1938). We also sought to replicate the Atlascope experience of toggling between the present urban landscape and different past ones. While our map captured the period during which Syrians departed from the neighborhood en masse, later Bromley atlases were not yet in the public domain. As a result, we chose to represent this phase by stitching together a pair of maps (1960/1962) produced by the Boston Redevelopment Authority. The BRA maps classified buildings along a spectrum from "standard" to "major blight," an assessment that laid the groundwork for demolition and redevelopment. We chose these intervals because they demonstrated the major stages of neighborhood transformation from the first manifestations of the Syrian presence at the end of the nineteenth century, to its rapid growth in the 1910s and 1920s, and finally to its shrinkage in the 1950s and 1960s.

We uploaded our dataset of sixty sites into QGIS, a free, widely used, and open source geographic information system (GIS) platform. For each point, the dataset included the name; address; site type (residence, church, civic organization, store, publication, sign/memorial, or food and entertainment); date range; narrative description; and image, if available. In QGIS, we were able to geocode the addresses using the free geographic database OpenStreetMap. From there, we created the map in Glitch, a platform for building web apps that streamlines the way developers interact with code; it was simple enough for us to navigate without a programming background. We adapted ("remixed," in Glitch terminology) a template previously developed by the Leventhal Center for producing web maps using the JavaScript library Leaflet.[56] We then imported the relevant Bromley map "tiles" from Atlascope and the Leventhal Center/Boston Public Library's digital collections. Because these tiles had previously been georeferenced—meaning the original paper maps from which they came were assigned geospatial coordinates—the addresses we had plotted as points in QGIS now appeared on each historical map layer in the proper location. Finally, we stored images and other supplementary media displayed on the map in a GitHub repository to ensure continued open access.

We hope one day to make the map accessible to mobile users as a guide for visiting the neighborhood independently. This could be paired with the podcast we produced for *Harvard Islamica* and the *Ottoman History Podcast* or with clips from oral history interviews we have conducted to make users' encounter with the map more immersive. Ideally, the map would mimic the experience of the walking tour by suggesting specific routes. For now, the points can be sorted by type and date, but they do not appear in any sequence. Especially important is the integration of a mechanism for community members to submit additions to the map. However, this requires someone to moderate, respond to, and implement changes on an ongoing basis.

Moving forward, we want to prioritize collaboration with other community groups invested in the past and present of the urban space. Walking tour participants are especially interested in the nature of relations between Syrian and Chinese residents of the South Cove. Although only the latter are visibly present there today, the two populations lived, studied, and worked side by side beginning as early as the 1880s; each has contributed recollections about the other to our research. We gave the first Chinatown/Syriantown joint walking tour with Lydia Lowe of CCLT in November 2024 and plan to replicate and expand this partnership.

These aspirations, some yet unmet, underscore the challenge of keeping sight of ethical and historiographical commitments while navigating technical limitations and finite resources. The technical and conceptual are often bound up together, of course; one persistent difficulty has been identifying specific dates when points featured on our map appeared and disappeared. Often, these cannot be found in any written sources. During a walking tour or a presentation, imprecision can easily be explained. But a dataset does not allow for best guesses. Placing a point on the map suggests a degree of certainty that may be impossible for us to achieve. What is more, the map is limited to displaying snapshots in time rather than a complete continuum from past to present. How, then, should it represent a restaurant that existed only briefly between two snapshots? Narrative contextualization of the data can only somewhat ameliorate the risk of misrepresentation.

Historian of cartography Bill Rankin describes two basic ways to radicalize mapmaking: "Place more emphasis on social landscapes, rather than the physical landscape alone" and "reimagine boundaries."[57] Both approaches push people to see their cities in new ways. The Boston Little Syria map may not employ cutting-edge digital techniques, but it does challenge users to see the city of Boston with fresh eyes. It is a map that encourages questions: How and why has the Arab history of central Boston become so nearly invisible? What other urban histories might still go unnoticed?

Conclusion

The history of Little Syria is not the only history of Arab Boston; it is only one piece of it. The overhaul of immigration regulations in the 1960s led to the increase and diversification of migration from West Asia and North Africa. Census data suggest that by 2020, there were at least 120,000 people of Arab origin living in the state of Massachusetts. While immigration from Lebanon and Syria has continued, spiking during the Lebanese Civil War (1975–1990) and the ongoing war in Syria (2011–), the largest number of Arab-identifying immigrants in the state after Lebanon come from Morocco and Iraq.[58] This Arabic-speaking population is predominantly Muslim, not Chris-

tian, and is concentrated in Boston metro area cities like Revere, Melrose, Lynn, and Lowell rather than in the South End. Important shifts aside, the history of Little Syria is part of the same story—just as it belongs to the history of urban renewal and the transformation of the downtown Boston cityscape.

Where will our project go next? In addition to hosting a participatory archiving event in April 2025, we are working with the Boston Public Library's Statewide Digitization team to preserve, link, and share family collections from the Syrian-Lebanese community with the public via the state's open-access Digital Commonwealth platform. We are also contributing to an Arab American National Museum exhibition on Arab Massachusetts that will travel around our state from 2025 to 2027 and will further situate the early Syrian history of Boston within a longer historical trajectory. Our foremost goal is to present Syrian Boston to the broader public in a way that challenges stereotypes and illuminates nuance—from heroic and hopeful moments to humble and painful ones. We remind participants on our tours and visitors to our exhibitions that Arabic-speaking immigrants have been in Boston since before the country's founding. Syrian teenager Nathan Badeen died fighting for the Eighteenth Continental Regiment on May 23, 1776, just weeks after his unit had helped push the British out of Boston in March of that year.[59] Conveying this history is particularly important in light of restricted immigration from West Asia, including Syria, and spikes in anti-Arab sentiment that have often corresponded with wars waged or funded by the United States. This book went to press amid Israel's complete destruction of Gaza, with more than 50,000 Palestinians killed since the start of the war in October 2023. Lebanon, where many of Boston's Syrian families came from, was being ravaged from the air. The destruction, abetted by U.S policy, underscores the urgency of work that roots Arab history in American history writ large.

We must also focus on the future. In September 2023, Little Amal—a twelve-foot-tall puppet representing a nine-year-old Syrian refugee girl who is looking for her mother—visited Boston as part of a North American tour highlighting immigration and refugee issues.[60] This provided an opportunity to connect the city's past and present. In front of the Chinatown Gate, Little Amal swayed alongside Chinatown lion dancers to the beat of a live Syrian band. Performers behind Amal unrolled a nine-foot by twelve-foot photograph printed on fabric of Syrians making lace and smoking hookah on their front steps on nearby Hudson Street in 1909. The inclusion of this enlarged photograph of Syrians in Boston from more than a century ago in our exhibition shows how Syrians have been a vital part of this city since well before the 2011 Syrian Revolution and ensuing war compelled Syrians to leave their country. Her name, *Amal*, "hope" in Arabic, is a nod to the future that

Syrian Americans and new Syrian immigrants to Boston should be able to imagine for themselves.

NOTES

1. "South End Home Values (Condo/Coop)," Zillow, accessed June 4, 2025, https://www.zillow.com/home-values/275429/south-end-boston-ma/.

2. Sarah M. A. Gualtieri, *Between Arab and White: Race and Ethnicity in the Early Syrian American Diaspora* (Berkeley: University of California, 2009), 66.

3. "Syrian American Club to Note Anniversary," *Boston Globe*, April 8, 1937, 6.

4. In the South Cove, the Syrian population was concentrated in the area bounded by Essex, Washington, and Albany Streets and Highway Interstate I-90. The two streets most closely associated with it were Hudson and Tyler Streets. In the South End, Syrians were concentrated between I-90 and Tremont, Albany, and Massachusetts Avenue—especially on Shawmut Avenue.

5. While the Arabic-speaking immigrants to Boston came from places that today are located in both Syria and Lebanon, most arrived before the establishment of these separate nation-states. Members of the community were all known as Syrians, as they were throughout the United States. After Lebanon gained independence in 1943, families who had come from what was now a separate country increasingly identified as Lebanese instead of Syrian.

6. The West End Museum, accessed June 4, 2025, https://thewestendmuseum.org; Boston Immigrant History Trail, accessed June 4, 2025, https://www.immigranthistorytrail.com; Armenian Museum of America, accessed June 4, 2025, https://www.armenianmuseum.org; Global Boston: A Portal to the Region's Immigrant Past and Present, accessed June 4, 2025, https://globalboston.bc.edu/.

7. Omar Duwaji, "The Lost Syrian Neighborhood in Boston (Part I)," *AJ+*, YouTube, 6 min., 33 sec., March 9, 2017, https://www.youtube.com/watch?v=EdAoG55bwuk&t=0s&ab_channel=AJ%2B; "My Immigrant Parents Starting Over: From Damascus to Boston (Part II)," *AJ+*, YouTube, 5 min., 50 sec., March 10, 2017, https://www.youtube.com/watch?v=5NsiqUtzWec&t=0s&ab_channel=AJ%2B; "Starting a New Life in America: A Syrian Refugee Story (Part III)," *AJ+*, YouTube, 6 min., 42 sec., March 11, 2017, https://www.youtube.com/watch?v=AWfykGrJkPQ&t=5s&ab_channel=AJ%2B.

8. We are also contributors to "Ottoman Diasporas in New England," a collaborative research program based at Brandeis University and funded by the New England Humanities Consortium.

9. Scholarly works useful for establishing basic details of Boston's Syrian community and contextualizing it in the New England diaspora include Linda K. Jacobs, "Massachusetts," in *Strangers No More: Syrians in the United States, 1880–1900* (New York: Kalimah, 2019); Elizabeth Boosahda, *Arab-American Faces and Voices: The Origins of an Immigrant Community* (Austin: University of Texas Press, 2003); and Stacy D. Fahrenthold, *Between the Ottomans and the Entente: The First World War in the Syrian and Lebanese Diaspora, 1908–1925* (New York: Oxford, 2021).

10. Adele Linda Younis, "The Coming of the Arabic-Speaking People to the United States" (Ph.D. diss., Boston University, 1961); republished by the Center for Migration Studies, ed. Philip Kayal (1995). Younis's papers are housed at the Center for Migration Studies of New York.

11. Evelyn Shakir, *Bint Arab: Arab and Arab American Women in the United States* (Westport, CT: Praeger, 1997). Shakir's papers are housed at the Arab American National Museum.

12. Elaine Hagopian, "The Institutional Development of the Arab-American Community of Boston: A Sketch," in *The Arab-Americans: Studies in Assimilation*, ed. Elaine Hagopian and Ann Paden (Wilmette, IL: Medina, 1969). Hagopian helped found the Association of Arab-American University Graduates in response to anti-Arab racism in U.S. media following the 1967 Arab-Israeli war. See Hagopian, "Reversing Injustice: On Utopian Activism," *Arab Studies Quarterly* 29, no. 3/4 (2007): 57. We conducted an oral history with Hagopian on November 22, 2024, archived with the Boston Center for Arabic Culture's Human Library.

13. The most prominent of these tropes is that of the pack peddler, which scholars have complicated in recent years. See Charlotte Karem Albrecht, "Narrating Arab American History: The Peddling Thesis," *Arab Studies Quarterly* 37, no. 1 (2015): 100–117. On Fred Shibley, see Alison Barnet, "Iben Snupin: Fred Shibley and the *Mid-Town Journal*," South End Historical Society Fall 2011 Newsletter (September 2011), https://036067b.netsolhost.com/wordpress1/wp-content/uploads/2012/08/Summer-2011-Newsletter.pdf; "Fred Shibley—Tumbler and Sandblaster—Started a Newspaper and Was Bankrupted by Catholic Churches and Urban Renewal," *The Harvard Crimson*, November 20, 1968, https://api.thecrimson.com/article/1968/11/20/fred-shibley-tumbler-and-sandblaster-started-a-newspaper/?page=1.

14. "History of St. George Church," St. George Orthodox Church of Boston, accessed June 4, 2025, https://www.stgeorgeofboston.org/about/history; "History of Our Parish," St. John of Damascus Church, accessed June 4, 2025, https://stjohnd.org/history/.

15. The "Calling to Remembrance" series, originally published in *The Messenger*, is now compiled on our website (https://bostonlittlesyria.org/want-to-learn-more/) with the permission of Father Timothy.

16. Elissa Menconi, "Evelyn Abdalah Menconi (1919–2003)," *MESA Bulletin* 40, no. 1 (2006): 141. The United South End Settlements (USES) recorded an oral history with Abdalah Menconi in 1995 (Evelyn Abdalah Menconi, Jeannette Hajjar, Laurie Malooly, interviewed by Guadalesa Rivera, USES), Boston, MA, video recording, Northeastern University Library, March 6, 1995, http://hdl.handle.net/2047/D20409834.

17. Noah Elias Habeeb, "The Arabic Hour: Understanding Arab-American Media Activism and Community-Based Media" (M.A. thesis, Tufts University, 2018).

18. Evelyn Abdalah Menconi, ed., *The Coffeehouse Wayn Ma Kan Collection: Memories of the Syrian-Lebanese Community of Boston* (West Roxbury, MA: William G. Abdalah Memorial Library, 1996).

19. See "Guide to the Faris and Yamna Naff Collection," Archives Center, National Museum of American History, Smithsonian Institution, accessed June 4, 2025, https://sova.si.edu/record/NMAH.AC.0078. Individual oral histories are best accessed via the Arab American National Museum, "Oral Histories from the Faris and Yamna Naff Arab American Collection," (1) Ramza A. [AC0078-OT0013_01], accessed June 4, 2025, https://aanm.contentdm.oclc.org/digital/collection/p16806coll10/id/35/rec/2; (2) Charles T./Assad S. [AC0078-OT0030_01], accessed June 4, 2025, https://aanm.contentdm.oclc.org/digital/collection/p16806coll10/id/69/rec/2; (3) Victoria S./Unknown/Charles T. [AC0078-OT0030_02], accessed June 4, 2025, https://aanm.contentdm.oclc.org/digital/collection/p16806coll10/id/68/rec/2; (4) Ramza A. and Skiyyie Saliba S. [AC0078-OT0013_02], accessed June 4, 2025, https://aanm.contentdm.oclc.org/digital/collection/p16806coll10/id/36/rec/2; (5) Assad S./Joseph K. [AC0078-OT0011_01], accessed June 4, 2025, https://aanm.contentdm.oclc.org/digital/collection/p16806coll10/id/32/rec/1.

20. "Records of the Lebanese Syrian Ladies' Aid Society (1917–2005)," Schlesinger Library, Radcliffe Institute, accessed June 4, 2025, https://hollisarchives.lib.harvard.edu

/repositories/8/resources/5948; "Records of Denison House (1890–1984)," Schlesinger Library, Radcliffe Institute, accessed June 4, 2025, https://hollisarchives.lib.harvard.edu/repositories/8/resources/4987. The Schlesinger Library also holds the papers of Carol Haddad and the Feminist Arab-American Network (1981–2015), which suggests the potential of placing the histories of the LSLAS and Denison House in dialogue with later forms of women's organizing. Along these lines, see Stacy Fahrenthold, "Ladies Aid as Labor History: Working Class Formation in the Mahjar," *Journal of Middle East Women's Studies* 17, no. 3 (November 2021): 326–347, https://doi.org/10.1215/15525864-9306818.

21. For example, Gladys Shibley Sadd, *True Love Stories* (Santa Clarita, CA: Glastebar, 2000), and *The Middle East, Its Wisdoms—Wit and Culture: My Legacy* (Santa Clarita, CA: Glastebar, 1989). Besides *Bint Arab*, cited earlier, Shakir published *Teaching Arabs, Writing Self: Memoirs of an American Woman* (Northampton, MA: Olive Branch, 2014). Of course, family histories are not limited to women. For example, Charles Malouf Samaha, "Khalil Gibran and Faris Malouf: The Story of an Unsuccessful Venture, 1924–25," Kahlil Gibran Collective, May 15, 2020, https://www.kahlilgibran.com/92-Khalil-gibran-and-faris-malouf-the-story-of-an-unsuccessful-venture-1924-1925.html.

22. "What Boston's Little Syria Neighborhood Tells Us about Immigrant Life in the City Today," interview by Yasmin Amer, WBUR, Boston, MA, February 8, 2023, https://www.wbur.org/radioboston/2023/02/08/boston-little-syria-chinatown-research; Yvonne Abraham, "Historians Tell the Story of Boston's Little Syria, Which Was Home to Thriving Arab American Community," *Boston Globe*, April 29, 2023, https://www.bostonglobe.com/2023/04/29/metro/reclaiming-our-heritage/; Rebecca Blandon, "Boston's Little Syria: How a Forgotten Neighborhood Lives On" [multimedia segment], *Boston Globe: Boston Globe Today*, October 23, 2023, https://www.bostonglobe.com/video/2023/10/19/multimedia/video/boston-globe-today/bgt-segments/bostons-little-syria-how-a-forgotten-neighborhood-lives-on/#:~:text=For%20more%20than%20seven%20decades,South%20End%2C%20along%20Shawmut%20Avenue.

23. Richard Breaux, "Anton Abdelahad: Music of the American-born Mahjar," Midwest Mahjar, June 23, 2019, https://syrianlebanesediasporasound.blogspot.com/2019/06/anton-abdelahad-music-of-american-born.html; Anton Abdelahad, accessed June 5, 2025, https://www.anton-abdelahad.com/.

24. Meryum Kazmi and Harry Bastermajian, "Ottoman Boston: Discovering Little Syria, with Chloe Bordewich and Lydia Harrington," *Harvard Islamica Podcast*, April 3, 2023, https://soundcloud.com/harvard-islamic/ep-14-ottoman-boston-discovering-little-syria-chloe-bordewich-and-lydia-harrington.

25. Anthony Abdelahad, email correspondence with the authors, October 11, 2022.

26. See Gualtieri, *Between Arab and White*.

27. On changes to the urban landscape, see Alex Krieger and David Cobb with Amy Turner, eds., *Mapping Boston* (Cambridge: MIT Press, 2001).

28. "Chinatown Atlas: The Garment District and Chinatown," accessed June 5, 2025, https://www.chinatownatlas.org/stories/garment-district-chinatown/.

29. William Cole, *Immigrant Races in Massachusetts: The Syrians* (Boston: Massachusetts Department of Education, 1921), 4–6. The state produced a series of ethnic portraits to argue for the assimilability of certain groups over others.

30. *Fatat Boston* was digitized by the Center for Research Libraries and is available upon request from the Khayrallah Center for Lebanese Diaspora Studies. Another Arabic newspaper, *al-Wafa'* of Lawrence, was established in 1907 and catered to Syrian readers in the industrial suburbs.

31. We discuss racial categories and the Syrian community in Boston at greater length in our article "Boston's Little Syria: The Rise and Fall of a Diasporic Neighborhood," *al-Jumhuriya*, November 19, 2022, https://aljumhuriya.net/en/2022/11/19/bostons-little-syria/. For more, see Gualtieri, *Between Arab and White*.

32. Evelyn Abdalah Menconi, Jeannette Hajjar, Laurie Malooly, interviewed by Gualadesa Rivera, USES, Boston, MA, video recording, Northeastern University Library, March 6, 1995, http://hdl.handle.net/2047/D20409834.

33. "Making Good American Citizens: Evening Schools of Boston," *Boston Daily Globe*, November 5, 1905.

34. "History of Parish," Our Lady of the Cedars of Lebanon Church, accessed June 5, 2025, https://www.ourladyofthecedars.org/history-of-parish. See also "From Orient to America: Boston's Strange Spectacle of Syrian Worship," *Boston Globe*, March 31, 1891, 6.

35. CCLT's important initiative, still in the early stages of implementation when this book went to press, is a major step toward conveying the degree to which the histories of the Chinese and Syrian communities were intertwined. It places a particular emphasis on the impact of gentrification and displacement, against which the struggle continues in Chinatown today.

36. Julie Miller-Cribbs and Julianne N. Mains, "Amelia Earhart (1897–1937): Social Worker, Women's Advocate, World Famous American Aviation Pioneer," *Social Welfare History Project* (2011), accessed June 5, 2025, https://socialwelfare.library.vcu.edu/people/earhart-amelia/.

37. Tamar Rabinowitz, "Settlement Houses: Sites of Service, Access, and Connection for Women," National Trust for Historic Preservation, March 12, 2021, https://savingplaces.org/stories/settlement-houses-sites-service-access-connection-for-women.

38. Lebanese Syrian Ladies' Aid Society, accessed June 5, 2025, https://ladiesaidsociety.net/.

39. In August 2023, the Chinatown Community Land Trust recorded an oral history with John's niece, Betty Lutfy Dimeco, for the Immigrant History Trail. Betty uses *Lutfy*, not *Lufty*.

40. "Corp John S. Lufty Square Dedicated," *Boston Globe*, September 26, 1921, 2.

41. Attempts to mend these ruptures are underway: Michael Norton, "Federal Grant Targets I-90's Negative Impact on Boston's Chinatown," WBUR, February 28, 2023, https://www.wbur.org/news/2023/02/28/boston-highway-divided-chinatown-gets-federal-grant.

42. Seth C. Bruggeman, *Lost on the Freedom Trail: The National Park Service and Urban Renewal in Postwar Boston* (Amherst: University of Massachusetts Press, 2022), 114.

43. Bruggeman, *Lost on the Freedom Trail*, 118.

44. "Oral History Interview with Nabeeha Hajjar" [transcript], conducted by James Green, Office of the Mayor, Boston, MA, ca. 1975/1976, City of Boston Archives, accessed June 5, 2025, https://cityofboston.access.preservica.com/uncategorized/IO_dddfcfcb-1ffc-43f1-b72f-1e4e558fbd00/.

45. *Boston Record American*, December 27, 1965, via The Passionate Foodie, "Closed for Nearly 50 Years," September 4, 2020, https://passionatefoodie.blogspot.com/2020/09/closed-for-nearly-50-years-history-of.html.

46. On this naming practice, see Matthew Jaber Stiffler, "Serving Arabness: Imagery and Imagination of Arab-themed Restaurants," in *Arab American Aesthetics*, ed. Therí Pickens (New York: Routledge, 2018), 63–85. Researcher Amy Smith of Flaming Cheese Productions (https://www.flamingcheeseproductions.com) has amassed an important archive on Boston's early Middle Eastern nightclub scene.

47. The Sahara Restaurant's fate has drawn the curiosity of a number of journalists and bloggers in recent years. See, for example, Tim Logan, "Why Have These Buildings Sat Empty for Years and Even Decades?," *Boston Globe*, June 17, 2019.

48. "Mass. Memories Road Show," *University of Massachusetts Boston Archives and Special Collections*, accessed June 5, 2025, https://blogs.umb.edu/massmemories.

49. Chloe Bordewich and Lydia Harrington, "Boston's Little Syria: The Rise and Fall of a Diasporic Neighborhood" [English], *al-Jumhuriya*, November 19, 2022; "Suriya al-Saghira fi Bustun" [Arabic], trans. by *al-Jumhuriya*, November 12, 2022, https://aljumhuriya.net/ar/2022/11/12/%D8%B3%D9%88%D8%B1%D9%8A%D8%A7-%D8%A7%D9%84D8%B5%D8%BA%D9%8A%D8%B1%D8%A9-%D9%81%D9%8A-%D8%A8%D9%88D8%B3%D8%B7%D9%86.

50. Rosie LeCours (1908–2006) and her husband owned several parking lots in South Cove before World War II. Rising gas prices nudged Rosie toward the cab business. She drove for more than fifty years, until the mid-1990s. Harry "Sonny" LeCours, phone conversation with the authors, May 11, 2023; Richard J. Connolly, "Where There's Smoke, There Won't Be Rosie," *Boston Globe*, January 31, 1964, 3.

51. The map can be viewed on the Boston Little Syria Project website, accessed June 5, 2025, https://bostonlittlesyria.org/map/.

52. James Smithies et al., "Managing 100 Digital Humanities Projects: Digital Scholarship and Archiving in King's Digital Lab," *Digital Humanities Quarterly* 13, no. 1 (2019): 2, https://www.digitalhumanities.org/dhq/vol/13/1/000411/000411.html.

53. Christine Barats, Valérie Schafer, and Andreas Fickers, "Fading Away . . . The Challenge of Sustainability in Digital Studies," *Digital Humanities Quarterly* 14, no. 3 (2020): 39, https://www.digitalhumanities.org/dhq/vol/14/3/000484/000484.html.

54. WSHS, Touring App, accessed June 5, 2025, https://alqalamjourney.org/en.

55. See Laura Lee Schmidt, ed. and curator, et al., *Building Blocks: Boston Stories from Urban Atlases* (Boston: Leventhal Map and Education Center, 2022), accessed June 5, 2025, https://www.leventhalmap.org/digital-exhibitions/building-blocks/.

56. For the basics of building Leaflet web maps in Glitch, see "Make a Web Map with Leaflet," *GlitchBlog*, March 26, 2019, https://blog.glitch.com/post/make-a-web-map-with-leaflet.

57. Laura Kurgan, "Bill Rank and Laura Kurgan: Seeing Cities," *Guernica*, December 15, 2015, https://www.guernicamag.com/seeing-cities/.

58. "Arab American Demographics: Massachusetts," Arab American Institute, 2024, accessed July 23, 2025, https://static1.squarespace.com/static/5faecb8fb23a85370058aed8/t/65ebcb2ede44ec4e33535fdd/1709951790366/AA+demographics+-+MASSCHUSETTS.pdf.

59. Grace Friar, "Arab Americans in the United States Military," *Arab America*, July 2, 2020, https://www.arabamerica.com/arab-americans-in-the-united-states-military/.

60. Solon Kelleher, "Little Amal Takes First Steps in Boston," WBUR, September 7, 2023, https://www.wbur.org/news/2023/09/07/little-amal-puppet-boston.

4

HOUSTON, WE HAVE A HAFLI!

Public History and Cultural Production among Arab American Communities in Texas and the Gulf Coast

MARIA F. CURTIS

During the month of Ramadan 2017, I was invited to attend a community organized cultural *iftar* dinner, hosted at the Arab American Cultural and Community Center (ACC) in Houston, Texas. The dinner's theme featured the unique Ramadan traditions of North Africa, and as a cultural anthropologist who had lived in Morocco for three years, I jumped at the chance to attend what I already knew would be a lively gathering. Nostalgic for the atmosphere of the *hafli*, a party, familial gathering, or festive event, I dug through my closet and found a kaftan from my time in Morocco. The observance of Ramadan in the United States for me has never quite matched the august atmosphere of its celebration in Morocco.[1] When teaching in the evening, I would sometimes find recordings on YouTube of the sound of the wave of muezzins in Fes Medina's hundreds of mosques, announcing the time to break the fast in a cascading call to prayer. In full-blown *hafli* mode, I arrived at the ACC's North African Ramadan Night in the most festive attire I could assemble. The parking lot was packed, and I could already hear music from the edge of the street as I made my way to the building.

Since arriving in Houston in 2007, when I began teaching anthropology at the University of Houston–Clear Lake, I had worked with the ACC on a number of cultural projects and initiatives. Teaching about the Arab world and navigating the post-9/11 academic landscape was challenging, and the ACC had been a place where I volunteered and did formal research; my soul just felt at home there. The ACC has created programming since 1995 in a center that serves the large Houston Arab American community estimated

to be at least 100,000 strong. The ACC is a malleable and adaptive space; it has created its own sense of welcome and hospitality amid the dizzying diversity of the Houston Arab American mosaic. The organization draws from various Arab communities—Egyptian, Lebanese, Moroccan, Palestinian, Libyan, Tunisian, Yemeni, Syrian, Iraqi, just to name some. It organizes events for both Christians and Muslims, and there is a healthy mix of first through fourth generations of Arab Americans. The center invites non-Arabs for various programming as well.

That night, the space had been reconfigured with large Ramadan lanterns. Dimmed lights shimmered across its oversized Damascene crystal chandeliers, the music evoked a North African soundscape, and a space routinely used for group meetings had been transformed into a prayer area. Like it is at a good Moroccan wedding, the music was lively and a bit too loud to really sustain a long conversation, but the menus in English and Arabic before us cued our attention to the food. I recognized the influence of my friend and colleague Dr. Faiza Zalila on the menu. A Tunisian-born gourmand with a vast knowledge of Arab regional micro cuisines, she curated delicacies from all of North Africa. Different members of the community took turns at the podium recounting traditions and stories from their respective corners of North Africa.

We looked on as a young man dressed as a whirling dervish began to spin; his layered robes lined with lights produced a spectacular show that outshined even the menu. He wore several layers of robes and periodically disrobed to reveal yet another one meant to represent the iconic colorful lanterns, the *fawanees*, seen in Ramadan. The dancer spun around and around without stopping for nearly forty minutes while managing costume changes without missing a beat. That was the first time I had seen the Egyptian Tanoura folk dance performed live, and the sheer athleticism of the choreography is forever inscribed in my mind. This is the kind of public history the Arab American community itself generates—cultural heritage that is felt, heard, bears muscle memory, and is tasted in the company of others, weaving together multisensory "epistemological, ontological, and social levels of representational belonging."[2] This effort to practice a living history anticipates multiple audiences and the "expectation of different methods of engagement."[3] The Arabs and Arab Americans I have worked with over the years have always pulled me in the direction of an engaged ethnography, invoking their own sense of what we call in this volume *public history*, a collaborative, participatory, and collective way of passing on and preserving cultural memory.

As the *iftar* was winding down and people mingled, I spotted a bright green kaftan I knew instinctively was Moroccan. The woman in the green kaftan was speaking with my friend Faiza; as I approached, they invited me closer for an introduction. This is how I first met Ruth Ann Skaff, a living legend in

Arab American circles, whose years of service include time working in the Peace Corps in Morocco, fundraising for St. Jude Children's Hospital in Memphis, advocating for social justice at the American-Arab Anti-Discrimination Committee (ADC) in Washington, D.C., and Houston, participating as a lifelong member of the Southern Federation of Syrian Lebanese American Clubs along the Gulf Coast, and much more. Representing the Arab American community, she traveled across the United States with Jesse Jackson's 1984 Rainbow Coalition during his presidential campaign. She introduced the Palestinian cause to mainstream America, something we might not imagine possible today. She was a close friend and colleague of Dr. Alixa Naff, considered by many "the Grande Dame of Arab American social history."[4] Carrying on the work of Naff, Skaff is a longtime advocate and supporter of the Arab American National Museum, for which she has collected numerous oral histories and served as senior outreach adviser. These are but a few of her many roles, accomplishments, and contributions.

Skaff eyed my kaftan and I hers while we shared stories about our time in Morocco. We took what would be our first of many *hafli* photos together. As we nestled on newly installed Iraqi traditional *majlis* banquettes and sipped our Moroccan mint tea, she began telling me about her life. After years of working abroad and in different cities, she had decided it was "finally time to come home to Houston." In a distinctive Southern accent, she explained that she had some of her "Daddy's papers" and asked if I might help her sort through them. Her father was a Syrian Orthodox priest who had brought his family from the Midwest when she was very young. I was not entirely sure what I was agreeing to in that moment, but I instinctively knew any time with Skaff would be well spent.

The surprises continue to astonish me as I work my way through her family's large archival collection, some sixty-five banker's boxes and counting. In the years that have followed since our first meeting in June 2017, Skaff has become a close friend and is the most learned person and best teacher on the history of the Syrian Lebanese community in the American South. She possesses an encyclopedic knowledge of the many rhizomatic Arab American organizations and their social justice work over many decades. She served as the Texas coordinator for the Arab American Institute (AAI) and was a charter member of the Arab-American Education Foundation (AAEF) and served as its director in Houston. She also served on the national boards of both the National Association of Arab Americans and Arab American University Graduates (AAUG). She dedicated years of service to the ADC, the Palestine Human Rights Campaign (PHRC), and the Arab American Business and Professional Association. She has assisted in supporting Arab Americans running for public office on both sides of the aisle, and her work in education

through the AAEF led to both an endowed professorship in Modern Arab History at Rice University as well as an endowed chair at the Center for Arab Studies at the University of Houston. Her contributions to Arab American scholarship, advocacy, the arts, and cultural production run the full gamut.

In addition to the fascinating collection belonging to her father, her archival contributions represent an invaluable window into the transition between the earlier turn-of-the-century Syrian Lebanese mostly Christian immigration and that which came later in 1965, bringing more Muslim Arab Americans from many parts of the Arab world. Among the children's educational materials in the collection, I came across Skaff's elementary school ABC lesson book for Orthodox Church Sunday School with a quote she had written in new cursive: "Let your light so shine for men, that they may see your good works, and glorify your father which is in heaven." This is a lesson that she apparently learned early and has served as a creed by which she has led her life.

Untapped Public History: Domestic, Family, and Community Archival Collecting

Skaff and her family's collected papers, not yet fully public, are a community archive in the making; these "untapped papers" will make their way into the world of future Arab American scholarship.[5] The Skaff Family Arab American Archive, a title we conjured together as she delivered and I retrieved boxes in succession, is believed to be one of the largest single family collections that we know about so far, according to Dr. Matthew Jaber Stiffler of the Arab American National Museum. The size and variety of materials make it a rich resource yet also make it difficult to know where the collection may one day physically and permanently reside. If it is ultimately divided into smaller subcollections, portions of it would easily fit within the parameters of a number of repositories' vision and scope for long-term custodianship. During the process of arranging the archival contents, some members of the Skaff family have grown fond of keeping it all in Houston, as the collection documents communities along the Gulf Coast. Despite its longtime presence, the Texas Arab American community has received scant scholarly attention given its size and diversity. Michelle Caswell, Marika Cifor, and Mario H. Ramirez describe the affective responses that contributors to archives experience after seeing their materials take on a concrete form as "the joy" of suddenly seeing yourself existing: "Representation in community archives catalyzes this ontological shift from not being/not existing/not documented to being/existing/documented, with profound and personal implications."[6] Skaff's family archive

actively un-silences the communal joy of the Syrian Lebanese American experience. The scope of the archive oscillates between instances of anger and advocacy in response to discrimination and the joy of heritage preservation in many forms, both in their own way radical.[7]

Studying the Arab American experience in the American South has implications far beyond the community itself. In fact, any examination of Arab American community development in the South beginning in the aftermath of the Civil War tests the limits of the promise of American democracy. Without understanding the ways in which Arab Americans bridged Black and white communities from post-Reconstruction to desegregation, we cannot have a full reckoning of America's lingering unfinished business with racism and exclusionism. *The Freedom's Journal*, the first newspaper owned and operated by African Americans, launched in New York in 1827, the year the state banned slavery, and asked white American Christians to apply their faith's commandments to their own assumptions about racial superiority not just from the comfort of the pew on Sundays.[8] They demanded to be seen equally in the eyes of their shared faith *every* day, everywhere. This same sentiment and sense of indignation are captured in early Arab American newspapers and community bulletins in Texas. The Arab American experience is not so different. It asks that America's Christian identity make good on its presumed connection to the Holy Land, to see Arab Americans in the historical, cultural, and religious fullness they deserve.

Some portions of the Skaff family's vast collection already reside in the Naff Collections in the Smithsonian in Washington, D.C., at the Arab American National Museum in Dearborn, Michigan, and at the Ideson Library, part of the original Houston Public Library. When I met Skaff, she had already donated some materials to the Houston Metropolitan Research Center (HMRC) and signed agreements with former director Laney Chavez.[9] After an initial review of some of the materials at her home, she arranged a meeting between us and the HMRC archivists. I shared my thoughts with Laney and her team about the contents, and although Skaff's materials were beyond the scope of just Houston, it made sense to keep everything together as a way of understanding the Houston Arab American community's broader contributions to the field of Arab American studies. Materials from different cities offered a unique side-by-side comparison. Laney and her team welcomed me and my students aboard and hosted us at the HMRC, even taking us into their frigid special collections vault that contains a fourteenth-century Quran from present-day Iraq and a Mesopotamian cuneiform stamp.

From a brief look at their holdings, I recognized they already had items on Dr. Michael DeBakey, a prominent heart surgeon, and a few other well-known Houston Lebanese individuals, although they were not referenced as

Arab American holdings per se. They created training documents for our team of nine, who eagerly joined as volunteers in fall 2017 at the University of Houston--Clear Lake. They visited our campus several times and developed training workshops to ensure that as we arranged the family papers, we would be using an approach consistent with theirs. They created internship positions for two of my graduate students, Lydia Newcomb and Yasmine Silva, who went on to careers in library science. We continued to meet and plan for moving some of Skaff's materials over to be formally archived after we did the first arrangement on campus. Joseph D. Jamail Jr., of the affluent Houston-based Jamail family, made a significant donation to help preserve and restore the building, a "Recorded Texas Historical Landmark, a City of Houston Protected Landmark, a Texas State Archaeological Landmark and a landmark listed in the National Register of Historic Places."[10] As the world reeled after the outbreak of COVID-19, many libraries and "nonessential" institutions either shut down or operated in never before anticipated ways. The HMRC experienced rapid change in staffing, management, and scope, and the vision shared previously by the institution changed to focus more narrowly on the city of Houston. Space considerations and staffing might make it difficult to accept her full collection now.

Though it is not yet clear where the Skaff collection may eventually go, I am continuing to work with my students—fifteen and counting—on arranging and providing historical background on the scope of its contents. My engagement with the collection has been ongoing, having "neither a beginning nor an end," in the words of Caswell and Cifor, who call for a different relationship to archival holdings in which a "feminist ethic of care" is embedded in long-term interaction with donors as we navigate the unknowns of a new digital turn.[11] It has been gratifying to witness the collective conversation on where the Skaff collection will one day be housed, as "community archives both provide support for history-making activities and are themselves a product of history-making processes."[12]

My chapter chronicles the collaborative work done alongside Skaff and her family, supported by two grant projects funded by the National Archives, where I have partnered with colleagues Stiffler from the Arab American National Museum and Dr. Akram Khater of the Moise Khayrallah Center for Lebanese Diaspora Studies at North Carolina State University. The grants have offered an opportunity to organize the collection and expand our knowledge of Arab Americans to more fully consider communities in the Gulf Coast region, known to have been there since at least 1857, when Hadji Ali Philip Tedro, or "Hi Jolly," and others arrived in Indianola, Texas, to launch the U.S. Camel Corps.[13] The Skaff collection contains materials on early immigrants from the Ottoman Empire, who were called Syrians when they began arriving

in Texas in the 1880s, as well as items through the mid-2010s, when the community Skaff affiliates with most referred to itself as Syrian Lebanese, Lebanese, or Arab American, depending on who you asked.

Our work represents a broader shift among cultural heritage information professionals to take on "convergent partnerships" across different memory and heritage institutions whose primary goal is to create "increased public accessibility."[14] Situated at the intersections of ethnography and applied anthropology, community archiving, and public history, I have worked to document new Arab American archival holdings in the South and to educate different Arab American community stakeholder groups in Texas about the importance of preserving their family papers. This led to the identification of local and regional Arab American community newspapers and newsletters as well as historic Texan newspapers and how they depicted early "Syrian colonies," as they were called in the late 1800s and early 1900s.

With funding from the National Historical Publications and Records Commission (NHPRC) in 2019, we launched a project that aimed to commemorate the hundredth anniversary of the literary and intellectual work of Al-Rabita Al-Qalamiyya (The Pen League). This work continued with an implementation grant in 2022, which my colleagues and I used to further our archival collaborations by engaging with different community stakeholders to increase the discoverability of collections like the Skaff collection and create workshops for families who might see something similar lingering "untapped" somewhere in their own homes, offices, garages, attics, and storage units. I received University of Houston–Clear Lake Faculty Research Support Funds and Faculty Development Support Funds that have enabled me to travel to conferences and workshops and to hire graduate and undergraduate research assistants.

As with all things Texan Arab American, the Skaff collection is larger than life; its contents are treasures spanning the cultural production from the established intellectual projects of Lebanese émigrés like Dr. Philip Hitti and Gibran Khalil Gibran, representing the work of the early Syrian Lebanese community. It also includes materials associated with a broader "Arab American collective subjectivity," which emerged post-1967 after the Six-Day War, in line with Edward Said's framing of *Orientalism* and the subsequent work produced from the AAUG.[15] The Skaff collection represents an example of what Arab American archiving practices might look like and of Arab American public history. This collection offers another take on what other contributors have described as "hidden in plain sight." Southern Arab Americans represent a sort of "nested" identity, where the dynamic cultural production of the large and vibrant community in Houston has not resulted in a corresponding scholarly literature as seen in other regions. This there–not there duality is similar to what Andrew Flinn, Mary Stevens, and Elizabeth Shep-

herd describe as "ephemeral traces of a hidden history" and lends "significant emotional resonance and historical value."[16] The Skaff archival materials confirm what we already felt was there, and there is a sublime tactile joy in this confirmation.

"Holding on to Things": Archives and Archival Aspirations

The Skaff collection is a work in progress; Stuart Hall reminds us that "an archive never arises out of thin air," and each has its own sort of "pre-history."[17] The collecting practices of Skaff and her father, Reverend Thomas Skaff, reveal how a community archive is born and the "archival thinking" that occurs over time to coproduce public history. We have processed no fewer than two hundred gala dinner brochures from events and programs across the country. Each of these events, gatherings, themed *haflis* like the one where Skaff and I first met, conventions, and conferences are time capsules that document how individuals created space for community across the diaspora and how Arab Americans thoughtfully responded to misunderstanding and discrimination in proactive ways. These events are enveloped in larger diasporic narratives that we can better understand by reading community bulletins, newsletters, newspapers, periodicals, and other writing. Hall describes the emergence of the archive as a collection of items moves from a sort of innocent curiosity and develops into a body of work with recognizable public figures, eventually becoming more self-conscious and reflective until it "slips into place" as if it were always a thing.[18]

For Arjun Appadurai, the archive begins as traces of some history until a coalescence, when it aspires to be more. This is particularly true for the "migrant archive," materials collected that reflect "disjunctures between location, imagination, and identity."[19] The migrant archive is a "doubly valuable space [where] some of the indignity of being minor or contemptible in the new society can be compensated, and the migrant narrative can be protected in the relative safety" of the collection.[20] Appadurai's thoughts here are directed to the possibility of digitized archival collections, and the hope is to bring the Skaff archives to as wide an audience as possible. Most compelling is the notion of the constitution of an archive as a means for establishing a moral discourse that rights the wrongs of indignity and prejudice. The digital turn in the humanities continues to make historic newspapers and other artifacts from across the country more readily available. When reading the Skaff materials in juxtaposition with historical Texan newspapers, we can clearly identify the cycles of discrimination and violence early Syrian immigrants faced in Texas and the Gulf Coast from both American and Mexican officials.

The Community Archive and Knowledge Transmission

It is instructive to discuss how the Skaff collection emerged in relation to the well-known collection built by Naff (1919–2013), the Lebanese-born historian whose body of work is considered the bedrock of Arab American studies as a discipline. Naff realized her dream of a college education later in life, as she had spent her early adulthood working alongside her father, who had arrived in the United States in 1921 and worked first as a peddler before operating his own store. She enrolled at University of California, Los Angeles (UCLA) in the 1950s and finished her Ph.D. in history in 1972. During her time at UCLA, Naff witnessed the development of the UCLA Institute of American Cultures, one of the first centers for ethnic studies that emerged in response to the Civil Rights movement. Her professors were supportive of her desire to create a basic body of knowledge around Arab American studies and helped her secure funding for some of her earliest work. As an undergraduate student tasked with writing about American immigration in one of her classes, she was motivated to begin collecting oral histories about Arab Americans for the simple reason that there were no books on the shelves to consult.[21] She dedicated her life to collecting oral histories and establishing the first Arab American archival collection, which bears her parents' names: the Faris and Yamna Naff Arab American Collection at the Smithsonian's National Museum of American History Archives.[22]

Her publishing began in 1965 with an article in the *Journal of American Folklore* on the belief in the evil eye among Christian Syrian Lebanese Americans and would continue with other notable works through 2002. She had always enjoyed clipping articles about the community, and once people knew about her oral histories, they began to pass things on to her. She encouraged people to preserve their historic documents and photos. Her own shift in consciousness from thinking of herself as Lebanese American while loving the food and dancing of her heritage occurred when she saw hurtful media representations of American Arabs after the 1967 Arab-Israeli Six-Day War—"at that time we all became Arab," she said.[23]

In comparison, Skaff was a new undergraduate student in the early 1970s at the University of Texas at Austin. She studied sociology and took courses with B. J. and Bob Fernea, who launched the university's Center for Middle Eastern Studies and were pioneers within the Middle Eastern Studies Association. The search for dignity that Appadurai describes in the migrant archive is present throughout the many documents and materials in the dozens of boxes in the Skaff collection. I wondered if Naff's presence might have in some way inspired the family's collecting practices, but the dates of the items indicate that the elder Skaff had already been engaged in preserv-

ing materials in his own way for many years. As a young man in 1938, Thomas Skaff was the president of the *Sioux City Crusaders* and wrote for this student publication.[24] He recounted his volunteer efforts with the Syrian American League working with older Syrian immigrants to prepare for the naturalization process during a time when the 1921 Emergency Quota Act and the 1924 Johnson-Reed Act made achieving citizenship much more difficult. His efforts would continue in different ways during his long career in the priesthood, where his pursuit of social justice informed his religious practice.

Naff had been a family friend and likely met Skaff's father while he served a parish in Spring Valley, Illinois. Reverend Father Thomas Skaff (1913–1989), the first Orthodox priest of Arab descent ordained in the United States, was originally from Sioux City, Iowa. He had moved with his family to various parishes in Michigan, Iowa, Minnesota, Kansas, and finally to Beaumont, Texas, where he had moved to serve St. Michael Orthodox Church, the second oldest Syria Orthodox Church in the United States, likely built in the area after the Spindletop oilfield was discovered. I attended an anniversary celebration of the founding of the church with Skaff and her sister Melanie Skaff Wood in early 2018. The church community displayed their own archival items, photos, documents, and ephemera outside the gala dinner hall, and we viewed them in between demonstrations of folkloric *debka* by the community's youth group interspersed with square dancing from the elders.

Established in 1898 when Orthodox families began to settle in the area, the church is situated within a stone's throw of Interstate 59 in Beaumont in the petrochemical corridor of Orange County, Texas, close to the Louisiana border.[25] Father Skaff's photos were there, an homage to his contributions to skillfully relocating the congregation after a devastating fire that destroyed the original building in 1953. What Ruth Ann Skaff remembered most about the fire was how her beloved white dress with red polka dots had gotten stained from soot and smoke that day. She described the lingering trauma of relocating the church family and how another church had welcomed their congregation until they could secure a new site for worship.

After the St. Michael anniversary event, Skaff spoke with church leadership about her family archive project. They expressed interest in donating materials and told us about how some church documents had been lost in recent flooding in the Gulf Coast area. As would happen often on our visits to speak with different people, I came away with the feeling that there was more Arab American archival material than could ever be captured or properly processed and preserved. My greatest wish is to create a larger conversation about collaborative conservation efforts dedicated to preserving the region's unique community papers and artifacts.

"I wasn't born here but got here as soon as I could" is one of Skaff's famous one-liners. She was born in Minnesota, but she and her siblings were

raised in Beaumont and then Houston, Texas, when her father relocated to serve Syrian Orthodox communities there. She grew up in the media's eye, and we have photos of Skaff as a rambunctious toddler in newspaper stories of her parents' travels from parish to parish. Father Skaff helped rebuild the church in Beaumont, Texas, then served in Houston as the original St. George Syrian Orthodox Church was transitioning from its first location on Chestnut Street (May 1936 to September 1954) to its current location near Rice University. The Syrian community's founders, who had started in 1893 as peddlers, merchants, and tradesmen in the Northside Village neighborhood, perched on the banks of the Buffalo Bayou (though many operated stalls in the Houston City Market), had outgrown their first church.

This pivotal movement from the working-class scene of the market district to a more spacious and affluent suburb during the late 1950s would position the community to better serve newcomers from the Arab world arriving after the 1965 immigration reforms of President Lyndon B. Johnson's administration. This was no easy transition and was considered a painful move for the church's founders, compared to "getting on the boat for a second time."[26] These recollections were gathered by Anna Faour, who created an office in her garage, where she sorted and culled through important community documents. She described being the point person to draft the commemorative booklet and engaged with the elder women of the community who had held on to the earliest documents. They delivered them to her in her garage, where she accepted bundles of precious documents in English and Arabic from the very women who had peddled and sold fruit and vegetables in the early marketplace and collected hard-earned money to purchase the church and outfit it in an Orthodox manner. Faour then dutifully compiled historic letters and documents and wove together the many threads from stories about the early days. As Edward E. Curtis IV has stated, it is often thanks to the memory work of women that we have community archives and public history at all.

By the time Skaff's father's next parish had been assigned, the Skaff family decided they would stay in Houston to keep the kids in school while he rented a residence in Spring Valley, Illinois, and served from November 1955 through spring 1958. Skaff believed it was during this period that her father met Naff in the new parish. The timeline here comes from the hard work of another graduate student volunteer, Mary Castagna, who organized Father Skaff's correspondence and sermons by city, decade, and parish.

Father Skaff was a voracious reader and would have been a young man during the formative years of The Pen League in the 1920s. He had collected older Arabic language newspapers like *Al Hoda* as well as early academic journals in English such as *The Syrian World*. There are gaps in some of the series, and we believe the items may have perished along with other things in

the Beaumont church fire, while others show traces of water and insect damage, common in collections of similar size and materials. When I asked Skaff about her father's collected papers, she said:

> We did not grow up in a spartan home. My mother tried her best to keep a handle on all of the papers, and we were just a bunch of pack rats, I guess, who liked to hold on to things. My mother held on to her own items as well, it was something that people just did then, whereas today we have email and other electronic communication. My parents kept sentimental things they thought were interesting. We lived in a small house, and we did not have the means for something like a library as we lived on a modest church salary. Mother used to collect things in bundles and store them in the back room of the house as a way of tidying up. It was the room where we had many things including the washer and dryer. When that space filled up, we just began storing stuff in the garage.

Skaff recalled her father having quite a bit of paperwork in his office at church.

When people passed away, relatives would bring what they thought might be interesting to him. Her father and mother kept track of tithing in the church—who contributed how much and how often and where they lived. Skaff's mother, Elaine Khoury Skaff, was an excellent record keeper and carefully updated church-member information in a sort of oversized rolodex with envelopes. Today, her bookkeeping can be read as a record of the demographic shifts as families began to move up the social ladder from trade to law, medicine, and other professions.

Father Skaff rented a larger house in Springfield, Illinois, while he was away from the family, and he worked with stacks of papers as a way of managing his multiple roles in the church. He frequently traveled to conferences and attended as many cultural events as he could to show support. As he moved from place to place, he took literature on the multiple dimensions of the history of the Arab American community. His correspondence reveals his level of involvement in the lives of his parishioners; he even advocated in instances of marital neglect and domestic abuse, writing in support of women seeking church support for the dissolution of unhappy unions. He and his wife started a day care as a way to offer women a means to earn a living. Though nothing is written about this, it was Skaff who told the story the day she delivered some materials, including contracts and business-related documents her parents had kept. Skaff's own bundling practices most likely resemble those of her mother. Her bundles are enveloped in stories she tells when she passes on another set of materials. Without these stories, the items would simply

be papers in boxes, and there would be no obvious cohesion between them. She is also fond of placing bundles in a special box or bag that is usually tied to one of the many events she attends. The name for this chapter comes from one such bag from the Southern Federation of Syrian-Lebanese American Clubs' 83rd Annual Convention, held in 2014. The convention's slogan was "Houston... We Have a Hafli!," a play on NASA's famous "Houston, we have a problem." The cover of the convention program features conventioneers getting down on the *debka* dance floor.

I have filled notebooks with Skaff's stories as she has released her bundles, which she sometimes decides to hold on to a bit longer after she has talked about them. I kept them at first as a way to inventory what she was donating and realize in retrospect that those notes must one day become part of her collection's finding aids. It is enthralling to listen to her reflect back on her life as a child of the civil rights movement and her positionality as an Arab American in the Deep South witnessing desegregation while living in a physical and liminal space between the Black and white neighborhoods of Houston. Her stories about not knowing which pool to go to in the summer—she received inquisitive stares from both the Black and white kids—are revealing.

Father Skaff attended city meetings in Houston in the wake of Black student protests in the early 1960s, and in a box of Christmas cards, we see thank-you notes from a number of immigrants, many of them Palestinian, Father Skaff had assisted in finding employment. Here we see him serving not only his own Orthodox community but newly arriving Muslim Palestinians as well. Father Skaff seemed to think that serving the entire Arab American community fell under the purview of his work as priest. As time passes, we understand his shift in perspective—he was no longer only serving within the church that he literally helped build; he was bringing his church to serve a larger community. The women in the church held dinners to raise money for various causes, and he attended those meetings and cooked alongside them. He leveraged volunteerism in the church to host televised debates between Zionists and Palestinian leaders in larger Presbyterian churches in Houston. This is the milieu Skaff was steeped in and what led her to her own activist work. Though the contents are highly varied, Skaff's stories make these boxes of paper come alive to recreate a time when their community sat squarely between Black and white neighborhoods in a segregated Houston yet residents were much freer to speak on concerns related to Palestine than we are today.

Skaff vividly remembers Naff visiting her parents' home in Houston in 1985 to interview them for her oral history collection. At that time, Skaff was newly returned from Morocco and entering a period of activist work in Hous-

ton. Naff had just published her first book, *Becoming American: The Early Arab Immigrant Experience*, and Father Skaff was serving the parish of St. Michael the Archangel Mission in Houston, the last of his eleven parish communities before he passed away in 1989.[27] While in town, Naff delivered a lecture entitled "A Tribute to the Earliest Syrian Lebanese Immigrants: The Pioneer Generation." After returning from Morocco, Skaff quickly immersed herself in work in multiple Arab American organizations. Like her father, when she came across interesting materials or attended conferences and conventions, she held on to whatever literature was available. Naff later visited her when she lived in Memphis, Tennessee, and was fundraising for St. Jude Children's Research Hospital, the first fully integrated children's hospital in the South, started by Danny Thomas. Skaff's home in Memphis was spacious, and she began to collect more things. Naff stayed for several days in Memphis and went through the family papers, according to Skaff's recollection: "I wanted her to take whatever she needed back to D.C. for the Naff Arab American archive."[28]

After her father passed away, Skaff began going through his materials in their Houston home and taking them back to her home in Memphis. When she took another position in Washington, D.C., her apartment was smaller, prompting her to rent two separate storage spaces for the family papers. Returning to Houston in 2016, she enlisted the help of various friends and her siblings to help her sort through the contents of the storage units. On a tight schedule to return to Houston, she discarded "an entire dumpster's worth" of materials. For a while, the photo of said dumpster was on her refrigerator in her high-rise apartment in Houston overlooking the museum district; we both winced while looking at it. When Skaff first invited me to her apartment to assess her family papers, I noticed it resembled a stylish Moroccan salon, with an array of textiles she had collected during her years there. The family papers, bundled and unbundled, filled up most of the salon. She would uncover it, chip away, and create boxes that she delivered to me or I picked up from her.

From 2017 to 2019, most of our time was spent processing and arranging the contents of the archive in the Archeology Lab at the University of Houston–Clear Lake. My students and I housed and rehoused categories as we came to understand their significance. All the while, I had been excitedly sharing the news of items I was coming across with my colleague Stiffler at the Arab American National Museum. His invitation to join him and Khater on an archiving grant with the National Historical Publications and Records Commission was a significant step forward in the larger project. Without the guidance, wisdom, and support of these two colleagues, the Skaff collection might have remained stagnant.

Arab American Newspapers, The Pen League, and Regional Cultural Production

When we were awarded the first of the NHPRC grants, my students and I began to revisit the Skaff collection with an eye to categorizing and delineating different types of newspapers and community bulletins, which gave the collection an organizational structure it had been lacking. The grant was intended to focus on lesser-known ethnic newspapers and community writings. With the help of my brilliant research assistant, Lauren Buchanan, we set about thoroughly organizing and categorizing all newsprint that we had. We created a master list of newspapers and publications by type. We began to understand that some of the bundles had been collected by a number of other individuals from the Lebanese or church communities. Handwritten Post-it notes with context popped up unexpectedly like Easter eggs from Skaff. This collection was indeed a public history, as it encompassed the collecting habits of a group of people who seemed to have a sort of shared methodology. Another student, Geraldo Hernandez, assisted in further organizing the newspaper collections. Fascinated with the aspects of overlap with Arab influence in Mexico and how this shaped his own family's experiences with Syrian Lebanese Mexicans, he stayed with me on the project for two years. I have been extremely fortunate to participate in a project that has inspired many students who have really given it their all.

While we were searching through the materials linked to the commemoration of the hundredth anniversary of the literary and intellectual work of Al-Rabita Al-Qalamiyya (The Pen League), the pandemic hit, and my university forbade group activity in enclosed spaces. I secured permissions to work in the lab with Lauren Buchanan and Geraldo Hernandez with the lab door open to increase ventilation, and we continued our work with full plastic face shields on. Another student, Ericka Hernandez, would also join. Though everyone had different feelings about vaccines, everyone got vaccinated so that we could continue to work in closer proximity in what felt like very surreal times. The only people we were in contact with during the pandemic were each other, and this work was done with masks, gloves, and hand sanitizer. Although the constraints of the pandemic slowed our progress, we found information on cultural production related to The Pen League and sent along what we found that could be included in Khater's online exhibition *Turath*. The Skaff archive was our cocoon, an imaginative space we shared that felt infinitely safer than the real world.

What we did not necessarily anticipate finding were such clear indications of cross-country writing and interactions through the earliest Arab American newspapers. While the *Al Hoda* newspaper and Salloum Mokarzel were well known and have been widely written about, it appears that there

was a parallel world of Gulf Coast newspapers and bulletins in circulation generated through local social clubs. During the 1930s, when Lebanon was still under French control and a newly nationalistic Lebanese identity was forming, East Coast Syrian Lebanese communities were engaged in weighing in on the ways Lebanon should or should not be represented in the 1931, 1935, 1937, and 1939 World Fairs.[29] The 1893 World's Columbian Exhibition in Chicago had put Syrian men and women on display as if they were objects to be possessed. Hitti and others proposed building a permanent project that would go beyond temporary World Fair expositions. A network of local Syrian Lebanese newspapers committed to boosting sales of subscriptions to raise funds to build the Syria-Lebanese Room, as it is called today, at the University of Pittsburgh. The project was of singular importance to the whole of the Syrian Lebanese American community. The colonial space of the World Fair was reclaimed and redesigned by the community and filled with objects, materials, and textiles entirely produced by Syrian Lebanese artisans. The space was a cultural classroom in Pennsylvania used for teaching purposes, and it still exists today. It is noteworthy that the Syria-Lebanese Room captures an authentic, if not idyllic, home space exalted with classical architectural elements and furnishings, a demystified and de-Orientalized counter representation to the World Fair temporary pavilions that blurred fantasy and fiction. The Syria-Lebanese Room focuses on a space created exclusively for experiencing traditional Arab hospitality.[30] The logic of the space resonates in the design of the ACC in Houston, apparent in its Arabic name, *Bait al-Arab*.

So far we have identified twenty-eight different Arab American newspapers, some of which we have not been able to locate in other repositories or databases. Among the oldest physical copies is *The Syrian Lebanonite Voice*, or simply *The Voice*. The paper was launched in 1933 as "the official organ of the Syrian and Lebanese American Federation of the Eastern States." It listed organization addresses in both Boston, Massachusetts, and St. John's, Newfoundland, Canada, and was printed in Albany, New York. The Skaff collection includes several issues from 1938 and 1939. The newspapers feature the writings of William "Bill" Anawaty, a Syrian Lebanese American journalist who lived in Port Arthur, Texas, and wrote for the *Port Arthur News*. In the January 1939 issue, he introduced a column called Southern Observations, stating, "we will elaborate about the South and its daily doings and welcome the thoughts and opinions of our 'Yankee' neighbors from way up north." He shared news from individuals in Lake Charles, Monroe, Lafayette, and Beaumont, Texas; Jacksonville, Florida; and San Antonio, Fort Worth, Corpus Christi, Victoria, and Houston, Texas. He also focused on Birmingham and Mobile, Alabama; Gulfport and Vicksburg, Mississippi; and Kansas City, Missouri. He concluded his first column by saying the Southerners had heard about the much-anticipated installation of the Syria-Leb-

anon Room. He noted that while their forefathers had accomplished many things, it would be a good idea to move on to contemporary issues, since the accomplishments to be heralded in the Syria-Lebanon Room "happened forty generations ago." He asserted that once the project was complete, many more of similar importance would occur. His language playfully includes Southernisms, and he leans into a storytelling narrative frame that is markedly different from that of his "Yankee" counterparts. I have seen the same linguistic playfulness among Syrian Lebanese community members from Louisiana who alternate between a Gulf Coast Southern drawl, Cajun, and Creole, with sprinklings of Arabic. Their avid participation in the Southern Federation demonstrates their loyalty to their Syrian Lebanese heritage, but the Southern part is certainly as central a dimension of their identity.

The Voice printed a comprehensive list of all local clubs in various cities and how much each local had raised to donate to the University of Pittsburgh Syria-Lebanon Room cultural preservation project, noting fundraising event themes that appear to be oriented around *hafli*-type celebrations. A Syrian Day Dance raised the largest single pool of funds, some $466.50. Other events included a skating party ($60), a Bingo benefit ($42.50), and numerous women's and girls' events. Syrian Lebanese identity was negotiated at the local level in the names that were selected, such as the Syrian People of Utica, New York; Cedars of Lebanon Club in Jackson, Mississippi; Sons of Syria in Greensburg, Pennsylvania; the Progressive Syrian-American Club of Oklahoma City, Oklahoma; the League of Americanized Syrians in Depwe, Oklahoma; the Syrian Girls Club of Vicksburg, Pennsylvania; and the L'Banette Club of Waco, Texas. In examining the enthusiasm for The Pen League, we can understand a broad community awareness and robust participation in writing and documenting local events in communities in the South. The cultivation of identity around literary circles, fledgling publishing houses, and newspapers as critical spaces for political exchange from the Ottoman period and World War I are reflected in this new wave of localized Mahjar journalism: The Southern clubs began to establish their own interests that spoke to their own local concerns.[31]

Particularly intriguing is reading the Texan press as a record of how early Syrians were welcomed, or not, by the communities they settled in. As far back as December 1878, the *Galveston Daily News* reported on "the Avant Couriers of a Colony" and the collaboration between the International and Great Northern Rail Road and the earliest Syrian immigrants, Professor Joseph A. Arbeely and his son Dr. Abraham J. A. Arbeely, who were traveling through Texas searching for a place to establish an immigrant house that would serve as a temporary home for new Syrian immigrants.[32] Texas sought to help fill labor and agricultural shortages after the Civil War by welcoming immigrants. The Skaff collection contains photocopied news clippings saved by

women of those early Syrian immigrant families who likely made their way through the immigrant house that was established in Palestine, Texas. Their own clippings from the *Palestine Daily Herald* detail how they were active participants in the Presbyterian Church and also invited Orthodox priests (Greek, Russian, and Syrian) to baptize, marry, and bury their community members. Here, early Syrians worked as grocers, wildcatters, or lawyers or in agriculture. They operated jitney services, transporting people and their belongings along a wide radius of rural Texas dirt roads. The operators of Syrian jitneys organized transportation for voting registration for women *before* they gained the right to vote, arguing that suffrage was a necessary patriotic duty while men were away during World War I.

The second-generation children from Palestine, Texas, were among some of the earliest to later establish the community in Houston. Americans were fascinated by the idea of an Arab-language press and published stories about the Arbeely family, who for a short time practiced medicine in Austin, Texas. Syrians are featured thousands of times in local Texas papers, sometimes disparagingly but oftentimes with much curiosity and appreciation. This leaves us with questions: How have Arab Americans been neglected in the historical record? And how have the descendants of these early Syrians forgotten them as well? Our volume discusses hidden histories, but how can we explain this apparent process of forgetting? Descriptions of the first newspaper printed in Arabic in New York (1892), *Kawkab Amrika* (American Star), circulated even in the tiny town of Hallettsville, Texas, which had a population of less than 2,000 and only just recovered its newspaper after the building burned down during the Civil War. The story depicts the news office with an illustration of a hardworking Syrian writer wearing a fez and bent over a desk amid Eastern decor.[33]

The strong encouragement within the Syrian Lebanese community to subscribe to publications and be active community members helps explain the large number of publications in the Skaff collection, and an examination of the Texan press shows great interest in newspaper more broadly. Father Skaff would have been a young man in the 1930s, when the larger community wrestled with issues of identity and acceptance within the American public sphere. Acquiring and reading community publications would have been understood as a practice of solidarity and patriotism. Anawaty's Southern Observations column continued in *The Voice*, and his stories hearkened to the establishment of the Southern Federation of Syrian Lebanese American Clubs (SouFed). According to a Southern Federation history written to celebrate its fiftieth-anniversary convention, organizers stated that Salloum Mokarzel's November 1928 article in *The Syrian World*, "Can We Retain Our Heritage?," had been a rallying cry to "a group of young people living in Port Arthur, Texas."[34] Standing up to "hatred, class prejudice, slander, and discrim-

ination," some four hundred Syrian Lebanese from Arkansas, Mississippi, Louisiana, and Texas gathered in Port Arthur on July 4, 1931; the event was sponsored by the local Young Men's Amusement Club (YMAC). SouFed was born from the community taking a stand and it continues on as a vibrant cultural organization today.

Texan papers documented that Syrian Lebanese men and women peddlers and store owners across the South fell victim to incidents of theft, burglary, and assault. In Texas, Syrians feared deportation and faced impromptu house-to-house searches by immigration agents looking for undocumented people and those believed to be spreading trachoma.[35] Despite it being established in court cases that Syrians were "white" and therefore entitled to naturalization and protections of citizenship, historic newspapers provide much evidence for periods of discrimination with regard to the ever-shifting sands of ethnic and racial equity in Texas.[36] A most alarming incident involved the murder of George Faddel, a widower who immigrated in 1876 and owned an established grocery store in Austin. He was murdered while sleeping in his own bed in 1906.[37]

The idea of creating a federation emerged in response to such discrimination over several decades, and the creation of souvenir booklets for conventions would provide a shared history as different cities took turns hosting. We see again and again this juxtaposition of justice and joy as the double rationale for creating local clubs and the regional federation. One of the draws for the large group who traveled to Port Arthur was watching the YMAC play baseball. In addition to writing for the *Port Arthur News* and Southern Observations for *The Voice*, Anawaty also cocreated the Syrian Lebanese Baseball League in Texas.[38] Two months later, the Syrian Girls Friendly Club in Austin sponsored the next gathering, wherein a constitutional committee was established with representatives from San Antonio, Tyler, Austin, and Dallas, Texas, as well as New Iberia and Lafayette, Louisiana. For the next year, they shared a draft constitution with clubs across the South, and they held the first official convention in Beaumont, Texas, in 1932.

In 1933, the *Southern Federation of Syrian Clubs Official Bulletin* was born in Port Arthur, Texas, and referred to itself as a "modest pamphlet" that aspired to be "worthy of the entire populace of the Syrian-American world in the southland."[39] The bulletin reads more like a constitution laying out its purpose, committees, and leadership, all of whom were from Houston and Port Arthur, Texas. In a section addressing why the community should organize a federation, the two objectives were "recognition and protection." The second page of the bulletin asserts, "By protection we mean that no man or men shall attempt to unduly sully the name of the Syrian, either by deploring or exaggerating living conditions in Syria or by attacking their scruples as a group. We aspire to be the mouthpiece of the Phoenician and help promul-

gate such conditions as will make our descendants as proud of us as we are of our ancestors."[40]

The lengthiest portion of the bulletin documents an incident of the "misfortune of being the target of unfair opposition" wherein the Jung Hotel of New Orleans, where the second convention was held in 1932, accused the group of poor behavior during their gathering. The Jung Hotel then wrote a letter of complaint to the Houston Hotel Association to dissuade hotels there from hosting their next convention. Amuny, who was federation president, traveled to the Jung Hotel to conduct his own investigation. The federation then collected letters of reference from other hotels, which they kept on file in their Beaumont office. Hence, the federation determined to protect its community did just that in its first year of existence. I shared this story with Skaff and showed her that bulletins had sponsors that constituted supporters and safe spaces for the traveling Syrian Lebanese youth who were eager to enjoy their rising middle-class status and to join the open roads during America's early love affair with the automobile. This generation was markedly different from their parents, who had been eager to leave behind their experiences of immigration, peddling, and living through the Great Depression and World War I; Anawaty said as much in a number of publications. Skaff coined the term *the Syrian Lebanese Green Book* as a way to think about the deeply courageous work that went into creating gala and convention brochures and the leisure spaces of conventions for a group that continued to face discrimination.[41] Her thinking reveals the inherently political work of creating spaces where the community could meet in public and experience the joy of the *hafli* without fear.

The inaugural *Southern Federation Bulletin* went on to salute regional clubs that generated two papers that "entered the field of combat" by creating published work on the Syrian community. One was the Syrian Ladies Educational Society of Oklahoma City, which produced a newspaper in both English and Arabic. The second was a "bulletin-form pamphlet mimeographed for organizational news by the Syrian-American Club of New Orleans." The presence and participation of women in the local Southern clubs is remarkable. Readers were directed to procure a copy of *The Syrian Voice* (i.e., *The Syrian Lebanonite Voice*) to read Anawaty's column there. Additionally, readers were encouraged to subscribe to the *Syrian-American News* of Los Angeles, *The Syrian World* of New York, and *Al Manarah* from Oklahoma City. Reading all of the local journals would both support local communities and help people living across different cities remain tuned into what they were all experiencing. A central ethic of community archiving was introduced as readers were instructed to consider things in their possession that might be useful: "Any item that might prove of interest to us, such as pictures of Syria and the like, should be sent to headquarters." In closing the very first federation

bulletin, the contributors wished readers a happy holiday season while reflecting on the birth of Jesus, "who first saw the light of day in Syria some two thousand years ago. In the name of those people who inhabit His natal land we wish you not only a MERRY CHRISTMAS but in the language of our fathers we sincerely proclaim—'SALAAM ALLAYKUM.'"

The Skaff collection's many publications are a continuation of this ethic of engaging in reading about and recreating the heritage of "Syria." The *Turath* online exhibition launched as a part of our first NHPRC grant captured accomplishments in the area of journalism: "The scope of this publishing effervescence is remarkable: A community that did not exceed 140,000 Arab Americans in 1930 sustained over 81 publications, the equivalent of one newspaper or journal for every 1,800 immigrants. By comparison, in the U.S. in 1930 there was one publication for every 50,000 Americans."[42] The Southern Federation authors of the fiftieth-anniversary history explained that *Syria* was "a generic term applying to all those coming from that particular part of the Middle East."[43] Though they continue to reinvent and renegotiate identity in new ways, the nexus between responding to discrimination through writing, sustaining clubs, associations, and federations, and offering cultural programming in the vein of public history can be seen as a pattern of interaction across regions and generations in the South.[44]

Community Engagement as the Cornerstone of Public History

With renewed funding from the NHPRC, in 2022, we continued our objectives from the previous grant by introducing the scope of our collective work to different Arab American groups. Workshops and presentations were given in our respective cities, and we worked together as a cultural committee under the guiding hand of Skaff in preparation for the 91st annual SouFed convention in Houston. We met virtually for nine months with members from the Southern Federation in various cities to prepare a program that featured our scholarly work to present to the community.[45] After dedicating our efforts toward archival discoverability, our charge with the second NHPRC grant was to introduce our collective work with the public at the Southern Federation Convention held in Houston in July 2022, under the slogan "Debka Down in H-Town." To meet our grant objectives, our team created introductory archival informational sessions available on the Arab American National Museum's website. We worked in partnership with the Southern Federation leadership to create a vision of cultural programming that would be appealing to the 900 attendees. The convention included a sponsored luncheon, a mountain of raffle prizes procured by Skaff, film screenings and documentaries,

our archival preservation workshop, and the collecting of oral histories aimed at youth to "sow the seeds" for future participation in the federation.

Rather than simply soliciting participants to donate their family's archival materials, we introduced the practice of archiving in the broadest possible sense. Stiffler offered advice on the nuts and bolts of conservation and distributed sample materials such as acid-free paper, plastic sleeves to protect photographs, and boxes and described the optimal conditions and temperatures at which important family items could be preserved at home. In an effort to promote lasting engagement and public buy-in through community-based training, this portion of the project helped guide local Arab American community members in the process of using best practices to preserve their own family histories. The training walked participants through the significance of their objects and how to properly document, store, and handle their materials and provided an overview of this project's scope and larger goals.

I presented the contents of the Skaff collection and showed images of different items that included various types of print material, photographs, clothing, and political posters and paraphernalia. I discussed the ways we might extract knowledge from photographs using an archeological perspective in cases where little is known about the photograph and the people in it. To shake off the formality of the notion of "an archive," I explained the ways in which Skaff and her family had acquired a unique assemblage of materials. I offered an example of how photographed newspaper clippings from Palestine, Texas, between 1915 and 1920 that featured stories about Syrian Lebanese weddings and *haflis* had the potential to rewrite or at least require us to seriously reconsider our predominant paradigms about Arab American public history. What might these small clippings about a sixty-five-pound wedding cake and fabrics carried from Damascus, Beirut, Paris, and New York by train, before phones and other technologies we take for granted today, to a small Texas town tell us about the importance of family and celebration? How does this circulation of people and goods via train reinvigorate our notions of "peddling" and trade? We encouraged participants to contact us or to reach out to repositories near them to seek input and advice from archivists. As a start, we advised workshop participants to consider thinking about their family papers and materials and ways to digitize them to share among their own family members.

Khater introduced "Texas Bound: Syrian-Lebanese Immigrants in the Lone Star State," a beautiful project that blends storytelling and data visualization to provide a better understanding of the long history of Syrian Lebanese communities in Texas. Akram then discussed the searchable Arabic newspaper database he and his team have been working on and how this tool will surely expand our understanding of the global Arab diaspora. Applying the concept of meta tagging used in library science databases, Akram

encouraged the workshop participants to get together with their families for a photo meta-tagging party, to record the conversation about photos and family members to preserve family knowledge, and to then begin to archive the materials. The question-and-answer session of the workshop ventured into reflections on what the future of archiving will look like, given that most of our devices are essentially digital archives, whether stored in our phones or curated in places like Facebook and Instagram. One participant asked if we are in danger of losing history since we will have fewer physical artifacts. Indeed, this is the million-dollar question on the minds of community archivists and public historians.

We wrapped up the Southern Federation convention in Houston in much the same sort of setting as I enjoyed the evening I first met Skaff, among those for whom heritage preservation is of central importance, in the company of friends who discussed the possible trajectories for her family's substantial collection. My role in the last phase of the project has been to continue to identify Arab American archival holdings throughout Texas and the Gulf Coast. These newly identified collections have become part of an Index of Arab American Archives aimed to increase new scholarship and new thinking around Arab American experiences.[46]

As anyone who has ever worked with archives knows, the work never really ends. As new technologies emerge, our ability to make portions of some larger archival collections available digitally can increase access and discoverability for future scholars and research. We still have so much to learn from the Skaff archive and the realities of an Arab American Christian community in the South that struggled to find acceptance as an Orthodox minority on the edge of whiteness during the period of immigration quotas and restrictions in the early twentieth century. The Supreme Court's declaration that they were provisionally "white" was the result of Arab American networks activated through churches and social organizations, and these struggles are documented in the ephemera of *hafli* program brochures, photographs, political buttons, and much more. An Arab American archive in the South is not a niche project; it is both the missing tile in the American mosaic and a chink in the armor of carceral liberalism.[47] The Arab American archive forces us to ask ourselves which bodies matter and under what historical and political circumstances. The archive unsilenced asks us to hear "I can't breathe" in new places and to connect instances from the past to the unimaginable horrors we still witness today.

Archives hold some of the most critically important stories, lessons, and answers to how ethnic and cultural groups have interacted, negotiated, and held space for each other over time. Arab American public history at the end of the day is American public history. A bellwether and mediation on the state of inclusion and exclusion, community archival collections reconsti-

tute our fragmented knowledge about struggles and challenges. The times in which we live perhaps pose the greatest injustices the Arab world has ever seen, and like those Arab American scholars who came before us, we will continue to respond through research and activism in new ways. Fortunately, our ability to discover, build, share, and access Arab American archival collections has never been greater than it is today.

NOTES

1. Maria F. Curtis, "On Fasting in Fes: Learning about Food, Family, and Friendship during Fieldwork in Morocco," in *Studying Islam in Practice*, ed. Gabriele Marranci (New York: Routledge, 2014), 8–20.

2. Michelle Caswell, Marika Cifor, and Mario H. Ramirez, "'To Suddenly Discover Yourself Existing': Uncovering the Impact of Community Archives," *American Archivist* 79, no. 1 (2016): 56–81.

3. Cherstin Lyon, Elizabeth Nix, and Rebecca K. Shrum, *Introduction to Public History: Interpreting the Past, Engaging Audiences* (Lanham, MD: Rowman & Littlefield, 2017), 14–15.

4. Helen Hatab Samhan, "Farewell to the Grande Dame of Arab American Social History: Reflections on My Debt to Alixa Naff," *Arab Studies Quarterly* 37, no. 1 (2015): 96–99.

5. Hani J. Bawardi, "'Someone Will Come Along and Write the Next Chapter': The Importance of Alixa Naff for Arab American Studies," *Arab Studies Quarterly* 37, no. 1 (2015): 118–123.

6. Caswell, Cifor, and Ramirez, "To Suddenly Discover Yourself Existing," 56–81.

7. Tina L. Ligon, "Experiencing Black Joy through Federal Archives," Rediscovering Black History, The National Archives, February 9, 2022, https://rediscovering-black-history.blogs.archives.gov/2022/02/09/black-joy-through-federal-records/; Michelle Caswell, "Feeling Liberatory Memory Work: On the Archival Uses of Joy and Anger," *Archivaria* 90 (Fall 2020): 148–164, https://muse.jhu.edu/article/775285; Melissa J. Nelson, "Reflections on Black Joy in the Archives," February 5, 2024, https://www.melissajnelson.com/blog/reflections-on-black-joy-in-the-archives.

8. *Freedom's Journal* Online Archive, Wisconsin Historical Society, accessed June 8, 2025, https://www.wisconsinhistory.org/Records/Article/CS4415.

9. Formerly known as the Houston Metropolitan Research Center, recently renamed the Houston History Research Center.

10. Julia Ideson Library Preservation Partners, accessed June 8, 2025, https://ideson.org/donors.php.

11. Michelle Caswell and Marika Cifor, "Neither a Beginning or an End: Applying an Ethics of Care to Digital Archival Collections," in *The Routledge International Handbook of New Digital Practices in Galleries, Libraries, Archives, Museums and Heritage Sites*, ed. Hannah Lewi, Wally Smith, Dirk vom Lehn, and Steven Cooke (Milton: Taylor & Francis, 2019), 159–168.

12. Marika Cifor, Michelle Caswell, Alda Allina Migoni, and Noah Geraci, "'What We Do Crosses over to Activism': The Politics and Practice of Community Archives," *The Public Historian* 40, no. 2 (2018): 69–95.

13. "Hadji Ali," The Arizona Memory Project, accessed June 8, 2025, https://azmemory.azlibrary.gov/nodes/view/252497; Ann Earney, "The Camels Are Coming," 1977, University of North Texas Libraries, Portal to Texas History, accessed April 30, 2024, https://

texashistory.unt.edu/ark:/67531/metapth39375/; Frank B. Lammons, "Operation Camel: An Experiment in Animal Transportation in Texas, 1857–1860," *Southwestern Historical Quarterly*, July 1957–April 1958.

14. Wendy Duff, Jennifer Carter, Joan M. Cherry, Heather MacNeal, and Lynn Howarth, "From Coexistence to Convergence: Studying Partnerships and Collaboration among Libraries, Archives, and Museums," *Information Research* 18, no. 3 (2013): 1–26.

15. Sarah M. A. Gualtieri, "Edward Said, the AAUG, and Arab American Archival Methods," *Comparative Studies of South Asia, Africa and the Middle East* 38, no. 1 (2018): 21–29.

16. Andrew Flinn, Mary Stevens, and Elizabeth Shepherd, "Whose Memories, Whose Archives? Independent Community Archives, Autonomy and the Mainstream," *Archival Science* 9 (2009): 71–86.

17. Stuart Hall, "Constituting an Archive," *Third Text* 15, no. 54 (2001): 89–92, https://www.doi.org/10.1080/09528820108576903.

18. Hall, "Constituting an Archive," 89.

19. Arjun Appadurai, "Archive and Aspiration," in *Information Is Alive—Art and Theory on Archiving and Retrieving Data*, ed. Joke Brouwer et al. (Rotterdam: V2_NAi, 2003), 14–25, see page 23.

20. Appadurai, "Archive and Aspiration," 14.

21. "In Memorium Alixa Naff (1919–2013)," *Arab Studies Quarterly* 35, no. 4 (2013): 340–342.

22. Fariha Khan, "Alixa Naff, Notable Folklorists of Color," accessed June 8, 2025, https://www.notablefolkloristsofcolor.org.

23. Khan, "Alixa Naff."

24. Thomas Skaff is listed as the president of the Sioux City Crusaders in the *Sioux City Syrian American Directory*, published in 1938; it is one of the Syrian directories in the Skaff collection.

25. Anna Rose Faour, "Call It Faith: A Brief History of the Saint George Antiochian Orthodox Church of Houston, Texas, from 1893 to April 22, 1990," edited by Archimandrite John Namie. This is a church history written in celebration of paying off the church mortgage and is part of the Skaff collection. See also James Patrick McGuire, *The Lebanese Texas and the Syrian Texans* (San Antonio: University of Texas Institute of Texan Cultures, 1988).

26. Faour, "Call It Faith," 1–3.

27. Alixa Naff, *Becoming American: The Early Arab American Immigrant Experience* (Carbondale: Southern Illinois University Press, 1985).

28. Ruth Ann Skaff, interview, December 2023.

29. Asher Kaufman, "'Too Much French, but a Swell Exhibit': Representing Lebanon at the New York World's Fair 1939–1940," *British Journal of Middle Eastern Studies* 35, no. 1 (2008): 59–77.

30. Maria F. Curtis, "From Longing to Belonging: Arab American Cultural Adaptation and Refugee Resettlement Practices in Houston, Texas and the Gulf Coast," in *The Urban Refugee: Space, Displacement, and the New Urban Condition*, ed. Bülent Batuman and Kıvanç Kılınç (Chicago: Intellect, 2024); "The Syria-Lebanon Room," University of Pittsburgh, accessed June 8, 2025, https://www.nationalityrooms.pitt.edu/rooms/syria-lebanon-room.

31. Stacey Fahrenthold, "Transnational Modes and Media: The Syrian Press in the Mahjar and Emigrant Activism During World War I," *Mashriq & Mahjar* 1, no. 1 (2013): 34–63. Here, I am adding a Southern piece onto Fahrenthold's model.

32. "Orient and Occident: Syrian Christians Seeking Homes in Texas," *Galveston Daily News*, December 1878, 4.

33. "Another Daily Newspaper: The First One Published in America in the Arabic Tongue Comes Out To-Day," reprinted from *New York Times*, July 8, 1898; see also W. A. Mair, *Halletsville Herald* 24, no. 24, May 23, 1895.

34. Southern Federation of Syrian Lebanese American Clubs Golden Year History, produced for the Fiftieth Anniversary Convention in 1981. Documents in the Southern Federation Series, box 1. Skaff collection, held at the University of Houston–Clear Lake.

35. "'How Syrians Cross the Line': Immigration Inspectors Think Their Admission of Greater Importance than the Chinese," *Brownsville Herald*, April 17, 1906; "To Examine Syrians in Texas: Those Found with Eye Disease Will Be at Once Deported," *Houston Post*, September 6, 1906.

36. Texas papers watched two cases on racial classification very closely. The first was that of Dr. Justin H. Kirreh in Washington, D.C. See "Seek to Remove Head of Federal Division: Chief of Naturalization Bureau Charged with Prejudice Against Syrians," *Fort Worth Star-Telegram*, November 2, 1909. The second concerned discrimination against "the Syrian Oscar Adwan, born 30 miles from Jerusalem," who was a theology student at Baylor University. See "Investigation of Officer's Conduct," *Waco Times Herald*, March 15, 1915.

37. "Search for Murderer: Officers Following Several Clues to Detect Murderer of George Faddal, the Syrian Merchant," *Austin American-Stateman*, December 31, 1906.

38. Diana Wray, "A League of Their Own," *Aramco World* 71, no. 6 (2020): 10–15.

39. *The Southern Federation of Syrian Clubs Official Bulletin*, no. 1, Port Arthur, Texas, 1933.

40. *Southern Federation*.

41. Curtis, "From Longing to Belonging," 83.

42. *Turath*, Moise Khayrallah Center for Lebanese Diaspora Studies, North Carolina State University, accessed June 8, 2025, https://www.turath2020.org/press.

43. Southern Federation of Syrian Lebanese American Clubs Golden Year History, produced for the Fiftieth Anniversary Convention in 1981. Documents in the Southern Federation Series, box 1. Skaff collection, held at the University of Houston–Clear Lake.

44. The Skaff collection's highly varied print collections include the following types of materials: Arab American Magazines (24), religious newspapers (20), U.S. newspapers (58), Texas newspapers (29), U.S. magazines (35), U.S./Texas newsletters, bulletins, and journals (12).

45. Convention, Southern Federation of American Syrian Lebanese Clubs, accessed June 8, 2025, https://www.sfslac.org/content.aspx?page_id=4002&club_id=702500&item_id=1665796.

46. An Index of Arab American Archives, Khayrallah Center for Lebanese Diaspora Studies, North Carolina State University, accessed June 8, 2025, https://storymaps.arcgis.com/stories/bb0bb5615b714861b2435e404a00b990.

47. Maria F. Curtis, "Vacant Refuge, Unfinished Resettlement: Syrian and Iraqi Refugee Women and Children Assembling 'Home,'" in *Carceral Liberalism: Feminist Voices against State Violence*, ed. Shreerekha Pillai (Chicago: University of Illinois Press, 2023), 190–210.

What is your race and/or ethnicity?
Select all that apply and enter additional details in the spaces below.

☐ **American Indian or Alaska Native** – *Enter, for example, Navajo Nation, Blackfeet Tribe of the Blackfeet Indian Reservation of Montana, Native Village of Barrow Inupiat Traditional Government, Nome Eskimo Community, Aztec, Maya, etc.*

☐ **Asian** – *Provide details below.*
- ☐ Chinese ☐ Asian Indian ☐ Filipino
- ☐ Vietnamese ☐ Korean ☐ Japanese

Enter, for example, Pakistani, Hmong, Afghan, etc.

☐ **Black or African American** – *Provide details below.*
- ☐ African American ☐ Jamaican ☐ Haitian
- ☐ Nigerian ☐ Ethiopian ☐ Somali

Enter, for example, Trinidadian and Tobagonian, Ghanaian, Congolese, etc.

☐ **Hispanic or Latino** – *Provide details below.*
- ☐ Mexican ☐ Puerto Rican ☐ Salvadoran
- ☐ Cuban ☐ Dominican ☐ Guatemalan

Enter, for example, Colombian, Honduran, Spaniard, etc.

☐ **Middle Eastern or North African** – *Provide details below.*
- ☐ Lebanese ☐ Iranian ☐ Egyptian
- ☐ Syrian ☐ Iraqi ☐ Israeli

Enter, for example, Moroccan, Yemeni, Kurdish, etc.

☐ **Native Hawaiian or Pacific Islander** – *Provide details below.*
- ☐ Native Hawaiian ☐ Samoan ☐ Chamorro
- ☐ Tongan ☐ Fijian ☐ Marshallese

Enter, for example, Chuukese, Palauan, Tahitian, etc.

☐ **White** – *Provide details below.*
- ☐ English ☐ German ☐ Irish
- ☐ Italian ☐ Polish ☐ Scottish

Enter, for example, French, Swedish, Norwegian, etc.

In 2024, the U.S. government mandated the addition of a "Middle East or North African" category for data collection on race and ethnicity. The term *Arab* was conspicuous in its absence. (*Credit: 2024 Federal Register*)

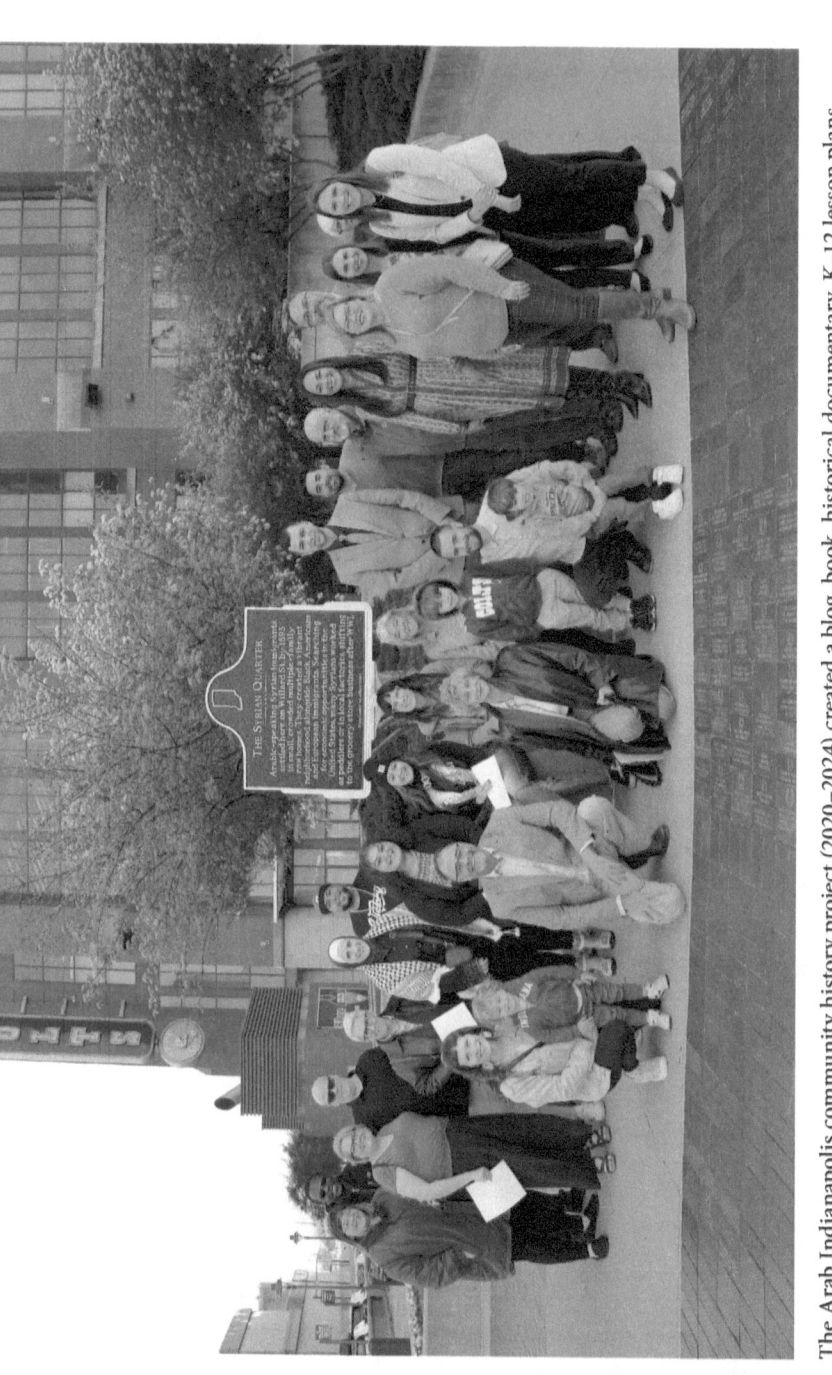

The Arab Indianapolis community history project (2020–2024) created a blog, book, historical documentary, K–12 lesson plans, heritage trail, community dialogues, and Indianapolis's first historical marker about Arab Americans in Indianapolis, located at Lucas Oil Stadium, once the site of the Syrian Quarter. (*Credit: Edward E. Curtis IV*)

A Yalla Eat! tour group interacts with staff at Hashems in Dearborn, Michigan. The shop roasts coffee and nuts and sells a wide variety of imported specialty goods. Hashems has been in business since the 1980s. (*Credit: Arab American National Museum*)

Standing in front of Saint Elias Antiochian Orthodox Church in La Crosse, Wisconsin, a tour group peruses Arab American 78 rpm records collected by tour leader Richard Breaux. (*Credit: Richard M. Breaux*)

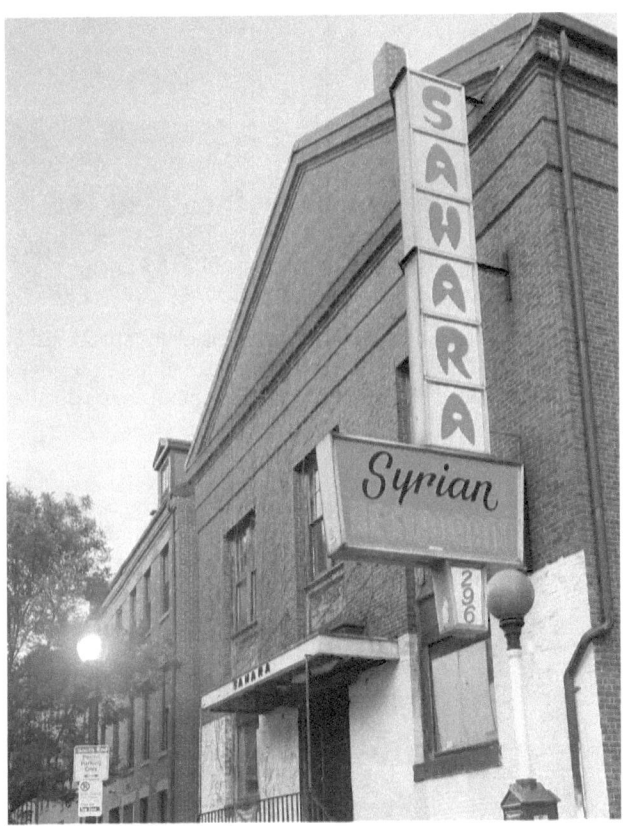

The former Sahara Syrian Restaurant at 296 Shawmut Avenue. It is one of the last extant buildings from Boston's once-vibrant Little Syria neighborhood. (*Credit: Chloe Bordewich*)

The National Society for Arab and Arab American Genealogy, established by Reem Awad-Rashmawi, has expanded beyond participating in national genealogy meetings to holding consultations and seminars specifically for Arab American audiences. (*Credit: Reem Awad-Rashmawi*)

Presenters at the daylong Arab American public history conference at the Indiana University Indianapolis campus on February 16, 2024. Left to right, back row: Richard M. Breaux, Reem Awad-Rashmawi, Matthew Jaber Stiffler, Randa A. Kayyali, Maria F. Curtis, Chloe Bordewich; front row: Naiara Müssnich Rotta Gomes de Assunção, Edward E. Curtis IV. (*Credit: Rebecca K. Shrum*)

5

Midwest Mahjar

Cityscapes, Soundscapes, and Centering Arab American Biographies in Public History

Richard M. Breaux

This chapter chronicles my efforts to uncover, document, preserve, and share the histories of Arab Americans in La Crosse, Wisconsin, and the Arab American musicians and singers people in this community listened to in the first sixty years of the twentieth century. My interests in the cultural lives and musical tastes of Arab Americans in La Crosse extend beyond just popular Arab American headliners to what record labels these musicians signed to, who owned them, and whether customers purchased these records from area music stores or local, regional, or national Arab American sellers that supplied La Crosse's residents with domestic and international Arabic-language music. Rather than retelling stories I have written and told in detail elsewhere, this chapter concerns itself with the process of making the stories I have heard, documented, and learned from. From the beginning, my interests lay with challenging the ways non-Arabs have omitted, distorted, and, as the late media scholar Jack Shaheen asserted, vilified people of Arab descent in the United States yesterday and today.

In January 2016, amid the Syrian refugee crisis, I launched three interconnected Arab American public history projects—a Facebook-based group page, "Syrian/Lebanese Community of La Crosse History, 1890s–1970s"; *Midwest Mahjar* [Diaspora], a blog centering the music and biographies of mostly Arab Americans involved in the early Arab-language music recording industry; and a Syrian/Lebanese La Crosse historic walking tour. The trio sprang from my interest in collecting 78 revolutions per minute phonograph records after a chance unearthing of seventy Arabic-language discs at a La Crosse es-

tate sale. Initially, I could not distinguish Arabic-language records produced in the United States for the Mahjar (Arabic-speaking populations who had been emigrating from Greater Syria and settling across the country since the 1870s and their descendants) from those phonograph discs recorded in the Middle East for consumption by the Mashriq (the Eastern Arab world from Egypt to Iraq). Using newspapers, city directories, immigration documents, military records, recorded oral histories, interviews, personal and professional connections, and secondary literature, I developed projects highlighting the lives, communities, and cultural expressions of Arab Americans. Soon these sites became archives, historical reference points, and educational resources demonstrating the transformative power of preserving, writing, and presenting public history that disrupts existing narratives about who is Midwestern and American.

These virtual public histories have, as Daniel J. Cohen and Roy Rosenzweig suggest in *Digital History*, compelled us "to rethink ways that [we] research, write, present, and teach the past" while allowing a global audience of "ordinary people a greater degree of participation in public historymaking."[1] Simultaneously, the digital sites and walking tour offer Arab American people's histories that elucidate this racially liminal, diversely religious, and laborious group that is "underrepresented in curricula, pop culture, and tourist experiences, like city and museum tours."[2]

I have taught African American history for over twenty years but have only taught Arab American history within the context of ethnic studies for approximately twelve years. I have been a 78 rpm record collector for just over ten years and only took up the hobby seriously when my wife suggested I buy an old 1953 Silvertone phonograph with 78 rpm records and listen to these to escape the stresses of being an academic. I primarily sought out jazz, gospel, and blues recordings until November 7, 2015, when I dropped by an estate sale in a small white two-story house with forest-green trim on La Crosse's Northside. Excited by the 78 rpm storage albums on the living room floor, I fingered through the discs and then noticed some with a combination of English and Arabic or only Arabic on the labels. Fortunately, my curiosity got the best of me, and I grabbed two or three storage albums and left the remainder there. Upon arriving home, I snapped several photos using my dated mobile phone and posted my findings to the "78 rpm Records & Cylinders Fan Group" on Facebook. After I relayed my story there, group members advised that I return to retrieve the remaining discs. Since the spring semester of 2016, I have taken a sample of these records to my Introduction to Ethnic and Racial Studies course to share with students as a local example of the larger theme of Arab immigrant cultural retention and production in the United States.

My initial discovery of Arabic-language 78 rpm records spawned three related public history projects, some of which have since taken on lives of

their own—(1) a public but moderated "Syrian/Lebanese Community of La Crosse History, 1890s–1970s" Facebook page; (2) a duo-location-based La Crosse Syrian/Lebanese Historic Walking Tour; and (3) *Midwest Mahjar*, a music-themed, biography-centered blog that highlights the lives and histories of Arab American musicians, record labels, record sellers, and record-label owners who served Arab American consumers during the era of mostly 78 rpm recordings (1900–1961).

To date (November 2023), I have completed four walking tours, seventy Facebook posts on the "Syrian/Lebanese Community of La Crosse" page, and over eighty music-related blog posts on *Midwest Mahjar*. These public history projects have reached 64 in-person tourists, 470 Facebook followers for the La Crosse page, and 562 Twitter/X followers of the blog. *Midwest Mahjar* has over 83,000 views from readers, researchers, and music lovers in sixty-six countries and on six continents.

Centering Biography

The three public history projects utilize and center biographies to tell a larger history of Arab Americans in La Crosse and the Arab American recorded music industry in the 78 rpm era. In my public history work, I have found that people outside academia are more interested in the lives of other people than the theoretical and analytical frameworks I have applied to pieces of writing or which academic scholars are in conversation with one another. As the researcher and author of all the narratives connected to these projects, however, I am very much aware of which stories affirm and challenge "the peddler thesis" interrogated by Charlotte Karem-Albrecht.[3] For example, both patriarchs and matriarchs in La Crosse's Wakeen and Markos families initially worked as self-employed peddlers. Other early settlers in the Addis, Abraham, and Ferris families found employment in the local shoe factory or for one of the five railroad companies that passed through La Crosse.

Biographies, like all stories, have a beginning, middle, and end, but they typically convey a larger message that this person did or created something you should know about; this is what that thing is, why it is important, and how it likely relates to the public. Stories may cover struggles with the process of immigration and naturalization, local conflicts within La Crosse's Arab American community or between the community and non-Arab locals, local Syrian and Lebanese cultural and social organizations, the Saint Elias Antiochian Orthodox Church or Our Lady of Lourdes Syrian Melkite Church, the Midwest Federation of Syrian and Lebanese Clubs, connections to local fraternal organizations like the Shriners, and the occupational exploits of those who were both employed and self-employed.

For those first- or second-generation Syrian and Lebanese American residents who attended public or private schools in La Crosse, there are stories of the ease and difficulty of assimilation and of experiences with marginalization based on food, language, clothing, and perceived racial identity. Those who immigrated as children and those who were U.S.-born could have very different experiences, especially in their roles as go-betweens helping their parents navigate a new country. Locally, those residents born in Greater Syria stood a better chance of marrying another Arabic speaker than those who were born in the United States.

Shared Content and Context

The content shared by my three public history projects is the contextual information grounded in Arab American history and historiography. It seems inevitable that almost any piece of Arab American history would draw from several foundational texts, including Alixa Naff's *The Arab Americans* (1988) and *Becoming American: The Early Arab Immigrant Experience* (1993); Eric Hooglund's *Crossing the Waters: Arabic-Speaking Immigrants to the United States before 1940* (1987); Gregory Orfalea's *Before the Flames: The Quest for the History of Arab Americans* (1988); Akram F. Khater's *Inventing Home: Emigration, Gender, and the Middle Class in Lebanon* (2001); Linda K. Jacobs's *Strangers in the West: The Syrian Colony of New York City, 1880–1900* (2015); and Sarah M. A. Gualtieri's *Between Arab and White: Race and Ethnicity in the Early Syrian American Diaspora* (2009). Drawing from these texts and local primary source material, I crafted a narrative that explains how the first three or four Arab immigrants came to La Crosse after the Columbian Exposition in 1893, worked, sent for relatives, and began to build La Crosse's Syrian community. I explain the links between why immigrants came to the United States and the collapse of the silk industry and describe the rise of Lower Manhattan's mother colony, connections to other communities in Boston and Detroit, the birth of the Arab American press, and the creation of local Syrian Orthodox, Melkite, Maronite, and Muslim religious institutions based on who settled where in the United States.

While the connection to New York's Little Syria may be abstract to some on the Facebook page and the tours, I point out that La Crosse was mentioned in Dr. Nassif Abdou's 1907 "Travels in America." *Al-Hoda* newspaper's Naoum Mokarzel visited La Crosse in 1914, and Brooklyn's Archbishop Reverend Raphael Hawaweeny visited in 1914. Philip Hitti's 1924 *Syrians in America* lists La Crosse's Saint Elias Syrian Orthodox (1909) and Our Lady of Lourdes Catholic Melkite (1906) churches among the congregations created in Arab American communities across the United States. Moreover, Elaine

Monsoor noted in an interview that the Shahadi Brothers in Brooklyn, New York, served as a major supplier to Monsoor's and Abraham's grocery stores in the 1930s and 1940. On the walking tour, I point out that Shahadi's still operates its flagship store on Atlantic Avenue in Brooklyn. Tour participants familiar with Brooklyn's Arab American presence are quick to confirm this to those unfamiliar with larger Arab American history and culture.

Recorded 78 rpm discs connected Arabic-speaking people throughout the diaspora, even as they came and went across international borders. Initially, musicians recorded for the larger commercial labels Columbia/Gramophone and HMV/Victor, but they soon branched out to German-based Odeon and other labels. Recordings by Arabic-speaking musicians began with two piano solos by Alexander Maloof on Victor, followed by Maronite minister Reverend George Aziz on Columbia and a slew of other artists, including Louis Wardiny, Nahum Simon, Constantine Souss, Zekia Agob, and Mohamed Zaineldeen, on either Victor, Columbia, or both labels. We do not have any record of how well or poorly Arabic records sold for Columbia or Victor, but we do know that U.S.-founded Macksoud and Maloof came to dominate about 80 percent of the Arabic-language music market in the United States by the early 1920s. Abraham J. Macksoud created the first Arab American label by pressing duplicates by the likes of Zaki Morad and by the 1920s as Victor and Columbia retrench releases of Arabic-language musicians in the United States. Macksoud and Maloof, in acts of entrepreneurial self-determination, launched domestic labels with both former Victor and Columbia artists as well as new singers and musicians by 1920.

Arab American residents of La Crosse such as Siad, Shahenne, and Elaine Addis and John, Nellie, and Elaine Monsoor held on to phonograph records from the first sixty years of the twentieth century. Their collections of recorded music included songs on the Baidaphon, Victor, Columbia, Macksoud, Maloof, Alamphon, Al-Chark, Abedelahad, Morad, Arabphon, and Alkawakeb labels, further demonstrating the connections between the Mashriq and the Mahjar and between Mahjari, or diasporic, communities spread across the United States. Readers of the Facebook group and *Midwest Mahjar* can see photographs of these records online and listen to digitally transferred music from these discs. People on the tour have an opportunity to see examples of ten different discs from my personal collection in real life just before the formal tour begins.

Additional shared contextual information about Arab immigrant and Arab American experiences in the Facebook group, on the tours, and on various *Midwest Mahjar* posts includes brief histories of naturalization, the 1790 Naturalization Act, the Chinese Exclusion Act of 1882, the George Najour, Faras Shahid, George Shishim, and George Dow cases between 1907 and 1915,

and the enactment and repeal of the 1924 Johnson-Reed Act.[4] These examples not only provide opportunities to reflect on the racialized and ethnic histories of the United States before 1965, they also offer people on the tour chances to contemplate and interrogate more recent histories of Arab Americans post-9/11, in connection with the role of Midwest governors in relocation efforts during the Syrian refugee crisis and the influence of the 2017 Refugee Ban on Arabs and non-Arabs from Muslim majority countries. People on the tour also learn about recent campaigns by some Arab Americans to have either MENA (Middle Eastern and North African) or SWANA (Southwest Asian and North African) as its own racial designation on the 2030 U.S. Census.[5]

The general public's response to all three projects has been mostly favorable and rooted in the nostalgia of the audiences' childhoods. People of Arab descent have reflected on the tour, Facebook page, and blog with pride and joy and sometimes with corrections or additional information. Because the people who settled in La Crosse were Levantine Arabs, few if any North Africans or Black Africans from Arab countries have taken the tour or follow our Facebook page; neither has any reader, tourist, or commentor questioned my ability as an African American to research, write, or produce Arab American history. Perhaps the greatest number of Maghrebi-descended Arabs (white, Black, or multiracial) who read *Midwest Mahjar* have expressed appreciation for posts about musicians like Mike Hamway, Jack Ghanaim, Djamal Aslan, and Naim Karacand, who collaborated with Black African or African American musicians, especially in the 1950s and 1960s. There has been no negative criticism and only appreciation expressed by these readers. Audience members who are not of Arab descent have largely shown appreciation for learning about their neighbors and people in their communities. As a tour guide and author of the Facebook page and blog, I have on occasion received anti-Arab messages from people I presume are non-Arab white Americans. The positive feedback has outweighed instances of expressed bigotry, intolerance, and racism.

Finally, Facebook group followers and people on the tour learn about the local Ku Klux Klan and its pro-White Anglo-Saxon Protestant, anti-Jewish, anti-Catholic, 100 percent American principles during its second iteration from 1915 to 1927. Approximately 15,000 Wisconsinites joined the Ku Klux Klan in the 1920s. In La Crosse, their numbers reached 500 by 1922.[6] Although there were no direct Ku Klux Klan–Arab American incidents in La Crosse, most Arab Americans in La Crosse were not Protestant; they were Melkite Catholic or Syrian/Antiochian Orthodox. The pro-WASP sentiment in the larger United States embodied by the Ku Klux Klan fed support for a series of immigration restrictions and quotas beginning in 1917 and largely culminating with the 1924 Immigration Act. In La Crosse, the Syrian Melkite Catholic Church closed and folded into Saint James Catholic Church by 1923.[7]

Facebook Group: "The Syrian/Lebanese Community of La Crosse, 1890s–1970s"

The three public history projects began following the death of Elaine Addis (1925–2015), whose father, Siad Addis (1880–1977) immigrated to the United States. Said Addis immigrated to the United States from Rachaya El-Foukhah, Greater Syria (now Lebanon). He married a distant cousin, Shahenne, and together they raised seven children. Four of their five sons—Ford, Fred, Michel, and Joseph—served in World War II.[8] Elaine Addis was the last of Siad and Shahenne's children to pass away. Elaine died in 2015, and it was from Elaine's estate that I purchased the first set of sixty or so 78 rpm Arabic-language records. While 99 percent of the phonograph records I purchased that day had been produced commercially, two or three were homemade recordings of Siad Addis and his children in 1946.

Siad and Elaine Addis became the first two people I researched and for whom I wrote short biographies. Using a combination of Census data, immigration and naturalization documents, high school yearbooks, Social Security documents, and newspaper reports, I documented Siad's and others' birth and death dates and locations, occupation(s), marriage dates and locations (if married), and spouses' birth and death dates and locations. Moreover, I made note of any children born to my subjects and any story that surfaced in the digitally available local press about these individuals. Of utmost importance to people with local connections to La Crosse, I made note of the various local addresses occupied by the Addises and other families, of where these were in proximity to the two churches established by Arab immigrants in La Crosse, and of the two neighborhoods occupied by Arab immigrants and their families (on the Northside centered around Mill Street/Copeland Avenue/Rose Street and the area closer to downtown, anchored by Pearl, Main, and State Streets). Over the years, this is a pattern I repeated about fifty times, and the information I compiled came to serve as the primary basis for the narratives that drive the Facebook group page. In later years, the site stops on the tours included Monsoor's Sport Shop, Markos Wholesale & Retail, and the former Fayze's Restaurant. Each of the fifty-plus biographies average five hundred words per person.

I initially had no predetermined way of identifying who in La Crosse's Syrian and Lebanese community I would research and feature. Eight preliminary oral interviews had been conducted by Rick Brown in 2002 in a joint effort between the La Crosse County Historical Society and the University of Wisconsin–La Crosse Oral History Project. These included interviews with Louis Ferris, Richard E. Markos, Elaine Addis, Mary Theep Bahl, Dorothy Theep Lawrence, Lucy Joseph Harris, James Asfoor, Elaine Monsoor, and Helen Markos Buschmann. Using the list of people this project interviewed,

I met with and talked to several of the former interviewees still alive in 2015–2016. In addition, I reached out to and worked with Patricia Markos, Ellynmarie Theep, and Patti Ferris-Emery. I also compiled a list of Syrian and Lebanese residents based on surnames and addresses in the La Crosse city directories for 1900, 1909, 1917, 1919, and 1924 and the 1900, 1910, 1920, 1930, and 1940 U.S. censuses for the City of La Crosse via Ancestry.com. Additional people who lived in La Crosse County with Syria listed as their place of birth on the 1900 through 1940 Census were added to this list.

In compiling photos for the Facebook group, I never take physical photographs from the people I talk to or interview, not even to copy. The days of having to take photographs to a photographer or retail photo service are largely over. I have found this an unnecessary inconvenience in the age of camera phones. If meeting with people from a family face-to-face, I take pictures of family photos using a smartphone camera and carefully write any detail concerning that photo in my notes for future use. I photographed existing and standing landmarks and buildings myself and used newspaper images, yearbook photos, or family-contributed images with proper attribution or credit. In some instances, a photo or information contributor asked me not to use their full name, and I obliged with an abbreviation of sorts. This, and communication through email or Facebook Messenger, is one of the ways I protect family contributors to the Facebook page.

The Facebook group is public and moderated, and the public can comment on any post with text or images of their own. The public cannot post features on the timeline and may only comment on featured posts or post photos in the comments or the comments of other group followers. In some instances, the public has played a corrective role in identifying family members in photographs, editing some of the biographical details related to the featured individuals, especially when additional children were born into a household after the 1950 U.S. Census or when names have been spelled incorrectly because of discrepancies in publicly available sources.

Some of the first posts or entries lacked the detail of later entries, and the narratives in these posts were more descriptive than story driven. The very first post on February 11, 2016, contained photos of Our Lady of Lourdes Syrian Melkite Catholic Church and Saint Elias Antiochian Orthodox Church. Our Lady of Lourdes Syrian Melkite Catholic Church no longer stands and dissolved in 1923. I contacted the Archdiocese of La Crosse and asked if they had an image of Our Lady of Lourdes that I could use on my Facebook page. They sent a scanned artist's rendering of the building, a photo of Father Philip Salmone, and a cornerstone-laying announcement from Our Lady of Lourdes printed in Arabic with an English translation dated 1906. I also located another photograph of Salmone, the church's only priest, from the Saint James Catholic Church rectory vault scrapbook. I photographed as much of the

scrapbook as the rectory supervisor would allow. I also photographed Saint Elias Antiochian Orthodox Church and photographed a few images shared with me by parish historian and business owner Markos. Sometimes posts featured photos of material objects representative of La Crosse's Syrian and Lebanese residents—a peddler's badge, a Saint Elias Antiochian Church cookbook, phonograph records, a Monsoor's Grocery calendar, a matchbook from Askar and Shain photographers, World War I ephemera, or a Salem Markos straight-edge razor. Other posts highlighted photos from Theep; Ferris; the *La Crosse Tribune*; the Central, Logan, or Aquinas high school yearbooks; or donated images from readers.

Although I drew from the fifty biographies in the Facebook group to contribute to the tour, I researched, wrote, and added some biographies to the downtown and Northside walking tour based on the addresses that were physically walkable in an hour's time. Both tours take a loop of about three-quarters of a mile to a mile. I revisited city directories for the years where La Crosse's Syrian Lebanese community's population was its largest, compiled a list of names and addresses along the initially mapped-out route, and added approximately a dozen biographies.

For all three projects, I made the conscious decision not to focus on just one or two prominent people or families and to include Arab American women's stories. The Ferris and Markos families are still well known because some members still operate businesses downtown today. Similarly, Philip Addis and Michael Ablan, whose relatives have been in La Crosse since the first and third decades of the twentieth centuries, occupy law offices downtown on Main Street and King Street, respectively. While none of the Skaffs, Wakeens, or Monsoors currently own any of the restaurants or sport shops named for their antecedents, members of these families are still well known locally. Remaining are the Abraham, Patros, Asfoor, Haddad, Juboor, Shaheen, Joseph, George, Abdo, Kouri, Karrib, David, and Mussallem families. At least two biographical profiles from each of these families have a corresponding Facebook group post and a stop on one of the two walking tours.

Women's histories have long been marginalized and omitted from larger political, social, and cultural histories; Arab American women are no different in this regard. Posts centering the stories or biographies of Arab American women make up 42 percent of the Facebook group page, 44 percent of the Northside Walking Tour, 16 percent of the Downtown Walking Tour, and 21 percent of *Midwest Mahjar*. Biographical profiles on the Downtown Walking Tour and *Midwest Mahjar* reflect gender disparities in business ownership in downtown La Crosse and in the music industry.

Locating stories about Arab American women in La Crosse and recorded music can get complicated because of the dated custom of referring to

women as *Mrs.* and then their husbands' names. Moreover, because straight women are expected to change their surname upon marriage, knowledge of birth and married surnames becomes equally important. When conducting oral interviews or talking to Arab American elders, I found it important to remember that women in the United States have a life expectancy of 79.3 years and men of 73.5 years. Combine this with the fact that, although in total men represent the majority of Facebook users, for users between the ages of thirty-five and seventy-five, women make up the majority. This has resulted in more older Arab American women with La Crosse connections reaching out to me to share family histories than men.

I completed the portions of the Facebook group that laid the groundwork for the two historical walking tours in October 2017. Using a combination of Google Maps, the 1900, 1910, and 1920 censuses, and city directories for 1900, 1909, 1915, 1919, 1924, 1930, and 1956, I created online maps with the home and business addresses of La Crosse's Arab American residents as pinned locations. For homes, I listed all residents at an address included in the Census for that year. I then used Google Earth and drove and walked La Crosse's Northside and downtown to identify which buildings still stood, which had been knocked down and replaced, and which were now empty lots.

Between 2016 to 2019, our Facebook group published an average of fourteen posts per year. Our average number of posts per year decreased to four to six posts per year as we shifted our energies to *Midwest Mahjar* and developed walking tours. The most popular Facebook posts correspond with two of the best known restaurants in La Crosse and the Arab American families that operated them—Digger's Sting, founded in 1970 by Victor Skaff, and Fayze's, the creation of Fred Wakeen in 1986. Neither family owned the respective restaurants after 2010, and as of October 2023, Fayze's had gone out of business. On occasion, we cross-listed posts between the Facebook group and *Midwest Mahjar* sites. For example, the May 6, 2022, Facebook group post highlighted the 1956 Midwest Mahrajan sponsored by the Midwest Federation of American Syrian and Lebanese Clubs. The event, held in Sioux City, Iowa, featured Alamphon Records stars Sana and Amer Kadaj. We posted a photo of the record label Alamphon A#2105–1 "Lila Yalila," a digitized copy of the 78 rpm record from the Elaine Monsoor estate, and a newspaper clipping noting that La Crosse's Joyce Josephine Ablan (1927–2016) and her mother, Mary Corey, attended the multiple-day event. It was the Midwest Federation's twenty-first annual event, and photos showed people dancing the *dabke* and Amer and Sana Kadaj singing. There was also a third photo of Ablan and her mother seated at the *mahrajan*. This document embodies the very spirit of both the Facebook group and the *Midwest Mahjar* blog.

The purpose of the Facebook group is to document and preserve the history and stories of La Crosse's Syrian/Lebanese community from the 1890s

to the 1970s, but essentially it has become much more. It is a digital space for some to reminisce and share family stories and memories, a source and guide for people whose family lives or once lived in La Crosse to dig deeper into their genealogy, and a virtual gathering space for people of Arab and non-Arab descent to think about the complexities of La Crosse's ethnic history and to challenge our communities and larger society's perceptions of who Arab Americans are, how long they have been in the United States and particularly the Midwest, and how they have shaped the social and cultural history of our country.

78 Rpm Records and *Midwest Mahjar*

The blog *Midwest Mahjar* has multiple start dates—February 2016, November 2018, and May 2019. The first date coincides with the beginning of the "Syrian and Lebanese Community of La Crosse" Facebook group. During this time, as I noted earlier, locating a collection of Arabic 78 rpm records led me to research and write about the various people, institutions, organizations, and experiences of Arab immigrants and Arab Americans in La Crosse. I had not heard of a single Arab or Arab American singer or musician on any of the records I found—except Danny Thomas. Nothing at my local library or in Murphy Library at the University of Wisconsin–La Crosse or in a single secondary source I initially consulted named or identified any of the singers, musicians, or composers whose names graced the labels of the various Maloof, Macksoud, Alamphon, Arabphon, Abdelahad, or Alkawakeb phonograph records I recovered that day in 2015.

Through a University of Wisconsin–La Crosse Faculty Development Grant, I hired a biology student, Taher Aldabbagh, from Jeddah, Saudi Arabia, to help with translating the song titles and sometimes artists' names from 78 rpm record labels. The research grant was not large enough for me to pay Aldabbagh to listen to and transcribe song lyrics. In total, Aldabbagh translated approximately 168 titles. A number of other friends, followers, scholars, and people interested in the work of *Midwest Mahjar* helped with label and text translation, including Akram Rayess, cofounder and board member of the Foundation for Arab Music Archiving and Research in Beirut, and record collectors Ahmed Abdel, Mohamed Sayed, Paul Balechion, and Henrique Tabchoury.

The first 78 rpm–related music profiles I wrote and posted were in the Facebook group on February 12 and 14, 2016. One drew from an article about Maloof based on the misidentification of Alexander Maloof (1884–1956) the musician, composer, and record-label owner with another Alexander Maloof who died much later. I noted Maloof's birth in Greater Syria, his immigration to the United States, his presence and the presence of his label in Lower Manhattan's Little Syria, and the previous ownership of the collection by

Siad Addis and his daughter Elaine Addis in La Crosse. I now know much of the non-music-related information about Maloof in other sources was flat-out wrong.

The second label I featured was the Brooklyn-based Karawan Records. Because violinist Karacand's (1891–1972) name was the only one I recognized on the label, I rightly presumed Karacand owned the label as well. I drew much of the career and biographical information about Karacand from two sources—documents from Ancestry.com and a short Portuguese-language YouTube film/presentation provided by Karacand's grandnephew, Jorge Klhat, currently living in Sao Paulo, about Karacand's life and career.[9] In addition, I managed to locate a copy of Richard K. Spottswood's *Ethnic Music on Record*, volume 5, one in a series of multivolume discographies that document a majority of phonograph records in languages other than English recorded in the United States before 1940.[10]

For context and a solid foundational history of Arab American music in the early twentieth century, any scholar must turn to Anne Rasmussen's *The Music of Arab Americans: A Retrospective Collection*.[11] The information Rasmussen provides in the liner notes of her CD are invaluable. *The Music of Arab Americans* features songs by Maloof, Karacand, Amer and Sana Kadaj, Russell Bunai, Tony Abdelahad, Philip Solomon, Danny Thomas and Toufic Barham as a duo, and Hanan. We still have much to learn about Arab American music, musicians, and the inner workings of the *hafla* (party) and *mahrajan* (festival) circuit and the nightclub era. But ethnomusicologists and social and cultural historians are not necessarily interested in answers to the same questions. In fact, I had so many more questions that Rasmussen's work did not answer based on the people she chose to include in *The Music of Arab Americans* and the musicians named and performing on the records I now owned. I view Arab American musicians as people first and musicians second. Their stories did not begin and end with their musical careers. Where were these musicians born, and what were their birth dates? Why did they become musicians, and where did they get their early training? What other musicians influenced them, and with what other musicians did they play and collaborate? Who owned the record labels they recorded on, and how did people in La Crosse and other cities across the United States come to acquire them? How long did these musicians' careers last? When did their careers reach their peaks, and when did these musicians die? What personal or professional obstacles did Arab American musicians face, and how were these connected to the larger social history of Arab America?

Before *Midwest Mahjar* became a blog, I researched several Arab American musicians and posted their biographical profiles on Facebook in "The Real Traditional Ethnic & Vernacular Music Forum." During the course of my research, the biographical details I had gathered were challenged after I

telephoned Lila Kadaj and Dr. Russell Bunai in 2016. Before this time, I had not thought about contacting or talking to the children of the largely deceased musicians of the "golden age" of 78 rpm Arabic records. Both Kadaj and Bunai offered information I had not gotten from previously available sources. I also sent a digital copy of the music on the five Star of the East discs produced and performed by Russell Bunai and his Ensemble to his son. As mentioned before, this became standard practice for me as I interacted with more descendants and relatives of Arab American musicians. In "The Real Traditional Ethnic & Vernacular Music Forum," I posted biographies of Alamphon stars Amer and Sana Kadaj on October 11, 2016, Maloof Records' Midhat Serbagi on November 26, 2016, four-label superstar Wardiny on February 7, 2017, Maloof Records' Anthony Shaptini on April 16, 2017, and Edward Ibrahim Abdo Urban on April 22, 1917.[12] This built a following of interested collectors, researchers, and ethnomusicologists almost two years before I published *Midwest Mahjar* as a blog.

Since the late 1990s, Stephanie Ho reminds us, the World Wide Web and blogging "have challenged historians to rethink the ways that [we] research, write, present and teach the past."[13] One of the major purposes is to preserve and document the history of Arab American expressive culture in the early twentieth century while challenging the idea that Arabs are only recent immigrants to the United States. What most non-Arabic-speaking people in the United States know about people of Arab descent has its roots in some of the most insidious ethnic stereotypes Hollywood and American media has to offer. "The blog," Stephanie Ho asserts, "bypasses traditional forms of mass media such as television, newspaper and book publishing with strong forms of gatekeeping." Most importantly, online public history via blogging "allows bloggers to reach a huge international audience." Creating *Midwest Mahjar* in Google's Blogger, I also set the blog's languages to offer translation options in French and Arabic to make published posts even more broadly accessible. At the time, I never could have anticipated the blog's popularity beyond record collectors and possibly a few academics.

Midwest Mahjar began with profiles of four priests—three Antiochian and one Melkite—for several reasons related to source availability. La Crosse's Siad Addis had phonograph records by Reverends Agapios Golam (Orthodox, 1882–1946) and Anton Aneed (Melkite, 1879–1970) in his collection, which he used to practice at home for his role as cantor at Saint Elias Antiochian Orthodox Church in La Crosse. These records and additional records purchased from the estate of Joseph Melan (1909–2011) in Janesville, Wisconsin, existed among the first and second collections I purchased in 2015 and 2016. Finding personal biographical information about several of the musicians featured on *Midwest Mahjar* has been extremely difficult. Locating birth dates, educational data, and information about family, career, immigration,

and death can be painstakingly tedious for some of the lesser-known musicians. Priests, however, are more public figures. They are connected to churches that have historically received ample attention in the press and are much easier to locate and track in publicly available sources. Moreover, Rasmussen did not include the recorded music of the Arab American church in her release of *The Music of Arab America*, so exploring this facet of Arab American music on 78 rpm records became uncharted territory.

My initial attempts to gather and present information about Antiochian Orthodox priests who recorded on 78 rpm met a mixed reception. Preliminary trips to the Arab American National Museum in Dearborn, Michigan, in 2017 rendered very little biographical data about early twentieth-century Arab American musicians. I collected bits of information about Maloof and Fedora Fadwa Kurban, but that was all. Most of what I uncovered beyond recording dates, label name, song titles, and musicians' first initials and surnames appeared in Spottswood and Rasmussen. Orthodox priests on 78 rpm became the exception and required primary research via Ancestry.com and Newspapers.com. I first presented at the 2018 International Society for Orthodox Church Music from June 20 to 24, 2018, in Minneapolis, Minnesota. A handful of people took serious interest in my findings about 78 rpm Antiochian hymnody, and I received a few requests to make my work accessible online. A combination of failed efforts to have articles published in *Mashriq & Mahjar* and *Midwest Review* and follow-up requests from International Society for Orthodox Church Music attendees led me to launch *Midwest Mahjar* in November 2018.

Source material I located online changed the trajectory of *Midwest Mahjar* forever in spring 2019. I posted five additional profiles by the end of May 2019. All drew upon a combination of immigration, Census, and military draft records, city directories, and related government documents. Then I came across the *Daleel* newspaper (Detroit, 1943–1951) on the United States Library of Congress website and *The Caravan* (Brooklyn, 1953–1961) on Newspapers.com the last week in May. More information about Arab American musicians, their family lives, and their concert/*hafla*/*mahrajan* schedules could be found in these two sources than in any I had looked at before. This period marked the height of what Rasmussen calls the "golden age," the beginning of the nightclub era and the end of the 78 rpm manufacturing period. Most importantly, researchers now have specific dates, including the year of events, to triangulate with existing undated documents and the stories collected via oral histories.

Drawing on biographical features I had already posted on Facebook, I created *Midwest Mahjar*, initially focusing on musical Arab American priests; this focus on mostly Arab Christians was related to which Arab immigrants settled in La Crosse and what records were in their existing collections. When

I found a recording artist had been Muslim, I contextualized the experiences of those musicians within the context of Arab and non-Arab Muslims who came to the United States and La Crosse during the 78 rpm era. The addition of other musical priests, such as Archbishop Samuel David, Reverend Ilyas Kurban, and Metropolitan Germanos Shehadi, expanded my goal to preserve Orthodox hymns.[14] More recently, blog posts by Maronite priests Reverend George Aziz and Reverend Boulous Hage expanded the coverage of Mahjari priests to the three Christian churches with the most significant ties to Arabic-speaking people in the United States—the Antiochian Orthodox, Melkite, and Maronite churches.

Between May 18 and September 6, 2019, I republished from my previously released Facebook posts or wrote and published twenty-four biographies of Arab American musicians with digitalized 78 rpm content. Posts included copies of photos, government documents such as immigration and military service records, city directories, news stories, and *hafla/mahrajan* ads from newspapers. In 1997, Rasmussen showcased twelve musicians in *The Music of Arab Americans*. I published blogs with more extensive biographical information about seven of these at the time. The remaining sixteen Arab American musicians to appear on *Midwest Mahjar* were those whose 78 rpm records I owned or had heard of but whose lives and music I had no additional information on.

Thanks to a mutual interest in Arab American history and Arabic-language 78 rpm records, Christopher Silver, ethnomusicologist and professor at McGill University, and Ian Nagoski, reissue record producer and creator of Canary Records, shared the link to *Midwest Mahjar* on Facebook and Twitter on June 27, 2019. This was the date I first published a biography of Maloof, the first Arab American to record music in the United States and a composer and record-label owner in the 1920s and 1930s. Maloof's notoriety both during his lifetime and among 78 rpm record collectors stems from his records, sheet music, piano rolls, submission of a proposed U.S. National Anthem in 1913, and "America Ya Hilwa," the unofficial National Anthem for Arab Americans at the time. More misinformation than fact about Maloof existed in academic literature and on the World Wide Web in 2019. Little information about Maloof in the 1940s, when he taught and wrote music books in New Jersey existed. His death date was wholly wrong and had been lost to future generations.[15]

Music connects all the posts on *Midwest Mahjar* across generations. For instance, Maloof, Moses Cohen, Wardiny, Souss, Agob, Karacand, Mohammed Zaineldeen, Aziz, Simon, and Melham Hawie constitute the trailblazing founders of Arab American music.[16] Corporate giants Victor and Columbia captured their voices and instrumentals, laying a crucial foundation of Mahjari music emerging from the *nahda*, or renaissance period. Some of

these musicians continued their careers into the 1920s and 1930s but only performed live; others left the scene altogether.

The 1920s to the 1940s constituted the period of self-determination. After Victor and Columbia virtually abandoned the genre minus a few big sellers, most musicians of this era first debuted on Macksoud's or Maloof's label. Wardiny, Karacand, and Aziz continued on, joined by Andrew Mekanna, Wadih Bagdady, Assad Dakroub, Shaptini, Edward Abdo Urban, Mosa Kalooky, Kurban, Salim Doumani, Serbagi, Prince Mohiuddin, and brothers Mayer and Nessim Murad.[17] Although the names of the two leading labels of this period—Macksoud and Maloof—come up frequently, we had mostly inaccurate biographical data about Maloof and none about Macksoud. *Midwest Mahjar* changed this. The public now has detailed accounts of Macksoud and Maloof and a fuller picture of the most invisible and understudied generation of recorded Arab American musicians.

The group of Arabic-speaking musicians who received the lion's share of coverage on *Midwest Mahjar* were those who peaked just after World War II through the early 1970s. When I launched *Midwest Mahjar*, more than a half dozen of these musicians who were still living were the elder statespeople of the *hafla/mahrajan* scene. Arab American baby boomers had memories of seeing these musicians in their youth, and some of the recordings, which had transitioned to 45 rpm and 33 rpm microgroove technology, stirred feelings of nostalgia and a bygone era. Based on the number of hits received by each *Midwest Mahjar* post, Olga "Kahraman" Agby and her brother Naif, Fadwa Abeid, Hanan, Odette Kaddo, Mohammed El-Akkad, Eddie Kochack, and Amer and Sana Kadaj continued the be the most popular.[18] Of these, only Abeid was alive when we personally interviewed her for our post, but she passed away in January 2022.[19]

One aspect of *Midwest Mahjar* noted by several interested parties is the impressive number of musicians we feature who never fronted their own groups or orchestras. Background singers often went uncredited during the 78 rpm era, and ensemble members like Joe and Leo Budway, Mike and George Hamway, John Nazarian, Ghanaim, Jalil Azzouz, Sam Fackre, and Solomon come up in conversations about the best musicians in particular regions of the United States or those who accompanied the *hafla* or *mahrajan* headliners.[20] In a history from the bottom up, the stories and music produced by ensembles are as important as those with national and international notoriety.

Midwest Mahjar made the unusual move of documenting the stories of Arab American record stores and record-label owners of the 78 rpm era of 1900 to 1961. Macksoud owned Macksoud Records from 1915 to 1937, Farid Alam Al-Din operated Alamphon Records from roughly 1939 to 1960, and Albert Rashid opened Al-Chark first in Detroit, then Manhattan, and finally in Brooklyn, operating it from the 1930s to 1990. Rashid's sons took over, ex-

tending the life of Rashid Sales into the 2000s. All owned storefronts and used their international business connections to maintain their companies. Macksoud started as the first Arab American record label in the United States, with a storefront and office in Manhattan's Little Syria. It launched as a reissue label with releases by Morad and eventually recorded Arab immigrant and Arab American musicians.

Today, collectors find the design of Macksoud's variant labels remarkably beautiful with the combinations of black, pink, and white; red, gold, and white; and brown and bronze. Ironically, when Macksoud died in 1938, Al-Din, also known as Fred Alam, bought much of Macksoud's inventory. Although associated with Atlantic Avenue in Brooklyn's Syrian neighborhood, Alamphon had its start at 81 Washington Street in one of Macksoud's former locations.[21] Like Macksoud, Alamphon initially sold reissue records from Lebanon, Egypt, and Tunisia. One of Alamphon's best-selling artists in its early years was Tunisian Hassiba Rochdi. Alamphon sold reissued discs by Mohammed Wahab, Farid Al-Atrache, and Asmahan. It also began to record Arab American musicians, including George Berbari, Yousef Hatem, Sana and Amer Kadaj, Mohamed El-Bakkar, and Elie Baida, domestically. Baida had been one of Baidaphon Records' most popular musicians before he immigrated to the United States. He was also a cousin of the label's founders.[22] One insight gained through the historic city directories is the changing locations of Macksoud's, Alam's, and Rashid's stores. In some instances, we can now pinpoint changes of address to specific dates. Alam died in 1961, a few years after his move to Atlantic Avenue, and Alamphon Records dissolved.

Impact of COVID-19

In September 2019, I had our first face-to-face meeting with Nagoski and Todd Fine, president of the Washington Street Historical Society. Fine invited me to dinner and a tour. I flew to New York City on September 19, 2019, and took an Ottoman American music walking tour led by Nagoski, Fine, and Turkish scholar Isil Acehan in what remains of Manhattan's Little Syria. I shared information about the "Syrian/Lebanese Community of La Crosse" Facebook group with Fine and Mary Ann DiNapoli, also a member of the Washington Street Historical Society, and continued publishing musician, record-label, and record-seller profiles on *Midwest Mahjar*. In January 2020, I moved to publishing the blog monthly instead of two or three times per month.

Readership of *Midwest Mahjar* skyrocketed between March 2020 and March 2021 because of the COVID-19 pandemic. The demands for remote work and quarantine meant people increasingly relied on their computers, especially email, social media, and Zoom, to remain connected to friends,

colleagues, and coworkers. We created a *Midwest Mahjar* Twitter account, expanding our reach beyond Facebook and recommendation via word of mouth. Interestingly, *Midwest Mahjar*'s Twitter account attracted more academics than laypeople. For example, the Khayrallah Center for Lebanese Diaspora Studies at North Carolina State University asked to use material from the blog for a special music portion of its *Turath* exhibition celebrating the centennial of Al-Rabitah Qalamiyah (The Pen League). *Turath* had a soft opening in fall 2020 and an official opening in spring 2021.[23] This was not our only opportunity to collaborate and reach an even wider public.

Warren David, editor in chief of Arab America, inquired about serializing posts from *Midwest Mahjar* as part of a weekly series. David had seen Nagoski's guest article published on *Midwest Mahjar* and read other published entries and believed his readers would be interested in learning about Arab American musicians of the 78 rpm era. The series ran on Arab America's website every Wednesday from June 10, 2020, to July 7, 2021. Like the "Syrian/Lebanese Community of La Crosse" Facebook group, the series raised challenging questions about the intended and unintended consequences of doing public scholarship, measuring the depth and breadth of who accessed and used the site's information, and determining whether it was for personal, commercial, or educational purposes. For instance, as the author and creator of *Midwest Mahjar*, I have the capability to track where the blog is being accessed from. I cannot, however, track or even tabulate the number of people who access my serialized content on Arab America without requesting the data from David. This means that the 80,000-plus views of *Midwest Mahjar*'s content may not be representative of who is reading the blog's content. Only readers inquisitive enough to seek out additional information via the blog directly are counted in the total views over 80,000.

The creation of *Midwest Mahjar* presented its own intended and unintended consequences. The purpose of the blog was to preserve, archive, contextualize, and make publicly accessible mostly 78 rpm Arab American records and to uncover the stories of Arab American musicians from that era. My intention was largely to educate record collectors about the lives of people who recorded on or founded record labels for an Arab American audience. However, *Midwest Mahjar* has become more than I intended. It, too, has become a source for family genealogists who seek information about relatives who trace their ancestry to Greater Syria. Families are often either all too familiar or wholly unfamiliar with the musical exploits and careers of the antecedents. Descendants of these musicians are often shocked if I contact them for information while doing research for future blog posts, and I have been equally astounded to hear from descendants I had difficulty contacting during the research phase of a blog post; in some cases, I did not know any descendants existed at all. Perhaps of most interest to public his-

torians, this fairly selfishly conceived project, rooted in my own desire to know for knowing's sake, has led to collaborations with numerous public and professional scholars and historians who have enriched my own understanding of Arab American history and cultural expression. It is the reason you are reading this chapter.

There are currently no plans to archive the work on the Facebook group or *Midwest Mahjar* beyond their existence in the current format and the files I have saved. Perhaps as time passes, I might donate the 78 rpm records to a repository of some kind; there are several that specialize in Arabic music, general Arab American history, and music preservation more broadly defined. I have yet to commit to making such a contribution.

Fascinatingly, despite the fact that people have accessed *Midwest Mahjar* from some sixty-seven countries and counting, I have returned to local public history, in the form of walking tours, to continue the work of extending education and public knowledge within and beyond the walls of academia.

La Crosse Historic Syrian/Lebanese Walking Tour

Most people in La Crosse have a story they like to tell themselves and others who visit about the city's history and the people who settled here. As many would have it, La Crosse is a town settled by and made up of people of German and/or Norwegian descent. It lacked any significant ethnic or racial diversity, and the few people outside of Germans and Norwegians who tried to call La Crosse home, like African Americans in the late nineteenth and twentieth centuries, faced hostility that locked them out of economic opportunities until the 1980s, when Hmong refugees arrived from Laos, Thailand, and other parts of Southeast Asia. Arab Americans who trace their ancestry to Greater Syria are almost always left out of this story. The omission of people of Arab descent has prompted me to champion the stories of marginalized and underrepresented voices in La Crosse's public and popular history. In 2020, I became a La Crosse County Historical Society Board member with the specific intention of making sure Arab peoples in La Crosse today and in the city's past are no longer omitted from its story.

The La Crosse Syrian/Lebanese Historic Walking Tour became the last phase of my Arab American public history project. I operate a Northside, mostly residential-centered, walking tour and a downtown, primarily business-centered, walking tour. I created the first walking tour using much of the research I had conducted for creating the Facebook group page because I included home addresses for many of the people I had researched, written, and posted about previously. I first had to drive around La Crosse's North-

side to see which homes and buildings connected to La Crosse's Syrian/Lebanese community remained. I knew Saint Elias Antiochian Orthodox Church still stood at 716 Copeland Avenue, although most of its parishioners are no longer of Syrian/Lebanese descent. I also knew from previous research that Our Lady of Lourdes Syrian Melkite Church, at 822 Copeland Avenue, had been abandoned and torn down. An automobile repair shop stands on the site of this former church. I remembered that a cluster of businesses owned by Syrian/Lebanese Americans that once operated on the 500 block of Copeland Avenue were largely not present, but the physical buildings remained. Moreover, Monsoor's Sporting Goods Store at 517 Copeland Avenue, no longer owned by the Monsoor family, continues to do business. Monsoor's and Saint Elias have the only remaining physical structures on La Crosse's Northside that have visible evidence of connections to the city's Arab American community.

Each of the walking tours covers about one mile and takes between an hour and one hour and ten minutes. I point out that some of the structures are original and still standing but that many more no longer exist. I provide an overview of the route and advise tour-goers that if they need to stop, turn back, or take shortcuts, they are welcome to. I encourage all participants to ask questions, add corrective information, or confirm any of the known information I provide. I usually ask if anyone on the tour has family connections to La Crosse's Syrian/Lebanese communities, and each person on the tour introduces themselves to the group. This allows participants to see and hear from the descendants of families with whom they may be familiar and gets people on the tour talking among themselves. It gives me the opportunity to talk about how I, a non-Arab and non-Arabic-speaking African American, came to study Arab American history and create and give the walking tours. Introductions also allow me to customize parts of the tour, because I have at least two narratives I can share for some locations, as I make it a point to include stories about the ancestors of at least some of the people on the tour. Tour groups are wholly unaware that I make these last-second adjustments, but it provides a more personalized experience that also encourages active dialogue and participation by people on the tour.

The Northside walking tour occurred on July 17, 2022, September 17, 2022, and May 23, 2023. Space was limited to sixteen people for the first two and twenty for the most recent tour. The Northside tour includes twelve to fourteen site stops—the current site of Saint Elias Antiochian Orthodox Church and former location of the demolished Our Lady of Lourdes Syrian Melkite Church, six former businesses (among them Monsoor's Sports, Teckla Abraham's grocery store, Carl Patros's scrap metal business, the Ferris Shoe Store, Shain's Photography Studio, and Juboor's movie theater), the current L & M Tavern, and four to six homes. None of the homes are the current residences

of people of Arab descent, and the stops are interspersed with a common and shared contextual narrative that frames both the Northside and downtown tours. The Northside tour ran at capacity each time, and I prearranged the first tour to run during a time slot that coincided with Saint Elias Antiochian Orthodox Church's annual Mediterranean Food Festival in 2022. The September 2022 tour ended with the reminder that the Historic Downtown La Crosse Syrian/Lebanese Tour would take place a few weeks later.

The only downtown tour offered so far took place October 8, 2022. Unlike the Northside tour that includes the church locations and former places of residence, the downtown tour includes eleven sites that were mostly places of business. These locations included restaurants, taverns, clothing stores, dry cleaners, shoe repair shops, and other businesses. There are only a handful of visible signs of downtown La Crosse's Arab American legacy and history. The tour starts and ends on Pearl Street, which once anchored the downtown Syrian/Lebanese community. It was to La Crosse what Hudson Street was to Boston, Washington Street was to Manhattan's Little Syria, Warren Avenue was to Detroit, or Willard Street was to Indianapolis. Demand for another set of tours is high, especially for the downtown tour. The La Crosse Public Library has expressed interest in cosponsorship, a role it assumed with the 2023 Northside tour.

A common theme in at least two other chapters in this book is the use of the walking tour as a modality to share and collect information about Arab Americans in our respective cities. The two La Crosse walking tours are an extension of the map work I did for the Facebook group. In mapping the route, I remained conscious of total walking distance and curb cuts for accessibility, and I reminded participants to dress appropriately for the weather. The tour adds a more interactive and tangible component to the information online. I make it a point to pass around a *Saint Elias Orthodox Church Cookbook* (1981), a matchbook from photographers Askar and Shain, a 1970s bumper sticker from Monsoor's Sports, a small piece of leatherwork from Ferris Shoe Repair, and copies of old newspaper clippings and store advertisements from the *La Crosse Tribune* to enhance the previously mentioned tangible and tactile tour experience. Walking tours help eliminate the possibility of technical issues, glitches, and unloadable images, and they promote real-time interactions including place-/space-triggered questions and answers.

Beyond a shadow of a doubt, *Midwest Mahjar*, the walking tours, and the Facebook group page have reached more people than I possibly could have imagined. If I could have anticipated the popularity and demand for this work, I possibly would have put more thought and effort into a more developed digital humanities project rather than a blog and Facebook group. Perhaps a professionally designed website would have attracted more readers and participants.

Readers of these sites are, perhaps, more aware of how Arab Americans have contributed to, shaped, transformed, and defined certain facets of life in the communities in which they lived. The number of record collectors, ethnomusicologists, and cultural historians our projects have reached belies the numbers of views, subscribers, followers, and likes quantifiable by social media and internet-tracking algorithms. Perhaps the greatest lesson or takeaway from these and similar public history projects is that even the most ordinary people can do extraordinary things. But what visible, sonic, or tangible evidence we will leave of our individual and collective efforts to make the world a better, more informed place remains to be seen—and heard.

NOTES

1. Roy Rosenzweig and Daniel J. Cohen, *Digital History: A Guide to Gathering, Preserving, and Presenting the Past on the Web* (Philadelphia: University of Pennsylvania Press, 2005).

2. Marianne Dhenin, "Walking Tours Get a Radical Makeover, Focusing on People's Histories," *Yes Magazine*, June 2, 2022, 2.

3. Charlotte Karem Albrecht, "Narrating Arab American History: The Peddling Thesis," *Arab Studies Quarterly* 37, no. 1 (2015): 101–102.

4. Sarah Gualtieri, "Becoming White: Race, Religion, and the Foundations of Lebanese Ethnicity in the United States," *Immigration & Ethnic History* (Summer 2001): 29, 32–34, and 37.

5. For more on the ways Arab Americans have been classified racially and ethnically, see Randa A. Kayyali, "U.S. Census Classifications and Arab American: Contestations and Definitions of Identity Markers," *Journal of Ethnic and Migration Studies* 39, no. 8 (2013): 1299–1318; see also Randa A. Kayyali, "Arab Christian Identity" (Ph.D. diss., George Mason University, 2013), 123–140.

6. "500 Members in La Crosse is Claim of Ku Klux Head," *La Crosse Tribune*, December 9, 1922.

7. "Syrian Catholic Church Is Given to St. James Parish: Few Syrians Left in the City," *La Crosse Tribune*, August 8, 1923.

8. "Fourth Son in Siad Addis Family Now Serving in the US Armed Forces," *La Crosse Tribune*, July 30, 1942.

9. "Naim Karacand in Brazil," liviapj, YouTube, 5 min., 27 sec., November 10, 2012, https://youtu.be/fIusZ1coQy0?si=JgHNMd2OgedBz0NL.

10. Richard K. Spottswood, *Ethnic Music on Record: A Discography of Ethnic Recordings Produced in the United States, 1893–1942, Volume 5* (Urbana: University of Illinois Press, 1990).

11. Anne K. Rasmussen, *The Music of Arab Americans: A Retrospective Collection* (Cambridge, MA: Rounder Records, 1997).

12. Richard M. Breaux, "Amer & Sana Kadaj: Alamphon Records' Power Couple," *Midwest Mahjar*, May 21, 2019, https://syrianlebanesediasporasound.blogspot.com/2019/05/amer-kadaj-and-sana-kadaj-musicians.html; Richard M. Breaux, "Midhat Serbagi: Arab Classical Music in Early 20th Century America," *Midwest Mahjar*, May 18, 2019, https://syrianlebanesediasporasound.blogspot.com/2019/05/midhat-serbagi-musician-midhat-serbagi.html; Richard M. Breaux, "The Many Facets of Louis Wardiny," *Midwest Mahjar*,

May 25, 2019, https://syrianlebanesediasporasound.blogspot.com/2019/05/elias-louis-nassour-wardini-this-lone.html; Richard M. Breaux, "E. Abdo = Edward Abdo on Maloof," *Midwest Mahjar*, May 25, 2019, https://syrianlebanesediasporasound.blogspot.com/2019/05/braheen-edward-abdo-urban-musician.html; Richard M. Breaux, "Anthony Shaptini: Songs of the Midwest Mahjar in America's Heartland," *Midwest Mahjar*, September 6, 2019, https://syrianlebanesediasporasound.blogspot.com/2019/09/anthony-shaptini-songs-of-midwest.html.

13. Stephanie Ho, "Blogging as Popular History Making, Blogs as Public History: A Singapore Case," *Public History* 14 (2007): 65.

14. Richard M. Breaux, "An Antiochian Schism: Metropolitan Samuel David," *Midwest Mahjar*, November 20, 2018, https://syrianlebanesediasporasound.blogspot.com/2018/11/metropolitan-samuel-david-metropolitan.html; Richard M. Breaux, "Rev. Ilyas T. Kurban: The Recording Legacy of a Tirelessly Working Musical Metropolitan," *Midwest Mahjar*, https://syrianlebanesediasporasound.blogspot.com/2022/01/rev-ilyas-t-kurban-recording-legacy-of.html; Richard M. Breaux, "Metropolitan Germanos Shehadi (Chehade): The Beloved Golden-Voiced Priest, Who Defied his Synod," *Midwest Mahjar*, November 1, 2020, https://syrianlebanesediasporasound.blogspot.com/2020/11/metropolitan-germanos-shehadi-chehade.html.

15. Richard M. Breaux, "Alexander Maloof: Guardian and Protector of Syrian Music in America," *Midwest Mahjar*, June 27, 2019, https://syrianlebanesediasporasound.blogspot.com/2019/06/alexander-maloof-guardian-and-protector.html.

16. Breaux, "Alexander Maloof"; Breaux, "The Many Facets of Louis Wardiny."

17. Breaux, "Midhat Serbagi."

18. Richard M. Breaux, "The Incomparable Kahraman and Naif Agby—The Sun and The Planets," *Midwest Mahjar*, August 7, 2019, https://syrianlebanesediasporasound.blogspot.com/2019/08/the-incomparable-kahraman-and-naif-agby.html; Richard M. Breaux, "Hanan: 'Don't Miss Her Wherever She Will Be,'" *Midwest Mahjar*, October 9, 2019, https://syrianlebanesediasporasound.blogspot.com/2019/10/hanan-dont-miss-her-wherever-she-will-be.html; Richard M. Breaux, "Odette Kaddo: Arab Music, It Gives Me Life!," *Midwest Mahjar*, September 3, 2019, https://syrianlebanesediasporasound.blogspot.com/2019/09/odette-kaddo-arab-music-it-gives-me-life.html.

19. Richard M. Breaux, "The Passing of Acclaimed Vocalist Fadwa Abeid: From Performing in the U.S. at an Early Age to an Accomplished Career in the Arab World," Arab America, January 19, 2022, https://www.arabamerica.com/the-passing-of-acclaimed-vocalist-fadwa-abeid-from-performing-in-the-u-s-at-an-early-age-to-an-accomplished-career-in-the-arab-world/.

20. Richard M. Breaux, "The Search for Farid Alam Al-Din (Al 'Fred' Alam) and Alamphon Records," *Midwest Mahjar*, June 22, 2019, https://syrianlebanesediasporasound.blogspot.com/2019/06/the-search-for-farid-alam-al-din.html.

21. Richard M. Breaux, "Chasing Little Syria's A. J. Macksoud," *Midwest Mahjar*, July 30, 2019, https://syrianlebanesediasporasound.blogspot.com/2019/07/chasing-little-syrias-aj-macksoud.html.

22. Richard M. Breaux, "The King of Baghdadi: Elie Baida," *Midwest Mahjar*, June 9, 2019, https://syrianlebanesediasporasound.blogspot.com/2019/06/the-king-of-baghdadi-elie-baida.html.

23. "Music," Moise A. Khayrallah Center for Lebanese Diaspora Studies, accessed April 8, 2025, https://www.turath2020.org/music.

6

THE ARAB INDIANAPOLIS COMMUNITY HISTORY PROJECT

EDWARD E. CURTIS IV

A three-time Emmy award–winning documentary broadcast on every PBS affiliate in Indiana.[1] *A book of stories and photographs.*[2] *A heritage trail.*[3] *A State of Indiana historical marker.*[4] *K–12 Lesson Plans on PBS Learning Media.*[5] *An educator workshop.*[6] *Twenty Indiana Humanities–sponsored statewide screenings and dialogues about the documentary.*[7] *A website viewed 40,000 times by early 2024.*[8] *All made possible through the wisdom of two dozen Arab Hoosiers as well as seventy-five individual donors and multiple units of Indiana University and other institutions.*[9] *Led by a descendant of the first generation of Arabic-speaking people to settle in the Midwest.*

From 2020 to 2023, the Arab Indianapolis community history project, the first research project to document the contributions of the tens of thousands of Arab-descended Hoosiers who have lived in central Indiana, claimed these accomplishments and more. This chapter provides a detailed narrative of the project, how my background as a public scholar influenced its design, the project's methods for practicing shared authority with Arab American community stakeholders, the effect of the COVID-19 pandemic on the work, and the use of multiple means to engage different audiences. Because Arab American public history has not been well-developed as an area of systematic concern in the fields of public history or Arab American studies, I have provided logistical details in hopes that a how-to approach may be helpful to others who will engage Arab American stake-

holders in such work elsewhere. In doing so, I also foreground how the team with whom I worked negotiated public history principles of shared authority, problem setting, and audience engagement, and I offer brief reflections on the course of the project.

Among the lessons that I draw from this case study are (1) the importance of prior connections to the community with whom public historians wish to work; (2) the significance of content expertise in design and interpretation; and (3) the need at times for public historians to produce some tangible product before stakeholders decide that it is really worth committing time, talent, and resources to a project.

How My Own Pre-commitments Informed This Project

This research project organically evolved from my own background as a public scholar of Black and Muslim American history and life. In the spring of 2020, I was researching and writing about Arabic-speaking Muslims from the Eastern Mediterranean who migrated to the U.S. Midwest before World War I. In order to understand their thoughts and feelings about that experience, I relied on oral histories, mainly from the Naff Collection at the National Museum of American History, and local and state libraries. So that I could accurately contextualize their lives in terms of their locality—where they lived, what their housing looked like, who their neighbors were, how they were received by their neighbors—I utilized Sanborn insurance maps, city directories, and local newspapers. I had not been trained to use these maps and directories as a graduate student in the 1990s, but my urban archaeologist colleague, Paul Mullins, taught me how to a few years before he invited me to research the presence of Muslims in Indianapolis in the 1920s. Learning to use these sources was essential to conceptualizing my work on Syrian-Lebanese Muslims in the Midwest, which in turn inspired me to focus my attention on Syrian-Lebanese migrants in my own city. I quickly discovered—just by scratching the surface of these sources—there was a rich Arab American history in Indianapolis that seemed to have been completely forgotten by scholars and by people in Indianapolis, too. In addition to the descendants of Syrian and Lebanese immigrants who arrived in Indiana in the 1800s, representatives from every one of the twenty-plus Arabic-speaking countries from Morocco to Iraq have made significant contributions to Greater Indianapolis.

Being employed at Indiana University School of Liberal Arts in Indianapolis, then part of Indiana University–Purdue University Indianapolis (IUPUI), now just Indiana University Indianapolis, was also a necessary precondition

to conceptualizing the project. Public scholarship of any sort is often difficult for humanities scholars to imagine, attempt, and sustain without institutional support, since the most prestigious and powerful people and institutions in fields such as history, religious studies, philosophy, and literature see specialized research that addresses other scholars, not a variety of publics, as our primary labor. Though there have been advancements in the support of public scholarship across the humanities and threats to the economic well-being of the humanities have led to calls for greater public engagement, it is still the case that writing for other scholars is the best way to gain and keep employment and to advance our careers.

IUPUI was different. In 2005, I was the runner-up in an IUPUI campus job competition for a newly endowed chair of liberal arts that required community engagement. The candidate who was initially offered the job declined, and I gladly accepted the chance to move back to the Midwest, where my own Syrian-Lebanese ancestors had settled in the late 1800s. The endowed chair to which I was appointed, now titled for its donors, William M. and Gail M. Plater, was part of a whole institutional ethos of community-engaged research across campus. In my school alone, the institution offered degrees in applied anthropology, museum studies, and public history, and the scholars who taught in these programs inspired and encouraged my work.[10] Community-engaged scholarship was in the air, so to speak.

The other major factor in my becoming a public and community-engaged scholar was my urge, in the aftermath of 9/11, to reduce Islamophobia and its violent effects on Muslim people (and those who "looked" Muslim) both at home and abroad. After 9/11, scholars of Islam, both Muslim and non-Muslim, were offered the spotlight as the U.S. government waged war in Afghanistan and Iraq, and Muslims Americans became the primary target of domestic intelligence and counterintelligence. Academic specialists had unprecedented access to government, foundation, and academic funding, publishing opportunities, and the media. We were called on as experts by funders as well as civic organizations who wished to increase cultural understanding and dialogue; to understand "the enemy"; to bolster human rights, women's rights, and democracy in the Muslim world; and so on. Some of us were focused on opposing war and reducing violence against Muslims, and we sought to identify various public partners in that task.[11] My pro-peace motivations were what the historian Marshall G. S. Hodgson called my "pre-commitments" as I prepared to lead the Arab Indianapolis community history project.[12] More than just the cultural assumptions, values, and beliefs that inspire and constrain our scholarly work, pre-commitments include our previous life experiences and our explicit and implicit scholarly goals.

"Setting Problems": Project Planning

Sometime in the fall of 2019 or maybe as late as January 2020, I was talking with my anthropology colleagues, Sue Hyatt and Mullins, about wanting to turn my attention toward Arab American history and life in Indianapolis. They suggested that I apply for IUPUI's Bantz Community Fellowship, which provides funding for "one year to support a collaborative research team made up of faculty, staff, students, and community partners/members to address a pressing community issue in Central Indiana." Though I was not awarded this fellowship, the process of planning and writing the grant provided a framework for the project and inspired me to lead and implement it. Some public historians refer to this as the "problem-setting" phase of a project. As Cherstin M. Lyon, Elizabeth M. Nix, and Rebecca K. Shrum observe, "The problem-setting phase includes, for example, the process of determining who the stakeholders are in any given project, determining what they believe the outcomes of the project should be, and the process of bringing . . . their disparate visions together into a single set of clearly identified problems."[13]

I did not know about the term *problem setting* at the time, but this is exactly what I tried to do. I reached out to a lot of Arab Americans and institutions as potential partners, including Eman Schools, Catholic Charities' immigrant and refugee services office, and Indiana Muslim Advocacy Network. Though these institutions were not majority Arab American groups—in fact, there has not been a significant Arab American–focused voluntary organization in Indianapolis since the 1970s—they had significant numbers of Arab American stakeholders. I shared my basic goal to document the history of the Arab American community in Indianapolis, to engage religious congregations and nonprofits, and to share and celebrate our community in public events. I also made clear that the shape of the project would depend on what community members wanted to see and work on. All of these institutions committed themselves in writing to supporting the project. I also asked St. George Antiochian Orthodox Church, founded by Arabic-speaking Syrian Lebanese immigrants to Indianapolis in the early 1900s, if they would like to sign on as a partner. Though they demurred on any official partnership, Father Joseph Olas, who was then deacon, offered lots of help—most importantly, access to the best single collection of photographs documenting the history of Arab Indianapolis.

Hiba Alalami, the inaugural executive director of the Indiana Muslim Advocacy Network and a longtime friend, met with me for an in-depth planning meeting. "I got excited," she recalled in an interview for this chapter. "I felt that this initiative was groundbreaking in nature given that very little was known about the early Arab immigrants in Indianapolis."[14] Alalami wanted to learn

about the parallels between the first two generations of immigrants and her own, especially whether they faced similar challenges, such as anti-Arab prejudice and discrimination. "I also felt that this research provided an opportunity to . . . underscore the many contributions that Arab Americans made and still make to this day," she said.

Alalami became an enthusiastic partner and helped to determine what the project eventually looked like. She supported the idea of producing a website and conducting oral history interviews but also recommended that we produce a book about our history. "I suggested a book as part of the project deliverables because books have always been a main source of knowledge," and the "book would be an opportunity to solicit the participation of the Arab community to co-create knowledge," she said. Alalami liked the idea that the book would make room for contemporary Arab American stories. "In that regard," she declared, "the research extended beyond a historical examination to include a community participatory aspect to it." I had not initially planned on writing a book—I was thinking of digital products like podcasts and a website—but I like publishing books, and it felt right, so I adopted the idea immediately.

Then, on January 30, 2020, Alalami tapped into her extensive local Arab American networks and asked forty to forty-five Arab Americans to join an Arab Indianapolis project WhatsApp group if they were interested in staying informed about and helping guide the project. Two dozen people accepted her invitation and remained part of the group for three years. This was one of the primary groups to which I held myself accountable, using this platform to seek "collaboration, commentary, and criticism at every stage" of the project.[15] As Alalami noted, "a core group of supporters demonstrated a strong engagement level" over the life of the group—about half a dozen or so people.[16] Others only occasionally participated. A minority of the group never said anything. I found the engagement and lack thereof to be instructive. Though there was no direct criticism aired in public, the group often made clear what it valued through its praise and what it did not value through its silence. My feeling was that the silence—that is, a lack of reaction or questions that went unanswered—became important indicators to me about whether the project's work was meaningful for the group's members. I did not always know *why* group members chose silence, but it felt right to honor it.

Between the WhatsApp group and the project's many other community stakeholders, *my* project began to turn into *our* project. Our collective goal was for Arab Indianapolis to be a form of community-based participatory research, which, for Lyon, Nix, and Shrum, "embodies the highest ideals of shared authority" in public history. The aim is for public historians to "share responsibility for the planning, design, research, analysis, interpretation, and dissemination of the findings with their community partners."[17] In the case

of Arab Americans in Indianapolis, this meant that we had to reach out to and develop partnerships with a variety of individuals who represented the diverse demographics of our community. For example, though Alalami had invited some Christians to the WhatsApp group, her social networks were mainly Muslim and immigrant, and it was mainly Muslim immigrants who participated in the group over the long term.

That the WhatsApp group became mainly Muslim in character did not surprise me. Religion among Arab Americans, like among other Americans, can lead to social homophily, a situation in which those on the edge of a social niche leave the group.[18] The fact that this was a supermajority Muslim group from the beginning meant that those who felt marginal might not stick around, even if they supported the cause of researching and celebrating Arab contributions to Indianapolis. I also knew from my work with both communities that there was a lack of meaningful social connections between the mostly Christian Arab Hoosiers who traced their heritage to the early twentieth century and the Muslim Arab Hoosiers whose Indiana stories began after 1965. One of the project's aims was to create a narrative of Arab Indianapolis in which Muslim, Christian, and secular Arab Americans could recognize their own history and commonality. Unlike in some other cities, there was no Arab American organization to turn to for assistance or partnership. There was no chapter of the American-Arab Anti-Discrimination Committee (ADC); the last Arab group in Indianapolis was a state chapter of the National Association of Arab Americans run by Helen Corey in the 1970s. I had talked with the ADC years ago about possibly establishing a group, but it became clear to me that it would likely fail to get off the ground because it had been hard to organize even occasional Arab-focused public events.[19] But now the Arab Indianapolis community history project could help foster an awareness of our past and the cultural traditions and anti-immigrant experiences that, despite our many differences, we shared. Though we did not map out all the topics the project would explore at this point—we could not do so since we did not know yet what we would find—Alalami and I talked about addressing the gap that developed in Indianapolis between Christians and Muslims. Since our community here is roughly half Christian, half Muslim, there would be an equal number of posts for each group.

We made clear that we would try to represent other forms of diversity in our community, as well. Men and women would be equally represented, as would national origins. Though the early history of the Indianapolis community was mainly Syrian, Lebanese, and Palestinian, we wanted to ensure that the final product would have stories from across the Arab world. We ended up with pieces about Moroccan, Algerian, Egyptian, Yemeni, Saudi, and Iraqi Americans as well as the long-standing Syrian, Lebanese, and Palestinian communities. We also wanted to explore the different kinds of work in

which our community engaged, from peddling, homemaking, and the grocery business to military service, the professions, and wage labor. The idea was to produce a rich and diverse portrait that would celebrate our community and also challenge the stereotypes or assumptions that many non-Arab Hoosiers had developed.

We forged ahead quickly in the planning process in order to make a grant deadline in February 2020. The institutional partners volunteered to become sites where a lot of the research might physically take place. For example, they agreed to hold community meetings for both organizing and presentation purposes. We planned to hold workshops on how to use the StoryCorps app to record each other's oral histories, and we scheduled times to invite both community and student researchers to present their findings to one another. I talked with the IUPUI Center for Digital Scholarship about holding a scan-a-thon so that historical documents and images could be preserved. I also met with the Indiana Historical Society Press and asked if they would like to publish the book. They declined, so I moved on to other publishers, eventually settling on the Cleveland-based, worker-owned Belt Publishing as the book's home. We purchased the rights to the ArabIndianapolis.com domain name for future use.

We then signed up the first four student researchers for the project. Two of them, Mickey Yoder and Emma Eldridge, were honors students—they would obtain credit for their research—while the other two, Ronnie Kawak and Jay Brodzeller, would receive an hourly wage for their work. Other students who eventually worked on the project were Dana Dobbins, Lily Malcomb, Layla Mitiche, Asrar Jaber, and Jamee West. In some cases, especially with the honors students mandated to conduct their own research, I invited them to work on whatever historical topics they wished. In other cases, I set out specific tasks, such as researching a certain individual or doing keyword searches in digitized newspapers for words like *Syrian* in the 1930s. I trained all of them how to use city directories, Sanborn insurance maps, digitized newspapers, and Ancestry.com (for which IUPUI purchased subscriptions). I also eventually hired Ziad Hefni, a local Arab American videographer and IUPUI student, to be the project's photographer, and many of his photographs were eventually included in the book. Overall, four out of the ten student researchers and workers were members of the Middle Eastern and North African communities on which they completed research. They became what Lyon, Shrum, and Nix refer to as "cultural brokers," not in the sense that they bridged any gap between the project and its stakeholders but in that they used their social networks, their family ties, and sometimes their Arabic language skills to determine whose stories were included.[20]

The grant required that the proposed activities focus on solving a problem. Problem-solving is a discourse perhaps better suited to social and ap-

plied sciences than the humanities, which, historically speaking, is as interested in beauty, goodness, and justice as inherently valuable ideals as it is in solving problems. But in this case, it was not difficult for me to frame my response in terms of the discrimination that I had been trying to address for years—except, instead of focusing on Muslims, I was now focusing on Arabs, both Muslim and Christian.[21] I wrote that "this is a perilous historical moment for Arab Americans. . . . Arab kids are regularly bullied in school; Arabs are the victims of hate crimes; and Arabs are often targeted for surveillance by the FBI."[22] I did not make such claims merely for the purposes of the grant; they would remain paramount in shaping the content and style of the project's many products.

Overall, I was surprised how easy the planning process was. Lyon, Nix, and Shrum rightly observe that "public historians cannot bring a team together effectively until they can identify the problems that will guide the team's work. In the real world of multiple experts and stakeholders working together, the process it takes to identify problems that will guide everyone's work is messy."[23] The process may have been messy in the sense that it was improvisational and community-responsive. But it did not feel emotionally messy. There was so much enthusiasm, so little known about Arab American history in Indianapolis, and such an experimental and organic quality to our work together that *messy* was not the right word to describe what was happening—it was more like *thrilling*. The process was made easier by the long-standing personal and professional relationships I had made over the past fifteen years with many of my community partners and the fact that I come from a Midwestern Arab American background. The team was also very flexible about what topics we would research and what products we would explore. I thought of myself partly as a midwife trying to give life to my community partners' ideas.

In sum, the beginning of the project went smoothly. What I could not anticipate, of course, was how the very next month, the COVID-19 pandemic would pose existential challenges to the project's design. It made certain elements impossible but also created completely unanticipated opportunities.

The Unexpected Outcome of Pandemic-Era Community History

On March 8, 2020, one week before many states started their official pandemic lockdowns, the Arab Indianapolis website was launched with the announcement that the project would document the history of Arab Americans in central Indiana and celebrate their contemporary contributions to the city and the region. One of the site's pages contained links to the StoryCorps

app with possible questions and helpful hints on how to record an oral history interview with a friend or family member. The app, which can be downloaded for free on a smartphone, is easy to use and reduces technical barriers to the recording and archiving of oral sources.[24] But without the ability to meet people in real life or hold public meetings, this aspect of the project, along with the archiving of personal documents and photographs, never took off. I continued to reach out periodically and systematically throughout 2020, encouraging my fellow community members to use the lockdown as an opportunity to record an interview with one of their family members. But I understand why people did not have the time or energy or even consider this act particularly important during the pandemic. Because I was thinking of my work as a collaboration with community members and they did not wish to participate in this aspect of the project, I chose to accept it as an act of community wisdom. Of course, I was disappointed that it had not worked, but it did not feel like a failure. The pandemic era was one of great powerlessness, and it seemed folly to try to fight what was a clear message.

Even though the team was unable to curate a collection of oral histories and family documents, what we could do is connect with our Arab American ancestors. Oddly, perhaps, those who were gone were more accessible during the lockdown than those who were present. Our research team discovered them in the archive.

I was not working full-time at this point. My spouse and I divided each day in half, taking turns caring for our three children who were on Zoom school. But in order to move the project forward, it made sense for me to take on more of the labor than I had first anticipated. In accepting Alalami's challenge to produce a publishable book, I knew that publishers would be more attracted to the project if the writing was stylistically consistent, elegant, and compelling. I decided to become the project's main author and editor. I made the choice deliberately, even though it meant that I was not always practicing shared authority for the analysis and interpretation of the data with my community partners. This decision meant that I would often be the one interpreting the meaning of the community in terms of larger historical events, trends, and contexts. Though I used plain rather than academic language to do so, I was thus able to apply my expertise in analyzing the changing racial identities of Arab Americans, the effects of xenophobia and nativism on their lives, large-scale economic changes in labor and commerce, the gendered nature of public service and voluntarism, and the politics of ethnicity. Because so many different people from different backgrounds were included, and because the blog posts and eventually the book featured interviews with community members, it still felt like I was mainly helping to amplify the community's many voices rather than fitting everyone into a narrow interpretive

framework. I eventually came to refer to the book as our community's scrapbook of stories and photographs.

Though many community members were not recording oral history interviews in 2020, the project's student researchers still wanted to work. They provided a lot of data that I then supplemented with additional research. I authored the blog posts, crediting student researchers in the notes. As the pandemic lockdown commenced, one of the project's articles was "Indianapolis' Syrian Colony, Buried Under Lucas Oil Stadium," the story of Indianapolis's first and perhaps only Arabic-speaking neighborhood, which flourished from the 1880s until World War I.[25] The post only scored 600 or so hits during the month it was released, but it seemed to create buzz among local historians and culture makers, just the kind of people who can help a project find larger audiences. The story contained many of the elements that make for good popular history. First, it was a genuine "discovery." Neither local historians nor descendants of those who had made up this community knew that it once existed; the memory of it had simply vanished. Second, it spoke to issues of gentrification, development, and the dislocation of urban communities. The community's location on the same land where one of Indianapolis's iconic buildings, the home of the National Football League's Indianapolis Colts, now sits, resonated as another example of the "price of progress." Third, the story revealed that Arabic-speaking people had lived in Indianapolis far longer than anyone had imagined. This long presence turned many readers' basic social and cultural assumptions about Arabs upside down, making the story seem counterintuitive. The same was true about the religious element: this was a community of Arab Christians, not Muslims, another fact that downright confused those who saw Arabs and Muslims as one and the same.

Among the many friends that I told about the project was local filmmaker Vincent Manganello. He suggested that the project overall would come to more people's attention if I made a trailer promoting it. It felt like a good idea. Manganello showed me how to write a basic film script, and I relied on what research we had in hand, also gathering additional historic photographs, maps, and other images to show as B-roll, the footage used in film to create an atmosphere, illustrate its themes, or, in the case of an early Ken Burns documentary, drive the plot of the story. The pandemic meant that we could not film interviews, that we would have to use a small, fully masked crew, and that we would shoot scenes outside. I would do all the stand-ups, and then we would fill in the rest with voice-over, music, and B-roll.

Besides the trailer being shot, which I paid for with my research funds, there was little activity on the project until the fall, when the research team began work on a variety of topics. These topics included the Syrian background of Governor Mitch Daniels, pre–World War I immigrant and store

owner Sadie Hider, the building of St. George Syrian Orthodox Church in the 1920s, the Syrian corner grocery before World War II, Palestinian American Indiana Senator Fady Qaddoura, economist Rabia Jermoumi, elementary-school teacher Dounya Muslet, political exiles Farid and Faouzia Mitiche, the history of Arab Hoosier physicians since the 1920s, Arab American leader Ann Zarick in the 1930s, the Syrian American Brotherhood Hall on Riverside Park, Iraqi poet Sajjad Jawad, and Egyptian American professor Nermeen Mouftah. In some cases, this research was mostly archival; in other cases, it involved conducting interviews with living persons. Our trailer, about five minutes long, was released on YouTube in November, followed by blog posts on the topics and figures we had been researching.

The rich documentary content and the release of the short film gave the project a substantial digital footprint, and our website logged thousands of views in a matter of two months. We received compliments from several people outside the Arab American community. Stephen Lane, who at the time was the Indianapolis Public Library special collections head, and Indiana Historical Bureau staff historian Jill Weiss Simins reached out to help. Most importantly, our Arab Indianapolis WhatsApp group came alive with support and feedback. "I am amazed," wrote one member, "by the civic engagement and leadership of the Arabs of Indianapolis. It shows pride, initiative, and strength of identity. You make us ever more proud, Edward. Keep up the good work." Another wrote, "I want to take this opportunity to thank each person who has been part of this project. We should be proud of our heritage and contribution to world civilization."

The group's reactions taught me that, at times, public historians must first work *for* the community before they can work *with* them. Principles of shared authority need to be flexible enough to deal with the sometimes difficult birth of new public history projects. In this case, we needed to offer our community something before they were willing to commit fully. They were busy people. Before giving up their valuable time, talent, and resources in the middle of a pandemic, they needed us to show them a concrete proof of concept demonstrating the potential power of this work. One person wrote, "I am sorry I haven't been active on this group but . . . things have been crazy. I would be interested in taking part."

The project began expanding quickly. As more blog posts were published, more Arab Americans, especially Christians who traced their roots to the period before World War I, reached out to become part of the project. One of the most compelling was Diana Najjar, a retired teacher who connected with a group of Arab Americans whose family histories went back as far as mine did—that is, before World War I. New stories were added to the project, and student researchers built on these opportunities, producing new historical data and conducting interviews with more Christian members of the com-

munity. Confident that we now had a wide-ranging set of stories reflecting the diversity of the community, I signed a contract in early February 2021 with Belt Publishing to publish a book of about 30,000 words and seventy or so images.

At the same moment, Manganello, the producer of the short film, approached me with the idea that we should make an hour-long documentary about Arab Indianapolis for WFYI-TV, the local PBS affiliate. The idea was an attractive one to me, to Alalami, and to Dr. Eyas Raddad, an executive at Eli Lilly and a local Muslim leader who was also a longtime friend. Alalami's spouse, Dr. Mohammad Al-Haddad, and Raddad's spouse, Samia Alajlouni, also became essential partners in this component of the project.

We were ready to take the next step, so Manganello connected me to local producer Rebecca Fisher, who jumped into the project enthusiastically. Fisher was an ideal partner. "I wanted to be sensitive to the fact that this was not my story to tell, and I also walked into this understanding that I know very little about Arab history and culture," she said, later reflecting on her role. "I needed to be quiet and learn."[26] Producing a high-quality hour-long film would cost $60,000 to $100,000, she said, outlining different filming options for us. These amounts scared me; I was a professor, not a filmmaker. Where would the funding come from? Raddad recommended that I set up a nonprofit organization to which tax-deductible contributions could be made. Alalami, who was a nonprofit leader and had a master's degree in nonprofit management, and I worked on setting up a group. A donations page went up on the website. The Arab Indianapolis Foundation, Inc., a 501c3 nonprofit incorporated under the laws of the State of Indiana, was born.

The next month, in March, WFYI wrote a letter of intent to air the documentary that we would produce, based largely on Manganello's previous work with them and the quality of the trailer we had released. This letter of intent was essential to our grant applications, which we began writing immediately. Indiana Humanities provided the first funding—$3,000—and we were happy to have their imprimatur. But we got the big break that we really needed when we won an IUPUI research support grant of $30,000. I also pledged $25,000 from my endowed chair and from grant money I had accumulated from what is called "indirect cost recovery," the money that one sometimes gets in addition to funds for "direct costs" from an external grant, in my case mainly from a series of federal grants.

Now we needed to write a script. For this, I turned for advice to veteran producer Graham Judd, who directed and produced *Oprah's Roots: An African American Lives Special* (2007) as well as episodes of *Frontline* (2002), *History Detectives* (2004), *African American Lives* (2006–2008), and *Nova* (2011). I knew Judd from having served as consultant on a series about American Muslim history, and he graciously mentored me on the basics of how to write a full-length script for a historical documentary. Judd thought that given the

disparate stories we would be including, the program would work best as a presenter-driven narrative, one in which the presenter's journey with other people through the past becomes the thread that holds the program together. I was concerned that I would be too front and center, but after watching other documentaries in which the host identifies as a member of the community whose history they are narrating, I decided that was an acceptable risk. Judd suggested that I watch Dr. Yasmin Khan's documentaries, including *A Passage to Britain* (2018) and *Britain's Biggest Dig* (2022), and I ended up looking to those works as models for what I wanted to do, sharing them with my documentary's director of photography (DP), Manganello; the producer, Fisher; and the editor, Cory Fisher.

In writing the initial script, I knew that I would have to pick and choose the narratives featured. The production team wanted about six scenes, each about ten minutes in length. Judd also emphasized that we needed to grab the audience in the first thirty seconds and that they would need to feel interested in me if we were going to keep them for an hour. We decided to begin with a hook about how Indiana Governor Mike Pence had tried to ban Syrian refugees settling in the state, explaining how shocking it was for our community. The plot of the film, driven literally by my footsteps around the city, would be that I had teamed up with other Arab Hoosiers to go back in Indianapolis history to reveal, just like the website and book, how we had belonged and contributed to our home. We began by recreating the Syrian neighborhood at Lucas Oil Stadium and the building of St. George Church, asking contemporary Arab Americans what this history meant to them, and then followed the same pattern in the other scenes. The family of an Arab Hoosier prisoner of war in World War II helped to tell his story. At the Indiana Capitol, Senator Qaddoura talked about Corey, the first statewide Arab American officer holder. Drs. Shadia Jalal and Al-Haddad explored the medical contributions and innovations of Drs. Waheeb Zarick and William K. Nasser. The movie ended with cooking and feasting at Alalami's house, where she, Alajlouni, and I cooked a meal for Raddad and Al-Haddad, who showed up to eat with us. We knew that we were leaving people out and that the film's lack of comprehensiveness would bother some people, but that is the nature of telling a story via film. It cannot be encyclopedic.

I was also conscious of—and a bit uncomfortable with—the film's lack of a radical critique of U.S. war-making and foreign policy, which had been so central to much of my specialized and public-facing work since 9/11. But the audience for the film, first and foremost, was made up of WFYI viewers—middle- to upper-class, older, educated Hoosiers, both Democrat and Republican. Our audience was similar, then, to the majority of U.S. consumers of public history "at traditional venues like cultural events, museums, and historic sites."[27] We avoided the radical critique that anti-Arab discrimination

and violence is a product of war-making and domestic counterintelligence, choosing to highlight other themes. The film did not hold back on surfacing the racial and xenophobic discrimination faced by Arab people in Indianapolis from the nineteenth century until today. But it presented this problem, including Pence's attempt to ban Syrian refugees from the state, as a violation of our own American principles, a denial of our shared creed that all people deserve equal opportunity and equal rights. As a student of Black history, I knew that many Black Americans had long embraced the country's foundational documents and patriotic symbols as a way to call for reform and sometimes revolution. We applied this liberal narrative to Arabs, choosing to claim our belonging to rather than alienation from America. The insistence that Arabs had done their part to build the Indianapolis we know today was a celebratory narrative meant to surprise and perhaps create cognitive dissonance for viewers who thought of Arab people as new Americans, recent immigrants, or even perpetually foreign or unassimilable. Those stories also surprised contemporary first- and second-generation Arab Hoosiers who were not aware of the long history of Arab Indianapolis.

Fisher scheduled the filming over the summer, organizing a crew that included the DP, a second camera operator, a sound engineer, a production assistant, a grip, a hair and makeup artist, and a location coordinator. Together, we decided to take a financial risk by using a full crew and generally devoting an entire day to filming each scene. This meant that we would use most of the money we had on hand and that as executive producer, I would have to raise around $40,000 more to pay additional preproduction, production, and postproduction costs. Fisher paid the crew and other out-of-pocket expenses first, meaning that she and Cory Fisher, her husband and the film's editor, would wait to get paid at the end. This made me nervous, especially when we did not win any of the external grants for which we applied. After the footage was in the can, Fisher then wrote the full script, selecting which lines in the interviews would be featured and writing transitions from one section to another, also adding to the voice-overs that I had already penned for the short shooting script. I focused on fundraising, which I looked at as a way not only of making sure that the Fishers got paid but also of gauging the community's support for the work, getting their input at screenings of rough cuts, and broadening the number of people who had a stake in the film. By the end, seventy-five individuals made donations of $10 to $4,500, totaling $28,684. An Indiana University (IU) Presidential Arts and Humanities production grant of $15,000, which came very late, made up for the remainder of the film's budget.

Making a film, as anyone involved in doing so will say, is by nature a collaborative endeavor. We were committed to telling the story of Arab Indianapolis's "hidden history" in a way that many—if not most—Arab Americans

in Indianapolis would recognize and support. We wanted to be accountable to our community. Fisher, the producer, reflected on the experience as a non-Arab filmmaker making a film about Arab people:

> I did find myself at various points sort of apologizing or explaining why I was working on this and not an Arab filmmaker. I did worry that people might think, "Wait, why is this white girl working on this film?" I did feel the need to say, "I am so appreciative of this opportunity. And although I myself do not have any Arab lineage, this is such a wonderful story and I'm excited I get to be part of telling it," and then really just explain that I came to be involved based on professional connections, rather than ethnic ones.[28]

In the end, however, none of the dozen Arab Americans who appeared in the film ever raised a question about Fisher's ethnicity. "I was delighted by how welcoming the community was to me in the production process. I would have absolutely understood being kept a bit at an arm's length as a non-Arab participant, but nobody made me feel anything but welcome," she said.[29]

As fundraising for the film continued in late 2021 and early 2022, we also looked for ways to put the history that my team had uncovered to work. It was becoming clear that, since this was a story still little known beyond some Arab Americans, local historians, and those who followed me on Twitter, we needed to find additional ways to put it in front of different audiences. In February 2022, Qaddoura, who was featured in the book and the film, sponsored a resolution declaring April to be Arab American Heritage Month. Adapting text supplied by the Arab American Foundation, Qaddoura's staff and I fashioned a bipartisan resolution that recognizes the variety of Arab American contributions to the state. The Indiana Senate, whose supermajority was Republican, passed Resolution 37 by voice vote on February 17, 2022.[30] During the legislative session that year, the Indiana Historical Bureau also presented a slide recognizing Corey as a pioneering Arab American politician.

We also authored an Arab American Heritage Trail on TheClio.com, a free educational website and GPS-integrated mobile application founded at Marshall University. The trail featured ten sites: the Syrian Quarter, Shaheen Oriental Rugs on Monument Circle, the Indiana War Memorials, the former American Lebanese Syrian Associated Charities headquarters on Massachusetts Avenue, Corey's office at the Indiana Capitol, St. George Church, Warren Central football stadium, the Syrian American Brotherhood Hall, the governor's residence, and the William K. Nasser Center on 86th Street.[31] Another form of outreach came when students in IU Indianapolis's Arab American studies and American studies classes utilized materials from Arab Indianapolis in public history class projects. While some gave public

presentations, others took friends and family on the Arab Indianapolis Heritage Trail, recording their experiences on Instagram, Twitter, and/or Facebook. The materials for the project were also put to use with the help of my colleague, IUPUI Museum Studies Program Director Dr. Laura Holzman, who sought to connect with classes that might be interested in the project. In April 2022, students in Cathy Hamaker's design class presented plans for a couple of exhibits featuring Arab Indianapolis history. Their impressive proposals considered factors such as exhibit layout, loan objects, high-tech interactive display, low-tech interactive display, graphics, floor plan, and how the exhibit would encourage social connections and civic engagement.

Finally, the Arab Indianapolis Foundation made an application to the Indiana Historical Bureau (IHB) for the community's first historical marker to be added to the grounds of Lucas Oil Stadium. The marker was eventually approved. Titled "Syrian Quarter," the marker's first side reads: "Arabic-speaking Syrian immigrants settled here on Willard St. by 1893 in small, crowded multiple-family row homes. They created a vibrant neighborhood alongside Black Americans and European immigrants. Searching for economic opportunities in the United States, many Syrians worked as peddlers or in local factories, shifting to the grocery store business after WWI." The second side says, "Syrian immigrants and their families faced xenophobia, racism, and debates over their 'whiteness' while fighting for naturalized citizenship in the early 1900s. Mostly Christians, they celebrated holidays here with traditional Arab foods and folk music. By 1920, they moved from this area and began establishing Arab cultural institutions in other parts of Indianapolis." The majority of the funding for the $3,300 marker and its installation came from donations to the Arab Indianapolis Foundation.

This flurry of activity was capped by the June 2022 premiere of the documentary and the publication of the book. These events, along with the two dozen blog posts that were now part of the website, generated more public attention than we had expected. In the months before and after the film premiered, the project got a front-page story in the *Indianapolis Star* as well as print and television coverage in *Indianapolis Monthly*, WFYI News, IU Research, WFYI's member magazine and website, WRTV, and WISH-TV. The pre-premiere showing of the film at the central branch of the Indianapolis Public Library drew about a hundred people, and then the film was broadcast on WFYI in central Indiana on June 16. It was broadcast subsequently on every other PBS affiliate station in Indiana: WNIN–Evansville, August 7; WVUT–Vincennes, September 1, 21, 26; WIPB–Muncie, September 3; WFWA–Fort Wayne, October 16; WTIU–Bloomington, October 23, 26; WNIT–South Bend, October 24; and WYIN–Gary, November 18, 2022. In addition, the program has been streamed thousands of times on PBS and the WFYI website.[32] The film was included in the Heartland Film Festival in

Indianapolis, and in 2023, it was nominated for five Emmy awards by the Great Lakes Chapter of the National Academy of Television Arts and Sciences. The project won three of the Emmy awards for which it was nominated: best writer of long-form content, best editor of long-form content, and, most importantly, best historical documentary. The Fishers and I felt deeply honored, but for all of us, it was even more important that Arab American community members found the film meaningful. "I was really moved by the positive feedback the film had from the Arab community," Rebecca Fisher remembered. "To me, that was the most important thing."[33]

Expanding Engagement with Different Audiences and Products

After the film was broadcast in June 2022, we faced a decision about what to do next with this expensive product. A PBS station wrangler, the kind of consultant that encourages PBS affiliates to broadcast a program nationwide, thought the story was too local to get much play on a national basis. Considering this blunt assessment, which made sense, we decided on a different afterlife for the film. What seemed at first to be a bit of disappointing advice turned into a chance for even more local and state engagement.

Multiplying the impact of the investments that all of the donors and grantors had made in the film, the production team and stakeholders talked about which niche audiences might find this narrative useful or compelling. We immediately identified K–12 educators and local nonprofits interested in culture and history. Carly Weidman, then a community engagement manager with WFYI in Indianapolis, agreed to curate an Arab Indianapolis collection for PBS Learning Media, the national platform that offers free video and lesson plans to classroom teachers.[34] The Fishers made eight video excerpts from the film of about three to ten minutes long. I then composed introductions, class discussion questions, active learning exercises, and written assignments, geared mainly toward national and Indiana state geography, history, and social studies standards, for the videos under the following headings: Arab American food traditions; Arab American military service in World War II; Arab American immigration, 1880 to World War I; the history of Arab American physicians; Arab Americans and anti-immigrant discrimination; Arab American political pioneer Helen Corey; contemporary anti-Arab prejudice and discrimination; and the founding of St. George Syrian Orthodox Church. Curriculum designers Susan Douglass of Georgetown University, Abeer Shinnawi of Re-Imagining Migration, and Lindsey Beckley of the IHB reviewed them and made suggestions for improvement.

PBS and WFYI promoted the lesson plans on their social media, including during Arab American Heritage Month in April 2023, and we extended our educational outreach by offering local teachers a professional development workshop about these resources. In addition to introducing the lesson plans, the film, the book, and other project resources, we asked participants to design an original lesson plan for their own classroom or school setting. And we paid them for their time—$350 for the daylong workshop and the lesson plan. We also partnered with the IU School of Liberal Arts' Kathleen Kozenski, the program management specialist for the Geography Educators' Network of Indiana. She made recommendations about how to structure the workshop, spread the word in her networks, and volunteered to oversee the process by which teachers could earn credit toward licensing renewal for completing the program. The workshop gave teachers the opportunity to ask questions, brainstorm and work together on lesson plans, eat an Arab-style lunch that featured some of the food in the film, and meet and talk with local Arab American leader Ruba Marshood, the CEO of Indy Reads. We offered fifteen spots, and more than twice that applied. The educators were mainly from central Indiana middle and high school social studies programs. Their final lesson plans for geography, government, history, literature, sociology, and English as a New Language classes addressed topics ranging from the legal case *Exodus Refugee Immigration, Inc. v. Michael Pence et al.* to writing a family foods cookbook.[35]

In addition to trying to get some Arab Indianapolis material into local classrooms, we wanted it to reach a greater number of adults, too. Indiana Humanities' Director of Programs Megan Telligman supported the idea of statewide screenings and small-group dialogues about the film. Indiana Humanities had been an enthusiastic supporter of the project from the beginning, not only awarding it a small grant but also promoting it on social media and in their email newsletter. They also brought a lot of expertise to this kind of work. Telligman recommended that we develop a robust tool kit to accompany the screenings, and we worked together to produce a twenty-four-page guide with a program planning checklist, facilitation tips and discussion questions, communication tips, an historical research exercise, a small group dialogue guide on immigration, an essay on Arab American history and identity, and Alalami's first-person account of her immigration story. The Plater Chair of Liberal Arts offered Indiana Humanities a $5,000 grant, which they would use to give each site $250 to cover refreshments or other costs. This was a token amount, but at least it was something. The program would offer twenty mini-grants, and I figured that if ten sites followed through, it would be a success. I also used all of my local connections to identify possible groups and then emailed, called, and just plain bugged them to host a program. I figured it would take all of 2023 to complete the program.

Happily, I was wrong. By June 2023, all twenty mini-grants had been claimed, and almost all of the small dialogues had taken place. About 570 people attended these small dialogues at universities, libraries, museums, and religious congregations in Bloomington, Fishers, Indianapolis, Muncie, and West Lafayette. At the conclusion, hosts submitted final reports that reflected on the outcomes of the events. The reports showed that the level of engagement was generally high. At Indy Reads, "the group was so into our discussion . . . that we didn't realize how much time had passed! [It was] a fun, honest exchange of ideas and information." Audiences were also demographically diverse, including people from different generations, domiciles, and racial, religious, and ethnic backgrounds. The stories presented in the film were often as new to Hoosiers of Arab descent as to non-Arabs. "Several people remarked that this was the first time they felt 'seen' and their family's history connected to a public film," said the organizers at Purdue University. One non-Arab participant at the University of Indianapolis dialogue noted, "I learned a lot from watching the film, especially as it relates to the history of immigrant communities in Indianapolis and the ways in which these histories have been covered over and under-appreciated." At the Purdue University Extension, Marion County 4-H showing, the organizer said, "Our participants came from varied backgrounds and ethnicities, and many of them shared the hope they felt as a result of watching this film, and their desire to continue to share or personally navigate conversations around culture." In their final report on the program, Indiana Humanities also remarked that the program connected them to Hoosier individuals and groups with whom they had engaged for the first time.

Several hosts sought cosponsors in order to bring together people with a variety of perspectives and experiences. "We were able to facilitate a lively discussion that drew a hybrid audience on our Facebook," explained the organizers at West Lafayette Public Library. "The Islamic Society of Greater Lafayette helped the library make it happen. Our in-person audience of dozens included families with young kids." At Fishers Public Library, Arab American Muslims from Al Huda Mosque and Arab American Christians from St. George Church teamed up to talk about the film. A similarly interfaith panel at All Souls Indianapolis discussed how their faith "related to their Arab identities. This in turn led to attendees sharing and discussing their own relationship to their family histories and immigration to the USA."

Anti-Arab discrimination and Arab American responses to it were often discussed in these dialogues, indicating that the film had successfully raised the topic of this long-standing problem. At the Indiana Historical Society, for example, one speaker "described their experiences as a school child being excluded from school lunch, parties, activities, and made to sit in the corner."

At IU Indianapolis, students, faculty, and staff discussed how anti-Arab prejudice had changed or stayed the same over time.

These showings as well as the educators' workshop were different in nature than publishing a book or releasing a movie, but even as they touched a smaller number of people, this more intimate, smaller-scale kind of public history was soul-satisfying. It is one thing to consume a movie or even a book but quite another when audience members become interpreters of what they hear, see, and experience when watching the film. The same is true when a teacher spends time creating a classroom lesson plan. This kind of engagement, which mirrors active learning in the classroom, is meaningful not only for consumers of public history but also for its producers. It means that what you have produced has been passed along and put in the hands of others, who try to make sense of it for themselves.

On Reflection

How do we measure the success of the project as a form of public history? In the summer of 2022, my Indiana University colleague Mullins, who had expressed concern about the project's ambitious agenda, confessed to me that he was surprised the project took off the way that it did. He was not the only one. All of us deeply involved were amazed how quickly it grew and how many directions it took. "I'm proud to say that the project exceeded my expectations," said Alalami. Reflecting on the project, Alalami pointed to the grassroots impact on K–12 educators, public television viewers of the documentary, and community dialogue participants as well as the institutional impact at the Indiana Historical Bureau, Indiana Humanities, and a variety of universities and colleges.[36]

Another way to measure impact, beyond the accomplishments outlined here, is by looking at the project's ripples in places beyond the scope of the project itself. For example, there is evidence that local historians, activists, and culture makers are now more likely to recognize Arab Americans as a real presence in local and state history. In 2023, Indy's Global Village staged an art and history exhibit for Arab American Heritage Month. The Riverside Promenade on Indianapolis's Riverside Park included a plaque about our community where the Syrian American Brotherhood Hall used to be. When the Bicentennial Unity Plaza, located outside the venue where the National Basketball Association's Indiana Pacers play, opened in 2023, it alluded to the history of the Freije family who once lived on Willard Street and featured narration by local Arab American leader Sara Hindi. In 2024, the Indianapolis Cultural Trail asked me to provide the verbiage for a plaque about the Syrian Quarter to be included in its South Street Extension. And finally, when

African American historian Leon Bates and activist Beverle Kane protested the proposed building of a bridge over the graves of those buried in the local Greenlawn Cemetery, both of them contacted me to ask if I knew of any Arab Americans buried there, too. I was deeply moved that they did so.

There is much more public historical work about Arab American history in central Indiana to do. As noted, the pandemic forced a shift in the community-based participatory research plan. Without being able to house the project in local mosques and other community spaces, we were not able to build an archive or conduct as many oral history interviews as we would have liked. Alalami hopes that future research projects about Arab Americans will adopt a "participatory action research framework" oriented toward social issues, one in which an even greater number of community members frame the "research questions, design, and method." Raddad, who led the film screening and dialogue at Al-Fajr Mosque in Indianapolis, has stated that there is a clear desire among Muslim Hoosiers of various ethnic and racial backgrounds to document their history in central Indiana. Alalami also looks forward to the history projects of other historically underrepresented communities. Arab Indianapolis, she argues, shows "the importance of uncovering the forgotten, or rather rarely investigated, history of marginalized communities.... I really hope to see similar projects exploring the ethnic, racial and religious tapestry of Indianapolis and other cities across the state."[37]

It is hard, I admit, to offer an extended, dispassionate analysis of the project at the moment. Feelings of joy dominate my heart and my head. Part of that comes from the strengthened connections that I have made with other Arab Americans by documenting, listening to, and sharing our stories. Whether it involved interviewing someone on camera for the film or writing about someone's life for inclusion in the book, the making of Arab Indianapolis forged a sense of mattering to one another's lives. These ties are the kind that can last, even as an informal network of friends and allies. This project leaves a record of a people whose history has been at least partially recovered. For me and other Arab Americans, that knowledge inspires us, providing the ancestral energy we need to survive, to prosper, and to face whatever challenges are ahead.

NOTES

1. *Arab Indianapolis: A Hidden History* (Arab Indianapolis Foundation, 2022), accessed April 8, 2025, https://www.pbs.org/show/arab-indianapolis-hidden-history/.

2. Edward E. Curtis IV, *Arab Indianapolis* (Cleveland, OH: Belt, 2022).

3. "Arab Indianapolis Heritage Trail," TheClio.com, February 10, 2022, https://www.theclio.com/tour/2122.

4. "Monument," Arab Indianapolis, accessed April 8, 2025, https://arabindianapolis.com/monument/.

5. "Arab Indianapolis: A Hidden History," PBS LearningMedia, accessed April 8, 2025, https://indiana.pbslearningmedia.org/collection/arab-indianapolis/.

6. "Educator Workshop," Arab Indianapolis, accessed April 8, 2025, https://arabindianapolis.com/educator-workshop/.

7. "Arab Indianapolis: A Hidden History," Indiana Humanities, accessed April 8, 2025, https://indianahumanities.org/arabindianapolis/.

8. "Arab Indianapolis," Arab Indianapolis, accessed April 8, 2025, https://www.arabindianapolis.com.

9. "Donations," Arab Indianapolis, accessed April 8, 2025, https://arabindianapolis.com/donations/.

10. IUPUI University Library curates the scholarship of many of these scholars. See, for example, "Susan Hyatt," ScholarWorks, accessed April 8, 2025, https://scholarworks.iupui.edu/handle/1805/11711; and "Paul R. Mullins," ScholarWorks, accessed April 8, 2025, https://scholarworks.iupui.edu/handle/1805/11714. See also Laura Holzman, Elizabeth (Elee) Wood, Holly Cusack-McVeigh, Elizabeth Kryder-Reid, Modupe Labode, and Larry J. Zimmerman, "A Random Walk to Public Scholarship: Exploring Our Convergent Paths," ScholarWorks, accessed April 8, 2025, https://scholarworks.iupui.edu/handle/1805/27021.

11. One excellent overview of the politics of scholarship after 9/11 can be found in Zachary Lockman, *Contending Visions of the Middle East: The History and Politics of Orientalism*, 2nd ed. (New York: Cambridge University Press, 2010).

12. Marshall G. S. Hodgson, *The Venture of Islam: Conscience and History in a World Civilization* (Chicago: University of Chicago Press, 1974), I:26–28.

13. Cherstin M. Lyon, Elizabeth M. Nix, and Rebecca K. Shrum, *Introduction to Public History: Interpreting the Past, Engaging Audiences* (Lanham, MD: Rowman & Littlefield, 2017), 13.

14. Hiba Alalami, email interview with author, November 20, 2023.

15. Lyon, Nix, and Shrum, *Introduction to Public History*, 38.

16. Alalami, email interview.

17. Lyon, Nix, and Shrum, *Introduction to Public History*, 35.

18. Miller McPherson, Lynn Smith-Lovin, and James M. Cook, "Birds of a Feather: Homophily in Social Networks," *Annual Review of Sociology* 27, no. 1 (2001): 415–444.

19. On April 15, 2024, I convened a meeting of eighteen Arab Americans and community allies who established a statewide chapter of the ADC. I withdrew my name from the elections so others could lead. Though my leadership of the Arab Indianapolis community history project helped me gather a diverse group of Arab Americans for this purpose, it was clear to me that the ongoing genocide in Gaza and its impact on Arab Americans were the primary reasons for the timing of the chapter's founding.

20. Lyon, Nix, and Shrum, *Introduction to Public History*, 42.

21. Studies of prejudice, discrimination, or violence against Arab Americans constitute an enormous body of literature. Google Scholar lists a thousand of them. For a heartfelt approach, see Moustafa Bayoumi, *How Does It Feel To Be a Problem? Being Young and Arab in America* (New York: Penguin, 2009).

22. Edward E. Curtis IV, "Arab Indianapolis Grant," Charles Bantz Community Fellowship, n.d.

23. Lyon, Nix, and Shrum, *Introduction to Public History*, 13.

24. "The StoryCorps App," StoryCorps, accessed June 12, 2025, https://storycorps.org/participate/storycorps-app/. For a critique of StoryCorps' strengths and weaknesses as a platform for oral history creation, see Aubrey Parke, "StoryCorps and Crowdsourc-

ing in the World of Digital Humanities," Oral History Association, accessed April 8, 2025, https://oralhistoryreview.org/technology/storycorps-and-crowdsourcing-in-the-world-of-digital-humanities/.

25. "Indianapolis' Syrian Colony, Buried Under Lucas Oil Stadium," Arab Indianapolis, accessed April 8, 2025, https://arabindianapolis.com/indianapolis-syrian-colony-buried-under-lucas-oil-stadium/.

26. Rebecca Fisher, interview with author, October 24, 2023.

27. Lyon, Nix, and Shrum, *Introduction to Public History*, 116.

28. Fisher, interview.

29. Fisher, interview.

30. Senate Resolution 37, Indiana General Assembly, accessed April 8, 2025, https://iga.in.gov/legislative/2022/resolutions/senate/simple/37.

31. "Arab Indianapolis Heritage Trail," TheClio.com.

32. "About," Arab Indianapolis, accessed April 8, 2025, https://arabindianapolis.com/about/.

33. Fisher, interview.

34. "Arab Indianapolis," PBS LearningMedia.

35. "Educator Workshop," Arab Indianapolis.

36. Alalami, email interview.

37. Alalami, email interview.

7

Arab American Genealogy Research as a Form of Public History

Reem Awad-Rashmawi

Being excited to figure out DNA matches, adding the names of women and girls who were previously excluded from a family tree, and figuring out what city their immigrant ancestor came from—these are a few reasons Arab Americans have jumped onto the genealogy bandwagon. It is estimated that around 3.7 million individuals living in the United States identify with ancestry from Arabic-speaking countries.[1] In contemporary U.S. society, there is a significant interest in history in the form of genealogy or family history research. DNA tests, numerous online data sources, and increased access to archives, libraries, and museums have drawn the public to explore their lineages and how their stories link their past to the present. In many ways, genealogical research and family stories are the epitome of public history. This can also be said for Arab American public history. Genealogy arguably engages more members of the public in the active creation of historical knowledge than many other popular forms of public history.

This chapter highlights how genealogical research is present primarily within the public rather than the academic sphere and how online forums, conferences, and local societies explore research methodologies through public engagement rather than academic discourse. Of particular interest is how genealogists, both professionals and hobbyists, use locality and historical research to understand the context of their ancestors' stories. For Arab immigrants, immigrants of other ethnicities coming from Arabic-speaking countries, and their descendants, the primary source of genealogical information remains in the traditional form of oral histories that are passed down to suc-

cessive generations. A growing connection through archival research and genetic reaffirmations is simultaneously occurring at an increasing rate. Although genealogy is a long-standing tradition in Arab countries, Arab Americans have more recently been researching beyond their immigrant ancestors thanks to the digitization of records, though hindrances still often prevent such research from moving forward. While Arab American genealogy is almost invisible in most genealogy forums, this chapter provides a practitioner's vantage point for integrating the Arab American narrative through ongoing genealogical research and education that can influence the discourse in academic and popular spheres. It also introduces the development of a nonprofit organization, the National Society for Arab and Arab American Genealogy, that is bringing researchers together to do just that.

Genealogy and Family History

The terms *genealogy* and *family history* are often interchanged. Technically, genealogy is the study of "a line of descent, traced continuously from an ancestor, often also called a lineage."[2] It is also more broadly defined as "the study of family lineages and family histories."[3] According to the National Genealogical Society (NGS), "There is some expectation that a genealogy is a formal or scholarly study of ancestral family lines and that documentary evidence of each generational bloodline connection can be proven with evidence and records."[4]

Family history also delves into the study of a family tree and generational relationships, but according to the NGS, "some feel it has a bit more connotation of a biographical study of a family and may include the heritage and traditions a family passed on."[5] The Research Guides@Tufts address the two terms (*genealogy* and *family history*) by stating, "Genealogy is the act of compiling your ancestors [sic] names, dates, and places of births, marriages, and death; family history is filling in the story behind those names and dates and bringing them to life."[6] In this chapter, the terms *genealogy* and *family history* are used interchangeably to refer to the study of ancestors of a family and their stories, lives, and histories.

The archiving or documenting of genealogical research is not consistent. In addition to being passed down in family stories, historically, genealogical research has ended up in physically written narratives, letters, books, family trees, family group sheets, and graphical photo displays. More often today, genealogical research is also documented in the form of curated online trees, emailed information, websites, and social media groups or posts. But much research is lost if it is not published or documented in some manner, either online or in other shareable formats. Even then, genealogical research is either

passed on or lost, depending on the interest of younger generations of family members and the availability of archives.

Genealogists today can be divided into two groups—professionals and hobbyists. Hobbyists are the majority of researchers engaging in genealogical studies for their respective families or those of others. Professional genealogists are those who engage in genealogical research for hire or, in some cases, meet the standards set for professional genealogists discussed later. Not all professional genealogists have certification or accreditation, nor are they required to possess such credentials in the industry. Some genealogists have academic backgrounds that assist in their research, but the majority do not.

The New Genealogy Boom: DNA Research and Access to Records

The book and subsequent blockbuster miniseries *Roots* by Alex Haley are cited as one of the main impetuses for the genealogy boom of the 1970s and 1980s, along with the county's bicentennial celebrations in 1976.[7] DNA testing, online tools, access to records, and television shows such as PBS's *Finding your Roots* and NBC's *Who Do You Think You Are?* have contributed to its resurgence today. In 2023, Ancestry.com had "more than 3 million paying subscribers and over 131 million family trees,"[8] and RootsTech, the largest genealogy conference in the world, claimed more than three million participants in person and online in 2023. The top two testing sites, AncestryDNA and 23andMe, had thirty-seven million people in their database as of August 2023. The 2023 season of *Finding Your Roots* reached sixteen million viewers. Pandemic boredom in 2020 and 2021 also drew researchers into this arena.

Genealogy-focused organizations such as FamilySearch and Ancestry.com, along with numerous international, national, and local archives, have provided access to original source materials. Many archives that do not provide online access have created searchable online indexes that allow researchers to request copies of documents at on-site locations. As a result, research skills developed using online materials have enabled genealogists to go further in their offline research than ever before.

Genealogy Methodologies and Standards of Research

While most people researching their family histories are hobbyists, the standards used by professionals are affecting the methods and level of documen-

tation used by hobbyists. Professional genealogists primarily rely on *Genealogy Standards*, which is published by the Board for Certification of Genealogists and asserts that "genealogists strive to reconstruct family histories or achieve genealogical goals that reflect historical reality as closely as possible."[9] The elements of these standards include reasonably exhaustive research, complete and accurate citations, analysis and correlation of sources, resolution of conflicts, and written conclusions.[10] The main factors permeating the professional standards are sources and documentation of facts.

Within genealogy research, locality studies play a large role in engaging with the families' stories. Genealogists are placing ancestors within historical and geographical time frames to provide a better understanding of their lives. In addition to this, there is an attempt to broaden resources and methodology beyond the primarily European lens, encouraging resource development in all areas of the world and communities in the United States. Being able to access the records of more diverse communities enables professionals and hobbyists alike to further document their family trees and enhance their stories.

While building family trees and writing down family histories, genealogy hobbyists are also completing online classes, attending genealogy institutes, and reading online articles, increasing the reach of professional standards and methodologies. Most researchers are also currently using cloud- or computer-based programs in an intentional and targeted effort to attach documentation to purported facts. Although they are not consciously applying professional standards to their research, the mere use of these online programs as a method of research and base-lining facts provides automatic documentation. When creating a family tree on an online platform, respective programs attach the source of the documentation to the noted fact as a matter of standard practice, providing documentation that would not have been captured in the past. Unfortunately, many researchers still use other unsupported trees as their source, merely perpetuating unsupported documentation. This may be one of the areas to be enhanced and addressed as the field further develops.

Genealogy, History, and Public History

Even before the increase in record accessibility and DNA scientific inquiry and the improved focus on evidence-based methodologies in genealogical research, genealogy was and has always been the quintessential form of public history. According to Robyn Fivush, "It is through their families that millions of people, all over the world, first engage with the subject of history, listening to family stories over the years and being told about where they sit in their family trees. Psychologists have revealed that these family stories about the past are crucial to an individual's sense of identity and well-being."[11] Rich-

ard J. Cox, when discussing the development of the American public history movement, claimed that "genealogy is literally the most 'public' of all history."[12] Despite this, there has been a contentious relationship between historians and genealogists in academia.[13] Some historians believe this is due to the use of genealogy in eugenics and anti-immigrant exclusionary practices,[14] while others attribute this divide to what they see as the lack of evidentiary historical scholarship and interest in a historical context.[15] In more modern discussions of the relationship between history and genealogy, this divide is somewhat muted.[16] Additionally, genealogists, local and state historians, and historical societies overlap in research when placing families and their stories in a particular locality.

Still, historians do not necessarily treat genealogy as a serious form of research, even when discussing genealogy as a form of public history. "Genealogy is a peculiar pastime," writes Carolina Johnsson Malm. "It is a form of historical research without a clear and answerable research question. What is the family historian trying to do when following the lineage through space and time?"[17] This view does not take into account the modern research practices of today's genealogists and the methodologies discussed previously. It also does not consider the depth of research family history enthusiasts undertake to understand who their family members were. A commenter addressing historian John Sedgwick's opinion piece in the *New York Times*, "The Historian Versus the Genealogists," countered, "I've learned more history doing genealogy than I ever learned in books or in school. The motivation is there because it's about your family, and the history is more meaningful because it's not just about the top dog."[18]

This personal attachment to family history brings genealogical research to the core of public history. The National Council on Public History defines public history as "the many and diverse ways in which history is put to work in the world." Like all historical scholarship, public history should be "based on a rigorous examination of available sources."[19] Jerome de Groot, in his 2015 article based on the plenary address delivered at a 2014 International Federation for Public History conference in Amsterdam, "On Genealogy," discusses how changes in genealogy challenge public historians.[20] He claims that "the development of new technologies of access to archival information has transformed genealogy, and that as public historians, we need to theorize the consequences of these developments."[21] Going beyond this, he ultimately questions what is public and what is history in the framework of genealogy. Although clearly considering the study of genealogy to be in the realm of "public history," he does not directly address genealogists as public historians or what scholarship is necessary to meet the definition of public history.

Many genealogists might argue that modern genealogical research is an evidence-based discipline that has evolved from the amateur's reliance on un-

sourced family trees to the professional's interpretation of DNA testing, archival historical documents, and family memories.[22] Today's genealogists look beyond the political, legal, and status incentives for documenting lineage and allow family stories and relationships to motivate the research into personal histories of everyday individuals—the very basis of public history.

Genealogy Education

Genealogy itself, as an academic disciple, has been touched on by scholars in the past.[23] Genealogical education is historically outside the realm of traditional academia. Again, there are exceptions—Brigham Young University offers a bachelor's degree in family history/genealogy,[24] the University of Strathclyde offers an online program toward a master's degree in genealogical, paleographic, and heraldic studies,[25] and Boston University offers a highly acclaimed certificate program.[26] Nonetheless, more often, universities and colleges only offer continuing or adult education courses on genealogy rather than formal academic majors. Genealogy institutes, along with organizations and societies outside of academia, offer the majority of genealogical education through conferences and courses.[27]

Academic research has generally looked at the study of the family itself rather than what is discussed in the context of family history. While some academic researchers use their own or others' family papers or histories in their work, they do not consider this genealogical research to be outside of historical, sociological, or anthropological academic contexts. These intersections between family history research, genealogy, and academia are primarily viewed by academics as outside of the genealogical framework.

Arab American Genealogy

When addressing Arab American genealogy, we must first identify who exactly is part of our research group and who is not. While Randa A. Kayyali's chapter in this book defines Arab American identity as an affective ethnic home with which Arab Americans identify, a genealogist like me would situate it in terms of our genealogical origins. Genealogy itself is a long-standing tradition in the Arab world, and it has been practiced primarily through the recording of patrilineal lineages. Even if these two approaches to Arab American identity making seem to be in conflict, it is important to acknowledge the many ways in which Arab American genealogical research and specialized Arab American studies research overlap. For example, Dr. Shirene Seikaly's great grandfather's life and family papers are discussed in a journal article and other publications.[28] Dr. Suad Joseph also documents her father and her Lebanese family in specialized academic forums.[29] Joseph considers this work to be social and oral history rather than genealogy. To a genealo-

gist's eyes, however, this research is genealogical, and many of the research techniques are similar to those we use in our work.

Arab Americans are not immune to the genealogy craze. Facebook groups, websites, online family trees, and DNA projects with a focus on ancestors of Arab Americans currently populate the internet. Many were excited to see actor Tony Shalhoub, who is of Lebanese ancestry, featured on an episode of *Finding Your Roots*.[30] Programming and projects relating to Arab American genealogy are slowly popping up in Arab American and mainstream forums.

Arab American family history research, carried out by those looking into the names, timeline, and histories of their ancestors, is as diverse as the Arab American community itself. Those engaging in genealogy research range from recent immigrants who retain close ties and family in the cities, towns, and villages they came from to those whose families came several generations ago and do not know exactly who their immigrant ancestor was or from where they originated. Arab American genealogical research may utilize different starting places, depending on the generational distance from the immigrant ancestor. While most researchers begin with themselves and move backward, others only know the "origin story" of the tribe, clan, or broader family and try to fit themselves in this larger family tree. This diverse range of backgrounds leads to numerous methodologies and resources for research.

Arab American Genealogy Research Methods and Resources

Most Arab American researchers begin with family stories that are passed from one generation to the next by the elders in the family or community. Such stories typically include immigration histories; accounts of hardship and dispossession, reaching economic or education opportunities, or building businesses and communities; and the recounting of names, dates, and domiciles of ancestors. Reciting the patrilineal line of ancestors based on naming traditions is a common practice passed down within families. Stories of grandparents, great-grandparents, cousins, and siblings and how things were done in the "old days" or "back home" are told at family gatherings or by relatives recollecting the past. These stories are documented in oral histories in various forms. Today, stories are also recorded on phones, on audio and video devices, and in writing. While even those who are recent immigrants rarely have documentation of past generations at their fingertips, they know many stories of their family's history. Those researching more distant relatives or those disconnected from their family may not have access to the same type of stories.

Photos are the next most frequently used tool in Arab American genealogy research, as they allow researchers to look into the eyes of their ances-

tors. Portrait photography studios in the Ottoman Arab world appeared in the late 1800s and approximately twenty years earlier in Europe and the United States.[31] Researchers are often digitizing and sharing photos of people's ancestors, labeling and sorting them as documentation. This is accomplished more successfully when older generations assist with identifying people and places in the photos. Many portraits are in postcard-style prints that have notes in Arabic, English, or French and can assist with the identification process. Reviewing old photos and associating names and relationships to faces can be a challenge as generations progress in time or when the originating family is distant or nonexistent.

Family trees that are passed down or built from scratch based on oral histories or research are the primary form of Arab American genealogy documentation. Family trees for modern-day researchers have moved from paper and pen to computer programs, although there are still many who keep all their records in handwritten form. Ancestry.com seems to be the most frequently used online program for family-tree building, but such a tool can be found across the spectrum of online systems. More and more Arab American researchers are attaching evidence to their trees, including photographs and documentation found outside the program. While this is helpful for other researchers, often this information is held on private trees, and only through the establishment of relationships and trust is the information released.

The family trees kept by past generations primarily contained the names of male ancestors. Adding female ancestors is one area many researchers have focused on, especially within the more recent generations. Additionally, while most genealogy programs are set up to build a tree going back in time, several Arab American genealogists have a tree naming the origin of a clan or tribe and building the paternal line downward toward modern-day descendants.

An additional focus of Arab American researchers is the confirmation of a family name. While many joke about the number of family names or different spellings of the same family name a set of first cousins may use, this phenomenon is disruptive to genealogy research. Ultimately, for those who have lost contact with their pre-immigration family, this is an almost insurmountable hurdle to their research. Since many immigrant families travel together or relocate to neighborhoods with familiar faces, researchers are finding clues in their neighborhood and Census records along with immigration documentation and research abroad.

Vital records, newspapers, immigration records, and other such sources are valuable resources for documenting Arab American family histories. Sharing their discoveries on websites and social media platforms where information and research are crowdsourced allows communities around the world to assist each other in this endeavor. Even with this additional help, language constraints may deter research. Documents or research materials may be found

in several languages, such as Arabic, English, French, Ottoman Turkish, Hebrew, and Kurdish. Non-English documents found in online databases, even when they exist, are rarely indexed and are difficult to discover.

DNA

DNA testing either augments or initiates Arab American genealogical research. Although many undertake DNA testing to explore the ever-changing ethnicity percentages, Arab Americans broadly use DNA testing to further their family history research. While DNA matches are most valuable to genealogical research, the entertainment value of ethnicity results are sometimes the biggest draw to such testing. Ethnicity percentages are amusing for some, such as those interviewed in the 2019 "Arabs Get a DNA Test" episode of the Kulana Arab YouTube channel.[32] Yet, these same results can also be confusing. Terminology defining the ethnicity in the region varies by site and changes, along with estimated DNA testing results (percentages), as each company redefines the reference populations. For example, as of 2023, 23andMe divides their Western Asia and North Africa section into Arab, Egyptian, Levantine, Northern West Asian, and North African, and FamilyTreeDNA divides their Middle East and North Africa section into Middle East, North Africa, Caucasus, Arabia, and Middle East Jewish. AncestryDNA terminated the use of *Middle East region*, stating that "this area of the world is reflected in one or more of three new ethnicity regions—Arabian Peninsula, Levant, and Egypt—or other neighboring regions."[33] Not only was the broader *Middle East* term dropped at AncestryDNA, but all three testing companies redefined the area "primarily located in: Israel/Palestine, Jordan, Lebanon, Syrian Arab Republic" as the Levant.[34]

The changing estimated results are also confusing. AncestryDNA bases their ethnicity estimates on a reference panel that is "a set of people whose DNA is typical for DNA from a certain place or group."[35] AncestryDNA 2013 v.2 included 26 population regions and 3,000 individuals in their reference panel; in the 2018 update, 43 population regions expanded to include 16,638 individuals in their reference panel.[36] In the 2023 update, there were 88 population regions, including a reference panel of 71,306 individuals, while the 2024 update has 107 regions, including a reference panel of 116,830 individuals.[37] Therefore, between 2013 and 2024, the number of regions increased by 412 percent and the reference panel individuals by 3,894 percent. For those with ancestors from the region initially denoted in 2018 as the Middle East, there were only 271 individuals in the reference panel. By 2023 and 2024, the more refined regions of Southwest Asia and North Africa included approximately 1,300 and over 6,000 individuals, respectively.[38] This increase from 271 to 6,000 individuals in the reference panel in a matter of

six years gives a higher percentage of accuracy for those tested from the region. Although the statistical inferences from these updates improve results, these changes have caused doubts for some regarding the veracity of DNA testing as a whole.

Moving beyond the ethnicity results, DNA matches themselves are the primary research tool on these sites. Autosomal DNA testing, which is the focus of most testing companies, is the most utilized by Arab American researchers. Autosomal segments in DNA are the twenty-two matching pairs of chromosomes found in most human cells. Researchers comb through the lists of these close relative and "cousin" matches to find how each result might be related. Surprising results for Arab American researchers have often occurred in which recent immigrants unexpectedly discover numerous matches while most known relatives remain abroad. While many purchase the tests for themselves or as gifts for others, some testers are invited to participate in family studies as descendants of a direct-line ancestor. For example, an Algerian American researching her family may ask her distant cousins in Algeria to take DNA tests to provide supplementary results for research. As a result, these test results become available in the system for other researchers to compare. Since only those who match a tester can interact with the DNA results, which are limited by the privacy setting each participant chooses, the actual number of Arab Americans participating in DNA testing is unknown.

Some researchers had no knowledge of having ancestors from the region, but DNA tests indicating connections to North Africa or the Levant, for example, help them discover unnamed ancestors, unidentified heritage, or nonparental events in their lineage.[39] Not everyone welcomes unexpected close matches, however, and many refuse to respond to those reaching out about unknown parental or other relationships. With the potential for unexpected results, consumers of DNA tests must make an educated decision when taking one. Curiosity and research are often strong enough reasons to test even when there is a risk that past family secrets will be revealed.

Autosomal DNA testing is used in conjunction with paper research and oral histories. DNA is passed down randomly, meaning that even though 50 percent is inherited from each parent, it is not necessarily 25 percent from each grandparent and so on. As researchers find matches connecting further generations back, after about five generations, a family relationship may not be detected by DNA. This does not mean that there is no family relationship; it only suggests that DNA may not have been passed down by a specific ancestor. Therefore, other means of connecting individuals to a family tree are necessary to accurately determine the relationship.

FamilyTreeDNA, in addition to providing autosomal DNA testing, focuses on paternal line DNA (Y-DNA) and maternal line DNA (mtDNA). There are some Arab American researchers whose primary focus is on Y-DNA re-

search, many of whom have taken the more expensive Big Y test. Arab Americans and descendants of other ethnicities from Arabic-speaking countries have joined group projects on FamilyTreeDNA that have numerous categorical focuses, including a common geographic origin, surname, ethnic heritage, and paternal or maternal lineage haplogroups.[40] These groups include DNA testers from all over the world who compare their DNA results and collaborate on genetic genealogical research.

Some Arab American researchers have concerns about the use of DNA in their work. These include the consequences of sharing health and identity data with the public and possible law enforcement–related issues such as human bias, innocent people being linked to crimes, and racial profiling. There is also hesitancy by those who have heard stories of family secrets being revealed through DNA tests and do not want to expose family members to information they cannot take back. Others regard DNA testing as an erasure of racial realities, seeing the ethnicity estimates as problematic due to the reduction of socially constructed categories of identity to mere biological markers.

Endogamy, the practice of marrying within a defined culture or location, also hinders the use of DNA testing for Arab Americans. The issue of endogamy arises when a population shares multiple ancestors with each other—cousins of all distances marrying other cousins over several generations. DNA testing companies provide matches and relationship estimates based on the amount of DNA shared with other test takers. These amounts are measured in centimorgans, units of "recombinant frequency which is used to measure genetic distance."[41] When test takers have multiple common ancestors, it becomes more difficult to provide accurate relationship estimates. For some Arab Americans coming from these communities and potentially marrying into them in the United States, DNA matches may seem closer in generational relationships than they actually are and need to be scrutinized with more detailed examination through chromosome mapping, document research, and other analysis.

The difficulty of DNA analysis in genealogical research adds to the complexity of research for Arab Americans. Many are addressing these factors through educational programs or hiring professional genealogists to assist in the research, while others have put off research for the "future."

Genealogy Research Organizations and Websites

Although Arab Americans utilize mainstream genealogy tools for research in the United States and sometimes abroad, there is limited focus on Arab American research in general genealogy forums and literature. Two published books that would seem to incorporate Arab American genealogy hardly touch on it except when addressing Jewish, Armenian, or Assyrian genealogy and

sharing generalities on oral history, DNA, and Ottoman records.[42] Limited resources lists and how-to guides related to Arab American and Middle East genealogy can be found only on a few sites, such as Cyndi's List, *Family Tree Magazine*, and professional genealogists' blogs.[43] Mainstream genealogy organizations rarely include Arab American or Middle Eastern programming.[44]

FamilySearch and its annual conference, RootsTech, are an exception. The development of content and user-based projects in the region has been a focus of FamilySearch, which has undertaken projects from Beirut to Dubai. Digital content includes Ottoman records for Palestine, tribal records in Gulf countries, and Lebanese surname books, for example. RootsTech 2021 introduced six online courses related to genealogy in Arabic-speaking countries, and the 2022 conference added several more courses to their library. FamilySearch Wiki, a genealogy guide, includes numerous links and recommendations for Arab American genealogy research. FamilySearch has also partnered with organizations such as the Arab American National Museum and the Khayrallah Center on projects, events, and presentations related to Arab American and Middle Eastern research.[45] While FamilySearch is the home of a shared global family tree, it is a public changeable tool that is not noted as universally used in Arab American research. Notwithstanding the unique position of FamilySearch, the most used platform for online family trees remains Ancestry.com, as previously indicated. Ancestry.com family trees provide options for levels of privacy and selective sharing that many Arab American researchers choose to utilize.

Arab American Organizations, Archives, and Projects

There are many organizations and research institutes that are not known as genealogy centers but that can, nonetheless, be utilized by Arab Americans in their genealogy research. The Arab American National Museum in Dearborn, Michigan, is the first and only museum dedicated solely to documenting the Arab American experience. While data is not available on how often its archives are utilized for genealogy research, the museum holds significant records, digital and on site. These records, including directories, family collections, digital scrapbooks, and oral history archives, are available for Arab American genealogists. The museum's digital collections include several oral history collections. For example, the Family History Archive: Syrian and Lebanese Families in the American South is rich with interviews conducted at annual conventions of the Southern Federation of Syrian Lebanese American Clubs (SFSLAC).

While there is currently no data on the extent to which Arab American community members are using the museum for genealogical research, the museum expects to see an uptick in usage and requests with the addition of genealogy-focused events to their programming. In 2022 and 2023, the museum began holding such family history programs as "Preserving Arab American Family History" in conjunction with the American Federation of Ramallah, Palestine (AFRP) and a family history workshop in conjunction with FamilySearch.

The AFRP is working on several projects that relate to the genealogy and family histories of people from Ramallah, Palestine. The Ramallah Family Tree Project takes the book *Ramallah, Its History and Genealogies* by Azeez Shaheen to the next step, allowing its members to expand on the trees by submitting updates to their family. Another AFRP initiative, the Ramallah Preservation Project, works to collect and digitize documents and photos and record oral history interviews connecting those in the diaspora. This includes more than 45,000 descendants in the United States and their respective histories and family stories in Ramallah. Curated exhibits are hosted at the annual AFRP conventions and then shown at the Arab American National Museum in Detroit. These exhibits have been a way for younger generations to learn about their family histories and encourage interest in this type of research and archival work. George Harb, the Ramallah Preservation Project director, also uses social media to help identify individuals in photos from their projects or obtained from research in Ramallah. He noted that they crowdsource metadata, meaning that when the program posts a photo on their social media platforms, followers can identify who is in the photo along with the approximate date of the photo. This information is then documented with the photos for future projects in the United States and Ramallah.

The Khayrallah Center for Lebanese Diaspora Studies at North Carolina State University provides resources for those researching ancestors of immigrants from Lebanon in the United States or potentially originating from the surrounding area, Syria and Palestine. Indexed digital archives, Arab American newspapers, directories, and sorted Census records are all searchable on their website. Khayrallah Center Director Akram Khater, in a FamilySearch presentation titled "Overcoming Challenges of Connection With Your Middle Eastern Roots," discussed the following challenges for genealogical research: (1) no central database to search for records; (2) suspicion around potential financial motives behind research; and (3) inability to read the language. Several Arab American organizations, along with others, are working on technology and resources to overcome some of these challenges—for example, artificial intelligence (AI) indexing and advanced optical character recognition (OCR) software for Arabic and Ottoman Turkish, ac-

cess to records across the Middle East, and digitization projects of broader databases for research.

Arab American Researcher Stories

As noted, Arab Americans have many reasons for researching their families and understanding their personal connections to history. These genealogy hobbyists are descendants of immigrants from Arabic-speaking countries and shared why this history is important to them.

> "I feel an obligation, if you will, to maintain that connection for the next generation. I don't want it to be lost on my watch."[46]
>
> —Hal

Hal, a Lebanese American whose four grandparents all immigrated to the United States just before and after World War I from what is part of Lebanon today, shared his dream of reclaiming a place in the village of his ancestors. His interest in his family history began in his early twenties, when he met other Arabs in Saudi Arabia on a work trip. He decided to visit his family village in Lebanon and worked to discover his actual family name. His ancestors who had immigrated to the United States had adopted an ancestor's first name instead of using the broader family name from Lebanon. His immigrant family members, facing prejudice against Arab Americans, wanted to leave their lives in Lebanon behind and blend into American society. During a visit to Lebanon, he initially faced some difficulty, since the broader family name was missing, but with assistance, he was able to find baptismal records at the village's Catholic church. This led him to discover more information about his grandparents and build out his family tree. Since his branch of the family was not listed in the 1921 Census, only when the baptismal records were approved as legal documentation for proof of relationships was Hal able to complete the steps to obtain Lebanese citizenship for himself and his daughters. With citizenship, he is working to register his grandfather's abandoned property for himself and his forty cousins. He wants to reestablish a connection to Lebanon for his children and future generations.

Maha, an Iraqi American, struggles with the lack of resources and language barriers in her research. She does not read Arabic. Even when looking into potential Ottoman historical sites, she has not been able to pinpoint where to start or how to understand the Ottoman Turkish documents. The information she does have on her Iraqi ancestors, passed down through family stories, mainly focuses on the paternal line, and the written information does not include women of the family. Her nieces have taken on the primary roles as family historians but have neglected their Arab side. Maha

is concerned that this will distance them from their connection to their Iraqi heritage.

"Recording my Palestinian family history is a form of resistance."[47]
—Rania

Rania, a Palestinian American teenager, sees being Palestinian as key to her identity, and knowing more about the history of her Palestinian grandfather is part of that identity. Rania has visited her grandfather's hometown on several occasions and has seen family records in Hebrew, Arabic, English, and Ottoman Turkish. She hopes that as she gets older, she can contribute to the recording of her family's stories. She was inspired to look at her family history during an elementary school project, and the interest has remained. She was excited to test her DNA and create a tree on Ancestry.com. As Rania has gotten more involved in activism around Palestine, however, she sees the stories of her family in a broader sense. Rania considers her family story as a tie to the history of Palestine as a whole and to the struggles her family has endured in the past and is continuing to endure today. Recording her family history is an act of survival, resistance, and perseverance to keep the history of Palestinians alive, as she explained.

Hussein, a Yemeni American, feels that family history is an integral part of his life. For him, as for most Yemenis, the tribe and its lineage are deeply ingrained in the culture. As such, he was taught to introduce himself by reciting his given name, followed by his father's name, grandfather's name, and tribal name. Many members of his family from previous generations primarily married within the tribe or, at the very least, within their village—a tradition that largely continues to this day. Their family in the diaspora has stayed deeply connected to their roots in Yemen. Hussein heard stories of his paternal grandfather living in England and Saudi Arabia but traveling back and forth to live in Yemen throughout his lifetime. Hussein's father came to the United States as a young teenager in the 1960s. He was a California farm worker organized under the United Farm Workers of America (UFW). Once he was able to open a business, he returned to his village to marry. His father then returned to the United States, where he continued to work and raise a family. Hussein's father to this day owns land and retains his status as an elder in his tribe in Yemen. Having grown up immersed in stories about his lineage, Hussein does not view his interest in family history as traditional research to undertake. While he acknowledges the need to interview family members to document their life stories, his primary focus lies in understanding how historical events have shaped his tribe and their village. Since his entire tribe is made up of his extended family and is one of three historically rooted in the village, this broader historical perspective forms the essence of Hussein's family history interest.

Kristin, a Palestinian Lebanese American, has been helping her mother research their family. Kristen's mother grew up a refugee in Lebanon before immigrating to the United States and lost all connection to her father's Palestinian family roots in Bethlehem, Palestine. They had visited Bethlehem and located the area where her family had lived but could not find any relations during the visit. DNA testing did not provide much information that helped. Recently, Kristen contacted Dar Al Sabagh Diaspora Studies and Research Centre in Bethlehem. After providing information about her great-grandparents and their siblings' names, Dar Al Sabagh was able to trace the identity of her third great-grandparents and tie them to a larger Bethlehem family. The feeling of being an imposter to the Palestinian community had clouded Kristen's ties to other Palestinians and the culture. The lack of knowledge of the ancestry of the Palestinian side of her family had given her a feeling that something was missing. Throughout her life, she had gained strength from her mother, her Lebanese *teta* (grandmother), and her great-grandmother, but she never knew about the history of her Palestinian *jido* (grandfather). Gaining the information about her *jido*'s family gave her back the ties to Palestine and its culture, including her favorite pastime, Palestinian embroidery—*tatreez*.

Denise, an Algerian American, is starting to research her Algerian mother's family to better understand her mother—and, by extension, herself. Denise's mother has always been a mystery to her, because after she left Algeria, her mother changed her name, her religion, and her language. Denise is hoping that this research will bring her closer to solving the mystery of her mother and give her a better idea of where she is from, who her mother is, and why she decided to leave in the first place. Most of all, she is hoping it will give them both a reason to go back.

Rae, a Lebanese American, has met many cousins after taking a DNA test. She and two of these cousins have collaborated on their Lebanese/Syrian genealogy research to figure out how they are related and to place themselves on a broader family tree. Through extensive research and meetings across the United States, they have begun to narrow down which line of a family tree each of them belongs to. They have located DNA matches on AncestryDNA, 23andMe, MyHeritage, and FamilyTreeDNA and reached out to the Khayrallah Center, the Maronite Church, members of the SFSLAC, and other researchers they met online in Lebanon and across the United States. Rae believes she has located the town her grandfather came from prior to his immigration in 1905. Although she has hit brick walls left and right, she continues to strive to educate herself on genealogy methodology and tools to dig further into her family tree.

Shayma, an Egyptian American who immigrated to the United States in 1992, travels back and forth to Egypt regularly and has much of her family still residing there. Her family lived in many places in Egypt due to educa-

tion and employment commitments. Her grandfather was educated as an engineer, despite the limitations placed on him by the British government. Her parents met at the university in Alexandria, and all their siblings attended the university; many later obtained graduate degrees outside of Egypt. Her father kept in contact with family from his original town, and although her mother's family lived in Alexandria for many generations, they carried the name *Ghareeb* (stranger), since her great-grandfather came from Morocco. Even though they knew the family name from Morocco, their legal documentation carried the descriptive name. Her brother is the family historian and took notes when he sat with her aunts to collect the family stories, uploading them onto a web-based platform. Shayma, unlike her brother, has not written down their family stories, but the stories have already been passed down directly to her children. Shayma sees her family's lived experience or legacy of education to be the history she carries on through her children.

Brian discovered late in life that he is Lebanese American. At fifty-four years old, he learned that his biological father is Lebanese and that he is the grandson of four Lebanese immigrants to the United States who came here between 1908 and 1910. Although not directly told, Brian had an idea that the man he thought was his biological father actually was not based on pieces of information inadvertently mentioned and his own physical characteristics. In 2020, with an interest to see what he might discover in his ethnicity estimate results, Brian decided to take a DNA test. He was shocked to find close family matches estimated to be first cousins. After additional matches were uploaded and genetic data updated, he discovered he had two paternal half-sisters. Brian was able to connect to his sisters and was introduced to his biological father. His father had never been informed of the pregnancy, nor that he had a son. Brian was welcomed into his father's larger Lebanese family and has become close to his father. In fact, he even changed his legal family and middle names to his biological father's last and first names respectively. Two of Brian's children also legally changed their last names to match their newly found Lebanese family name. Interested in knowing more about his ancestry, Brian hired a professional genealogist through AncestryProGenealogists to dig deeper into his family history and transferred his DNA data to MyHeritage.com for additional DNA analysis. He gathered photos and immigration records that were given to him by his biological father. He was also able to acquire records from the Maronite church in Cincinnati, where his great-grandparents lived, finding their records and those of additional cousins. Brian continues to research and hopes someday to obtain records from Lebanon. He looks forward to furthering his knowledge of his Lebanese family history and learning the traditions of his ancestors.

Stories such as these instigated the foundation of a public nonprofit organization, the National Society for Arab and Arab American Genealogy

(NSAB).⁴⁸ The impetus behind the organization came from the lack of resources for those doing research on their ancestors from Arab countries. A presentation about Arab American genealogy research at the 2022 NGS Conference in Sacramento caught the attention of several attendees. They or their spouses had ancestors from Lebanon, Syria, Palestine, and Iraq. Although not all in the group identified as Arab, they acknowledged a shared history and frustration with their research in the area, having faced various obstacles in their research or postponed and effectively terminated research altogether when they lost hope for success. Access to records and language barriers were the main reasons discussed, but the need for an organization similar to those for other ethnically identified groups at the conference was addressed. Several genealogists in attendance were familiar with how a Japanese American genealogy research group had started and suggested that one for Arab Americans could be developed to share resources and tools and bring speakers to support those in their same situation. Although it is a newly formed society, NSAB has been received with excitement by those in the field, both within Arab American research arenas and the broader genealogical community.

NSAB's first annual Arab American Family History Day was held online in June 2024, and this inaugural event gathered those interested in Arab and Arab American family history research to learn about resources and methodologies from related archivists and genealogy experts. The event was free and open to anyone interested. Attendees included participants from across the United States and Canada, Lebanon, Palestine, Qatar, Tunisia, and the United Kingdom. Following the day of webinars, NSAB members met online during the "NSAB Connect" session. They engaged in a casual discussion and shared their ideas, successes, brick walls, and best practices in Arab and Arab American family history research. Many participants expressed that they were happy to find a place that addressed their needs. One researcher noted that it was exactly what she had been waiting for. Since its kickoff, NSAB has held bimonthly webinars on topics ranging from research education on immigration to the methodology of writing everything down. It has also held alternate-month "NSAB Connect" meetings. Since the live webinars are free and open to all interested, many genealogists without ancestors from the region join in to learn skills shared by NSAB presenters.

NSAB has created family tree handouts in English and Arabic for children (and adults) to fill out and bring about conversations about family history. These handouts were shared at NSAB outreach tables and provided to interested Arab American organizations for use with youth events. They are also online for NSAB members to download. NSAB has become an organization member of NGS so that it can engage with other genealogical societies, museums, and libraries to share in the nationwide networking and col-

laboration that takes place during their Delegate Council and other facilitated communication forums. NSAB is planning to expand its outreach and engagement in the future.

Becoming an Arab American Genealogist

After learning about the possibility of discovering their Arab American roots, many ask how to become researchers themselves. The methodologies for research are numerous, and each family, and even branch of a family, may need a different approach. In general, a few basic steps can be taken to begin the process.

First, it is important to assess what is known and what is already available. Writing out stories, names, dates, places, events, religious affiliations, and historic context related to a family, even if they are only conjecture, can be a place to start and may inspire further ideas for research. When recording names, it is helpful to write out all related names. For example, if a person named Hussein was referred to commonly as Abou Jamal, meaning "father of Jamal," both of these names should be recorded. Another example is if there was an immigrant ancestor with the last name Khoury, the Arabic language word for priest. Though they may have used their occupational title as a last name, they would have also had a family name. In this case, both the name and the description of the occupation should be noted.

Additionally, records that are already accessible or in the hands of family members can be significant. These include photos, videos, vital records (birth, death, marriage), passports, family books, religious and legal documents, journals, letters, and even objects that have related family stories attached. These items can be gathered, organized, digitized, and, most importantly, documented with information about content and origin. An object can be photographed and the story written out—such as photographing *Sittee*'s (grandmother's) *thobe* and recording what it symbolizes to the family. Adding metadata or notes about where each item was obtained along with any identifying information would be helpful for future reference. An online tree or software program can be used to organize the information from each source. Alternatively, one could use a spreadsheet or word document to list and correlate related facts as a form of a research report.

The next step would be to interview family members if they are available. Starting from either the eldest family member, or maybe the most accessible one, begin to ask questions about the names and dates of ancestors, the story of their lives, how historic events affected the decisions they made, how they or their ancestors ended up in a specific city or village, and their (or their ancestors') immigration story. If a family member lives in another country, they can be interviewed virtually. If language barriers exist, ask for help from

someone to translate. Oral history interviews are one form of research that should not be put off for a better time, if possible. An additional consideration when conducting interviews is what the final product looks like and where it will be preserved. A family member may only agree if the interview is privately held, but others may be comfortable with their story being shared more widely. Oral history interviews of a family member are not only useful for personal genealogy research; they may also provide historic context for Arab American research in general. In that case, consider whether an archive, such as the Arab American National Museum, would be an appropriate destination for the recording or transcript.

These are but a few ways to get the research started before diving into online or on-site archive research or analyzing DNA tests. NSAB is working on addressing more in-depth methodologies and education for genealogy researchers with Arab ancestors and is therefore another good place to start.

The Future of Arab American Genealogy

Bolstered by broader resources, technology, and organizational focus, interest in Arab American genealogical research is increasing. Mainstream resources and outreach related to Arab American researchers, the establishment of research contacts, the digitization of documents in Arabic-speaking countries, and technological advances that will allow for faster translation and indexing of digitized records all will allow research to flourish and expand for Arab American genealogists and family historians. The foundation of NSAB and the previously addressed partnerships by more established institutions such as the Khayrallah Center and National Arab American Museum and their expanding programming around Arab American genealogy provide additional education and access for researchers. Increased interest in these areas will also spark even more programming and the expansion of relationships in mainstream genealogical arenas. Combined with the expansion of Arab American historical research in general and the broader acceptance of genealogy as a form of history, these initiatives will provide the seeds for this field to grow.

NOTES

1. "National Arab American Demographics," Arab American Institute, accessed June 15, 2025, https://www.aaiusa.org/demographics.
2. "About NGS: Interested in Family History?," National Genealogical Society, accessed September 26, 2023, https://www.ngsgenealogy.org/family-history/.
3. "About NGS."
4. "About NGS."
5. "About NGS."
6. "Family History & Genealogy," Research Guides@Tufts, Tufts University, accessed December 27, 2023, https://researchguides.library.tufts.edu/GenealogyFamilyHistory.

7. Matthew F. Delmont, *Making Roots: A Nation Captivated* (Berkeley: University of California Press, 2016).
8. "Company Facts," Ancestry.com, accessed June 15, 2025, https://www.ancestry.com/corporate/about-ancestry/company-facts.
9. Board for Certification of Genealogists, *Genealogy Standards*, 2nd ed. (Nashville: Ancestry, 2019).
10. Board for Certification of Genealogists, *Genealogy Standards*.
11. Robyn Fivush, "The Development of Autobiographical Memory," *Annual Review of Psychology* 62 (2011): 559–582; and Robyn Fivush and Catherine A. Haden, *Autobiographical Memory and the Construction of a Narrative Self: Development and Cultural Perspectives* (Mahwah, NJ: Psychology Press, 2003), as quoted in Tanya Evans, *Family History, Historical Consciousness and Citizenship: A New Social History* (London: Bloomsbury, 2023), 1.
12. Richard J. Cox, "Genealogy and Public History: New Genealogical Guides and Their Implication for Public Historians," *The Public Historian* 6 (1984): 91–98.
13. John Sedgwick, "The Historians Versus the Genealogists," *New York Times*, April 12, 2018, https://www.nytimes.com/2018/04/12/opinion/sunday/historians-versus-genealogists.html.
14. Elizabeth Shown Mills, "Genealogy in the 'Information Age': History's New Frontier?," *National Genealogical Society Quarterly* 91 (2003): 260–277. See also Francesca Morgan, *A Nation of Descendants: Politics and the Practice of Genealogy in US History* (Chapel Hill: University of North Carolina Press, 2021).
15. Sedgwick, "The Historians Versus the Genealogists."
16. Sheila O'Hare, "Genealogy and History," *Commonplace: Journal of Early American Life* 2, no. 3 (April 2002), https://commonplace.online/article/genealogy-and-history/. See also Russell Martin, "Historical Genealogy: The Evolving Definition and Uses of an Ancillary Historical Discipline," *Russian Studies in History* 55: no. 1 (2016): 1–9; and David Lowenthal, "The Timeless Past: Anglo-American Historical Preconceptions," *Journal of American History* 75, no. 4 (March 1989): 1263–1280.
17. Carolina Johnsson Malm, "Genealogy and the Problem of Biological Essentialism," National Council on Public History, September 10, 2015, https://ncph.org/history-at-work/genealogy-and-biological-essentialism/.
18. Nancy Rockford, Comment Section, Sedgwick, "The Historians Versus the Genealogists," April 13, 2018.
19. "How Do We Define Public History?," National Council on Public History, accessed September 8, 2023, https://ncph.org/what-is-public-history/about-the-field/; Cherstin M. Lyon, Elizabeth M. Nix, and Rebecca K. Shrum, *Introduction to Public History: Interpreting the Past, Engaging Audiences* (Lanham, MD: Rowman and Littlefield, 2017), 2.
20. Jerome De Groot, "On Genealogy," *The Public Historian* 37 (2015): 102.
21. De Groot, "On Genealogy."
22. Elizabeth Shown Mills, "Bridging the Historic Divide: Family History and 'Academic' History," Historic Pathways, 2007, accessed June 15, 2025, https://www.historicpathways.com/download/bridghisdivideivide.pdf. See also Jill Morelli, "Genealogy as an Academic Discipline," *Genealogy Certification: My Personal Journal*, 2015, accessed June 15, 2025, https://genealogycertification.wordpress.com/2015/02/05/academic-discipline/.
23. Elizabeth Shown Mills, "QuickLesson 18: Genealogy? In the Academic World? Seriously?," Evidence Explained, accessed June 15, 2025, https://www.evidenceexplained

.com/content/quicklesson-18-genealogy-academic-world-seriously; Morelli, "Genealogy as an Academic Discipline"; and Martin, "Historical Genealogy."

24. "Family History," Brigham Young University Department of History, accessed June 15, 2025, https://history.byu.edu/family-history.

25. "MSc/PgDip/PgCert Genealogical, Palaeographic and Heraldic Studies," University of Strathclyde, accessed September 16, 2023, https://www.strath.ac.uk/courses/post graduatetaught/genealogicalpalaeographicheraldicstudies/#coursecontent.

26. "Online Genealogy Studies Program," Boston University, September 16, 2023, https://genealogyonline.bu.edu/.

27. Most local, regional, and national genealogy societies, along with historical and ethnicity-based societies and museums, offer some sort of genealogical research classes, either in person or virtually. Examples of genealogy institutes are the Salt Lake Institute of Genealogy, Genealogy Research Institute of Pittsburgh, Institute of Genealogy and Historical Research, and Genealogy Institute on Federal Records.

28. Sherene Seikaly, "How I Met My Great-Grandfather: Archives and the Writing of History," *Comparative Studies of South Asia, Africa and the Middle East* 38, no. 1 (2018): 6–20.

29. Suad Joseph, "Searching for Baba," in *Intimate Selving in Arab Families: Gender, Self, and Identity*, ed. Suad Joseph (Syracuse, NY: Syracuse University Press, 1999), 53–75.

30. "The Shirts on Their Backs," *Finding Your Roots*, season 7, episode 4, February 9, 2021, https://www.pbs.org/video/shirts-their-backs/.

31. Stephen Sheehi, *The Arab Imago, a Social History of Portrait Photography 1860–1910* (Princeton, NJ: Princeton University Press, 2016).

32. "Arabs Get a DNA Test," Kulana Arab, YouTube, 16 min., 25 sec., August 9, 2019, https://www.youtube.com/watch?v=WcqBfQ9ya-Q.

33. "What Might Change?," Ancestry.com, accessed December 8, 2023, https://www.ancestry.com/cs/dna-help/ethnicity/faq.

34. "DNA Origins: Regions: Levant," Ancestry DNA Results Ancestral Regions, Where do people with this region live?, Ancestry.com.

35. "AncestryDNA® Reference Panel," Ancestry.com, accessed November 20, 2024, https://support.ancestry.com/s/article/AncestryDNA-Reference-Panel.

36. Jayne Ekins, "DNA Ethnicity Estimation: Reference Panel," *Your DNA Guide*, June 13, 2019, https://www.yourdnaguide.com/ydgblog/dna-ethnicity-estimation-refer ence-panels.

37. "AncestryDNA® Reference Panel."

38. "AncestryDNA® Reference Panel."

39. The term *nonparental event*, also known as a *nonpaternity event, not parent expected or NPE*, is used when a parent is presumed to be the biological parent and is discovered not to be.

40. A haplogroup is a genetic population group of people who share a common ancestor on the patrilineal or matrilineal line.

41. "Centimorgan," International Society of Genetic Genealogy Wiki, accessed September 8, 2023, https://isogg.org/wiki/CentiMorgan.

42. Annie Hart, *Searching Your Middle Eastern and European Genealogy: In the Former Ottoman Empire's Records and Online* (Lincoln, NE: iUniverse, 2004); and Annie Hart, *Where to Find Your Arab American or Jewish Genealogy Records* (Lincoln, NE: iUniverse, 2005). Both books are a compilation of general data but have limited information directly of assistance to Arab American genealogy researchers.

43. "Middle East," Cyndi's List, accessed September 8, 2023, https://www.cyndislist.com/middle-east/; *Family Tree Magazine*, accessed September 8, 2023, https://familytreemagazine.com/; "Asia and Middle East," FamilySearch Wiki, accessed September 8, 2023, https://www.familysearch.org/en/wiki/Middle_East; Alison Ensign, "Discover Your Middle Eastern Heritage," FamilySearch, January 11, 2022, https://www.familysearch.org/en/blog/discover-your-middle-eastern-heritage-ethnicity; "Blog," *Photographs and Memories by Reem*, accessed December 30, 2023, https://photosmemoriesbyreem.com/blog/.

44. Presentations about Arab American genealogy were made by the author at the National Genealogical Society 2022 conference and other state and local societies in 2021 and 2022. Most mainstream interest in the region focuses on colonial records or Jewish genealogy.

45. "Overcoming Challenges of Connecting with Your Middle Eastern Roots," FamilySearch, YouTube, 26 min., 8 sec., July 25, 2023, https://www.youtube.com/live/SXeqRH1lmF4?si=HPlHrESWZMxJdbZ; "Telling Your Story: Family History Preservation Workshop," Arab American National Museum, April 8, 2023, https://arabamericanmuseum.org/event/telling-your-story-family-history-preservation-workshop-2/.

46. Hal M., interview with the author, December 1, 2023.

47. Rania F., interview with the author, November 22, 2023.

48. National Society for Arab and Arab American Genealogy, accessed June 15, 2025, https://www.arabamericangenealogy.com. *NSAB* was chosen as the acronym because the word itself (نَسَبْ) in Arabic means "lineage."

8

Yalla Eat!

Walking an Arab American Food Landscape

Matthew Jaber Stiffler

The Arab American National Museum's (AANM) Yalla (Let's go) Eat! program consists of walking tours of Arab American commercial districts, pop-up dinners, special tasting events, an Instagram chef series, and a food map of the Dearborn, Michigan, community. The program started in 2013 with some seed money from Michigan Humanities. The idea of a culinary walking tour in an ethnic neighborhood is not novel. But the creation of one by a community-based cultural museum for the most visible Arab American community in the country created some major buzz. Yalla Eat! events typically sell out to a mostly non-Arab audience and have been featured in national and global media outlets like *Eater*, NPR, and the *Toronto Star*.

As AANM staff began planning and executing the Yalla Eat! Culinary Walking Tours, the focus of this chapter, we took as our premise that (1) food, especially through culinary tourism,[1] was the most poignant way to engage non-Arabs in the history, culture, and experiences of Arab Americans; (2) most non-Arabs in metro Detroit have only a surface-level familiarity with the broad range of Arab and/or Middle Eastern cuisine; (3) by bringing people into direct contact with Arab American business owners and by walking through Arab American commercial districts, we could help to dispel stereotypes about Arabs and Arab Americans, especially considering all of the negative attitudes toward the mostly Muslim Arab community of Dearborn;[2] and (4) as a community-based cultural organization, it is beneficial to take our visitors outside of the walls of the museum and allow the

community to tell their own story through the lens of cultural identity and entrepreneurship.[3]

In this chapter, I situate the AANM within the Arab American community of Dearborn. I then give an inside look into how the public history elements of the tours were produced, with a particular focus on the most popular and frequently given tour, the Warren Avenue tour. I offer a detailed walk-through of this tour followed by a discussion of its implications to Arab American public history and its impact on the AANM. Finally, the chapter concludes with a culinary walking tour creation guide. The goal of the guide is to assist any Arab American groups or organizations in creating tours in other areas of the country.

A Museum in Dearborn

The first and only of its kind, the AANM, an institution of the Arab Community Center for Economic and Social Services (ACCESS), was established in 2005. Founded in 1971, ACCESS is AANM's parent organization. The largest Arab American community nonprofit organization in the country, ACCESS has grown from a small storefront to a multisite multiservice organization with an annual budget of $35 million and over a hundred different programs. Local and statewide services include public clinical and mental health programs, such as employment and workforce development programs, English language learning services, domestic violence support services, infectious disease prevention and awareness programs, the Center for Survivors of Violence, entrepreneurship training and support services, adult education courses, youth education and leadership courses, immigration and citizenship services, and comprehensive case management programs.

ACCESS's arts and cultural programming (formerly known as the ACCESS Cultural Arts Department), established in 1987, transitioned to the museum and became the foundation of its programming upon its opening in 2005. The outgrowth of twenty years of developing, promoting, and delivering public arts and humanities-based programs across Michigan, AANM is a 38,500-square-foot facility that houses core historical exhibits, a gallery for rotating exhibits, a library and resource center, a rich community archive, an auditorium, a multipurpose community courtyard, a gift shop, and a 4,700-square-foot gathering, performance, and maker space.

AANM is a Smithsonian Affiliate and accredited by the American Association of Museums. In 2016, AANM was awarded membership to the National Performance Network, an invitation-only member-based capacity-building network that provides resources for participating organizations. AANM is located in the heart of East Dearborn, an economically deprived area that borders Detroit to the east, north, and south. The city of Dearborn

is home to the largest concentration of Arab Americans. More broadly, Michigan's Arab American population, estimated at 350,0000, includes first-, second-, third-, and fourth-generation individuals and families of Arab descent. The community spans broad socioeconomic and religious backgrounds and is an influential component of our state's cultural, economic, and political landscape.

In a typical year, AANM receives an average of 30,000 visitors. Portions of our public programming—particularly youth-centered arts and cultural programs—seek to engage young people and families from Southwest Detroit, Hamtramck, the South End of Dearborn, and East Dearborn, which are home to low-income Arab, Latinx, and African American communities. Additional outreach targets artists, arts educators, museum professionals, scholars and students, families, and ethnic and mainstream organizations.

Prior to the pandemic, over 60 percent of AANM's general-admission ticket sales were to Michigan residents, including a large percentage of students from community colleges, universities, and public, private, and charter K–12 schools across the region and from as far as the Upper Peninsula of Michigan, Indiana, Illinois, and Ohio. AANM reaches diverse audiences not just locally but across the country. In a typical year, we serve over 150,000 through individual and group visits, general-admission programs, and web-based initiatives. During the height of the pandemic, we pivoted to a virtual format that reached approximately 100,000 through online engagement programming. Since AANM reopened its building in February 2022, we have continued to engage audiences locally and globally through in-person, virtual, and hybrid programming.

What makes AANM unique is that a visitor can experience much more than the historical artifacts, art, and stories contained within the walls of the building. Within a few blocks' radius of AANM, there are dozens of Arab American–owned restaurants, cafés, clothing stores, grocery stores, and gift shops. The Dearborn Arab American community is often featured in national and global media for its size, visibility, and impact. Especially during moments of crisis in the homeland or when domestic policies impact the community (e.g., Donald Trump's "Muslim Ban"), reporters descend on Dearborn and often visit AANM looking for comment from leadership or connections to the community.

Beginning in 2021, with major support from the Wallace Foundation, Ford Foundation, and other local and national foundations, museum staff began strengthening their focus on engaging the hyperlocal Arab American community in the neighborhoods surrounding the museum. The Yalla Eat! tours have been one component of that engagement and have recently expanded to include an architectural driving tour and a neighborhood garden tour.

Walking the Food Landscape

We have planned and executed three distinct culinary walking tours. The first was in Eastern Market in Detroit, which is not only home to the oldest continually operating farmers' market in the country but is also a business district that includes enormous meat-processing facilities, wholesale produce distributors, and import/export companies serving many ethnic communities. The Arab American presence in Eastern Market dates back more than a century; it began with a few produce sellers at the market and continues today with the two largest meat-processing facilities in the market—one halal, one not.[4]

The second tour was developed to highlight East Dearborn's Warren Avenue, the centerpiece of Arab American public foodways in the region for three decades. On the two-mile stretch east from Wyoming Avenue to Greenfield Road in the west, there are nearly a hundred food-related businesses owned and operated by Arab Americans. Though as business districts, Warren Avenue and Eastern Market could not be more different, they share a similar trait—almost all of the Arab American–owned businesses are Lebanese (with the exception of a handful of Palestinian, Syrian, and Iraqi places on Warren Avenue). As William and Yvonne Lockwood detailed in their exploration of the culinary roots of Detroit's Arab American community, Lebanese were not only the first to open Arab restaurants and hold a "monopoly"; they also "standardized the Arab American menu, establishing a fairly standard set of expectations."[5] This fact led us to develop our third and most recent tour, Michigan Avenue in East Dearborn.

The Michigan Avenue corridor, once the main shopping district for the city, is an up-and-coming section of town featuring a couple of well-established Arab American restaurants along with new businesses owned and operated mostly by young Arab Americans, many of them Yemeni. As of this writing, there are three full-service Yemeni restaurants within three blocks of each other, six Lebanese-owned restaurants and cafés, and a smattering of hookah lounges, burger joints, and pizza shops, all owned by young Arab Americans.

With an almost endless potential for food-related businesses to include, we are limited by only one factor: how far a group of people could eat their way through a neighborhood in a few hours. As the home of Henry Ford and the Ford Motor Company, Dearborn, like much of the Detroit area, was not designed with pedestrians in mind. The various Arab ethnic business districts are spread out across many square miles, connected only by major thoroughfares where nary a pedestrian is ever seen.

Working with the available and willing businesses, we tried to showcase the broad range of food items that could be purchased in each commercial district. On the two Dearborn tours, we were lucky to have access to large full-

service Arab American grocery stores. At each of these stores, tour participants could sample unique in-season produce, like sour plums and green almonds, as well as get a behind-the-scenes tour of a halal butcher shop. The grocery stores also showcased what scholars have called the "adaptation" process, where immigrant ethnic communities meld tastes of home with popular goods and items available in diaspora, like halal pepperoni and hotdogs.[6] Both Warren Avenue and Michigan Avenue have an abundance of restaurants, so participants could sample shawarma and falafel along with some of each restaurant's specialties, like Yemeni *fahsa* (stewed lamb and potatoes served in a hot stone bowl) and lamb *haneeth* (slow-cooked lamb) at Sheeba and the Lebanese diaspora–favorite potato balls at Habib's. On Warren Avenue, the Lebanese breakfast treat *knafeh bi ka'ak* (a melty, sweet cheese dessert served in a sesame bun) was always a hit among participants, both for its unique qualities and—well, do I really need to explain why fresh *knafeh* was a hit? No Arab American food tour would be complete without *qahwa* (coffee), and Dearborn is blessed with Hashems, which roasts its own coffee and nuts, as well as a plethora of Yemeni coffee shops.

Developing the Warren Avenue Tour

Although the food is the star of the show, the tour script is vital to contextualizing the experience. Why are there so many Arab Americans in the area? Where did they come from? When did they start to open food businesses? How does religious identity play out in the food landscape? Does anti-Arab racism affect the community in East Dearborn? Is the food sold in Dearborn the same as what is eaten back home in Lebanon, Iraq, or Yemen?

To construct the tour, we needed to answer these questions about historical context and the individual experiences of each featured business. The larger historical context questions were the easiest to answer. There is an ever-growing body of scholarship about the Arab American community of Dearborn and metro Detroit. Much of this portion of the tour script was compiled from secondary sources and existing information used in AANM exhibit tours.

To answer the more minute questions about the histories of each business on the tour or foodways in the community, we enlisted the help of two public historians who literally wrote the book (or at least the book chapter) on Arab foodways in Dearborn and Detroit. From the funds of the Michigan Humanities grants that kickstarted the Yalla Eat! tour program, we contracted with scholars Yvonne and William Lockwood, who had intimate working knowledge of the community that stretched back to the 1980s. Additionally, the pair wrote a book chapter for the seminal volume *Arab Detroit: From Margin to Mainstream* (2000). Their chapter, "Continuity and Adaptation in Arab American Foodways," was—and remains—the only aca-

demic piece to offer a history of the foodways and food-business history of the community in metro Detroit. But since the piece was published in 2000 and the tours were beginning in 2013, we asked the Lockwoods to walk the tour route and engage with business owners in order to update the history they had written more than a decade earlier. They spent a few months talking with staff and owners at restaurants, bakeries, and shops along the Warren Avenue corridor. Their notes from these conversations were valuable for writing the tour script and determining which businesses might be included.

Because nobody has written a history of the Warren Avenue commercial district, save for a few newspaper articles or blog posts, there was primary research to be done to situate what the contemporary commercial landscape looks like against a historical backdrop. Driving down Warren Avenue today, you will notice that almost every single business on both sides of the street for more than a mile are Arab owned. You will see signs in Arabic and English, smoke billowing from the chimneys of the kabob shops, parking lots packed with cars, and people lined up for fresh knafeh and unique produce items. But what did this landscape look like in the 1970s and 1980s, when the first Arab-owned businesses started popping up on Warren Avenue, as the community expanded beyond the confines of the factory neighborhoods in the South End of the city? When did this corridor take on its distinctively Arab flavor?

I was armed with one vital piece of information: I knew from talking to community elders that the Arab community revitalized the Warren Avenue corridor in the late 1980s. The area was a ghost town of empty storefronts and abandoned buildings following the decline of the auto industry in the 1970s. This changed thanks to the entrepreneurial spirit of the Arabs, the story goes, coupled with the growth of the community sparked by continual immigration from Lebanon, Iraq, Palestine, and Yemen due to civil strife or crisis in those countries.

To find these answers, I scoured phone books and directories and constructed historical maps of the street, plotting all of the Arab-owned establishments. This was part archival work and part anthropological. Anyone who has done historical work on the Arab American community knows that you cannot identify who is Arab and who is not using last names or names of businesses alone. Sometimes it is obvious. Anytime you see *Beydoun*, *Saad*, or *Dabaja* on a business record or in a directory, you can assume this is an Arab establishment, as these are common Arab names in Dearborn. But what about the last names *Thomas* or *David* or *Berry*? These are also common Arab names but could just as easily be non-Arab people. To confirm whether a business was Arab, I would consult people who grew up in the community. I would show them the directory entry and ask if they remembered that business or if they knew the owners. What about Palace Fine Foods or Sheik's

Gourmet? Definitely either of these could potentially be Arab owned based on the name.[7]

From these directories and conversations, I was able to visualize the growth of the community along Warren Avenue: 2 Arab-owned businesses in 1975, 10 in 1980, 50 in 1990, 90 in 2000, and more than 175 in 2013. Clearly the story to tell is one of tremendous growth and investment. Since the tour was taking place in the present moment, though, the most important historical source was the stories from the staff and owners of the businesses, which is why we included their voices in the tour whenever possible. The participation of business owners and their staff is a major part of what makes the tours so appealing and engaging.

The Tour

Although we have produced multiple versions of the walking tour, two in East Dearborn and one in Detroit's Eastern Market neighborhood, they all essentially follow the same formula—gather ten to fifteen people and spend two to three hours visiting a number of Arab American food establishments and learning about the community and its food traditions along the walk in between each stop.

The Warren Avenue tour is the version we have run the most and has garnered the most media attention for AANM and the Yalla Eat! program. Walking along the oldest and most visible Arab American commercial district in East Dearborn, tour guests get a strong sense of the scale of the community and its history in Dearborn. The stretch of Warren Avenue that the tour traverses (nearly a three-quarter-mile section) contains Arab American–owned businesses lining both sides of the street—dozens of them. From gas stations, to accountants, to bakeries, to doctor's offices, almost every single business is either Arab owned or caters to the community.

The tour begins and ends at Super Greenland Market. Super Greenland is part of the Greenland Market chain, founded by the Koussan family in the early 1990s. Super Greenland was the first "mega mart" in the Dearborn community and functions as a one-stop shop, with its own bakery, butcher, and deli located within a full-service grocery and household-goods market. On a typical tour visit, Yalla Eat! guests will get a behind-the-scenes look at the in-house halal butcher shop, walking between slabs of frozen lamb hanging from metal hooks. Guests will explore the spices, cheeses, and produce that have made Super Greenland a destination shopping experience for thirty years. The tour usually ends in the small café at the rear of the market, where samples of tabbouleh, *manaqeesh* (open-face pies topped with either cheese, zaatar, or meat), and in-season produce (like green almonds or sour

plums) are prepared. Guests learn about the importance of having produce, canned goods, and spices available to the large immigrant community. Tour guides usually mention "Wild Wednesdays," a Dearborn tradition in which grocery stores offer deep discounts on produce.

Super Greenland serves as an anchor for the east end of Warren Avenue and is thus a perfect spot from which to launch the tour. Heading west on Warren Avenue, tour guests walk past one of many bakeries and Islamic fashion stores that sell modest clothing and scarves to the large population of Muslim women in the area.

The second stop on the tour is one of the longest-operating Arab American businesses on Warren Avenue. Hashems, a small shop that specializes in roasting coffee and spices, is very different from Super Greenland, more closely resembling the shops that the immigrant owners would have run (and in many cases did run) back in Lebanon, Jordan, Palestine, Iraq, or Yemen.

As guests approach Hashems, they smell the coffee and spices, most of which are roasted next door to the shop. Hashems employees usually greet tour guests with a piece of chocolate or halwa imported from Lebanon and then pass around containers of coffee and spices to smell. For the lucky few tours, staff even prepare some Arabic coffee (or Turkish coffee). Guests are then given a few moments to browse and, hopefully, purchase some items to carry in their Yalla Eat!–branded tote bags that are given at the start of the tour.

The walk between Hashems and the third stop is a bit longer than the first stretch, which gives the tour guide a chance to delve into the history of the community and how it came to dominate the business landscape of East Dearborn. Using a personal amplified device, the tour guide points out the residential neighborhoods to the north and south, which are more than 75 percent Arab American. The guide talks about the nightlife as the group passes one of the many hookah bars and might elaborate on the cultural makeup of the different neighborhoods in Dearborn, some of which are predominantly Lebanese, Iraqi, or Yemeni, and these populations are reflected in the businesses. On the Warren Avenue tour, though, the vast majority of the businesses are Lebanese owned, though just west of where the tour reaches is the large Iraqi Muslim community of Dearborn and Detroit.

The third stop is one of the newer businesses on Warren Avenue, but it has quickly become a staple. When we started the Warren Avenue tour, Lebon Sweets had just opened and made a name for itself by specializing in selling a Lebanese treat: *knafeh bi ka'ak*, or *knafeh* in a bun. A hunk of warm, freshly made *knafeh* is slid inside of a fresh-baked bun and covered in simple syrup. This is often eaten for breakfast. On the tour, employees cut two of the *knafeh bi ka'ak* into six pieces each, which is still a hefty sample of the calorie-dense treat.

The (much-needed) walk to the next stop showcases the car-centric design of Warren Avenue, a four-lane thoroughfare that runs from downtown Detroit west through Dearborn and on into the western suburbs of Wayne County. There is almost no greenery on this stretch of Warren, and no design attention is given to pedestrians or cyclists. There are intersections to cross that are harrowing, not only due to the lack of pedestrian safety features, but because in this suburb of the Motor City, home to Ford Motors, like most Detroit suburbs, car is king and pedestrians are few and far between.

The fourth stop is a kitchen and gift emporium, where shoppers can browse tightly packed rows of serving ware, coffee cups, and religious-themed gifts like artwork featuring Quranic verses. Tour guides often usher guests into one of the rows where large, commercial-sized stock pots are sold and tell stories about how, for many Arab Americans in this enclave, preparing a meal means making large amounts of food for typically large families and as part of the Arab tradition of hospitality. Guides also point out the shelves of intricately designed tea and coffee services—another feature of Arab hospitality.

Crossing Warren Avenue, we head to the fifth stop, which is the most iconic establishment on the tour and offers guests the first real chance to sit down in nearly two hours. Shatila Bakery was opened in 1979 by Lebanese immigrant Riad Shatila. Shatila opened its newest building on Warren Avenue in 2004, and it is probably the most recognizable and one of the most visited Arab food establishments in East Dearborn. Shatila is a household name for its baklava and other Arabic sweets, and it ships globally. Shatila's large, ornate seating area (including life-sized fake palm trees) allows tour guests a moment of reprieve while they sample some baklava. They are also encouraged to taste Shatila's own ice cream, since they produce more than ten flavors, including pistachio and *kashta* (clotted cream). At Shatila, guests learn that Riad revolutionized the sweets industry in the Arab American community by switching from selling baklava by the pound to offering it in the more recognizable rectangular trays.

The final stop adds a bit of the savory. There are many iconic restaurants on Warren Avenue, some dating back to the mid-1980s. Although the majority of the restaurants are Lebanese owned, there are a number of notable Iraqi, Syrian, and Yemeni restaurants as well. Depending on the day of the tour, guests might sample the flame-grilled meat skewers at Iraqi Kabob, taste Syrian food at Al-Chabab, or head into the forty-year-old Lebanese restaurant Al Ameer—a recipient of the James Beard "America's Classic" award in 2016.

When we end the tour back at Super Greenland, guests are usually full and tired. We hope that tour participants, after walking, eating, and learning for two to three hours, see the Arab American community in a new light. We also give everyone free tickets to AANM in order to spur a return trip to Dearborn with friends and family.

According to an interview with one of the longest-serving Yalla Eat! tour guides, an Iraqi immigrant and entrepreneur himself, the preceding description closely matches his ideal Warren Avenue tour:

> I think it's a good idea to start at Suwaq al-Mustapha [Super Greenland], just to give an exposure to you know, where the Arabs get their food from. And then, you know, we usually try Lebanese food there, and then definitely go to Hashems for coffee—a good place to stop and try the different coffees and sweets and stuff. And then I always do actually stop at Kabob al-Iraqi [Iraqi Kabob], because people are not familiar with Iraqi foods. What happens usually, I call them ahead of time, and he has a kebob—that's what the place is known for—the Iraqi kabob, which is a little bit different than what people are used to, the Lebanese kabob. The server usually just serves the food outside. So we are just kind of waiting outside and kind of sample the food, and then we just make our way to Lebon Sweets, which is another great place to stop by. They have the *knafeh* sandwich, which is something that is very new, a lot of people are not familiar with it, and people love it. They love that.[8]

Yalla Eat! as Culinary Tourism and Public History

The overwhelming majority of tour participants are not Arab or Arab American.[9] Most are from the metro Detroit region, and many have experience with Arab or Middle Eastern food, though rarely beyond the few well-known restaurants in the area. Most of the participants are only familiar with Levantine cuisine, widely available in metro Detroit for the last forty-plus years, and Levantine cuisine has come to stand in for all Middle Eastern or Arab food. Through our walking tours, which admittedly visit mainly Lebanese-owned establishments with an increasing number of Yemeni places, we try to situate the available Arab food in metro Detroit in a larger historical and culinary context. The majority of participants were not familiar with the real history of Arab Americans in the region, beyond the oft-repeated statistic of Dearborn having the highest concentration of Arab Americans in any city in the United States.[10] This was the unique aspect of the Yalla Eat! tours—the mixing of food tasting, stories about culinary tradition, and physically traversing the history of the Arab American community, all led by a community-based cultural center.

In Detroit, like other U.S. cities, the first restaurants to introduce Arab cuisine to the public were almost always owned and operated by Lebanese,

Syrian, or Palestinian immigrants. These restaurants firmly established Levantine dishes and palates as the dominant Arab cuisine in the area. Even as newer immigrants from Yemen arrived in large numbers in the 1970s and 1980s and set up restaurants, they tended to focus on Levantine cuisine, especially in the areas outside of the Yemeni community. It is only recently, as in the last few years, that Yemeni-owned restaurants serving mostly Yemeni cuisine have sprung up in many areas of metro Detroit. Our Michigan Avenue tour specifically highlights the demographic shift in East Dearborn, where the Yemeni community is becoming not only more numerous but more visible.

Within the span of a few months in 2015, for instance, two Yemeni-owned restaurants opened—both specializing in Yemeni cuisine—a first for this neighborhood of East Dearborn, dominated by Lebanese people and their food for the last few decades. As the Lockwoods detailed in their 2000 essay, "With just one exception, every Middle Eastern pastry shop in the Detroit area is Lebanese."[11] Almost twenty years later, that figure still mostly holds. A few smaller Yemeni and Iraqi bakeries opened in Dearborn beginning in 2017, and some Yemeni women sell their homemade pastries to Yemeni cafés. Lebanese-style pastries and sweets dominate the landscape, and the opulent Shatila Bakery on Warren Avenue is emblematic of this.

During the pandemic years (2020–2022), the Dearborn area was home base for the national growth of Yemeni-owned and Yemeni-themed coffee shops and cafés. Ibrahim Alhasbani opened Qahwah House in East Dearborn in 2017. It was a major success in the community, and Qahwah House received regional and national media coverage for using Yemeni-grown coffee beans from AlHasbani's family farm in Yemen.[12] Qahwah House has grown to more than fifteen locations across seven states, and as of summer 2024, there are at least two dozen Yemeni-style coffeehouses in metro Detroit alone.

While the Yalla Eat! tour was established before this explosive growth of Yemeni-owned coffee shops, later versions of the tour, especially those that incorporated van transport in addition to walking, have included stops at some of these newer Yemeni places, and participants can sample the unique coffee and tea drinks and the famous "honeycomb" dessert, *khaliat al nahl*, so named for its honeycomb appearance of pastry filled with sweet cheese and drizzled with honey.

The fact that the walking tour is limited to brick-and-mortar establishments also means that some of the burgeoning food scenes, such as that in the Sudanese community, where food is limited to home-based production and pop-up shops, cannot easily be included in the traditional culinary tour model. But the AANM has vibrant public and community outreach programs with more flexibility in presentation. For example, the Sudanese community has held multiple gatherings at the museum, often centered around

food. One of those events was covered by PRX's famous radio program, *The World*, during Ramadan 2024.[13] On the episode, the reporter is sampling a well-known Sudanese drink, *hilo mur*, which is produced and sold by local community organizer and entrepreneur Khadega Mohammed and her mother. Mohammed, who has also been a staff member at AANM, has produced and served the drink at other museum programs as well. The Yalla Eat! tour, along with associated food-based programming at the museum, will continue to evolve as the community in Dearborn and metro Detroit expands and changes.

Another challenge with taking groups with a preconceived notion of Arab ethnic cuisine into a vibrant, ever-changing ethnic enclave is that there is no "timeless" quality to the Middle Eastern food in metro Detroit. Almost every dish has been adapted in some way to fit the contemporary context. In some pastries, cashews are used instead of the more expensive pine nuts. Beef is often used in place of lamb. And there is often a bottle of Mexican-style hot sauce on the tables in many restaurants. Combine this with the fact that restaurants owned by younger and/or American-born Arabs tend to have, as a focus, menu items that are more "American" than Arab. In Dearborn, for instance, a variant of a Philly cheesesteak is nearly ubiquitous, as is the "chicken sub," which is a fried chicken breast on a French roll, smothered in mayonnaise. If we wanted to show our tour participants how to eat like an Arab American, we would most likely get a chicken sub, pizza with halal beef pepperoni, or a hamburger with *kafta* instead of plain ground beef. The story of adaptation is at the forefront of the tours' narrative, as it is not only the reality of the food experience in Dearborn; it also helps convey the complexity of a community that is generations old but continuously receives new immigrants and refugees from the homelands.

The final act of negotiation in developing the tours was ensuring that we did not create a "human zoo" by bringing tourists into the Dearborn "ethnoscape" to gawk at the locals in their ethnic habitat.[14] To avoid this ethical dilemma, we intentionally stayed away from residential areas and only visited businesses that were willing participants. Further, since the AANM, and its parent institution, ACCESS, grew up within the heart of the East Dearborn community, the Yalla Eat! tours were not some outside commercial venture that treated the Arab American community as props. The goal of the tours was to let the community speak for itself, as much as is possible with a program being run by a large cultural institution.[15] Acknowledging that "people and not artifacts are the vital center of dynamic community-based museums," we believe this project will benefit the Arab American community, the general public, and our internal institutional culture as we continue to embed our programs and exhibits in the communities we intend to

represent.[16] It will benefit local Arab American purveyors and food producers who will have a prominent voice in the program, hopefully generating a sense of pride, confidence, and belonging.

Impact of Yalla Eat!

Of the more than 300 guests that completed the tour through 2019, about 150 completed a post-tour survey. According to the survey data, the tour participants have largely been non–Arab American (slightly more than 75 percent white, non-Arab). And, based on observation by tour guides, the Arab Americans who have taken the tour tend to be third- or fourth-generation. Slightly more than 60 percent of respondents were over fifty-five years old. This profile largely matches the exhibits visitor profile for the AANM (excluding K–12 school field trips). Guests for AANM programs held in the museum (film screenings, concerts, literary events, etc.) tend to include more Arab Americans (roughly 35 percent).

The older, mostly white audience for the Yalla Eat! tours makes sense for a tour that navigates the heart of a predominantly Arab and Muslim immigrant business district. One of the most common comments from this group of participants is that the tour offered them a pathway to return to Dearborn's Arab American community to patronize the businesses. Overall, 90 percent of respondents said they were very likely or extremely likely to visit the participating businesses in the future. One participant wrote, in response to the question of whether they would return, "We already have, two days after, for produce, cheese, and coffee." Another wrote, "My husband and I took the Warren Ave tour to become familiar with more of the businesses in the area. The tour was just what we were looking for. The businesses all made us feel very welcome, the samples were very generous, and we look forward to returning to each of them." A third said simply, "I will go back to Dearborn and shop there and feel comfortable."

Our Yalla Eat! business partners have shared numerous stories of tour participants coming back and spending money. It is difficult to measure the impact of the Yalla Eat! tour program on both the Arab American community and the general public. The walking tours along with their featured businesses have been the subject of dozens of local and national media stories, food blogs, and videos. In my personal role in the museum and as one of the administrators of the walking tours program, I always try to complicate the food landscape for local and visiting journalists in addition to tour participants. I encourage them to branch out beyond the main tourist restaurants and bakeries, to experiment with new foods and flavors, and to visit burgeoning neighborhoods beyond the ethnic business district of Warren Avenue. I want Arab cuisine to be seen as more than hummus and shawarma.

Even as food serves as a bridge between cultures and engages all of the senses, focusing solely on the food often leaves the culinary tourist with a very "thin" level of understanding of the ethnic group and its issues and experiences. Through public foodways, cultural identity is often presented through a noncritical multiculturalist lens. In discussing public culture and constructed ethnic displays in the Arab Detroit context, Andrew Shryock speaks to the argument that multiculturalism requires a "thinness" to which public foodways are perfectly suited. Occurring in the "mainstream," "homeland culture" is reduced to a nonthreatening "heritage" or "identity."[17] This is an issue that we have grappled with throughout the development of the Yalla Eat! tours—using food as an introduction to, but not the only avenue for, discussing the lived experiences of Arab Americans.[18]

Food, in the liberal multicultural mainstream, is often depoliticized and extracted from the lived experiences of the ethnic community that produces it. Lisa Lowe states it most clearly:

> Multiculturalism levels the important differences and contradictions within and among racial and ethnic minority groups according to the discourse of pluralism, which asserts that American culture is a democratic terrain to which every variety of constituency has equal access and in which all are represented, while simultaneously masking the existence of exclusions by recuperating dissent, conflict, and otherness through the promise of inclusion.[19]

The Yalla Eat! tours actively work against the thin construction of identity that can result. The walking tours combine food with a deeper experience of eating and purchasing ethnic food in context, conversing with actual Arab American business owners, absorbing the community's history (although mostly scripted), and engaging with the Arab American community on its own terms for a two- to three-hour journey.

As one of the museum tour guides states about the role of food in having deeper, more meaningful conversations:

> So they asked all sorts of questions, you know, political, religious, social, because you know, after an hour walking and getting to know people, we sit down. And this is where people like, after you feed them, they feel comfortable about asking, well, all sorts of questions. And it feels a lot more relaxed, too. Because people are just like, you know, it's more comfortable. Because they sit down with you. They're eating, and now you are like sitting with them at a dinner table. So they feel comfortable talking about anything and everything.

This same tour guide, revisiting the importance of taking tour participants to a diverse selection of places, says:

> In addition to talking about the food and how it's different, because a lot of people have this idea that all the food is falafel and hummus and stuff all across the Arab world, which is not true. I mean, Yemeni cuisine does not have hummus, does not have falafel at all. So, we talk about how different Arab countries have different types of foods. And then you cannot really talk about food without talking about how Yemeni culture is totally different than Lebanese culture and Moroccan culture. So we talk a lot about Yemen and then we bring in the immigration story, too. . . . This is why it's very important to include different, you know, cuisine, different restaurants, or at least coffee shops.

Through this lens, then, the food and culture brought by the people who have settled in Dearborn are intertwined with their stories. You cannot talk about the development of Arab American cuisine in metro Detroit without talking about the lived realities of the people who produce the food.

So, what makes the Yalla Eat! tours so popular? Is it the food? The chance to interact with real, live Arabs? The role of the AANM? The heightened tension of exploring an Arab American enclave in a neighborhood maligned by popular and political discourse as a foreboding, un-American place? To answer my own rhetorical questions, I think the popularity comes from the unique combination of all of these factors. But ultimately, it is the food that draws people in—and usually keeps them coming back.

APPENDIX

The brief "Guide to Establishing an Arab American Culinary Walking Tour" from the AANM serves as a primer for establishing culinary walking tours in an Arab American neighborhood or enclave. This guide is prepared by staff at the AANM who have been administering the successful Yalla Eat! Culinary Walking Tour program since 2013. We hope to enable other communities to showcase their history and culture through food.

The Goals of a Culinary Walking Tour
There are multiple interrelated goals for building and operating a culinary walking tour of the Arab American community. Tour participants

- meet Arab American business owners and hear their stories;
- learn about the history, culture, and experiences of the local Arab American community;
- understand more about Arab Americans in general and even learn about Arab countries; and,
- of course, get a taste of the broad range of Arab American cuisine.

Questions for Establishing a Walking Tour
Before putting in the work of planning the tours, there are a few essential questions to ask:

- *Is there a walkable area with at least three to five different Arab American–owned food establishments?*
 - A walkable tour would, ideally, be less than two miles and allow visitors to experience different types of Arab American cuisine—such as cuisines from different nationalities (Egyptian, Lebanese, Yemeni, etc.) or different types of food preparation (bakery, butcher shop, grocery store, restaurant).
 - If you have access to a twelve-passenger van, you could expand the area for the tour.
- *Are the businesses and the larger community amenable to having groups of visitors walking around?*
 - This is a difficult but important question to engage with. A culinary tour of an ethnic community should not be reduced to a "human zoo." Tour participants should not be walking through community spaces or residential areas where Arab American community members would feel like they were on display. Tour participants should engage with willing community members only.
- *Do you, or does your organization, have the capacity and commitment to develop and run a culinary tour program?*
 - The background research and relationship building can take months to complete.
 - Do you have staff to create and manage promotional materials, including handling media inquiries?
 - You might need some sort of patron management system to keep track of tour participants and any payments or fees for the tour program.

Establishing Relationships with Businesses
The relationships with businesses are the most important aspect of building a tour program. The businesses should be *willing* partners in the enterprise. After all, it is their space, history, and products that tour participants will experience. Here are some guidelines for building and maintaining strong relationships:

- You may need to visit a business three to five times (or more!) before including them in a walking tour. Expect to spend a few weeks (or months) building the relationship.
- The concept of a walking tour may be new to some business owners, so it takes time to explain the concept and make them comfortable with it.
- Even if you have an existing relationship with a business, bringing ten to twelve guests on a walking tour is a new dynamic, and it takes time to build the trust and understanding necessary to ensure a positive experience for everyone.
- Parameters to discuss: What time of day is best to visit? Who will be the main contact at the establishment? What will the main contact tell the tour guests (history of the business, highlight of products, etc.)? What will the business offer to tour guests (a sample, a discount)? How will you compensate the business for the samples? Note: Most businesses will decline any compensation, deferring instead to a duty of hospitality for guests. You should offer numerous times to compensate. If they adamantly decline, you can still provide a gift at the conclusion of the tours, but do not call it a payment.

- Allow businesses space to decline participation. A business owner or manager may decline participation for a number of reasons—all of them valid.
- Once you have an agreement about tour parameters, bring a brief letter outlining the dates and times of the tours. This is helpful for businesses that have many employees, because it can be confusing when you show up with a group of people at a busy time or when an employee was not a part of the original discussion.

Research and Script Writing
Besides sharing the food of the Arab American community, the goal of this type of walking tour is to provide a sense of the history and experiences of the community. The time spent walking between establishments should be utilized to tell the story of the community: When did they begin coming to the area? Why? Where were they coming from? What types of things have they done? The food should be a gateway to learning more about the experiences of the contemporary community as well as their history. This is one major reason why it is helpful to have food-based businesses that serve different cuisines from various countries or regions—it allows the tour guide to connect the history of the community to a more diverse Arab/Arab American experience.

The research and writing of the scripts could take anywhere from a few weeks to a few months. There are many resources that will help you get started with researching the history of your local Arab American community. The best resource is to talk to the business owners and community leaders. They often have the most valuable bits of historical information. You can also browse the vast collections at the AANM and the Moise A. Khayrallah Center for Lebanese Diaspora Studies.

The script for the tour should offer brief historical tidbits and bullet points of interesting aspects of the contemporary community—it is tough to give a full history lecture in the middle of a busy parking lot or sidewalk. As you walk, point out other businesses and organizations of note, tell stories of other ethnic and immigrant groups that live or have lived in the area, and offer suggestions for further self-exploration following the tour.

Timing is very important on a walking tour that visits several small businesses. The script and the tour stops should be coordinated so that you arrive at a business at the time agreed upon with the owner or manager. Running late or showing up early can create stress for a small business with limited staff.

Marketing and Promotion
Once you have established relationships with the businesses and have drafted a script, you will need to set tour dates and times and begin publicizing. Setting dates, times, and pricing should take the following into account:

- What days of the week and time of day work best to visit the businesses? You may want to avoid bakeries during the breakfast rush and avoid sandwich shops during lunch. Grocery stores might be crowded closer to dinner time. Some days of the week are bad, depending on when businesses expect their weekly shipments.
- For tour participants, the best times are usually the early evening on weekdays or late morning and early afternoon on weekends.
- If you are charging for the tours, determining a fair rate depends on a few factors. What are similar tours in your area charging? Are you reimbursing the businesses for their participation? What are the operating/overhead costs of the tour program?

A culinary walking tour of an Arab American community is a unique experience, and local media usually jump at the chance to join a tour and write about it. Hold a practice tour a few weeks before the tour program starts and invite local media (especially food bloggers and Instagram foodies in your area) to take the tour for free.

Preparing for the Walking Tour
As the walking tour approaches, you will want to ensure everything is in place for a great experience. Here are some recommendations:

- The tour guide should have some sort of personal public address system. Even with a booming voice, talking to a group of ten people next to a public thoroughfare is difficult. A battery-operated speaker that clips onto a belt or waistband, with an accompanying headset, is a great option for around $30. And always carry extra batteries for the portable address system.
- Check in with businesses the day before the tour or the morning of to make sure they will have someone available to meet your group and offer samples.
- Determine if you will have any handouts or other materials for tour participants—perhaps a map of the area, historical photos, or a reusable shopping bag (to encourage them to buy items from the tour stops).
- Send an email to tour participants a few days before the tour with the following information:
 - Where will the tour start? Is there available parking?
 - How far will they walk? This is crucial information for folks with mobility issues.
 - Are there any barriers for folks who use wheelchairs, walkers, or canes?
 - Will there be any places to sit or rest on the tour?
 - Will there be available bathrooms and water fountains?
 - Are there any contingency plans for inclement weather?
 - How will the tour guide be identified? Will they be wearing something specific or standing in a specific place?

On the Tour
All of the hard work and relationship building pays off during the tour. Introducing tour participants to new foods and watching them interact with the business owners, purchase items, and learn the history of the community can be exhilarating. Here are some tips to help ensure it all goes according to plan:

- Greet the tour guests promptly. Give them an overview of what will happen. What will they learn? What will they eat? Who will they meet? Explain where and when there might be available restrooms or places to sit. Encourage them to ask questions and, of course, shop!
- Have a backup plan. Sometimes the staff is not ready for you to walk into the business. Sometimes the sidewalk is closed for repairs. Sometimes the weather changes abruptly. In these situations, stay calm and go to one of your reserve plans. Maybe you have a story you could tell. Maybe you have an alternative location to visit that does not require an employee as a guide. Due to the nature of a culinary walking tour, flexibility is key.

- Mind your walking pace. Is everyone able to keep up? Have you given folks adequate time to shop and ask questions at each stop? Hopefully, the tour script has built in some extra time for these cases.
- As you walk between stops, some guests will engage you in conversation, while others are happy to take photos or enjoy the stroll in relative silence. Do not feel obligated to speak to everyone all of the time.
- Ask for instant feedback following a tour stop, such as, What was your favorite item? Did you learn anything new?
- At the conclusion of the tour, encourage the guests to come back to the businesses and bring friends, and tell them that when they do, they should remind the business owners or staff that they were a participant in the walking tour program. It helps to remind the businesses that participating in the tour can have financial incentives.

Following the Tour
After each tour, you will want to do three things:

- Distribute and collect any surveys or feedback from participants.
- Check in with each business. How was their experience? Does the time still work for them?
- Adjust the script and timing as necessary.

Final Words
Once you have an established culinary walking tour program, it becomes easier to build relationships with new businesses, attract tour participants, and earn media coverage. You can then also branch out into themed tours, such as a Ramadan tour or one highlighting a specific ingredient or dish. There is always a hunger to learn more about the Arab American community and their cuisine. As long as the walking tour program is respectful of the businesses and the larger community and engages the participants in the history, culture, and contributions of Arab Americans, you will have a successful culinary walking tour program.

NOTES

1. My understanding of culinary tourism in this essay is drawn from the work of Lucy Long, "Culinary Tourism: A Folkloristic Perspective on Eating and Otherness," in *Culinary Tourism*, ed. Lucy Long (Lexington: University of Kentucky Press, 2004), 20–50.

2. The Arab American community of Dearborn is often portrayed as un-American in media discourses. There is even a widespread (and ultimately moronic) belief that neighborhoods of Dearborn are "no-go zones," where the police are afraid to enter because of the threat of "jihadist" terrorism. See, at your own risk, Raheem Kassem, *No Go Zones: How Sharia Law Is Coming to a Neighborhood Near You* (Washington, D.C.: Regnery, 2017).

3. In her article "Coming to the Center of Community Life," Dr. Maria-Rosario Jackson of the Urban Institute in Washington, D.C., suggests that museums should be challenged to "stretch their boundaries, step away from the sidelines, come to the center of civic life, and become a more active participant and even a leader in social capital and the community building process." See Jackson, "Coming to the Center of Community Life," in *Mastering Civic Engagement: A Challenge to Museums* (Washington, D.C.: American Association of Museums 2002), 29–30. This is further reinforced by people in the

field who are examining the role of historical societies in preserving and interpreting history. Barbara Franco, executive director of the Historical Society of Washington, D.C., writes: "Rather than viewing themselves as elite or scholarly experts who take responsibility for telling the community's history, historical societies increasingly see themselves as facilitators who are helping various communities within the city tell their stories. This approach not only reflects a general trend toward multiculturalism within the academic community, it is also indicative of a new emphasis on public relations.... A strong relationship with the local community is essential to this equation." See Franco, "In Urban History Museums and Historical Agencies," in *Public History: Essays from the Field*, ed. James B. Gardner and Peter S. LaPaglia (Malabar, FL: Krieger, 1999), 313.

4. The businesses we visited on the Eastern Market tour were Germack, founded by an Armenian immigrant from Syria in the 1920s; Gabriel Imports, founded by a Lebanese immigrant; Sweiss Imports, owned and operated by a Jordanian immigrant; and Saad Meats and Wolverine Packing, both founded by Lebanese immigrants, though Wolverine Packing began in the 1930s and Saad really developed in the 1980s.

5. William and Yvonne Lockwood, "Continuity and Adaptation in Arab American Foodways," in *Arab Detroit: From Margin to Mainstream*, ed. Nabeel Abraham and Andrew Shryock (Detroit: Wayne State University Press), 524. Lebanese Americans have cornered the market on Arab food in Dearborn and metro Detroit in general (with the two exceptions being the Iraqi Chaldean community's own dominance in Detroit's northern suburbs and the growing influence of the Yemeni community in Hamtramck).

6. Lockwood and Lockwood write at length about the process of adaption that the Arab community in Detroit has been undergoing for decades.

7. For a history of Arab Americans using Orientalist terminology to market food establishments, see Matthew Jaber Stiffler, "Serving Arabness: Imagery and Imagination of Arab-themed Restaurants," in *Arab American Aesthetics*, ed. Therí Pickens (New York: Routledge, 2018), 63–85.

8. Yalla Eat! tour guide, interview with author, AANM, March 14, 2014.

9. Of more than five hundred tour participants (as of February 2018), 75 percent were non-Arab white. Most are not from Dearborn or the immediate area.

10. According to the 2020 U.S. Decennial Census, over 50 percent of Dearborn's population of nearly 100,000 people is of Arab ancestry.

11. Lockwood and Lockwood, "Continuity and Adaptation in Arab American Foodways," 523.

12. Zahir Janmohamed, "Coffee Shop Entrepreneur Shows Customers Yemen Is About More Than War," *NPR*, January 3, 2018, https://www.npr.org/sections/thesalt/2018/01/03/574694134/coffee-shop-entrepreneur-shows-customers-yemen-is-about-more-than-war.

13. Ronia Cabansag, "Special Sudanese Beverage for Ramadan," *The World*, April 1, 2024, https://theworld.org/segments/2024/04/04/special-sudanese-beverage-for-ramadan.

14. As Blythe Collins writes in her thesis about cultural tourism in Dearborn, "Dispelling Misconceptions through Cultural Tourism: A Case Study of Dearborn, Michigan" (Leeds Beckett University, 2017): "Ethnoscapes are occasionally described as 'human zoos' by residents who feel as though they are being looked at through a lens of 'otherness.'" For her research, she interviews multiple people involved with the Yalla Eat! tours. She writes, "Three interviewees . . . mentioned the term 'human zoo' explicitly, though it should be noted that each of them spoke only of the potential for this to happen and did not assert that it was currently happening."

15. Here I am thinking about scholarly critiques of organizations in the metro Detroit area that, following the terrorist attacks of 9/11, worked to shield the Arab American community from the fallout, while some organizations also exploited their positions as spokespersons. Andrew Shryock, Nabeel Abraham, and Sally Howell write, in their introduction to their volume, *Arab Detroit 9/11* (Detroit: Wayne State University Press, 2011), that "a focus of concern for activists, community organizers, business investors, and political problem solvers who realize that Detroit's availability as a target has turned it into a valuable resource."

16. Ron Chew, "Community Roots," in *Mastering Civic Engagement: A Challenge to Museums* (Washington, D.C.: American Association of Museums, 2002), 63–64.

17. Andrew Shryock, "In the Double Remoteness of Arab Detroit: Reflections on Ethnography, Culture Work, and the Intimate Disciplines of Americanization," in *Off Stage/On Display: Intimacy and Ethnography in the Age of Public Culture*, ed. Andrew Shryock (Stanford, CA: Stanford University Press, 2005), 279–314.

18. Shryock, "In the Double Remoteness of Arab Detroit."

19. Lisa Lowe, *Immigrant Acts: On Asian American Cultural Politics* (Durham, NC: Duke University Press, 1996), 86.

9

Conclusion

Shared Authority and Reflective Practice in Public History

Rebecca K. Shrum

Historians love to say that everything has a history, because it serves as an important reminder that we have much to learn about the current state of something by exploring how we arrived at the present situation over time. This is certainly true for the field of public history, which aspires to be a liberatory practice: a collaborative, inclusive, and multivalent undertaking between historians and citizens. Yet in the past—and still in the present—public history has often been an instrument of power that silences the voices of the oppressed and marginalized. The projects in this volume continuously attest to the potential of public history in the ways they demonstrate the importance of sustained relationship building, working with communities to teach the tools of the historian so that people can experience the liberatory potential of history for themselves, showing people their presence in the past, and connecting people of different backgrounds. The commitment of these authors to public history's potential has produced this important book, the first of its kind, on Arab American public history.

The authors of this volume demonstrated their collaborative spirit by coming together in February of 2024 at Indiana University (IU) Indianapolis for a daylong conference about their projects, which engaged one another, the staff of the National Council on Public History (headquartered on the campus of IU Indianapolis), local public historians, Arab American community members, IU Indianapolis students, and others interested in the subject. Like so many public historians, the authors of this volume came to the field along many varied pathways. In Chapter 4 of this book, for example, Maria F. Curtis ex-

plains how she sees her previous work connecting to public history in this project: "The Arabs and Arab Americans I have worked with over the years have always pulled me in the direction of an engaged ethnography, invoking their own sense of what we call in this volume *public history*, a collaborative, participatory, and collective way of passing on and preserving cultural memory." At the conference, we considered shared authority and reflective practice, two of the core principles that guide public history practice. These principles are woven throughout the chapters of this volume; considering them here provides us the opportunity to reflect on the development of the field of public history. Framing this conclusion around a discussion of shared authority and reflective practice will also accomplish one of the things the authors hope their work will do: encourage readers to explore this history that is waiting to be told in and with their own communities.

Michael Frisch developed the term *shared authority* in his work as an oral historian and wrote about it in his 1990 book, *A Shared Authority: Essays on the Craft and Meaning of Oral and Public History*. This term is central to public history practice but has been frequently misused and become increasingly contested in recent years. In defining the term initially, Frisch began with a core question: "Who, really, is the author of an oral history?"[1] An oral history is a conversation between two people, one of whom has experienced certain events (this person is known as the narrator or experient) of interest to the other person, who, as a historian, is there to record and preserve the narrator's memories of those events. Who, then, should we credit as the author, Frisch wondered: Is it the person being interviewed, whose lived experiences are the central core (Frisch called this the "heart") of what is produced from an oral history interview? Or is it the historian, often an expert in the academic field in which the narrator's experiences are rooted, who prepares the questions that will be asked beforehand and who asks the questions in the interview itself, invariably shaping what the narrator says, who produces the transcript and may be one of the people who draws on the material in future projects? Frisch developed the idea of shared authorship—what he came to call shared authority—to account for the idea that both people involved in an oral history are its authors.[2]

Frisch also saw a deep connection between what he knew as an oral historian and what had been happening in the field of public history in the 1970s and 1980s. Frisch explored this link between "authorship" (who has the right to claim they are the author of something) and "authority" (who has the authority to speak on behalf of whom). Frisch had witnessed firsthand the work of public historians who were waging what he called "a kind of guerilla war" against historians who wanted to be seen as the sole authorities on their subjects. The war offered "the promise of community history, of people's video, of labor theater, of many applications of oral history . . . return-

ing to particular communities or generating from within them the authority to explore and interpret their own experience, experience traditionally invisible in formal history." Just as the person with the lived experience and the trained scholar shared the role of author in an oral history, so should the people with the lived experience and the public historian recognize their shared authority over the stories they tell.[3]

Too often, as Frisch and others have argued, what public historians have practiced is not "shared authority" but "sharing authority." In this formulation, historians wrongly believe that they have authority over the stories that they tell and on occasion decide to share some of that authority with others. Sharing authority is the antithesis of what Frisch sought to establish in public history practice. Shared authority should always be the recognition of the multiple places in a community where authority exists, not the doling out of authority in a hierarchical system that privileges trained historians. Frisch described the difference this way: "'Sharing Authority' suggests this is something we do—that in some important sense 'we' have authority, and that we need or ought to share it." Aleia Brown, an interdisciplinary scholar and history professor, has compellingly criticized "sharing authority" in her work on an "ethic of care" in public history, asking, "If you can now declare that you are sharing authority, doesn't that mean that you always thought of yourself as holding authority? . . . If the need for sharing authority implies one group's previous dispossession, why wouldn't the solution be redress rather than sharing?" GVGK Tang, a public historian and community organizer with a background in transnational queer politics, rightly challenges us to consider how "more often than not, public history is a tool wielded by those in power."[4]

One of the foundational reasons why public historians in the United States have rightly been accused of "sharing authority" rather than practicing shared authority is that the field has been dominated by white historians who have all too often practiced their craft in the service of what bell hooks identified as "white-supremacist capitalist patriarchy" in which memories of the past have supported the false narrative of white supremacy for centuries by misusing and ignoring historical evidence.[5] Sharing authority, again, the antithesis to what Michael Frisch envisioned, in the hands of public historians has too often been a tightly controlled invitation to historically marginalized and oppressed groups to enter the conversation about what the narrative of American history should contain only if they do not fundamentally challenge white Americans' claim to shape and control that narrative in service to white-supremacist capitalist patriarchy.

Even when public historians intend to practice shared authority as Frisch envisioned it, there have been enduring struggles to apply it ethically and effectively in real-world situations. One of the questions that was raised about shared authority at the 2024 Arab American Public History Conference and

that resonated with many in attendance that day was how we understand shared authority when working with communities whose memories are not supported by historical evidence. I shared that I would begin with the premise that the memory in question is serving an important function and try to find out what the ongoing purpose of the historically inaccurate memory is. While this is an important starting point, historians cannot stop there. Public historian Mary Rizzo's study of *Baltimore Voices*, a play produced in 1980, shows what happened when inaccurate memories were not contextualized by historians. In this case, oral and public historians transformed hundreds of oral history interviews of elderly Baltimoreans into *Baltimore Voices*. White narrators discussed racism in their interviews but understood it only as "individual prejudice" rather than as systemic and structural forces. The historians who developed the play from these oral histories did not challenge the narrators' interpretation and, as a result, "forced the stories of Black Baltimore residents into a white ethnic immigrant narrative frame, eliding the privileges that allowed white immigrants to rise in social status and distorting Black history," among other problems. Rizzo argues that historians have an "ethical responsibility to frame and contextualize oral history to present complicated histories to the public." In the case of *Baltimore Voices*, Rizzo concludes, "they cede rather than share authority."[6]

Importantly, Rizzo writes, shared authority "is *not a solution* but, rather, a process that raises ethical questions for every project that includes interpretation for the public."[7] Public historians—including me—have too often conceptualized shared authority wrongly as some kind of goal to which all of our work should aspire. This obscures situations in which the practice of shared authority is not appropriate. There are cases in which the application of shared authority cannot go far enough to recognize the marginalization communities have endured at the hands of historians. Public historians must be prepared to recognize how their profession has oppressed communities. Historically oppressed groups know that professionally trained historians have created the narrative that has sought to erase their people from memory and thus may have significant misgivings about engaging with them to tell their community histories. Recognizing this, historians Christopher D. Cantwell, Stuart Hinds, and Kathryn B. Carpenter describe a project to document Kansas City's LGBTQ past where they approached their work as an act of allyship rather than shared authority. They write that "the term 'allyship' here is drawn from the work of anti-oppression activists who use it to describe how privileged communities can best advocate for those that face systemic discrimination." They frame the role of historians in this situation as "a resource that communities that face systemic discrimination can use." Importantly, they argue, "In light of the fact that the institutions where public historians typically find themselves have likely played a role in

obscuring the history of these oppressed groups, the entry of oppressed communities into once hostile institutions should be on their terms."[8] As allies, public historians can contribute to the critical redress that Brown has called for. But public historians must take *no* for an answer when historically oppressed groups do not want them involved in their work.

There are also situations in which public historians must say *no* to practicing shared authority with groups who are not willing to recognize historical truth. As Naiara Müssnich Rotta Gomes de Assunção, a presenter at the February 2024 conference focused on this volume, and her coauthors have written, "in the Brazilian political context, we do not wish to 'share authority' with racists, Islamophobes, homophobes, and chauvinists."[9] In *Public History for a Post-Truth Era*, Liz Ševčenko, founding director of both the International Coalition of Sites of Conscience and the Humanities Action Lab, grapples with how the premium placed by the International Sites of Conscience movement on "celebrating multiple perspectives on US history" may have contributed to an unintended and dangerous outcome. Ševčenko writes that the movement's emphasis on the idea that museums and historic sites "should strive to be inclusive spaces for dialogue from multiple perspectives" ignored the warnings of leaders in the movement (including Viktor Shmyrov and Tatiana Kursina from the Gulag Museum near Perm, Russia, and Patricia Valdez from Memoria Abierta in Argentina) that "'democracy cannot exist without justice based on a single incontrovertible truth, and that dialogue on the past can expose hard-won facts to corruption and denial, and degenerate into an all-permissive moral relativism.'"[10] For example, as Ševčenko recounts, in developing the *Guantánamo* public memory project, the team's "leadership set boundaries for what should be asked, to invite multiple perspectives without devolving into moral relativism. Certain questions would not be up for debate, such as whether torture occurred at Guantánamo, or whether torture is justified."[11]

Navigating the complexities of how and when to engage ethically and effectively with the principle of shared authority, as this discussion has attempted to demonstrate, requires a deliberative, careful, and ongoing assessment and reassessment of the history being engaged with and the stakeholders in any particular public history project. This is why the concept of reflective practice is central to the work of public history. The concept of reflective practice was developed by Donald A. Schön, a philosopher and professor of urban planning. In his 1983 book, *The Reflective Practitioner*, Schön explores how professionals could be better trained to meet the needs and demands of a complex, modern world with seemingly intractable problems.[12] In the 1970s, the usefulness of professional expertise was, as Linda Candy recounts in *The Creative Reflective Practitioner*, "under attack because [professionals] were deemed to be unable to deliver remedies for the complex, systemic prob-

lems" that the world faced. If anything, critiques of the usefulness of professional expertise have only increased in the decades since *The Reflective Practitioner* was first published, a dynamic that is closely intertwined with the dynamics of the post-truth era explored by Ševčenko. As Candy describes it, "The role of specialist expertise in informing opinion and guiding behavior, coupled with persistent doubts about the ability of professional knowledge not only to cure medical and social diseases, but more broadly, to address the major global problems faced today, from climate change to the spread of contagious disease, is the subject of contemporary debate."[13] While Schön and Candy both advocate strongly for the key role professionals and professional expertise should play in today's society, they argue that people need specific training on how to do successful work in challenging circumstances.

Schön explored how professionals urgently needed to be trained to engage in what he called "reflective practice" to be able to more effectively solve real-world problems. Professional practice, he argued, relied too heavily on the idea that successful outcomes could be achieved by applying a predetermined set of steps that guaranteed success (that kind of technical endeavor might be something like following a set of printed directions in order to assemble a piece of furniture). No such set of steps could be relied on, Schön argued, because professionals needed to respond to the unique qualities of each situation they faced.

In applying these ideas to the field of public history, Noel J. Stowe, public historian and professor of history at Arizona State University, argued that "every new project, every engagement with new clients, every alliance with a new institution requires a re-examination of basic principles and issues," including "what it means to think and act *historically*, that is, as historians." This includes understanding historical research methodologies, how sound historical scholarship is produced, the ethical principles that guide the work of historians, and what it means to develop and tell history collaboratively.[14] Because each project is unique, public historians must constantly interrogate whether the actions they are undertaking have the potential to be effective in a particular situation. Public historians ask themselves questions like "What am I seeing here? What criteria am I using to judge this? What procedures am I using, and does it work?" as they engage in reflective practice in their work.[15]

Reflective practice, Stowe argued, is not only central to the practice of public history, it is "the key factor that separates public history practitioners from their traditionally prepared peers." Academic historians, the people Stowe refers to as "traditionally prepared," undertake many research projects over time, and their interests may shift significantly during the course of their careers, but they are able to "create and manage their own agendas."

Moreover, when a traditionally prepared academic historian encounters a roadblock, they have flexibility to change course or even abandon a project. Public historians, on the other hand, work in environments in which "clients, supervisors, boards, agency directors, and public needs bring the questions to them for addressing" and are often working on a project, for example, like an exhibit whose content and opening date have already been advertised to potential audiences. Stowe argued that the type of people likely to succeed as public historians "are comfortable with ambiguity, have flexible minds capable of greater endurance, are intellectually agile, and are entrepreneurial" and are those who will "not be overwhelmed by the uncertainties they encounter" in public history practice.[16]

Examples of reflective practice fill the chapters in this volume. In their chapter, "Syrian Boston from Ottoman Emigration to Urban Renewal," Lydia Harrington and Chloe Bordewich discuss how they changed the title of their first exhibition from *Ottoman Boston: Little Syria* to *Boston's Little Syria* and later *Wandering Boston's Little Syria* based on concern from community members about the history of Ottoman oppression. Harrington and Bordewich also consider how they would apply lessons learned from the composition of a speakers' panel to create more diverse representation in future events.

Throughout the chapters, different authors consider the impact that the COVID-19 pandemic had on their work and consider how lessons learned during the height of the pandemic might positively impact future projects, from the ways in which being able to be more safely in the presence of other people outside allowed opportunities for closer readings of historical landscapes than had been originally planned to the unexpectedly meaningful ways in which communities could be built in digital spaces. Rather than seeing the conditions set forth by the height of the pandemic as impediments to carefully laid plans, the authors of these chapters instead embraced the opportunity to work in unplanned ways and to see their current and future work as enriched by the experiences.

In Chapter 6 of this book, Edward E. Curtis IV explores how the *Arab Indianapolis: A Hidden History* documentary ultimately "avoided the radical critique that anti-Arab discrimination and violence is a product of warmaking and domestic counterintelligence" and focused on claiming "our belonging to rather than alienation from America." This conscious choice reflected his best assessment of how to introduce this history to both Arabs and non-Arabs in Indianapolis who were not yet familiar with it. Acknowledging that a different path could have been taken and why it was not shows careful reflective practice in this project.

Richard M. Breaux concludes his "Midwest Mahjar" chapter in this book with the reflection that "perhaps of most interest to public historians, this fairly selfishly conceived project, rooted in my own desire to know for know-

ing's sake, has led to collaborations with numerous public and professional scholars and historians who have enriched my own understanding of Arab American history and cultural expression. It is the reason you are reading this chapter." Breaux's insight reminds us that there is no one roadmap that we can follow in doing this work because there are unexpected encounters at every turn.

This volume introduces us to the history of Arabs throughout the Americas and to the meaningful work being done in the field of Arab American public history. But a book can only take us so far. We hope the histories, places, music, foods, and memories that fill the pages of this volume will inspire you to engage with this history in your own communities and to build relationships that will foster deeper understanding and appreciation of the Arab past—and present—in the Americas. The field of public history provides both helpful guidance and a series of cautionary tales in considering how to undertake this work.

NOTES

1. Michael Frisch, *A Shared Authority: Essays on the Craft and Meaning of Oral and Public History* (Albany: State University of New York Press, 1990), xx.

2. Michael Frisch, *A Shared Authority*, xx–xxi.

3. Michael Frisch, *A Shared Authority*, xx–xxi. Compelling and successful examples of shared authority, as Frisch conceptualized it, can be seen in Ari Kelman, *A Misplaced Massacre: Struggling over the Memory of Sand Creek* (Cambridge, MA: Harvard University Press, 2013); and Michelle Daniel Jones and Elizabeth Nelson, eds., *Who Would Believe a Prisoner? Indiana Women's Carceral Institutions, 1848–1920* (New York: The New Press, 2023).

4. Michael Frisch, "From *A Shared Authority* to the Digital Kitchen, and Back," in *Letting Go? Sharing Historical Authority in a User-Generated World*, ed. Bill Adair, Benjamin Filene, and Laura Koloski (Philadelphia: Pew Center for Arts & Heritage, 2011), 127; "An Evening with Aleia Brown," Twitter chat, July 8, 2020, https://blackfreedomproject.notion.site/AN-EVENING-WITH-ALEIA-BROWN-TWITTER-CHAT-e3e6215cb08340fdbe455a2499164e93; GVGK Tang, "We Need to Talk About Public History's Columbusing Problem," History@Work, June 25, 2020, https://ncph.org/history-at-work/we-need-to-talk-about-public-historys-columbusing-problem/.

5. bell hooks, "Cultural Criticism & Transformation," transcript (Northampton, MA: Media Education Foundation, 1997), https://www.mediaed.org/transcripts/Bell-Hooks-Transcript.pdf. hooks recounts here that she began using this term because she "wanted to have some language that would actually remind us continually of the interlocking systems of domination that define our reality and not to just have one thing be like, you know, gender is the important issue, race is the important issue, but for me the use of that particular jargonistic phrase was a way, a sort of short cut way of saying all of these things actually are functioning simultaneously at all times in our lives and that if I really want to understand what's happening to me, right now at this moment in my life, as a black female of a certain age group, I won't be able to understand it if I'm only looking through the lens of race. I won't be able to understand it if I'm only looking through the lens of gender. I won't be able to understand it if I'm only looking at how white people see me."

6. Mary Rizzo, "Who Speaks for Baltimore: The Invisibility of Whiteness and the Ethics of Oral History Theater," *Oral History Review* 48, no. 2 (2021): 155–157.

7. Emphasis added. Rizzo, "Who Speaks for Baltimore," 156.

8. Christopher D. Cantwell, Stuart Hinds, and Kathryn B. Carpenter, "Over the Rainbow: Public History as Allyship in Documenting Kansas City's LGBTQ Past," *The Public Historian* 41, no. 2 (May 2019): 260.

9. Naiara Müssnich Rotta Gomes de Assunção, Ana Terra de Leon, Francismara Lelis, Jéssica Melo Prestes, and Nina Ingrid Caputo Paschoal, "Arab Public History in Brazil: The Experience of the Hunna Collective: Historians Who Dance," unpublished manuscript.

10. Brandon Hamber, Liz Ševčenko, and Ereshnee Naidu, "Utopian Dreams or Practical Possibilities? The Challenges of Evaluating the Impact of Memorialization in Societies in Transition," *International Journal of Transitional Justice* 4, no. 3 (November 2010): 418, as quoted by Liz Ševčenko, *Public History for a Post-Truth Era: Fighting Denial Through Memory Movements* (New York: Routledge, 2023), 109–110.

11. Ševčenko, *Public History for a Post-Truth Era*, 170.

12. Donald A. Schön, *The Reflective Practitioner: How Professionals Think in Action* (New York: Basic, 1983).

13. Linda Candy, *The Creative Reflective Practitioner* (New York: Routledge, 2020), 13.

14. Noel J. Stowe, "Public History Curriculum: Illustrating Reflective Practice," *The Public Historian* 28, no. 1 (Winter 2006): 55, 57. See also Patricia Mooney-Melvin, "Reflective Practice, Public History's Signature Pedagogy, Course Design, and Student Engagement," in *Teaching Public History*, ed. Julia Brock and Evan Faulkenbury (Chapel Hill: University of North Carolina Press), 13–35. For an example of reflective practice applied to analysis of primary sources, see Sam Wineburg, *Historical Thinking and Other Unnatural Acts: Charting the Future of Teaching the Past* (Philadelphia: Temple University Press, 2001), 17–22.

15. Candy, *The Creative Reflective Practitioner*, 17.

16. Stowe, "Public History Curriculum," 46–47, 50.

Acknowledgments

The idea for this book formed during my stint as an Indiana University Presidential Arts and Humanities Fellow in 2022–2023, and I was able to continue my work on it as a public scholar in residence at the IU Indianapolis Arts and Humanities Institute in 2023–2024. I issued a call for papers, sent it to the Arab American Studies Association, distributed it through my networks, and tried to recruit writers directly. I was pleased that the call was heard outside the normal academic channels and that several independent scholars adjacent to the academic subfield of Arab American history submitted proposals. I kept in communication with the writers throughout 2023 as they drafted their chapters, sending them regular reminders that their work was due by the end of the year.

I emphasized the need to adhere to the deadline, since our chapters would be read not only by academic peer reviewers but also by Arab American community members. I asserted that community volunteers who are not professional historians deserved plenty of time to digest and react to the hundred thousand words that we intended to share with them. I do not know whether it was this explanation, my constant bugging, or perhaps just the extraordinary nature of this particular group of people, but they all submitted their chapters on time. That does not happen very often, at least not in my experience.

Next, we all met in person. An IU Research and Creative Activity Conference Grant and an INCommon grant from Indiana Humanities to the Arab Indianapolis Foundation, Inc., funded a public conference about Arab American public history on February 16, 2024, held at the IU Indianapolis Library.

During the daylong meeting, the writers gave quick summaries of their chapters, but most of the time was devoted to questions and feedback from community members and public historians. Hiba Alalami, treasurer of the Arab Indianapolis Foundation and a Ph.D. student in American Studies, brought together community members Ruba Marshood, Josh Chitwood, and Maria Nimri to help us think about our chapters but also about the impact of our work in the Arab American community more generally. Indiana Historical Bureau Staff Historian Jill Weiss Simins and IU Indianapolis Public History Program Director Rebecca K. Shrum organized the public historians' responses. National Council on Public History Executive Director Stephanie Rowe, Indiana Historical Society Multicultural Collections Curator Nicole Martinez-LeGrand, and Indiana Historical Bureau Blog Editor Nicole Poletika identified the innovative aspects of our work while also helping to compare it to other public history endeavors. Other guests included Houston's Ruth Ann Skaff, known to many of us as one of the great community historians of Arab America; Layla Azmi Goushey, the secretary of the Arab American Studies Association; Thomas Tadros, president of the Midwest Federation of American Syrian Lebanese Clubs; and Lindsey Waldenberg, research director at North Carolina State's Khayrallah Center for Lebanese Diaspora Studies. The flow of conversation was easy, as many if not most of the crowd of about fifty people participated in some way throughout the day. The feedback was extremely positive, and there was something magical about how we connected with one another across not only academic disciplines but also different walks of life. There was a palpable sense that the gathering and our work mattered.

In addition to garnering feedback at the conference, writers received written suggestions from one another and a couple of our community and public historian interlocutors. I am especially grateful to Rebecca K. Shrum, who generously offered substantive and stylistic comments to every single author. During the revision process, I also encouraged the volume's contributors to refer to and identify commonalities and differences in one another's chapters so that the volume was both intertextual and coherent. Writers submitted their final drafts around the end of April, and I then prepared the manuscript for peer review.

I thank Steven Conn and Aaron Javsicas for their interest in this work. The excellent copyediting of Amy Azmoun made it better. Jeremy Rehwaldt, Ph.D., proofread the book. I appreciate all of the funders mentioned earlier for their commitment to their work, though they share no blame for any errors or mistakes of judgment. I feel most grateful for the writers and the community members who believe that Arab American history deserves to be known far and wide and who delight in its telling.

About the Contributors

Reem Awad-Rashmawi (J.D., Golden Gate) is president and founder of the National Society for Arab American Genealogy. One of the few genealogy experts who uses Arabic and Ottoman records in her research, Awad-Rashmawi is a pioneer in this subfield of public history.

Chloe Bordewich (Ph.D., Harvard) is at work on her first book, *Facts and Fakes: Empire, Authoritarianism, and the Fight for Justice in the Modern Middle East*. The recipient of a Social Science Research Council dissertation fellowship, she brings her experience as a public historian to the study of Little Syria in Boston.

Richard M. Breaux (Ph.D., Iowa) is associate professor of race, gender, and sexuality studies at the University of Wisconsin–La Crosse. Breaux, a scholar of African American and Arab American history, is known for his path-breaking work in documenting the thriving culture of Arabic-language 78 rpm records in the first half of the twentieth century.

Maria F. Curtis (Ph.D., Texas) is professor of anthropology at the University of Houston–Clear Lake. The author of numerous book chapters and articles on a range of topics in Arab, Muslim, and American studies, she is the recipient of grants and awards from the American Institute of Maghrib Studies, the U.S. National Archives, the U.S. Department of State, the Arab American National Museum, the National Council on U.S.-Arab Relations, and Marilyn Mieszkuc Women and Gender Studies Fellowships.

Lydia Harrington (Ph.D., Boston) is at work on a manuscript entitled "'Improve and Reform Them': Creating Citizenship and Crafts in Vocational Schools of the Ottoman East." An expert on art and architecture, she has led initiatives to preserve and present the cultural heritage of Syria.

Randa A. Kayyali (Ph.D., George Mason) is cofounder of the Arab American Studies Association. She is an independent, community-engaged scholar and author of multiple articles, book chapters, and books, including *The Arab Americans*, one of the most popular introductions to Arab American history.

Rebecca K. Shrum (Ph.D., South Carolina) is director of the Public History Program at Indiana University Indianapolis. Coauthor of one of the leading textbooks on public history, Shrum also penned *In the Looking Glass: Mirrors and Identity in Early America*. She has a national reputation for service to both the National Council of Public History and the American Association for State and Local History.

Matthew Jaber Stiffler (Ph.D., Michigan) is research and content manager at the Arab American National Museum, director of the Center for Arab Narratives, and a lecturer in Arab American studies at the University of Michigan. He serves as the grants chair of Michigan Humanities.

About the Editor

Edward E. Curtis IV is a community-engaged scholar of Black, Muslim, and Arab American history and life. He is the author or editor of over a dozen books, including *Muslims of the Heartland: How Syrian Immigrants Made a Home in the American Midwest* (2022), which received the 2023 Evelyn Shakir book prize from the Arab American National Museum. The winner of two regional Emmys as executive producer and cowriter of *Arab Indianapolis: A Hidden History* (2022), Curtis has also been awarded Mellon, Fulbright, Carnegie, and National Endowment for the Humanities grants and fellowships. He serves as the William M. and Gail M. Plater Chair of the Liberal Arts and Director of Arabic and Islamic Studies Program at Indiana University Indianapolis.

Index

AAEF. *See* Arab-American Education Foundation
AAI. *See* Arab American Institute
AANM. *See* Arab American National Museum
AAUG. *See* National Association of Arab Americans and Arab American University Graduates
Abdelahad, Anthony "Tony," 50
Abdou, Nassif, 109
Ablan, Michael, 113
Abourezk, James, 7
Abraham, Nabeel, 193n5, 194n15
academic historians, 200–201
academic history, public history contrasted with, 11
ACC. *See* Arab American Cultural and Community Center
ACCESS. *See* Arab Community Center for Economic and Social Services
ADC. *See* American Arab Anti-Discrimination Committee
Addis, Elaine, 111
Addis, Philip, 113
Addis, Shahenne, 111
Addis, Siad, 111
AFRP. *See* American Federation of Ramallah Palestine

AI. *See* artificial intelligence
Ajemian, Michael, 55
Akkad, Moustapha, 7
Alajlouni, Samia, 139
Alalami, Hiba, 131–132, 139, 147, 148
Alamphon Records, 120–121
Alamri, Neama, 15
Aldabbagh, Taher, 115
Algorithms of Oppression (Noble), 29
AlHasbani, Ibrahim, 184
allyship, shared authority contrasted with, 198
American Arab Anti-Discrimination Committee (ADC), 7, 23, 41n5, 74, 133, 148
American Federation of Ramallah Palestine (AFRP), 163
American South, 76, 84–85
American Star (*Kawkab Amrika*) (newspaper), 89
the Americas, Arab histories in, 3–4
Amuny (federation president), 91
Anawaty, William "Bill," 87
Ancestry.com, 153, 158
AncestryDNA, 42n13, 159
AncestryProGenealogists, 167
Aneed, Anton, 117

Antiochian Orthodox priests, 78 rpm records recorded on by, 118–119
Appadurai, Arjun, 79
Arab, 18n17, 23, 24, 99
Arab America, 122
Arab American Almanac, 8
Arab American community, 5
Arab American Cultural and Community Center (ACC), 72–73, 87
Arab American culture, consumerism and, 10
Arab-American Education Foundation (AAEF), 74
Arab American ethnic home, 40–41
Arab American Family History Day, 168
Arab American Heritage Month, 147
Arab American Heritage Trail, 142–143
Arab American identity, 29–30, 34–35, 36, 156; contested definitions of, 25–28; public history and, 3
Arab American Institute (AAI), 23, 74
Arab American National Book awards, 12
Arab American National Museum (AANM), 11, 25, 35–36, 50–51, 66, 162–163; oral history interviews digitized by, 49; visitors to, 176; Yalla Eat! Culinary Walking Tours of, 12, 174
Arab American public histories, geography and, 41
Arab American Public History Conference, 197–198
Arab Americans. *See specific topics*
Arab Americans (Kayyali), 12
Arab American women, public history initiatives launched by, 6
Arab Community Center for Economic and Social Services (ACCESS), 12, 175
Arab cuisine, cultural belonging shared through, 41
Arab Detroit 9/11 (Shryock, Abraham and Howell), 178, 194n15
Arab ethnic home, 37–39
Arab histories, in the Americas, 3–4
Arab homeland (*al-watan*), 37–38
Arabic Hour (television program), 49
Arabic language, 3–4, 26, 40–41
Arabic-speaking American, communal institutions created by, 6
Arabic-speaking Muslims, Midwest migrated to by, 129
Arabic-speaking settlers, naturalization and, 5
Arabic World, Middle East contrasted with, 32
Arab identity, 4, 37–38; Black identity intersecting with, 39–40; geographic definition of, 26; MENA contrasted with, 25
Arab Indianapolis (documentary), 10–11
Arab Indianapolis community history project, *100*, 128
Arab Indianapolis Foundation, 143
Arab-Israeli war (1967), 68n12
Arab National League, 7
Arabs, Semitic family and, 25–26
Arab World, 36
Arax Grocery, 55
Arbeely, Abraham J. A., 88
Arbeely, Joseph A., 88
archives, 92–94; Arab Americans, 162–164; community, 80–85; Hall on, 79; processing and arranging, 85
archiving practices, for public history, 78–79
artificial intelligence (AI), 28, 33–34, 44n40, 163
Asian American Civic Association, 56–57
Asian Exclusion Acts, 5, 27–28
assimilation, 108
Association of Arab-American University, 68n12
Association of Arab American University Graduates, 7
Atlascope tool, of Leventhal Map and Education Center, 63
Atlas of the City of Boston (Bromley), 63
audiences: expanding engagement with, 144–147; for public history, 1–2
authority, authorship and, 196
authority, shared. *See* shared authority
Awad-Rashmawi, Reem, 42n13, *104*
Aziz, George, 109

Badeen, Nathan, 66
Balitmore Voices (play), 198
Bantz Community Fellowship, 131
Bates, Leon, 148
Battery Tunnel, in New York, 58
Becoming American (Naff), 85
bias: Levantine, 14; public history projects countering, 1. *See also* discrimination

Big Red Lollipop (Khan), 17
Bint Arab (memoir), 48
biography, 107–109, 113
Black Arab Americans, 15–16
Black Arabs, 42n6
Black identity, Arab identity intersecting with, 39–40
Black Muslims, 17n6
Blogger, by Google, 117
blogging, 117
Board for Certification of Genealogists, 154
books, Arab Americans printing, 8
Boston (Massachusetts), 55, 60, 63, 69n30; Chinatown Gate in, 52; Garment District in, 54; John S. Lufty Square in, 57; Little Syria in, 45–46, 50–51, 56, 65–66, *103*; Mary Soo Hoo Park in, 52; "Ottoman," 47; public history in, 46–51; South Cove in, 67n4, 71n50; South End of, 45
Boston Globe (newspaper), 45–46
Boston Little Syria digital map, 61–65
Boston Little Syria Project, 27, 45–46, 61
Boston Public Library, 55; Leventhal Map and Education Center at, 61; Statewide Digitization team of, 65–66
Boston Public Schools, 48
Boston Redevelopment Authority (BRA), 57–58, 64
Boston's Little Syria (exhibition), 60
BRA. *See* Boston Redevelopment Authority
Brandeis University, 67n8
Breaux, Richard M., 50, 51, *102*
Brian (Lebanese American), 167
British Colonial Office, Middle East Department in, 32
Brodzeller, Jay, 134
Bromley, G. W., 63
Brown, Aleia, 197, 199
Brown, Rick, 111
Bruckman, Amy, 32–33
Bruggeman, Seth, 58
Bryant, Gridley J. F., 55
Buchanan, Lauren, 86
Bunai, Russell, 117
businesses, building relationships with, 189–190

Cainkar, Louise, 31
Candy, Linda, 199–200
Cantwell, Christopher D., 198

"Can We Retain Our Heritage?" (Mokarzel), 89
The Caravan (newspaper), 118
Carpenter, Kathryn B., 198
Castagna, Mary, 82
CCLT. *See* Chinatown Community Land Trust
Census, U.S., 4, 35, 39, 110, 164
Census Bureau, 23–24, 41n6
Center for Digital Scholarship, at IUPUI, 134
Center for Research Libraries, 69n30
Al-Chark (record store), 120
ChatGPT, 28, 33–34, 44n40
Chavez, Laney, 76
Chinatown Branch, of Boston Public Library, 55
Chinatown Community Land Trust (CCLT), 46, 70n35
Chinatown Gate, in Boston, 52
Chinese Consolidated Benevolent Association of New England, 55
Christians, Muslims and, 52, 133
churches, 48–49, 56, 96n25
citizenship, Johnson-Reed Act of 1924 limiting, 6
civil rights, urban renewal and, 58
Clifford, James, 38
TheClio.com, 142
Cohen, Daniel J., 106
Cole, William, 54–55
Collins, Blythe, 193n14
Columbia/Gramophone (label), 109, 120
Columbian Exposition, 108
"The Coming of the Arabic-Speaking People to the United States" (Younis), 48
communal institutions, Arabic-speaking Americans creating, 6
community archive, knowledge transmission and, 80–85
community engagement, public history and, 92–95
community history, pandemic-era, 135–144
community voices, 2
consumerism, Arab American culture and, 10
Corey, Helen, 133, 142, 144
COVID-19 pandemic, 47, 86, 121, 135–144, 201; HMRC impacted by, 77; *Midwest Mahjar* popularized during, 122–123
Cox, Richard J., 154

The Creative Reflective Practitioner (Candy), 199
La Crosse County Historical Society, 111
La Crosse Syrian/Lebanese Historic Walking Tour, 105
Culcasi, Karen, 37
culinary tourism, 174, 183, 192n1
culinary walking tour, 188
cultural belonging, Arab cuisine sharing, 41
cultural tourism, 193n14
Curtis, Edward E., IV, 27, 36, 50, 82
Curtis, Maria F., 6, 12

Daifallah, Nagi, 15
Daleel (newspaper), 118
Daniels, Mitch, 137
Dar Al Sabagh Diaspora Studies and Research Centre, 166
David, Warren, 122
Dearborn (Michigan), 174–180, 185, 192n2
DeBakey, Michael, 76
Delegate Council, 169
Denise (Algerian American), 166
Denison House, 56–57
Department of Education, Massachusetts, 54
desegregation, 84
Digger's Sting (restaurant), 114
Digital History (Cohen and Rosenzweig), 106
digital map, Boston Little Syria, 61–65
digital platforms, social inequalities reproduced by, 42n13
Al-Din, Farid Alam, 120–121
DipNote (series), 29–30
discrimination: discussions about, 146–147; politics responding to, 10; public history projects countering, 1
DNA testing, 42n13, 151, 159–161, 166–167
documentaries, 139–144
Douglass, Susan, 144
Dow v. United States (federal court case), 5
Dr. Maria-Rosario Jackson of the Urban Institute, 192n3
Duwaji, Omar, 47

East Dearborn (Michigan), 36
educational outreach, 145
Egyptian Tanoura folk dance, 73
Eldridge, Emma, 134

Elhillo, Safia, 16
Emergency Quota Act, 81
Emmy awards, 144
endogamy, 161
ethnicity, 159–160

Facebook, 107, 116–117, 122
Faculty Development Grant, University of Wisconsin–La Crosse, 115
Faddel, George, 90
Al-Fajr Mosque, 148
family history, 154, 163–165, 168; Arab American, 157; genealogy and, 152–153; public history and, 155–156
family name, 158
FamilySearch, 162, 163
FamilyTreeDNA, 42n13, 160–161
family trees, 158
Faour, Anna, 82
Faris and Yamna Naff Arab American Collection, at National Museum of American History Archives, 80
Fatat Boston (newspaper), 48, 55, 69n30
Fayze's (restaurant), 114
Federal Register, 22, 23
Ferguson, Timothy, 48
Fernea, B. J., 80
Fernea, Bob, 80
Ferris family, 113
Finding Your Roots (television show), 153
Fine, Todd, 121
"first writing since" (poem), 9
Fisher, Cory, 140, 144
Fisher, Rebecca, 139, 141–142, 144
Fivush, Robyn, 154
food, role of, 187–188
food landscapes, 177–178
Ford, Henry, 178
Ford Motor Company, 178
foreign policy, war-making and, 140–141
Franco, Barbara, 192n3
The Freedom's Journal (newspaper), 76
Frisch, Michael, 50, 196–197
funding, 131, 141

Gabriel Imports (business), 192n4
Galveston Daily News (newspaper), 88
Gamel, Bobby, 61
Garment District, in Boston, 54
Gaza, 66
genealogical education, 155

genealogical methodologies, 153–154
genealogical research, 151–152, 155–156
genealogy: Arab American, 156–159, 173n44; family history and, 152–153; history, public history and, 154–156; research organizations and websites on, 161–162
genealogy, Arab American, 169–170
Genealogy Standards (Board for Certification of Genealogists), 154
geographic definition, of Arab identity, 26
geographic origins, racial and ethnic identities and, 24
geography, Arab American public histories and, 41
Geography Educators' Network of Indiana, 145
Germack (business), 192n4
Gibran, Gibran Khalil, 5, 55–56, 78
Glitch (platform), 64
Global Village, 147
Golam, Agapios, 117
Gomes de Assunção, Naiara Müssnich Rotta, 199
Google, 28–32, 117
Google Earth, 114
Google Scholar, 149n21
GPT-4, 34
grocers, 46–47, 51, 55, 58
grocery stores, 109, 180–181
Groot, Jerome de, 155
Grossmann Gallery, at University of Massachusetts Boston, 60
Guantánamo, 199

Al-Haddad, Mohammad, 139
hafli. See party
Hagopian, Elaine, 48, 68n12
Haiek, Joseph R., 8
Hal (Lebanese American), 164
Haley, Alex, 153
Hall, Stuart, 79
Halloween (series), 7
Hamad, Suheir, 9
Hamaker, Cathy, 143
Hamawi, Ernest, 5
Harb, George, 163
Harvard, 50
Hashems (shop), *101*, 181
hate crimes, 9
Hawaweeny, Raphael, 108

Hefni, Ziad, 134
Hernandez, Ericka, 86
Hernandez, Geraldo, 86
Hider, Sadie, 137
Hinds, Stuart, 198
"Historian Versus the Genealogists" (Sedgwick), 155
history, family. *See* family history
history, genealogy, public history and, 154–156
Hitti, Philip, 78, 108–109
HMRC. *See* Houston Metropolitan Research Center
HMV/Victor (label), 109, 120
Ho, Stephanie, 117
Al Hoda (newspaper), 86, 108
Hodgson, Marshall G. S., 130
Holzman, Laura, 143
honors students, 134
hooks, bell, 10, 197, 202n5
Hourani, Albert, 26
Houston Hotel Association, 91
Houston Metropolitan Research Center (HMRC), 76–77
Howell, Sally, 194n15
"Hunna Collective" (public history project), 16
Hussein (Yemeni American), 165, 169
Hyatt, Sue, 131

IBH. *See* Indiana Historical Bureau
identity. *See* Arab American identity; Arab identity
iftar, 73–74
"Immigrant Races in Massachusetts" (Cole), 54
immigration, Lebanese Civil War impacting, 65–66
Immigration Act (1924), 110
Immigration and Nationality Act, 54
Immigration and Naturalization Act, 4
impact, measuring, 147
Indiana Historical Bureau (IBH), 142, 146–147
Indiana Historical Society Press, 134
Indiana Humanities, 145
Indiana Muslim Advocacy Network, 131–132
Indiana Pacers, 147
Indianapolis (Indiana), 131, 133
Indianapolis Colts, 137

"Indianapolis' Syrian Colony" (article), 137
Indiana Senate, Resolution 37 passing, 142
Indiana University (IU), 129–130, 141
Indiana University Indianapolis, *104*, 142–143, 195
Indiana University–Purdue University Indianapolis (IUPUI), 129–131, 134
Indiana University School of Liberal Arts, 129–130
Indy Reads, 145–147
Institute for Arab American Affairs, 7
Institute of Museum and Library Services, 36
"The Institutional Development of the Arab-American Community of Boston" (Hagopian), 48
instrument of power, public history as, 195
International Federation for Public History conference, 155
International Sites of Conscience movement, 199
Islam, 17n6. *See also* Muslims
Israel, 7, 66
IU. *See* Indiana University
IUPUI. *See* Indiana University–Purdue University Indianapolis

Jackson, Jesse, 74
Jacobs, Linda, 13
Jamail, Joseph D., Jr., 77
Jawad, Sajjad, 138
Jermoumi, Rabia, 138
John F. Fitzgerald Expressway, 54
John S. Lufty Square, in Boston, 57
Johnson, Lyndon B., 82
Johnson-Reed Act, 6, 81
Joseph, Suad, 156
Joseph P. Healey Library, at University of Massachusetts Boston, 60–61
Josiah Quincy Grammar School, 55
Judd, Graham, 139
al-Jumhuriya (magazine), 61–62
Jung Hotel, 91

Kadaj, Lila, 117
Kane, Beverle, 148
Karacand, Naim, 116
Karawan Records (label), 116
Karem-Albrecht, Charlotte, 107
Kawak, Ronnie, 134
Kawkab Amrika. See American Star

Kayyali, Randa, 12
Kfoury-Keefe Funeral Home, 58
Khan, Rukhsana, 17
Khan, Yasmin, 140
Khater, Akram, 12, 77, 86, 93–94, 163
Khayrallah, Moise A, 12
Khayrallah, Vera, 12
Khayrallah Center for Lebanese Diaspora Studies, 12–13, 162, 163–164, 170
Khoury (immigrant ancestor), 169
knowledge transmission, community archive and, 80–85
Koussan family, 180–181
Kozenski, Kathleen, 145
Kristin (Palestinian Lebanese American), 166
Ku Klux Klan, in Wisconsin, 110
Kulana Arab YouTube channel, 159

La Crosse (Wisconsin), *102*, 105, 108–109, 123
La Crosse Historic Syrian/Lebanese Walking Tour, 123–126
La Crosse Public Library, 125
Lane, Stephen, 138
Lebanese Civil War, 4, 65–66
Lebanese national origin, 3–4
Lebanese Syrian Ladies' Aid Society (LSLAS), 48, 56
Lebanon, 67n5, 87
LeCours, Rosie, 71n50
Levantine bias, 14
Leventhal Map and Education Center: Atlascope tool by, 63; at Boston Public Library, 61
libraries. *See specific libraries*
Lion of the Desert (film), 7–8
Little Amal (puppet), 66–67
Little Syria, in Boston, 45–46, 50–51, 56, 65–66, *103*
Little Syria, in New York City, 14, 63
Lockwood, William, 178, 184
Lockwood, Yvonne, 178, 184
Lowe, Lisa, 187
LSLAS. *See* Lebanese Syrian Ladies' Aid Society
Lucas Oil Stadium, 137, 140
Lufty, John S., 57

Macksoud, Abraham J., 109, 120–121
Macksoud Records, 120–121

Maha (Iraqi American), 164–165
Maloof, Alexander, 115–116, 119
Manganello, Vincent, 137, 139
Mann, Carolina Johnsson, 155
Mansfield, Peter, 26
Mansour, Joe, 46
marginalization, 108
marketing, promotion and, 190–191
Markos family, 113
Marshood, Ruba, 145
Mary Soo Hoo Park, in Boston, 52
Massachusetts. *See* Boston
Massachusetts Bay Colony, 46
Massachusetts Department of Education, 54
Massachusetts Historical Society (MHS), 60
Massachusetts Institute of Technology (MIT), 59
Melan, Joseph, 117
MENA. *See* Middle Eastern or North African
Menconi, Evelyn Abdalah, 48, 49
MERIP. *See* Middle East Research and Information Project
The Message (film), 7–8
The Messenger (newspaper), 48–49
MHS. *See* Massachusetts Historical Society
Middle East, 31–32, 37, 159
Middle East Department, in British Colonial Office, 32
Middle Eastern or North African (MENA), 22–24, 42n6, 99, 110; Arab identity contrasted with, 25; "white" and, 35
Middle East Research and Information Project (*MERIP*) (journal), 31
Midwest: Arabic-speaking Muslims migrating to, 129; Syrian refugees in, 9
Midwest Mahjar (blog), 9, 105–106, 107, 114; COVID-19 pandemic popularizing, 122–123; 78 rpm records and, 115–121
MIT. *See* Massachusetts Institute of Technology
Mitiche, Faouzia, 138
Mitiche, Farid, 138
Mizna (journal), 16
Modern Standard Arabic, 40
Mohammed, Khadega, 185
Moise A. Khayrallah Center for Lebanese Diaspora Studies, 190
Mokarzel, Naoum, 108
Mokarzel, Salloum, 86, 89

Mommy's Khimar (Thompkins-Bigelow), 17n7
Monsoor, Elaine, 109
Monsoor's Sporting Goods Store, 124
Morad, Zaki, 109
Mouftah, Nermeen, 138
Mullins, Paul, 129, 131, 147
multiculturalism, 187
museums, 35–36, 49, 80, 170, 192n3. *See also* Arab American National Museum
music, 119–120
The Music of Arab Americans (Rasmussen), 116, 118
Muslet, Dounya, 138
Muslim Americans, 9/11 impacting, 130
Muslim Ban, by Trump, 9
Muslims, 3; Arabic-speaking, 129; Black, 17n6; Christians and, 52, 133; Sunni, 26
MyHeritage.com, 167

Naff, Alixa, 6, 49–51, 74, 80–81, 84–85
Naff Collection, 49, 80
Nagoski, Ian, 119, 121
Najjar, Diana, 138
Nassar, Khalil, 52
National Academy of Television Arts and Sciences, 144
National Arab American Museum, 170
National Association of Arab Americans and Arab American University Graduates (AAUG), 74, 78
National Basketball Association, 147
National Content Test (NCT), 23, 42n6
National Council of Public History, 1, 195
National Football League, 137
National Genealogical Society (NGS), 153
National Historical Publications and Records Commission (NHPRC), 78, 85, 86, 92
National Museum of American History, 49
National Museum of American History Archives, of the Smithsonian, 80
national origin, Lebanese, 3–4
National Origins Act of 1924, 3–4
National Performance Network, 175
National Register of Historic Places, 55
National Society for Arab and Arab American Genealogy (NSAB), *104*, 167–168, 170, 173n48
National Society of Arab and Arab American Genealogy, *104*

National Trust for Historic Preservation, 56
naturalization: Arabic-speaking settlers and, 5; history of, 109–110
NCT. *See* National Content Test
Newcombe, Lydia, 77
New England Humanities Consortium, 67n8
News Circle Publishing House, 8
newspapers, Arab American, 86–92
New York City (New York): Battery Tunnel in, 58; La Crosse connected to, 108–109; Little Syria in, 14, 63
New York Times (newspaper), 155
NGS. *See* National Genealogical Society
NHPRC. *See* National Historical Publications and Records Commission
Nichols, John, 53
Nikola, Hanna (aka John Nichols), 53
Noble, Safiya Umoja, 29, 42n13
North Carolina State University, 12–13, 163–164
nostalgia, 110
NSAB. *See* National Society for Arab and Arab American Genealogy

OCR. *See* optical character recognition
Office of Management and Budget (OMB), U.S., 22–23, 35
Olas, Joseph, 131
OMB. *See* Office of Management and Budget
"On Genealogy" (Groot), 155
OpenAI, 34
oppressed community, public history and, 198–199
Oprah's Roots (live special), 139
optical character recognition (OCR), 163
oral history, 134–136, 196
Oral History Project, University of Wisconsin–La Crosse, 111
organizations, Arab American, 162–164
Orientalism (Said), 78
Orthodox Church Sunday School, 75
Ottoman Boston (exhibition), 59–61
"Ottoman Boston," 47
"Ottoman Diasporas in New England" (research program), 67n8
Ottoman Empire, 27
Our Lady of Lourdes Syrian Melkite Catholic Church, 112, 124

Our Lady of the Cedars of Mount Lebanon Church, 56
"Overcoming Challenges of Connection With Your Middle Eastern Roots" (presentation), 163

Palestine, 7, 66, 84
Palestine Daily Herald (newspaper), 88
Palestine Human Rights Campaign (PHRC), 74
pan-Arab ethnicity, 37–38
pandemic, COVID-19. *See* COVID-19 pandemic
Park, Sadie, 57–58
partnerships, 131, 186–187
party (*hafli*), 72
PBS, 139, 144–145
"the peddler thesis," 107
peddling, 54, 90
The Pen (*Al Qalam*) (art installation), 14
Pence, Mike, 140
The Pen League (*Al-Rabita Al-Qalamiyya*), 78, 82, 86–92
periodicals, Arab Americans printing, 8
Peters, George, 57
phonograph records, 109, 111
photos, 157–158
PHRC. *See* Palestine Human Rights Campaign
political causes, public history supporting, 7
politics, discrimination responded to with, 10
Population Division, Census Bureau of, 23–24
Port Arthur News (newspaper), 87, 90
prejudice, public scholarship influencing, 1
Presbyterian Church, 89
"The Presence of the Past" (Rosenzweig and Thelen), 35–36
"Preserving Arab American Family History" (program), 163
Presidential Arts and Humanities production grant, from IU, 141
problem setting, 131
products, expanding engagement with different, 144–147
professional expertise, 199–200
projects, Arab Americans, 162–164
promotion, marketing and, 190–191
PRX, 185

public history, Arab American. *See specific topics*
Public History for a Post-Truth Era (Ševčenko), 199
public history initiatives, Arab American women launching, 6
public scholarship, prejudice influenced by, 1
public trust, in museums, 35–36

Qaddoura, Fady, 138, 142
al-Qaeda, 8
Qahwa House, 184
Al Qalam. *See The Pen*
QGIS (geographic information system), 64
Quora (crowd-sourcing platform), 32

Al-Rabita Al-Qalamiyya. *See* The Pen League
RACE.ED (journal), 31
racial and ethnic identities, geographic origins and, 24
racial classification, 97n36, 126n5
racial structures, U.S., 39
racism, 8–17, 19n37, 25–26, 68n12, 198
Radcliffe Institute, 50
Raddad, Eyas, 139, 148
Rainbow Coalition, 74
Ramadan month, 72–73
Ramallah (Shaheen), 163
Ramallah Family Tree Project, 163
Ramallah Preservation Project, 163
Rania (Palestinian American), 165
Rankin, Bill, 65
Rashid, Albert, 120–121
ar-Rashid, Harun, 5
Rasmussen, Anne, 116, 118
records. *See* 78 rpm records
reflection, 147–148
reflective practice, 2, 196, 199–200
The Reflective Practitioner (Schön), 199–200
regional cultural production, 86–92
religion, among Arab Americans, 133
Renan, Ernest, 25–26
research, 31, 67n8, 69n30, 76–78, 166; genealogical, 151–152, 155–156; script writing and, 190; standards of, 153–154
researcher stories, Arab American, 164–169
Research Guides@Tufts, 152
Resolution 37, Indiana Senate passed by, 142

restaurants, 45, 52–53, 58, *103*, 114, 182–184
Rizzo, Mary, 198
Roots (miniseries), 153
RootsTech, 153, 162
Rosenzweig, Roy, 35–36, 106
Rotch Library, in School of Architecture and Planning, at MIT, 59

Sahara Syrian Restaurant, 45, 58, 71n47, *103*
Said, Edward, 78
Saint Elias Antiochian Orthodox Church, *102*, 112–113, 117, 124
St. George Orthodox Church, 48–49, 82, 131, 138
St. Michael's Orthodox Church, 81
St. Michael the Archangel Mission, 85
Salmone, Philip, 112
Salt Lake Institute of Genealogy, 172n27
Schlesinger Library, at Radcliffe Institute, 49–50
Schön, Donald A., 199–200
School of Architecture and Planning, at MIT, 59
School of Liberal Arts, Indiana University, 129–130
script writing, research and, 190
Sedgwick, John, 155
Seikaly, Shirene, 156
Semitic family, Arabs and, 25–26
9/11, 8–9, 130, 194n15
settlement houses, 56
Ševčenko, Liz, 199–200
78 rpm records, 9, 106–107, 109, 111; Antiochian Orthodox priests recording on, 118–119; *Midwest Mahjar* and, 115–121
Shahadi Brothers, 109
Shaheen, Azeez, 163
Shaheen, Jack, 105
Shakir, Evelyn, 48, 67n11
Shakir, Hannah Sabbagh, 48
Shakir, Wadie, 48, 55
shared authority, 2, 132, 136–138, 196, 199–200, 202n3; allyship contrasted with, 198; sharing authority contrasted with, 197
A Shared Authority (Frisch), 50, 116
sharing authority, shared authority contrasted with, 197
Shatila, Riad, 182
Shatila bakery, 182
Shayma (Egyptian American), 166–167

Shibley, Fred, 48
Shibley, Moses Khalil, 53
Shibley, Richard, 48
Shinnawi, Abeer, 144
shops, *101*
"Should You Believe Wikipedia" (Bruckman), 32
Shrum, Rebecca K., 50
Shryock, Andrew, 187, 194n15
Silva, Yasmine, 77
Silver, Christopher, 119
Simins, Jill Weiss, 138
Six-Day War, 78, 80
Skaff, Elaine Khoury, 83
Skaff, Ruth Ann, 6, 73–76, 77, 81–84, 91
Skaff, Thomas, 79, 81–85
Skaff, Victor, 114
Skaff Family Arab American Archive (Skaff collection), 12, 75–79, 83, 86, 92–95, 97n44
Smithsonian, 80
social inequalities, digital platforms reproducing, 42n13
SouFed. *See* Southern Federation of Syrian Lebanese American Clubs
South Cove, in Boston, 67n4, 71n50
South End, of Boston, 45
Southern Federation of Syrian Clubs Official Bulletin (pamphlet), 90–92
Southern Federation of Syrian Lebanese American Clubs (SouFed), 89, 92, 97n43
Southwest Asian and North African (SWANA), 18n17, 29, 35, 110
Spangler, Ian, 63
stakeholders, determining, 131
State Department, 29–30
"Statistical Policy Directive No. 15," 22
Stiffler, Matthew Jaber, 10, 51, 75, 77
StoryCorps app, 134, 135
Stowe, Noel J., 200–201
Sunni Muslims, 26
Super Greenland Market, 180–181
SWANA. *See* Southwest Asian and North African
Sweiss Imports (business), 192n4
Syria, 67n5, 92
Syria-Lebanese Room, 87–88
Syrian American Brotherhood Hall, 138, 147
Syrian American Club, 53–54
Syrian community, 57, 108

Syrian Day Dance, 88
Syrian Girls Friendly Club, 90
Syrian Grocery, 46–47, 51
Syrian Grocery Importing Co., 58
Syrian Ladies Educational Society of Oklahoma City, 91
"Syrian/Lebanese Community of La Crosse History" (Facebook page), 105, 111–115
The Syrian Lebanonite Voice (newspaper), 87–88, 89
Syrian refugees, 105; in Midwest, 9; Pence opposing, 140
Syrians, 27–28, 108–109; Cole on, 54–55; in South Cove, 67n4
Syrians in America (Hitti), 108–109
The Syrian World (newspaper), 89

Tang, GVGK, 197
tatreez (needlework patterns), 10
Tedro, Hadji Ali Philip, 77
Teebagy, John, 48–49
Telligman, Megan, 145
Texas, 75–76, 78–79, 81
"Texas Bound" (website), 13, 93–94
Thelen, David, 35–36
Thomas, Danny, 84–85
Thompkins-Bigelow, Jamilah, 17n7
Tibbits Opera House, 15
tourism: culinary, 174, 183, 192n1; cultural, 193n14
"Travels in America" (Abdou), 109
Trump, Donald, 9
Tufts University, 54
Turath (exhibition), 86, 92
Turnpike extension project, Syrian community impacted by, 57–58
23andMe, 42n13
Twitter, 107, 122

UCLA. *See* University of California Los Angeles
United Farm Workers of America (UFW), 15, 165
United South End Settlements (USES), 48, 68n16
United States (U.S.), 99, 140–141, 199. *See also specific places*
University of California Los Angeles (UCLA), 80
University of Houston–Clear Lake, 72, 78, 85

University of Massachusetts Boston, 60
University of Pittsburgh, 87
University of Texas, 80
University of Wisconsin–La Crosse: Faculty Development Grant from, 115; Oral History Project by, 111
urban renewal, civil rights and, 58
U.S. *See* United States
U.S. Census, 4, 35, 39, 110, 164. *See also* Middle Eastern or North African
USES. *See* United South End Settlements
U.S. racial structures, 39

virtual public histories, 106

al-Wafa' (newspaper), 69
Wakeen, Fred, 114
walking tours, 51–59, 189, 191
Wandering Boston's Little Syria (exhibition), 60
war-making, foreign policy and, 140–141
Warren Avenue tour, 178–182
Washington Street Historical Society (WSHS), 13–14, 63, 121
al-watan. *See* Arab homeland
Al-Wataniyya Hotel and Restaurant, 52
Weidman, Carly, 144
West Lafayette Public Library, 145–146
WFYI-TV (PBS affiliate), 139, 144–145
WhatsApp, 132

"white," 5; Arab Americans as, 38–39; MENA and, 35
"White, But Not Quite" (article), 31
white-supremacist capitalist patriarchy, 197, 202n5
Wikipedia, 28, 32–33
William G. Abdalah Memorial Library, 49
Wisconsin, *102*, 105, 108–109, 110, 123
women's histories, 113–114
Wood, Melanie Skaff, 81
The World (radio program), 185
World Fairs, 87
World's Columbian Exhibition, 87
WSHS. *See* Washington Street Historical Society

xenophobia, 19n37

Yazbek, Joseph, 56
Yemeni Americans, public history projects on, 14–15
YMAC. *See* Young Men's Amusement Club
Yoder, Mickey, 134
Young Men's Amusement Club (YMAC), 90
Younis, Adele, 48
YouTube, 138, 159

Zalila, Faiza, 73
Zarick, Ann, 138

www.ingramcontent.com/pod-product-compliance
Lightning Source LLC
Chambersburg PA
CBHW020653230426
43665CB00008B/415